# MARILYN MANSON

*the long hard road out of hell*

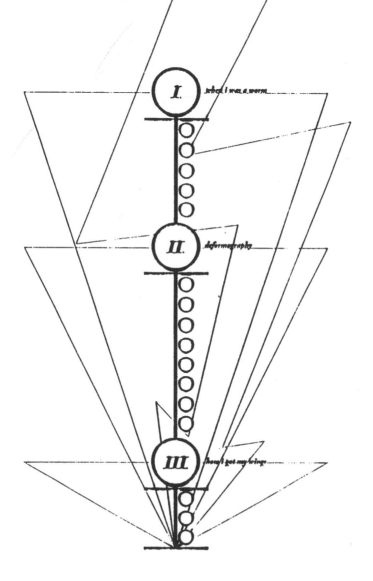

I. *when i was a worm*

II. *deformography*

III. *i have got my wings*

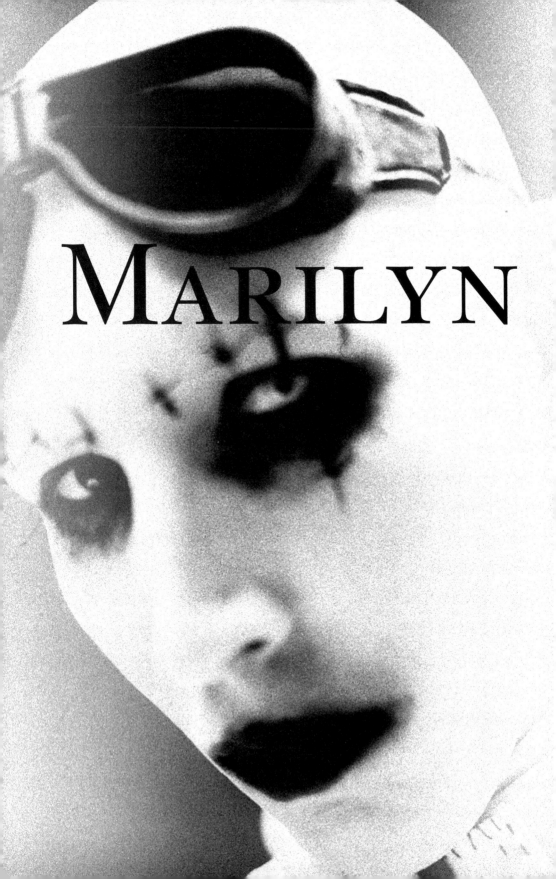

MARILYN

# MANSON

## *the long hard road out of hell*

### WITH NEIL STRAUSS

I. *what I was a worm*

II. *deformography*

III. *through your nose to your toes*

HC

*An Imprint of HarperCollinsPublishers*

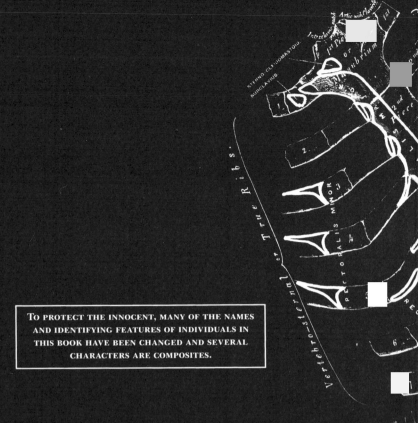

TO PROTECT THE INNOCENT, MANY OF THE NAMES
AND IDENTIFYING FEATURES OF INDIVIDUALS IN
THIS BOOK HAVE BEEN CHANGED AND SEVERAL
CHARACTERS ARE COMPOSITES.

A HARDCOVER EDITION OF THIS BOOK WAS PUBLISHED IN 1998 BY
HARPERCOLLINS*PUBLISHERS*.

*the long hard road out of hell.*

HARPERCOLLINS BOOKS MAY BE PURCHASED FOR EDUCATIONAL, BUSINESS, OR SALES
PROMOTIONAL USE. FOR INFORMATION PLEASE WRITE: SPECIAL MARKETS DEPARTMENT,
HARPERCOLLINS*PUBLISHERS*, INC., 10 EAST 53RD STREET, NEW YORK, NY 10022.

FIRST HARPERPERENNIAL EDITION PUBLISHED 1999.

DESIGNED BY P.R. BROWN @ BAU-DA DESIGN LAB, INC.

ISBN 0-06-039258-4
ISBN 0-06-098746-4 (PBK.)

08 09 ❖/RRD H  40 39 38 37 36 35

*But someday,*

IN A STRONGER AGE THAN THIS DECAYING, SELF-DOUBTING
PRESENT, HE MUST YET COME TO US, THE REDEEMING MAN, OF GREAT
LOVE AND CONTEMPT, THE CREATIVE SPIRIT WHOSE COMPELLING
STRENGTH WILL NOT LET HIM REST IN ANY ALOOFNESS OR ANY BEYOND,
WHOSE ISOLATION IS MISUNDERSTOOD BY THE PEOPLE AS IF IT WERE
FLIGHT FROM REALITY—WHILE IT IS ONLY HIS ABSORPTION, IMMERSION,
PENETRATION INTO REALITY, SO THAT, WHEN HE ONE DAY EMERGES AGAIN
INTO THE LIGHT, HE MAY BRING HOME THE REDEMPTION OF THIS REALITY;
ITS REDEMPTION FROM THE CURSE THAT THE HITHERTO REIGNING IDEAL
HAS LAID UPON IT. THE MAN OF THE FUTURE, WHO WILL REDEEM US NOT
ONLY FROM THE HITHERTO REIGNING IDEAL BUT ALSO FROM THAT WHICH
WAS BOUND TO GROW OUT OF IT, THE GREAT NAUSEA, THE WILL TO
NOTHINGNESS, NIHILISM; THIS BELL-STROKE OF NOON AND OF THE GREAT
DECISION THAT LIBERATES THE WILL AGAIN AND RESTORES ITS GOAL TO
THE EARTH AND HIS HOPE TO MAN; THIS ANTICHRIST AND ANTINIHILIST;
THIS VICTOR OVER GOD AND NOTHINGNESS—
HE MUST COME ONE DAY.

*— Friedrich Nietzsche, On the Genealogy of Morals*

# CONTENTS

Fig. 565.—Femoral hernia. Superficial dissection.

# INTRODUCTION

Outside it was raining cats and barking dogs.
Like an egg-born offspring of collective humanity, in
sauntered Marilyn Manson. It was obvious—
he was beginning to look and sound a lot like Elvis.

David Lynch—New Orleans 2:50 a.m.

To Barb and Hugh Warner
May God forgive them for bringing me into this world

*when i was a worm*

I.

PART

*I.*

# I

## *the man that you fear*

AMONG ALL THINGS THAT CAN BE CONTEMPLATED UNDER THE
CONCAVITY OF THE HEAVENS, NOTHING IS SEEN THAT AROUSES THE
HUMAN SPIRIT MORE, THAT RAVISHES THE SENSES MORE, THAT
HORRIFIES MORE, THAT PROVOKES MORE TERROR OR ADMIRATION
THAN THE MONSTERS, PRODIGIES AND ABOMINATIONS THROUGH
WHICH WE SEE THE WORKS OF NATURE INVERTED,
MUTILATED AND TRUNCATED.
— *Pierre Boaistuau, Histoires Prodigieuses, 1561*

**CIRCLE ONE - LIMBO**

HELL to me was my grandfather's cellar. It stank like a public toilet, and was just as filthy. The dank concrete floor was littered with empty beer cans and everything was coated with a film of grease that probably hadn't been wiped since my father was a boy. Accessible only by rickety wooden stairs fixed to a rough stone wall, the cellar was off-limits to everybody except my grandfather. This was his world.

Dangling unconcealed from the wall was a faded red enema bag, a sign of the misplaced confidence Jack Angus Warner had in the fact that even his grandchildren would not dare to trespass. To its right was a warped white medicine cabinet, inside of which were a dozen old boxes of generic, mail-order condoms on the verge of disintegration; a full, rusted can of feminine-deodorant spray; a handful of the latex finger cots that doctors use for rectal exams; and a Friar Tuck toy that popped a boner when its head was pushed in. Behind the stairs was a shelf with about ten paint cans which, I later discovered, were each filled with twenty 16-millimeter porno films. Crowning it

all was a small square window—it looked like stained glass, but it was actually stained with a gray grime—and gazing through it really felt like looking up out of the blackness of hell.

What intrigued me most in the cellar was the workbench. It was old and crudely made, as if it had been constructed centuries ago. It was covered with dark orange shag carpeting that looked like the hair on a Raggedy Ann doll, except it had been soiled from years of having dirty tools laid on it. A drawer had been awkwardly built into the bench, but it was always locked. On the rafters above was a cheap full-length mirror, the kind with a wooden frame meant to be nailed to the door. But it was nailed to the ceiling for whatever reason—I could only imagine why. This was where my cousin, Chad, and I began our daily and progressively more daring intrusions into my grandfather's secret life.

I was a scrawny thirteen year old with freckles and a bowl cut courtesy of my mother's shears; he was a scrawny twelve year old with freckles and buck teeth. We wanted nothing more than to become detectives, spies or private investigators when we grew up. It was in trying to develop the requisite skills in stealth that we were first exposed to all this iniquity.

At first, all we wanted to do was sneak downstairs and spy on Grandfather without him knowing. But once we started discovering everything that was hidden there, our motives changed. Our after-school forays into the cellar became half teenage boys wanting to find pornography to jerk off to and half a morbid fascination with our grandfather.

Nearly every day we made new and grotesque discoveries. I wasn't very tall, but if I balanced carefully on my grandfather's wooden chair I could reach into the space between the mirror and the ceiling. There I found a stack of black and white bestiality pictures. They weren't from magazines: just individually numbered photographs that looked like they had been handpicked from a mail-order catalog. There were early-seventies photos of women straddling giant horse dicks and sucking pigs' dicks, which looked like soft, fleshy corkscrews. I had seen *Playboy* and *Penthouse* before, but these photographs were in another class altogether. It wasn't just that they were obscene. They were surreal—all the women were beaming real innocent flower-child smiles as they sucked and fucked these animals.

There were also fetish magazines like *Watersports* and *Black Beauty* stashed behind the mirror. Instead of stealing a whole magazine, we would take a razor blade and carefully cut out certain pages. Then we'd fold them into tiny squares and hide them underneath the large white rocks that framed my grandmother's gravel driveway. Years later, we went back to find them, and they were still there—but frayed, deteriorated and covered with earthworms and slugs.

One afternoon in the fall as Chad and I sat around my grandmother's dining room table after a particularly uneventful day at school, we resolved to find out what was inside the locked workbench drawer. Always hell-bent on stuffing her brood with food, my grandmother, Beatrice, was force-feeding us meat loaf and Jell-O, which was mostly water. She came from a rich family and had tons of money in the bank, but she was so cheap that she'd try to make a single Jell-O package last for months. She used to wear knee-high hose rolled down around her ankles and odd gray wigs that obviously didn't fit. People always told me I resembled her because we were both skinny with the same narrow facial structure.

Nothing in the kitchen had changed as long as I'd been eating her inedible food there. Above the table hung a yellowing picture of the pope in a cheap brass frame. An imposing-looking family tree tracing the Warners back to Poland and Germany, where they were called the Wanamakers, was plastered on the wall nearby. And crowning it all was a large, hollow, wooden crucifix with a gold Jesus on top, a dead palm leaf wrapped around it and a sliding top that concealed a candle and a vial of holy water.

Under the kitchen table, there was a heating vent that led to the workbench in the cellar. Through it, we could hear my grandfather coughing and hacking down there. He had his CB radio on, but he never talked into it. He just listened. He had been hospitalized with throat cancer when I was very young and, for as long as I could remember, I never heard his actual voice, just the jagged wheezing that he forced through his tracheostomy.

We waited until we heard him leave the cellar, abandoned our meat loaf, poured our Jell-O into the heating vent and ventured downstairs. We could hear our grandmother calling futilely after us: "Chad! Brian! Clean the rest of your plates!" We were lucky all she did was yell that afternoon. Typically, if she caught us stealing food,

CARPI RADIALIS LONGUS

CARPI RADIALIS BREVIS

Capitate

Hamate

Artic. with 7b

Artic. with 5b

Base

1ST DORSAL

INTEROSSEOUS

2ND DORSAL

INTEROSSEOUS

3RD DORSAL

INTEROSSEOUS

4TH DORSAL

2nd

3rd

Body

4th

Head

Base

Body

EXT. D

COMMU

EXT. DIG

QUIN

Head

Base

EXT. DICIT.

COMMUN.

EXT. DICIT.

COMMUN.

Body

Head

Body

Head

FIG. 226.—Bones of the left hand.    Dorsal surface.

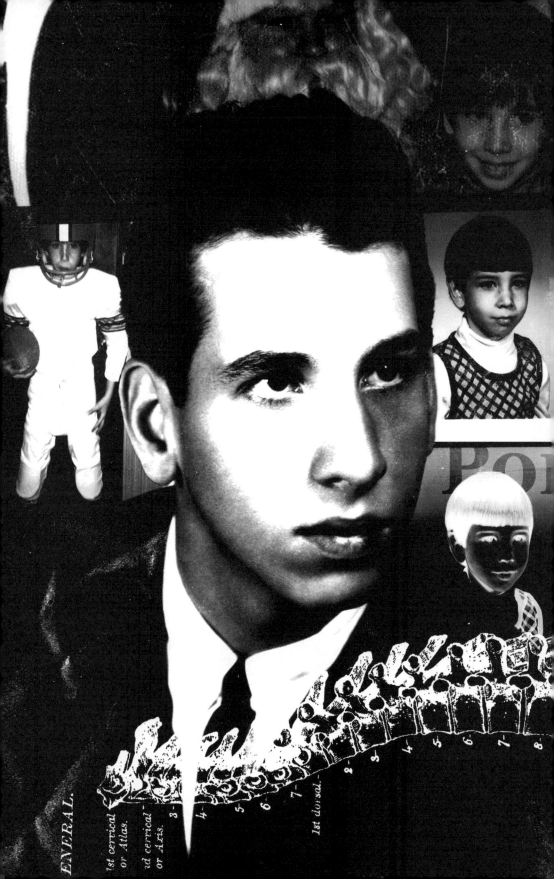

PORTRAIT *of an American Family*

talking back or goofing off, we were forced to kneel on a broomstick in the kitchen for anywhere from fifteen minutes to an hour, which resulted in perpetually bruised and scabbed knees.

Chad and I worked quickly and quietly. We knew what had to be done. Picking a rusted screwdriver off the floor, we pried the workbench drawer open wide enough so we could peek in. The first thing we saw was cellophane: tons of it, wound around something. We couldn't make out what it was. Chad pushed the screwdriver deeper into the drawer. There was hair and lace. He wedged the screwdriver further, and I pulled until the drawer gave way.

What we discovered were bustiers, bras, slips and panties—and several tangled women's wigs with stiff, mottled hair. We began unwrapping the cellophane, but as soon as we saw what it concealed, we dropped the package to the floor. Neither of us wanted to touch it. It was a collection of dildoes that had suction cups on the bottom. Maybe it was because I was so young, but they seemed enormous. And they were covered with a hardened dark orange slime, like the gelatinous crust that builds up around a turkey when it is cooked. We later deduced that it was aged Vaseline.

I made Chad wrap the dildoes up and put them back in the drawer. We'd done enough exploring for the day. Just as we were trying to force the drawer shut, the cellar doorknob turned. Chad and I froze for a moment, then he grabbed my hand and dove under a plywood table that my grandfather had his toy trains set up on. We were just in time to hear his footsteps near the bottom of the stairs. The floor was covered with train-set paraphernalia, mostly pine needles and fake snow, which made me think of powdered donuts trampled into dirt. The pine needles were prickling our elbows, the smell was nauseating and we were breathing heavily. But grandfather didn't seem to notice us or the half-open drawer. We heard him shuffling around the room, hacking through the hole in his throat. There was a click, and his toy trains began clattering around the large track. His black patent leather shoes appeared on the floor just in front of us. We couldn't even see as high as his knees, but we knew he was sitting. Slowly his feet began scraping against the ground, as if he were being violently rocked in his seat, and his hacking grew louder than the trains. I can't think of any way to describe the noise that issued from his useless larynx. The best analogy I can offer is an old, neglected lawn mower trying to

sputter back to life. But coming from a human being, it sounded monstrous.

After an uncomfortable ten minutes passed, a voice called from the top of the stairs. "Judas Priest on a pony!" It was my grandmother, and evidently she'd been yelling for some time. The train stopped, the feet stopped. "Jack, what are you doing down there?" she yelled.

My grandfather barked at her through his tracheostomy, annoyed.

"Jack, can you run to Heinie's? We're out of pop again."

My grandfather barked back, even more annoyed. He didn't move for a moment, as if debating whether or not to help her. Then he slowly rose. We were safe, for the time being.

Fig. 984.—Transverse section of the trachea, just above its bifurcation, with a bird's-eye view of the interior.

After doing our best to conceal the damage we had done to the workbench drawer, Chad and I walked to the top of the stairs and into the breezeway, where we kept our toys. Toys, in this case, being a pair of BB guns. Besides spying on my grandfather, the house had two other attractions: the woods nearby, where we liked shooting at animals, and the girls in the neighborhood, who we were trying to have sex with but never succeeded until much later.

Sometimes we'd go to the city park just past the woods and try to pick off little kids playing football. To this day, Chad still has a BB lodged beneath the skin in his chest, because when we couldn't find any other targets we would just shoot at each other. This time, we stuck close to the house and tried to knock birds out of trees. It was malicious, but we were young and didn't give a shit. That afternoon I was out for blood and, unfortunately, a white rabbit crossed our path. The thrill of hitting it was incommensurate, but then I went to examine the damage. It was still alive and blood was pouring out of its eye, soaking into its white fur. Its mouth kept meekly opening and closing, taking in air in a last, desperate attempt at life. For the first time, I felt bad for an animal I had shot. I took a large flat rock and ended its suffering with a loud,

quick and messy blow. I was very close to learning an even harsher lesson in killing animals.

We ran back to the house, where my parents were waiting outside in a brown Cadillac Coupe de Ville, my father's pride and joy since landing a job as manager of a carpet store. He never came into the house for me unless it was absolutely unavoidable, and rarely even talked to his parents. He usually just waited outside uneasily, as if he were afraid of reliving whatever it was he had experienced in that old house as a child.

Our duplex apartment, only a few minutes away, wasn't any less claustrophobic than Grandpa and Grandma Warner's place. Instead of leaving home after she married, my mom brought her mother and father home with her to Canton, Ohio. So they, the Wyers (my mother was born Barb Wyer), lived next door. Benign country folk (my dad called them hillbillies) from West Virginia, her father was a mechanic and her mother was an overweight, pill-popping housewife whose parents used to keep her locked in a closet.

Chad fell ill, so I didn't go to my father's parents for about a week. Although I was disgusted and creeped out, my curiosity about my grandfather and his depravity still hadn't been satisfied. To kill time while waiting to resume the investigation, I played in our backyard with Aleusha, who in some ways was my only real friend besides Chad. Aleusha was an Alaskan malamute the size of a wolf and distinguishable by her mismatched eyes: one was green, the other was

blue. Playing at home, however, was accompanied by its own set of paranoias—ever since my neighbor, Mark, had returned home on Thanksgiving break from military school.

Mark was a roly-poly kid with a greasy blond bowl cut, but I used to look up to him because he was three years older than me and much more wild. I'd often see him in his backyard throwing stones at his German shepherd or thrusting sticks up its ass. We started hanging out when I was eight or nine, mostly because he had cable television and I liked watching *Flipper*. The television room was in his basement, where there was also a dumbwaiter for dirty laundry from upstairs. After watching *Flipper*, Mark would invent games like "Prison," which consisted of squeezing into the dumbwaiter and pretending like we were in jail. This was no ordinary jail: the guards were so strict that they didn't let the prisoners have anything—even clothes. When we were naked in the dumbwaiter, Mark would run his hands all over my skin and try to squeeze and caress my dick. After this happened a few times, I broke down and told my mother. She went straight to his parents, who, though they branded me a liar, soon sent him to military school. From then on, our families were bitter enemies, and I always felt that Mark blamed me for tattling on him and causing him to be sent away. Since he had returned, he hadn't said a word to me. He just glared maliciously at me through his window or over his fence, and I lived in fear that he'd try to exact some kind of revenge on me, my parents or my dog.

So it was somewhat of a relief to be back at my grandparents' the next week, playing detective again with Chad. This time we were determined to solve the mystery of my grandfather once and for all. After forcing down half a plateful of my grandmother's cooking, we excused ourselves and headed for the cellar. We could hear the trains running from the top of the stairwell. He was down there.

Holding our breath, we peered into the room. His back was to us and we could see the blue-and-gray flannel shirt that he always wore, with the neck stretched out, revealing a yellow and brown ring around the collar and a sweat-stained undershirt. A white band of elastic, also blackened with dirt, clung to his throat, holding the metal catheter tube in place over his Adam's apple.

A slow, tense wave of fear shuddered through our bodies. This was it. We crept down the creaky stairs as quietly as we could, hoping the trains would cover up the noise. At the bottom, we turned around

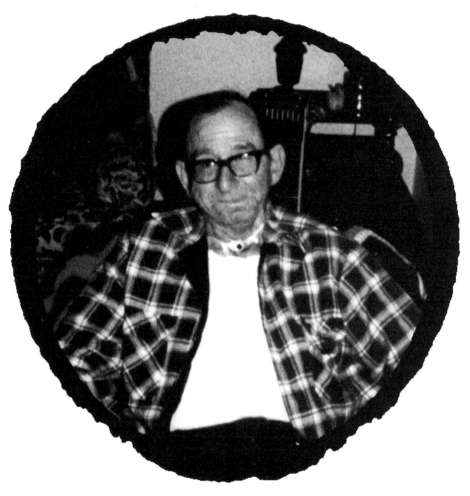

**JACK WARNER**

and hid in the stale-smelling alcove behind the staircase, trying not to spit or scream as cobwebs clung to our faces.

From our hiding place, we could see the train set: There were two tracks, and both had trains running on them, clanking along the haphazardly built rails and letting off a noxious electrical smell, as if the metal of the track were burning. My grandfather sat near the black transformer that housed the train's controls. The back of his neck always reminded me of foreskin. The flesh hung wrinkled off the bone, old and leathery like a lizard's and completely red. The rest of his skin was gray-white, like the color of birdshit, except for his nose, which had reddened and deteriorated from years of drinking. His

hands were hardened and callused from a lifetime of work, his nails dark and brittle like beetle wings.

Grandfather wasn't paying attention to the trains circling furiously around him. His pants were down around his knees, a magazine was spread over his legs, and he was hacking and moving his right hand rapidly in his lap. At the same time, with his left hand, he was wiping phlegm from around his tracheostomy with a yellow-crusted handkerchief. We knew what he was doing, and we wanted to leave right away. But we had trapped ourselves behind the stairs and were too scared to come out into the open.

Suddenly, the hacking sputtered to a halt and grandfather twisted around in his chair, staring straight at the stairwell. Our hearts froze. He stood up, pants sliding to his ankles, and we pressed against the mildewed wall. We couldn't see what he was doing anymore. My heart stabbed at my chest like a broken bottle and I was too petrified even to scream. A thousand perverted and violent things he was about to do to us flashed through my mind, though it would have taken nothing more than for him to touch me and I would have dropped dead with fright.

The hacking, jacking and shuffling of feet began again, and we let our breath out. It was safe to peer around the staircase. We didn't really want to. But we had to.

After several excruciatingly slow minutes, a gruesome noise leapt from his throat, like the sound a car engine makes when someone turns the key in the ignition when it's already on. I turned my head away, too late to keep from imagining the white pus squeezing out of his yellow, wrinkled penis like the insides of a squashed cockroach. When I looked again, he had lowered his handkerchief, the same one he'd been using to wipe away his phlegm, and was sopping up his mess. We waited until he left and then clambered back up the stairs, vowing never to set foot in that cellar again. If Grandfather knew we were down there or noticed the broken workbench drawer, he didn't say anything to us.

During the ride home, we told my parents what happened. I had the feeling that my mother believed most if not all of it, and that my father already knew from having grown up there. Though Dad didn't utter a word, my mother told us that years ago, when my grandfather still worked as a trucker, he was in an accident. When the doctors undressed him at the hospital, they found women's clothes under-

neath his own. It was a family scandal that no one was supposed to talk about, and we were sworn to secrecy. They were in utter denial of it—and still are to this day. Chad must have told his mother what we had seen, because he wasn't allowed to hang out with me for years afterward.

When we pulled into our driveway, I walked around back to play with Aleusha. She was lying in the grass near the fence, vomiting and convulsing. By the time the vet arrived, Aleusha was dead and I was in tears. The vet said someone had poisoned her. I had a funny feeling I knew who that someone was.

**ALEUSHA**

**THE LONG HARD ROAD OUT OF HELL**

# ②

## *for those about to rock,*
## *we suspend you*

[Brian Warner] was just average. He's always been really skinny like a twig. I would go over to his house and we'd listen to records together, stuff like Queensryche, Iron Maiden, lots of Judas Priest. I was more into it than he was. . . . I didn't think he really had anything going for him [musically] and maybe he doesn't. Maybe he just got lucky.
— *Neil Ruble, Heritage Christian School, class of 1987*

Brian Warner and I were in the same class at a Christian school in Canton, Ohio. Both Brian and I rejected the religious pressure of our education quite strongly. He, of course, promotes himself as a Satanist. I've rejected the whole idea of God and Satan, first by being an agnostic and then recently by becoming a witch.
— *Kelsey Voss, Heritage Christian School, class of 1987*

I'd like to ask [Marilyn Manson], "Did I influence you in any way to this lifestyle?" I keep thinking, "Wow, did I do something I should have done differently?"
— *Carolyn Cole, former principal, Heritage Christian School*

Jerry, I sometimes believe we're heading very fast for Armageddon right now.
— *Ronald Reagan, speaking to the Reverend Jerry Falwell*

# THE end of

the world didn't come when it was supposed to.

I was brainwashed to believe, in seminars every Friday at Heritage Christian School, that all the signs were there. "You will know the beast has risen up out of the ground, because there will be heard everywhere a great gnashing of teeth," Ms. Price would warn in her sternest, most ominous voice to rows of cowering sixth-graders. "And everyone, children and parents alike, will suffer. Those that don't receive the mark, the number of his name, will be decapitated before their families and neighbors."

At this point, Ms. Price would pause, dip into her pile of flash cards of the apocalypse and hold up an enlarged photocopy of a UPC symbol—but with the number at the bottom manipulated to read 666. This was how we knew the apocalypse was around the corner: the UPC code was the mark of the beast spoken about in Revelation, we were taught, and the machines being installed in supermarkets to read them would be used to control people's minds. Soon, they warned, this satanic price code would replace money and everyone would have to get the mark of the beast on their hands in order to purchase anything.

"If you do deny Christ," Ms. Price would continue, "and take this tattoo on your hand or forehead, you will be allowed to live. But you will have lost eternal"—and here she'd hold up a card showing Jesus descending from heaven—"life."

For other seminars, she had a card with a newspaper clipping detailing John Hinckley, Jr.'s then-recent attempt to assassinate Ronald Wilson Reagan. She would hold it up and read from Revelation 13: "Let him that hath understanding count the number of the beast: for it is the number of a man; and his number is 666." The fact that there were six letters in Reagan's first, middle and last names was one more sign that this was our final hour, that the Antichrist was here on earth and that we must prepare for the coming of Christ

and the rapture. My teachers explained all of this not as if it was an opinion open to interpretation, but as if it were an undeniable fact ordained by the Bible. They didn't need proof; they had faith. And this practically filled them with glee in anticipation of the coming apocalypse, because they were going to be saved—dead but in heaven and freed from suffering.

It was then that I began having nightmares—nightmares that continue to this day. I was thoroughly terrified by the idea of the end of the world and the Antichrist. So I became obsessed with it, watching movies like *The Exorcist* and *The Omen* and reading prophetic books like *Centuries* by Nostradamus, *1984* by George Orwell and the novelized version of the film *A Thief in the Night*, which described very graphically people getting their heads cut off because they hadn't received 666 tattoos on their forehead. Combined with the weekly harangues at Christian school, it all made the apocalypse seem so real, so tangible, so close that I was constantly haunted by dreams and worries about what would happen if I found out who the Antichrist was. Would I risk my life to save everyone else? What if I already had the mark of the beast somewhere on me—underneath my scalp or on my ass where I couldn't see it? What if the Antichrist was me? I was filled with fear and confusion at a time when, even without the influence of Christian school, I was already in turmoil because I was going through puberty.

Sure evidence of this is that despite Ms. Price's terrifying seminars detailing the world's impending doom, I found something sexy about her. Watching her preside over class like a Siamese cat, with her pursed lips, perfectly combed hair, silk blouses concealing a fuck-me body and stick-in-the-ass walk, I could tell there was something alive and human and passionate waiting to burst out of that repressed

## CIRCLE TWO - THE LUSTFUL

Christian facade. I hated her for giving me nightmares my entire teenage years. But I think I hated her even more for the wet dreams she inspired.

I was an Episcopalian, which is basically diet Catholic (same great dogma but now with less rules) and the school was nondenominational. But that didn't stop Ms. Price. Sometimes she'd start her Bible class by asking, "Are there any Catholics in the room?" When no one answered, she'd lay into Catholics and Episcopalians, lecturing us about how they misinterpreted the Bible and were worshipping false idols by praying to the pope and the Virgin Mary. I would sit there

mute and rejected, unsure whether to resent her or my parents for raising me as an Episcopalian.

Further personal humiliation came during Friday assemblies, when guest speakers would talk about how they had lived as prostitutes, drug addicts and practitioners of black magic until they found God, chose His righteous path and were born again. It was like a Satanists Anonymous meeting. When they were done, everyone would bow their heads in prayer. If anyone wasn't born again, the failed pastor leading the seminar would ask them to come on stage and hold hands and be saved. Every time I knew I should have walked up there, but I was too petrified to stand on stage in front of the entire school and too embarrassed to admit that I was morally, spiritually and religiously behind everybody else.

The only place I excelled was the roller-skating rink, and even that soon became inextricably linked with the apocalypse. My dream was to become a champion roller skater, and to that end I nagged my parents into squandering the money they had been saving for a weekend getaway on professional skates that cost over $400. My regular roller-skating partner was Lisa, a sickly, perpetually congested girl but nonetheless one of my first big crushes. She came from a strict, religious family. Her mother was a secretary for Reverend Ernest Angley, one of the more notorious televangelist faith healers of the time. Our pseudo-dates after skating practice usually began with making "suicides" at the rink's soda fountain—discolored combinations of Coke, 7-Up, Sunkist and root beer—and ended with a trip to Reverend Angley's ultraopulent church.

The Reverend was one of the scariest people I'd ever met: his perfectly straight teeth gleamed like bathroom tiles, a toupee sat clumped on top of his head like a hat made from wet hair caught in a bathtub drain and he always wore a powder blue suit with a mint green tie. Everything about him reeked of artificiality, from his plastic, over-manicured appearance to his name, which was supposed to evoke the phrase "earnest angel."

Every week, he called a variety of crippled people to the stage and supposedly healed them in front of millions of TV viewers. He would poke his finger in a deaf person's ear or a blind person's eye, yelling "Evil spirits come out" or "Say baby," and then wiggle his finger until the person on stage passed out. His sermons were similar to those at school, with the Reverend painting the imminent apocalypse in all its horror—except here there were people screaming, passing out and speaking in tongues all around me. At one point in the service, everyone would throw money at the stage. It would rain hundreds of quar-

ters, silver dollars and wadded-up dollar bills as the Reverend went right on testifying about the firmament and the fury. Along the walls of the church were numbered lithographs he sold depicting macabre scenes like the four horsemen of the apocalypse riding through a small town not unlike Canton at sunset, leaving a trail of slit throats behind them.

The services were three to five hours long, and if I fell asleep, they'd reprimand me and take me to a separate room where they held special youth seminars. Here, they'd chastise me and about a dozen other kids about sex, drugs, rock and the material world until we were ready to throw up. It was a lot like brain-washing: we'd be tired and they purposelessly wouldn't give us any food so that we were hungry and vulnerable.

Lisa and her mother were completely devoted to the church, mainly because Lisa was half-deaf when she was born and supposedly the Reverend had wiggled his finger in her ear and restored her hearing during a service. Because she was a churchgoer and her daughter had been blessed by a miracle of God, Lisa's mother constantly condescended to me, as if she and her family were better and more righteous. Every time they dropped me off at home after services, I imagined Lisa's mother making her wash her hands because they had touched mine. I was always distressed by the whole experience, but I went to church with them anyway because it was my only chance to be with Lisa outside of the skating rink.

Our relationship, however, soon went awry. Occasionally, something will happen that will change your opinion of someone irrevocably, that will shatter the ideal you've built up around a person and force you to see them for the fallible and human creature they really are. This happened when we were heading home after church one day, goofing off in the back seat of her mother's car. Lisa was making fun of how skinny I was, and I put my hand over her mouth to shut her up. As she began to laugh, she spewed a huge wad of thick, lime-green snot into my hand. It didn't seem real, which made it even more revolting. When I pulled away, a long string of it hung between my fingers and her face like apple taffy. Lisa, her mother and I were all equally horrified and embarrassed. I couldn't get rid of the feeling of her mucus stretched out and webbed between my fingers. In my mind, she had debased herself and shown me her true nature, proven herself to be a monster behind a mask, much like I imagined Reverend Angley to be. She wasn't any better than me, as her mom would have me believe. I didn't say another word to her— not then or ever.

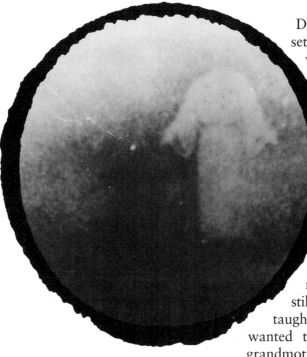

Disillusion had begun to set in at Christian school as well. One day in fourth grade I brought in a picture that Grandma Wyer had taken on an airplane flight from West Virginia to Ohio, and in the photo there appeared to be an angel in the clouds. It was one of my favorite possessions and I was excited to share it with my teachers, because I still believed everything they taught me about heaven and wanted to show them that my grandmother had seen it. But they said it was a hoax, scolded me and sent me home for being blasphemous. It was my most honest attempt to fit in with their idea of Christianity, to prove my connection with their beliefs, and I was punished for it.

It confirmed what I had already known from the beginning—that I wouldn't be saved like everybody else. I knew it every day when I left for school trembling with fear that the world would end, I wouldn't go to heaven and I'd never see my parents again. But after a year passed, then another, then another, and the world and Ms. Price and Brian Warner and the prostitutes who were born again were still there, I felt cheated and lied to.

Gradually, I began to resent Christian school and doubt everything I was told. It became clear that the suffering they were praying to be released from was a suffering they had imposed on themselves—and now us. The beast they lived in fear of was really themselves: It was man, not some mythological demon, that was going to destroy man in the end. And this beast had been created out of their fear.

The seeds of who I am now had been planted.

"Fools aren't born," I wrote in my notebook one day during ethics class. "They are watered and grown like weeds by institutions such as Christianity." During dinner that night, I confessed it all to

my parents. "Listen," I explained, "I want to go to public school, because I don't belong here. Everything I like, they're against."

But they wouldn't have any of it. Not because they wanted me to have a religious education, but because they wanted me to have a good one. The public school in our neighborhood, GlenOak East, sucked. And I was determined to go there.

So rebellion set in. At Christian Heritage School, it didn't take much to rebel. The place was built on rules and conformity. There were strange dress codes: on Mondays, Wednesdays and Fridays, we had to wear blue pants, a white button-down shirt and, if we wanted, something red. On Tuesdays and Thursdays, we had to wear dark green pants and either a white or yellow shirt. If our hair touched our ears, it had to be cut. Everything was regimented and ritualistic, and no one was allowed to stand out as better than or different from anyone else. It wasn't very useful preparation for the real world: turning all these graduates loose every year with the expectation that life will be fair and everyone will be treated equally.

Beginning at age twelve, I embarked on an ever-escalating campaign to get kicked out of school. It started, innocently enough, with candy. I've always felt a kinship with Willy Wonka. Even at that age, I could tell that he was a flawed hero, an icon for the forbidden. The forbidden in this case was chocolate, a metaphor for indulgence and anything you're not supposed to have, be it sex, drugs, alcohol or pornography. Whenever they showed *Willy Wonka and the Chocolate Factory* on the Star Channel or in our rundown local movie theater, I would watch it obsessively while eating bags and bags of candy.

At school, candy and sweets—except for the Little Debbie snack cakes on the lunchroom menu—were contraband. So I would go to Ben Franklin's Five and Ten, a neighborhood store that looked like an old soda shop, and load up on Pop Rocks, Zotz, Lik-M-Stix and

## CIRCLE THREE - THE GLUTTONOUS

those pill-like pastel tabs that are glued to white paper and impossible to eat without digesting small shreds of paper as well. Looking back on it, I gravitated toward candies that were the most like drugs. Most of them weren't just sweets, they also produced a chemical reaction. They would fizz in your mouth or make your teeth black.

So I became a candy pusher, peddling the stuff during lunchtime for as much as I wanted because no one else had access to sweets during school. I made a fortune—at least fifteen dollars in quarters and

New Kuwatch Sex Aid Adventure Kit Supplement
Special OFFER

## ONE TIME ONLY!

WITH THE PURCHASE OF THE KUWATCH SEX AID KIT
AND 12 PROOFS OF PURCHASE FROM AUNT JEMIMA
SYRUP YOU CAN RECIEVE THIS EXCITING SUPPLEMENT.
INCLUDING: WHIP, TWO-OVERSIZED GROIN GRINDERS, FISHING ROD
NIPPLE TASSLES, METAL SHOP GOGGLES, FISH-NET STOCKINGS,
BRONZED DOG DICK NECKLACE AND GEMINI DOUBLE-FUN HELMET.

dimes—in the first month. Then someone narced on me. I had to turn in all my candy and the money I had made to the authorities. Unfortunately, I wasn't kicked out of school—just suspended.

My second project was a magazine. In the spirit of *Mad* and *Cracked*, it was called *Stupid*. The mascot was, not unlike myself, a buck-toothed, big-nosed kid with acne who wore a baseball cap. I sold it for twenty-five cents, which was pure profit because I copied the pages for free at the Carpet Barn, where my dad worked. The machine was cheap and worn down, with an acrid, carbonlike odor, and it never failed to smear all six pages of the magazine. In a school starved for smut and dirty jokes, however, *Stupid* quickly caught on—until I was busted again.

The principal, Carolyn Cole—a tall, slouched, prissy woman with glasses and curly brown hair piled on top of her birdlike face—called me into her office, where a roomful of administrators were waiting. She thrust the magazine into my hands and demanded that I explain the cartoons about Mexicans, scatology and, especially, the Kuwatch Sex Aid Adventure Kit, which was advertised as including a whip, two oversized groin grinders, a fishing rod, nipple tassels, metal shop goggles, fishnet stockings and a bronzed dog dick necklace. As would happen many times later in life, they kept interrogating me about my work—not understanding whether it was supposed to be art, entertainment or comedy—and asking me to explain myself. So I exploded and, in exasperation, threw the papers up in the air. Before the last one had fluttered to the ground, Mrs. Cole, red in the face, ordered me to grab my ankles. From the corner of the room, she picked up a paddle, which had been so sadistically designed by a friend in shop class that it had holes in it to minimize wind resistance. I was given three hard, fast Christian whacks.

By then, I was truly lost. During Friday seminars, the girls kept their purses under the wooden chairs they sat in. When they bowed their heads, I would drop to the floor and steal their lunch money. If I discovered any love letters or notes, I'd purloin them as well and, in the interest of fairness and free speech, give them to the people that they were about. If I was lucky, they caused fights, tension and terror.

I had already been listening to rock and roll for years—but, as my penultimate project, I decided to start making money off it. The person who lent me my first rock album was Keith Cost, a big, dopey, oafish kid who looked like he was thirty but was actually in third grade. After listening to Kiss's *Love Gun* and playing with the toy pop gun that came with it, I became a card-carrying member of the Kiss Army and the proud owner of countless Kiss dolls, comics, T-shirts

and lunchboxes, none of which I was allowed to bring to school. My dad even took me to see their concert—my first—in 1979. About ten different teenagers asked him for his autograph because he was disguised as Gene Simmons from the *Dressed to Kill* album cover—complete with green suit, black wig and white makeup.

The person who irrevocably entrenched me in rock and roll and the lifestyle that accompanies it was Neil Ruble: He smoked cigarettes, had an actual mustache, and had allegedly lost his virginity. So, naturally, I idolized him. Half friend, half bully, he opened up the floodgates to Dio, Black Sabbath, Rainbow—basically anything with Ronnie James Dio in it.

My other unflappable source of album recommendations was Christian school. As Neil was turning me on to heavy metal, they were conducting seminars on backward masking. They would bring in Led Zeppelin, Black Sabbath and Alice Cooper records and play them loudly on the P.A. system. Different teachers would take turns at the record player, spinning the albums backward with an index finger and explaining the hidden messages. Of course, the most extreme music with the most satanic messages was exactly what I wanted to listen to, chiefly because it was forbidden. They would hold up photographs of the bands to frighten us, but all that ever accomplished was to make me decide that I wanted long hair and an earring just like the rockers in the pictures.

At the top of my Christian schoolteachers' enemies list was Queen. They were especially against "We Are the Champions" because it was an anthem for homosexuals and, played backwards, Freddie Mercury blasphemed, "My sweet Satan." Regardless of the fact that they had already taught us that Robert Plant said the exact same thing in "Stairway to Heaven," once they had planted the notion that Freddie Mercury said "My sweet Satan," we heard it every time. Also in their satanic album collection was Electric Light Orchestra, David Bowie, Adam Ant and anything else with gay themes that would give them another opportunity to align homosexuality with wrongdoing.

Soon, the wood panels and high rafters of my basement bedroom were covered with pictures from *Hit Parader*, *Circus* and *Creem*. Every morning I woke up staring at Kiss, Judas Priest, Iron Maiden, David Bowie, Mötley Crüe, Rush and Black Sabbath. Their hidden messages had reached me.

The fantasy element of much of this music soon drew me to Dungeons & Dragons. If every cigarette you smoke takes seven minutes off of your life, every game of Dungeons & Dragons you play delays the loss of your virginity by seven hours. I was such a loser that

I used to walk around school with twenty-sided dice in my pockets and design my own modules like Maze of Terror, Castle Tenemouse and Caves of Koshtra, a phrase that, much later in life, became slang for the sensation of having snorted too much coke.

Naturally, none of the kids in school liked me because I played Dungeons & Dragons, I liked heavy metal and I wasn't going to their youth group rallies and engaging in social activities like burning rock albums. I didn't fit in any better with the kids from public school, who used to kick my ass on a daily basis for being a sissy from private school. And I hadn't been roller-skating much since Lisa slimed me. My

only other source of friends was a study and play group for the children of parents who had come in contact with Agent Orange during Vietnam. My father, Hugh, was a helicopter mechanic and a member of the Ranch Hands, the covert group responsible for dumping the hazardous herbicide all over Vietnam. So from the day I was born until the end of my teenage years the government brought my father and me to a research center for yearly physical and psychological studies in search of adverse effects. I don't think there were any, though my enemies might disagree. One of the side effects the chemical had on my father was that because he went public with information on Agent Orange, resulting in a front-page story on him in the *Akron Beacon Journal,* the government severely audited his taxes for the next four years.

Because I wasn't deformed, I didn't fit in with the other children in the government study group or at the regular retreats for kids whose parents were suing the government for exposure to the chemical. The other children had prosthetic limbs, physical irregularities

THE LONG HARD ROAD OUT OF HELL

and degenerative diseases, and not only was I comparatively normal but my father was the one who had actually sprayed the stuff on their fathers, most of whom were American infantry soldiers.

In an effort to accelerate my delinquency and feed my growing addiction to money, I graduated from peddling candy and magazines to music. The only other kids in my neighborhood who went to Heritage Christian School were two skinny, all-American, Latter-Day Saint brothers with matching buzz cuts. The older brother, Jay, and I had nothing in common. He was only interested in the Bible. I was only interested in rock music and sex. The younger brother, Tim, was more rebellious. So just as Neil Ruble had turned me on to rock music, I introduced Tim to heavy metal and bullied him the rest of the time. He wasn't allowed to listen to music in his house, so I sold him a cheap black tape recorder with big rectangular push buttons and a carrying handle on the end.

Next, he needed some music to hide under his bed with the cassette deck. So I began making regular bicycle rides to a place called Quonset Hut, which didn't allow minors in the door since it was a head shop as well as a record store. I looked exactly my age—fifteen—but no one stopped me. It didn't matter anyway because the pipes, roach clips and bongs there were a complete mystery to me.

When Tim started buying the tapes at the jacked-up prices I told them they had cost me, I realized that there were at least a hundred other potential customers at school. I started buying all the albums played during backward-masking seminars and selling them to schoolkids, from third-graders to upperclassmen. A W.A.S.P. album purchased for seven bucks at Quonset Hut was worth twenty dollars at Heritage Christian School.

Instead of squandering the profits on tapes for myself, I later decided to just steal back the albums I had sold. Since there was an

## CIRCLE FOUR - THE AVARICIOUS

honor system at school, none of the lockers were locked. And since no one was allowed to listen to rock and roll, if anyone told on me they'd be incriminating themselves as well. So during class I'd ask for a hall pass and steal the cassettes out of the lockers.

It was a perfect system, but it didn't last long. Tim decided that, even if he was to be punished himself, it was worth turning me in. Once again I found myself face to face with Mrs. Cole and a bevy of administrators and disciplinarians in the principal's office. But this time I didn't have to explain the music—they already thought they

knew what it was all about. They had caught me buying rock tapes, selling them and stealing them; they knew I was continuing to make magazines and branching out into cassette tapes (full of prank calls and dirty songs about masturbation and flatulence recorded with my cousin Chad under the name Big Bert and the Uglies). And I had already been punished in the principal's office twice in the past few months. The first time was for accidentally hitting my music teacher, Mrs. Burdick, in the crotch with a slingshot I had made out of a heavy-duty rubber band, a wooden ruler and, as ammunition, melted chunks of Crayola crayons stolen from art class. The second was for fulfilling Mrs. Burdick's homework assignment of bringing in an album for the class to sing by showing up with AC/DC's *Highway to Hell*. But all of that still did not add up to an expulsion.

My final desperate caper involved revisiting the dreaded basement of my grandfather and stealing a dildo from his secret workbench drawer. I wore gloves so I wouldn't get any of the crusted Vaseline on me. After school the next day, Neil Ruble and I snuck into Ms. Price's classroom and pried open her desk drawer. It contained her own secrets, which were just as taboo to Christian school as my grandfather's were to suburbia: semierotic romance novels. There was also a handheld vanity mirror, which made sense since Ms. Price was always very concerned about her appearance. At the time, Chad and I regularly attempted to get the attention of two sisters who lived near my grandparents by throwing rocks at cars and trying to cause accidents so they'd come running outside. In the same sick, twisted way, putting a dildo in Ms. Price's drawer was the only outlet I had for expressing my latent, frustrated lust for her.

To our disappointment, no one said a word about it in school the next day. But I was definitely the chief suspect, which I discovered when Mrs. Cole called my parents into school. She didn't mention the dildo; instead, she lectured them on disciplining and instilling the fear of God in the juvenile delinquent they had raised. That's when I realized that I would never be expelled. Half the kids at Heritage Christian School were from lower-income families, and the school received a pittance from the state to enroll them. I was among the children who could pay, and they wanted the money—even if it meant dealing with my dildoes, heavy metal cassettes, candy, dirty magazines and smut-filled recordings. I realized that if I ever wanted to get out of Christian school, I would have to exercise my own free will to walk away. And two months into tenth grade I did just that.

# ③

## *teen dabbler*

**"I KNOW SOME NEW TRICKS," SAID THE CAT IN THE HAT.
"A LOT OF GOOD TRICKS. I WILL SHOW THEM TO YOU. YOUR MOTHER
WILL NOT MIND AT ALL IF I DO."**
—*Dr. Seuss, The Cat in the Hat*

I lay on my bed, hands clasped on the back of my neck beneath my long brown hair, and listened to the hum of the washing machine in my parents' basement. It was my last night in Canton, Ohio, and I had decided to spend it alone, reflecting on the past three years of public school. Everything was packed for the move to Fort Lauderdale: records, posters, books, T-shirts, journals, photographs, love letters and hate letters. Christian school had prepared me well for public school. It defined the taboos, then held them away at arm's length, leaving me reaching for them in vain. As soon as I switched schools, it was all there for the taking—sex, drugs, rock, the occult. I didn't even have to look for them: They found me.

I've always believed that a person is smart. It's people that are stupid. And few things bear this out better than war, organized religion, bureaucracy and high school, where the majority mercilessly rules. When I looked back on my first days there, all I saw was an insecurity and doubt so overwhelming that a single pimple was capable of throwing my life out of balance. Not until my final days did I have self-confidence and self-respect, even a measure of individuality.

That last night in Canton, I knew that Brian Warner was dying. I was being given a chance to be reborn, for better or worse, somewhere new. But what I couldn't figure out was whether high school had corrupted me or enlightened me. Maybe it was both, and corruption and enlightenment were inseparable.

\*   \*   \*

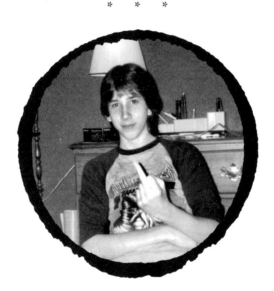

# THE INAUGURATION OF THE WORM

By the end of my second week in public school, I knew I was doomed. Not only was I starting two months into sophomore year, after most friendships had already formed, but after my eighth day in class I was forced to take another two weeks off. I developed an allergic reaction to an antibiotic I was taking for the flu. My hands and feet blew up like balloons, a red rash broke out across my neck, and I had trouble breathing because my lungs were so swollen. The doctors told me I could have died.

At that point, I had made one friend and one enemy at school. The friend was Jennifer, who was cute but fish-faced with naturally big lips that were swollen even larger by her braces. I met her on the

bus to school, and she became my first girlfriend. My enemy was John Crowell, the epitome of suburban cool. He was a big, stocky burnout perpetually clad in a denim jacket, an Iron Maiden T-shirt and blue jeans with a big-handled comb in the back pocket and a crotch area faded white from being worn too tight. When he walked down the halls, the other kids would trip over one another to get out of his way. He also happened to be Jennifer's ex-boyfriend, which put me at the top of his ass-kicking list.

The first week I was in the hospital, Jennifer came to visit me nearly every day. I'd talk her into the closet (where it was dark and she couldn't see my rash) and make out with her mercilessly. Until then, I hadn't gotten very far with women. There was Jill Tucker, a blond-haired minister's daughter with crooked buck teeth whom I kissed in the playground at Christian school. But that was in fourth grade. Three years later, I fell in mad, desperate love with Michelle Gill, a cute, flat-nosed girl with feathered brown hair and a wide mouth that probably went on to give good blow jobs in high school. But my chances with her went up in flames on a Christian school fund-raiser hike, during which she tried to teach me how to French kiss. I understood neither the point nor the technique, and consequently became a laughingstock after she told everyone in school.

Despite my utter lack of experience, I was determined to lose my virginity to Jennifer in that closet. But try as I might, all she let me do was grope her flat chest. By my second week in the hospital, she had grown bored and dumped me.

Hospitals and bad experiences with women, sexuality and private parts were completely familiar to me by that point in my life. When I was four, my mother took me to the hospital to get my urethra enlarged because my urinary tract wasn't wide enough for me to piss through. I'll never forget it, because the doctor took a long, razor-sharp drill and stuck it into the end of my dick. For months afterward, it felt like I was pissing gasoline.

Pneumonia marred my elementary school years, sending me to the hospital for three long stretches. And in ninth grade, I wound up in the hospital again after I feathered my hair, snapped on my ELO belt buckle, slipped into a pink button-down shirt and decided to head to the roller rink after a long absence. A girl whose frizzy hair, big nose and thickly painted eyeliner stand out more in my memory than her name asked me to couple-skate with her. When we were finished, a huge black guy with thick glasses known in the neighborhood as Frog walked toward us. He pushed her aside and, without saying a word, punched me solidly in the face. I crumpled, and he looked down at me

and spat: "You danced with my girlfriend." I sat there stunned, mouth bleeding and front tooth dangling off a red string from my gums. Now that I look back on it, I shouldn't have been so surprised. I was a sissy: I would have hit me too.

I didn't even like that girl, but she almost cost me my career as a singer. In the emergency room, they told me that the damage was permanent. To this day, I still have TMJ (temporomandibular joint) syndrome, a disorder that gives me headaches and a tight, sore jaw. Stress and drugs don't help it much.

Frog somehow found my number the next day, called to apologize and then asked if I wanted to work out with him some time. I declined. The idea of working up a sweat lifting weights with some guy who had just kicked my ass and the prospect of having to shower with him afterward didn't seem too appealing that afternoon.

The next time I ended up in the emergency room was because of Jennifer. Back in school after two weeks in the hospital, I roamed the halls alone and humiliated. No one wanted to make friends with a squirrely, long-haired guy with a rash-covered neck poking out of his Judas Priest jersey. Making matters worse were my long earlobes, which hung conspicuously below my hair like misplaced scrotum sacks. But one morning as I was leaving homeroom, John Crowell stopped me. It turned out we had something in common: our hatred of Jennifer. So we formed an alliance against her, and began devising ways of tormenting her.

One night I picked up John and my cousin Chad in my baby blue Ford Galaxie 500 and drove to an all-night grocery store, where we stole twenty rolls of toilet paper. We threw them in the back seat of the car and sped to Jennifer's house. Creeping into her yard, we began TP'ing her house, hanging toilet paper everywhere we could think of. I walked up to her window to paint some sort of obscenity on it. But, as I was trying to think of something suitably offensive, someone switched the light on. I sprinted away, reaching a gargantuan oak tree just as Chad was jumping off a branch. He dropped directly on top of me, and I collapsed onto the ground. Chad and John had to drag me away with a dislocated shoulder, a chin gushing blood and a jaw problem that, they told me in the emergency room later, was even worse than before.

Back in school, I had so many pressing reasons to want to get laid: to spite Jennifer; to be on equal terms with John, who had supposedly fucked Jennifer among many others; and to stop everyone else from making fun of me for being a virgin. I even joined the school band to meet girls. I started out playing macho instruments like bass and snare

drums. But I ended up on the last instrument anybody who feels insecure about himself should be playing: the triangle.

Finally, toward the end of tenth grade, John came up with a foolproof plan to get me laid: Tina Potts. Tina was even more fishfaced than Jennifer, had bigger lips and a more severe overbite. One of the poorer girls in school, she had a slouched, sunken posture that advertised her insecurity and internal misery, as if she had been abused as a child. All she had going for her were big tits, tight jeans that showed off her bovine ass and, according to John, she fucked—which was good enough for me. So I began talking to Tina. But, because I was hopelessly obsessed with my social standing, I only spoke to her after school when nobody else was around.

After a few weeks, I worked up the nerve to ask her to meet me in the park. In preparation, Chad and I went to my grandparents' house, stole one of the decrepit generic condoms from the cabinet in the cellar, and emptied half a bottle of Jim Beam from my grandmother's cupboard into my Kiss thermos. I knew it wasn't Tina I needed to get intoxicated—it was me. By the time we arrived at Tina's, which was about half an hour away, the thermos was empty and I was nearly falling over drunk. Chad continued home, and I rang her doorbell.

We walked together to the park and sat down on the side of a hill. Instantly, we began making out, and within minutes I had my hand down her pants. The first thing that went through my mind was how hairy she was.

CHAD AND ME

Maybe she didn't have a mother to teach her about shaving her bikini line. The next thing that went through my mind as I was fingering her and squeezing her tits was that I was on the verge of coming in my pants because I was so close to getting laid. To keep from losing it, I suggested that we take a walk.

We ambled downhill to a baseball diamond and, underneath a tree just behind home plate, I maneuvered her to the ground, not even realizing the significance of where we were. I wrestled with her tight pants, eventually peeling them off her ass, then pulled my pants down to my knees and tore open the faded package of grandfather's crusty rubber as if it were a Cracker Jack prize. Placing myself between her yawning legs, I began to slide inside her. Just the thrill of penetration was enough to make me orgasm, and before I was even in all the way, it was over. It was literally a pump and a dump.

To preserve what little was left of my dignity, I pretended I hadn't prematurely ejaculated.

"Tina," I squeaked. "Maybe we shouldn't be doing this. . . . It's so soon."

She didn't protest. She just stood up and put her pants on wordlessly. On the way home, I kept smelling my hand, which seemed permanently stained with the odor of high school girl pussy. In her mind, we hadn't even had sex. But for me and my friends, I was no longer a desperate boy. I was a desperate man.

I didn't talk much to Tina after that. But I soon got a taste of my own medicine—courtesy of the richest and most popular girl in school, Mary Beth Kroger. After staring wantonly at her for three years, I summoned all my courage and asked her out to a party when we were seniors. To my amazement, she accepted. We ended up at my house drinking beer, with me sitting next to her uncomfortable and too scared to make a move because she seemed like a complete prude. But my ideal of Mary Beth Kroger quickly disintegrated as she tore off her clothes, jumped on top of me and, without even bothering to use a condom, fucked me like a wild animal astride a high-speed rowing machine. The next day in school, Mary Beth put her prissy facade back on and proceeded to ignore me just as she always had. All I got out of it was deep scratch marks all over my back, which I proudly displayed to my friends, who, in honor of *A Nightmare on Elm Street*'s Freddy Krueger, renamed her Mary Beth Krueger.

By this time, my first fuck, Tina, was seven months pregnant. The father, ironically, was the person who had set me up with her: John Crowell. I didn't see much of John after that, because he was stuck dealing with the consequences of not using a rubber. I sometimes wonder whether they ever married, settled down and raised big-titted burnouts together.

<p style="text-align:center">*　　*　　*</p>

## PUNISHING THE WORM

Once Tina opened up the floodgates, I went on a rampage. Not a rampage of getting laid, but of trying to get laid. After months of

**CIRCLE FOUR - THE PRODIGAL**

rejection and masturbation, I met a blond cheerleader named Louise when I was drunk on Colt 45 during a high school football game in a farming community outside of Canton called Louisville. Though I

didn't know it at the time, she was the Tina Potts of Louisville: the local slut. She had thick lips, a flat nose and big, smoldering eyes, as if she was part mulatto and part Susanna Hoffs of the Bangles. She also had a Shirley Temple quality to her, because she was short with curly hair, but she seemed more into lap dancing than tap dancing. She was the first girl to give me a blow job. But, unfortunately, that wasn't all she gave me.

Nearly every day I picked her up and brought her down to my bedroom while my parents were still at work. We would listen to Rush's *Moving Pictures* or David Bowie's *Scary Monsters* and, now that I was more experienced in orgasm control, have normal teenage sex. She gave me so many hickeys that at one point my neck was too sore to even move. But I didn't mind, since I was able to wear them like badges of honor at school. She also swallowed, which gave me more bragging rights. One day she brought me a blue glitter bow tie that looked like something a Chippendale would wear. I think she wanted to try role-playing, but the only role-playing I was familiar with was Dungeons & Dragons.

After a solid week of fucking, Louise stopped returning my calls. I was worried I had gotten her pregnant, because I hadn't used a condom every time. I had this image of her mother sending her away to a convent and putting her—our—child up for adoption. Or maybe Louise was going to make me pay child support for the rest of my life. There was also the possibility that she'd gotten an abortion, something had gone wrong, she had died, and now her parents wanted to murder me. After I hadn't heard from her for several weeks, I decided to call her one more time, disguising my voice with a cloth over the telephone in case her parents answered.

Fortunately, she picked up the phone.

"I'm sorry I haven't called you in so long," she apologized. "I've been sick."

"What kind of sick?" I panicked. "You don't have a fever, do you? Are you throwing up in the morning or anything like that?"

It turned out that she was simply avoiding me because she was a slut and having a boyfriend would ruin her reputation. Those weren't her words exactly, but that was basically what she meant.

A few days later during math class, my balls started itching. It continued all day, spreading throughout my pubic hair. When I returned home, I went straight to the bathroom, dropped my pants and stood on the sink to examine myself. I instantly spotted three or four black scabs directly above my dick. I picked one off, and as I was looking at it, a little blood bubbled out.

I still thought it was a piece of dead skin, but when I held it up closer to the light, I noticed that it had legs—and they were moving. I screamed in shock and disgust. Then I smashed it into the sink, but it didn't splatter like I thought it would. It crunched like a little shellfish. Not knowing any better, I brought it to my mother and asked her what it was.

"Oh, well, you've got lice," she sighed good-naturedly. "You probably picked it up from the tanning bed."

As shameful as this is to admit, I was going for indoor tans regularly at the time. I had a terrible complexion—my face was literally swollen with acne—and the dermatologist told me there was a new type of tanning bed that would dry out my skin and help my social life.

My mother was clearly in denial that her young son had been fucking girls and getting crabs. Even my father, who always promised that the day I got laid we were going to celebrate with a bottle of champagne he had tucked away while working at Kmart, didn't really want to admit it. This was mainly because ever since I had discovered tits in junior high, he had been wanting to take me to a prostitute to lose my virginity. So I just played along with the tanning bed story.

My mother bought me medicine for body lice, but in the privacy of my bathroom I shaved off all my pubic hair and took care of the crabs myself. (At the time, shaving off body hair was still unusual to me.)

As far as I know, I've never had another venereal disease since then. And, to the best of my knowledge, my parents still think I'm a virgin.

\*   \*   \*

## CHARMING THE WORM

John Crowell and I stood on top of the hill in front of his house, taking turns swigging out of a bottle of Mad Dog 20/20 that we had conned an older kid into buying for us. We had been there for at least an hour, getting wasted and gazing out at the sleepy farmland around us, at the sky bruised and swollen with the threat of rain, and at the occasional automobile passing by on its way to civilization. We had fallen into a tipsy, self-satisfied daze when suddenly there was an explosion of gravel.

Engulfed in a cloud of dust, a green GTO veered recklessly into the driveway and skidded to a halt. The door slowly opened, and a black-booted foot struck the ground. A big head appeared above the door, with an enormous skull stretching the skin taut. His hair was curly and disheveled. The eyes sunken deep into his head blazed like pinpoints in the center of two dark circles. As he stepped away, I

noticed that, like Richard Ramirez, the Night Stalker, his hands, feet and torso were oversized and elongated. He wore a denim jacket emblazoned on the back with the universal symbol of rebellion: a pot leaf.

With his right hand, he pulled a gun out of the waistband of his pants. He raised his arm wildly into the air and squeezed out shot after shot, each kickback jerking his arm further in our direction. When the chamber was empty, he strode toward us. As I stood there stunned, he shoved me backward onto the ground, pushed John and grabbed the bottle of Mad Dog, draining it in seconds and throwing it into the grass. Wiping his mouth on a denim sleeve, he muttered something that sounded like lyrics from Ozzy Osbourne's "Suicide Solution" and strode into the house.

"That's my brother, dude," John said, his face, pale with fear moments ago, now glowing proudly.

We followed his brother upstairs and watched as he slammed shut his bedroom door and locked it. John wasn't allowed to set foot in his brother's room under penalty of serious pain. But he knew what went on in there: black magic, heavy metal, self-mutilation and conspicuous drug consumption. Like my grandfather's basement, the room represented both my fears and my desires. And though I was frightened, I wanted nothing more than to see what was inside.

In hopes that his brother would leave the house later that night, John and I walked outside to his barn—or at least the wooden skeleton of what had once been a barn—where we had stashed a bottle of Southern Comfort.

"You wanna see something really cool?" John asked.

"Sure," I nodded. I was always up for anything cool, especially if John deemed it so.

"But you gotta fucking promise not to say a word to fucking anyone."

"I promise."

"Promises aren't good enough," John snapped. "I want you to swear on your fucking mother's . . . No. I want you to swear that if you ever tell, may your dick shrivel and grow putrid and wither away."

"I swear that if I tell anyone may my dick wither and die," I said solemnly, knowing full well that I would need it in years to come.

"Wieners take all," John sneered, punching me painfully in the muscle beneath my shoulder. "So let's go, wiener."

He led me to the back of the barn, and we climbed a ladder to a hay loft. The straw was splattered with dried blood. Strewn around it

were bird carcasses; snakes and lizards with half their bodies missing, and partially decomposed rabbits with maggots and beetles eating away at the flesh still left on their bones.

"This," announced John, gesturing to the giant pentagram drawn in dripping red on the floor, "is where my brother holds his black masses."

It was like something out of a bad horror movie, where a troubled teen dabbling in the black arts takes things too far. There were even blood-caked pictures of various teachers and ex-girlfriends nailed to the walls and covered with obscenities written in thick, jagged strokes. As if he was taking on a starring role in the movie, John turned to me and said, "Do you want to see something even scarier?"

I was torn. Maybe I'd seen enough for one day. But I was also curious, and I nodded my assent. John picked up off the floor a stained and tattered copy of *The Necronomicon*, a book of spells which he claimed contained black magic incantations from the Dark Ages. We walked back to the house and John filled a backpack with flashlights, hunting knives, snack food and a few trinkets he said had magical powers. Our destination, John said, was the place where his brother sold his soul to the devil.

To get there, we had to climb through a sewer pipe that started near John's house and ran underneath a cemetery. We walked crouched over in the sludgy, rat-infested water, with no entrance or exit in sight, constantly conscious of the fact that in the mud on all sides of the pipe were dead bodies. I don't think I've ever been more terrified of the supernatural in my life. On that half-mile odyssey, every small noise produced a large, ominous echo, and I kept thinking I was hearing skeletons knocking on the outside of the pipe and undead creatures ripping through the metal, ready to grab me and bury me alive.

When we finally reached the other side, we were covered from head to foot with a thin film of sewage, spiderwebs and mud. We were in the middle of nowhere in a dark forest. After a half-mile of hacking through the overgrowth, a huge house loomed over us. Weeds had grown all around it, as if the forest was trying to reclaim the space, and every exposed patch of concrete was covered with pentagrams, upside-down crosses, renderings of Satan, heavy metal band logos and words and phrases like "cocksucker" and "fuck your mother."

We cleared away the vines and dead leaves covering an open window, climbed inside and searched the room with the beams of our flashlights. There were rats, cobwebs, broken glass and old beer cans.

In a corner the embers of a dying fire let us know that someone had recently been here. I turned around, and John was gone.

I called his name nervously.

"Up here," he yelled from the top of the stairs. "Check this out." Though I was starting to panic, I followed him upstairs and through a cluttered doorway. The room looked inhabited. There was a putrid yellow mattress on the floor, which was littered with hypodermic needles, a bent spoon and other drug paraphernalia. Lying around the mattress, like dried-out snake skins, were half a dozen used condoms alongside disintegrating pages from gay porno magazines that had been smashed into the floor.

We walked into the next room, which was completely empty except for a pentagram drawn on the south wall and surrounded by indecipherable runes. John pulled out his copy of *The Necronomicon.*

"What the fuck are you doing?" I asked.

"Opening the gates of hell to summon the spirits that once lived in this house," he said in as ominous a voice as he could muster. He traced a circle in the dust on the floor with his finger. As he completed it, a sharp sound came from downstairs. We stood completely still, barely even breathing, and listened to the darkness. Nothing, except for the sound of my pulse beating like a triphammer in my neck.

John stepped into the middle of the circle, and paged through the book to find the right incantation.

A metallic crash, much louder than the previous sound, echoed from downstairs. If whatever we had begun to do had any powers, we weren't ready for them. The alcohol in our blood turned to adrenaline and we ran—down the stairs, out the window and into the forest until we were breathless, sweaty and dry-mouthed. Dusk had fallen, and a few raindrops splattered around us. We avoided the sewer pipe, stumbling the rest of the way home through the woods as quickly as possible in complete silence.

By the time we were safely back in John's house, his brother was hopelessly stoned, roaming the house dazed and red-eyed. The drugs had worn down his aggressive edge, and he seemed almost sedate, which wasn't any less frightening than when he was manic. A snow-white cat was cradled in his arms, and he kept stroking it.

"That cat's his familiar," John whispered to me.

"His familiar?"

"Yeah, it's like a demon that's taken on animal form to help my brother with his magic."

This pure white, innocent-looking cat instantly transformed into a malevolent, dangerous creature in my mind. John's brother set it on

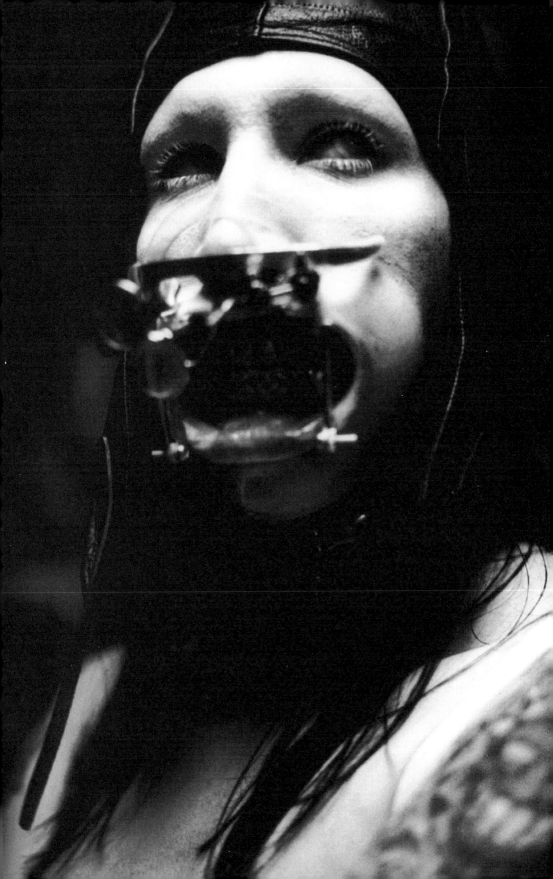

the ground, and it just sat there with its ears pinned back, staring straight at me through shining green eyes. Suddenly, its lips pulled back over its teeth and it began hissing at me.

"Man, that cat's gonna kill you," John said in a successful attempt to frighten me even more. "When you go to sleep, she's gonna scratch your eyes out and then bite off your tongue when you try to scream."

His brother looked us both over, glanced down at the cat, and said quietly, "Come on, let's go upstairs." And that was it: We didn't have to sneak behind his back or play detective. We were allowed to enter the forbidden room: Maybe John's spell to open the gates of hell had worked.

Though it was new and exciting to me, the room was exactly what you'd expect from a rural wastoid with a penchant for Satan. There was a black light shining on a poster of the grim reaper on a horse, half a dozen Ozzy Osbourne photos and red candles everywhere. In the back of the room stood a small altar draped in black velvet and surrounded by lit candles. But on top of it, instead of a skull or a pentagram or a sacrificed rabbit, there was a tall cylinder of yellowed glass with what looked like piss water inside. The gun sat threateningly on a table near the bed.

"Wanna smoke?" John's brother asked, lifting the cylinder off the altar.

"Smoke what?" I asked dumbly. I'd never even touched a bong or smoked pot before.

"The wacky weed," John grinned devilishly at me.

"That's alright, man. I don't do that stuff anymore," I lied unconvincingly.

Unfortunately, I didn't have a choice. It soon became apparent that John and his brother were going to beat the shit out of me if I didn't smoke their drugs.

John's brother lit up the bong, which was already filled with crumbled brown leaves, and took a Herculean puff, filling the room with sickly sweet smoke when he exhaled. I hacked and coughed through my first drags, but I soon felt it. Combined with the Mad Dog 20/20, the Southern Comfort, the bottle of wine being passed around and the *Blizzard of Ozz* album playing in the room, it sent my head reeling. The fact that nobody liked me at school began to fade out of my mind like blue Magic Marker reminders scrawled on the back of a greasy fist.

I sat there dizzily, cycling in and out, as John's brother began ranting. His face was flushed and twisted, and he was naming dozens of ancient spirits and demons he planned to conjure up and order to kill

people: teachers who had failed him, girlfriends who had dumped him, friends who had betrayed him, relatives who had mistreated him, employers who had fired him—basically anyone who had crossed his path since he was old enough to feel hatred.

Pulling a switchblade out of his pocket, John's brother made a long slice along the surface of his thumb and let it drip into a small bowl filled with a crusty brown-and-white flecked powder. "Bad Angarru!" he began chanting. "Ninnghizhidda! Thee I invoke, Serpent of the Deep! Thee I invoke, Ninnghizhidda, Horned Serpent of the Deep! Thee I invoke, Plumed Serpent of the Deep! Ninnghizhidda!"

He paused and took another toke, then rubbed the bloody powder against his lips, only vaguely aware of our presence.

"I summon thee, Creature of Darkness, by the works of darkness! I summon thee, Creature of Hatred, by the works of hatred! I summon thee, Creature of the Wastes, by the rites of the waste! I summon thee, Creature of Pain, by the words of pain!"

If this was what pot was like, I didn't want to be on it. I just kept staring at the gun, hoping John's brother wouldn't pick it up. At the same time, I was trying not to let him know I was staring at the gun because I didn't want to draw attention to it. He was clearly deranged, and if he wasn't a murderer already, there seemed to be no reason why he couldn't be one by the end of the night.

Minutes or hours elapsed. The bong kept coming around, but the water inside had been replaced with Southern Comfort in an attempt to get us even more fucked up. The Black Sabbath song "Paranoid" was playing on the stereo or in my head, the cat was hissing at me, the room was spinning, John's brother was daring me to drink the Southern Comfort out of the bong and John was chanting "chug it." Spineless worm that I was, I lifted the bong to my pot-parched lips, held my breath and downed what may have been the foulest shot ever concocted. Then . . . I don't know what happened. I can only assume that I blacked out and became just another canvas for the various subtle cruelties of the Crowell brothers.

I awoke to the sound of hissing at five P.M. (which seemed like a late time for me to wake up back then). The cat was still stalking me. I felt my eyes: They were still there. Then I threw up. Then I threw up again. And again. But as I knelt doubled over above the toilet, I realized that I had learned something from the previous night: that I could use black magic to turn the lowly lot life had given me around—to attain a position of power that other people would envy and accomplish things that other people couldn't. I also learned that I didn't like smoking pot—or the taste of bongwater.

## THE WORM SHEDS ITS SKIN

The first time I realized something was wrong with our family was when I was six and my father bought me a book about a giraffe that had been personalized so that I was a character in the story, going on adventures with the animal. The only problem was that my name was spelled Brain all through the book, which made for a disturbing image of a giraffe with a brain clinging to its back. I don't think my father even realized the mistake—and he had supposedly named me.

It was emblematic of the way he had always treated me, which is that he didn't treat me at all. He didn't care and wasn't around to care. If I wanted his attention, it was usually given to me with a belt doubled-over to make a loud snapping sound when it connected with my backside. When he came home from work and I was laying around playing Colecovision or drawing pictures, he would always find an excuse, like an unmown lawn or a full dishwasher, to blow up at me. I soon learned to look busy and responsible when he walked in, even if there was nothing to do. My mother always dismissed his violent outbursts as part of the same Vietnam War post-traumatic stress disorder that caused him to wake up in the middle of the night screaming and smashing things. As a teenager, whenever I brought friends home, he would ask them, "Have you ever sucked a sweeter dick than mine?" It was a trick question because, whether they said yes or no, they still ended up with his dick in their mouth, at least in the comedic sense of the question.

Occasionally, my father promised to take me places, but more often than not something more pressing would come up at work. Only on a few memorable occasions did we do anything together. Usually, he took me on his motorcycle to a strip mine near our house, where, using a rifle he had removed from the corpse of a Viet Cong soldier, he taught me how to shoot. I inherited good aim from my father, which served me well whether shooting BB guns at animals or throwing rocks at cops. I also inherited a bad temper with a short fuse, a headstrong ambition that can only be stopped by bullets or bouncers, a blunt sense of humor, an unquenchable appetite for tits and an irregular heartbeat, which is only made worse by ingesting lots of drugs.

Although I had so much in common with my father, I never wanted to admit it. Most of my childhood and adolescence was spent in fear of him. He constantly threatened to kick me out of the house and never failed to remind me that I was worthless and would never amount to anything. So I grew up a mama's boy, spoiled by her and

ungrateful for it. In order to make sure I clung even closer to her side, my mother used to try to convince me that I was more sickly than I was so she could keep me at home and care for me. When I first began breaking out in acne, my mother told me that it was an allergic reaction to egg whites (which gave her hives), and for a long time I believed her. She wanted me to be just like her, to be dependent on her, to never leave her. When I finally did at age twenty-two, she sat in my room every day and cried until one afternoon she thought she saw Jesus in silhouette against the doorway. Taking her vision as a sign that I was being watched over, she stopped lamenting and began keeping as pets the rats she was supposed to be feeding my snake. In her own overprotective way, she replaced me with the sickliest rat, which she named Marilyn, and not only went on to give mouth-to-mouth resuscitation to the rodent, but now keeps it in a crudely constructed oxygen tent made from Saran Wrap to prolong its life.

As a child, you accept whatever happens in your family as normal. But when puberty hits, the pendulum swings in the other direction, and acceptance turns into resentment. In ninth grade, I began feeling more and more isolated, friendless and sexually frustrated. I used to sit at my desk in class with a pocketknife, making cuts up and down my forearm. (I still have dozens of scars beneath my tattoos.) For the most part, I didn't bother to excel at school. Most of my education took place after class, when I escaped into a fantasy world—immersed in role-playing games, reading books like the Jim Morrison bio *No One Here Gets Out Alive*, writing macabre poems and short stories, and listening to records. I began to appreciate music as a universal healer, an entryway to a place where I could be accepted, a place with no rules and no judgments.

The person who had to bear the biggest brunt of my frustration was my mother. Perhaps my vitriolic outbursts against her were something else I inherited from my father. For a period, my parents had violent screaming matches because my father suspected her of cheating on him with an ex-cop turned private investigator. My father had always been by nature suspicious and was never able to let go of his jealousy even for my mother's first boyfriend, Dick Reed, a scrawny guy whose ass my dad

**Mom**

beat the day he met my mother at the age of fifteen. One of their louder fights took place after my father went through her purse, pulled out a wadded-up washcloth and demanded an explanation for it. I never figured out what was so suspicious about the item—whether it was from a strange hotel or it had been used to mop up semen. I remember the investigator in question coming by the house a few times with machine guns and *Soldier of Fortune* magazines, which impressed me because I was still interested in a career in espionage. Hate and anger are infectious, however, and I soon began resenting my mother because I thought she was breaking up the marriage. I used to sit on my bed and cry thinking about what would happen if my parents split up. I was afraid I'd have to choose between them and, because I was scared of my father, end up moving away and living in poverty with my mother.

In my room along with my Kiss posters, hand-drawn cartoons and rock albums, I also had a collection of glass Avon cologne bottles that my grandmother had given me. Each one was shaped like a different car, and I think it was the Excalibur that sent my mother to the hospital one night. She had come home late and wouldn't tell me where she had been. Suspecting her of cheating, I lost the temper my father had handed down to me and threw the bottle at her face, opening up a bloody gash over her lip and scattering cheap perfume and shards of blue glass across my floor. She still has a scar, which has

CIRCLE FIVE - THE WRATHFUL

served as her constant reminder never to have another child. In altercations that followed, I hit her, spit on her and tried to choke her. She never retaliated. She just cried, and I never felt sorry for her.

The anger I had pent up for being sent to Christian school, however, began to dissipate later in public school. My mother would let me stay home sick if, say, I couldn't comb my hair flat and didn't want any girls to see me or if someone at school wanted to beat me senseless. I began to appreciate her for it. But that, too, was only a phase.

As I lay in my bed that last night in Canton, I hated my parents more than I had ever hated them before. I was finally beginning to fit in in Canton, and now I had to live on the outskirts of frat-boy Fort Lauderdale because my father had gotten a new and boring job as a furniture salesman. I'd made it through the darkest places—from haunted houses to high school gyms. I'd had bad drugs, worse sex and no self-esteem. It was all over and behind me, and now I had to start all over again. I wasn't excited to move. I was bitter and angry—not just at my parents, but at the world.

# ④

## *the road to hell is paved with good rejection letters*

I WAS SOMEWHAT LONELY, AND I SOON DEVELOPED
DISAGREEABLE MANNERISMS WHICH MADE ME UNPOPULAR
THROUGHOUT MY SCHOOLDAYS. I HAD THE LONELY CHILD'S HABIT
OF MAKING UP STORIES AND HOLDING CONVERSATIONS WITH IMAGI-
NARY PERSONS, AND I THINK FROM THE VERY START MY LITERARY
AMBITIONS WERE MIXED UP WITH THE FEELING OF BEING ISOLATED
AND UNDERVALUED. I KNEW THAT I HAD A FACILITY WITH WORDS
AND A POWER OF FACING UNPLEASANT FACTS, AND I FELT THAT THIS
CREATED A SORT OF PRIVATE WORLD IN WHICH I COULD GET MY
OWN BACK FOR MY FAILURE IN EVERYDAY LIFE.
— *George Orwell, "Why I Write"*

January 20, 1988

Brian Warner
3450 Banks Rd. #207
Margate, FL 33063

John Glazer, Editor
*Night Terrors Magazine*
1007 Union Street
Schenectady, NY 12308

Dear John Glazer,

Enclosed is my previously unpublished story, "All in the Family." It is being submitted only to your magazine at the time. I would appreciate your consideration for a possible publication of the above mentioned story. I thank you for your time, and will be looking forward to your reply.

Sincerely,
Brian Warner

# ALL IN THE FAMILY
## by Brian Warner

He hoped the tape recorder would still work. It was one of those small portable ones often used in schools or libraries. Teddy didn't even realize the irony of his action—Angie was in fact the one who had bought it for him. He wiped the hair and blood off the corner and released a sigh of frustration. "Mother will probably ground me from the television," he considered, looking to the mess he had made.

"Damn her. Damn them all. Why did she have to hurt Peg? Why?" Balefully, he kicked the corpse beside him. Her glazed eyes stared back at him with empty fascination. "You bitch. You killed Peg."

His sister's dead look gave no response. (He wondered why.) Her face looked so shadowed. He lifted her head up by her clotted hair and saw that it was dried blood on her cheek that created the mock shadow. He saw, too, that the dent in her skull had stopped gushing; the coagulated blood had formed a gelatinous plug.

Mother would be home soon. He would have to dig a grave.

Teddy got up and walked to his bedroom where Peg's plastic body lay deflated. Atop her bloodless chest was a kitchen knife and she stared at the ceiling with her permanent expression—mouth in the shape of an O. She looked as if she would scream.

He picked up the doll's head and looked tearfully at the flat terrain of her airless, life-sized figure. Cradling her head, he began to cry—each tear held a thousand wishes to bring her back. He was glad Angie was dead—she had deserved every last blow. As Teddy stroked her artificial hair he noticed the stench coming from his sister who lay several feet away. He knew it was urine—he had heard her bladder release when he struck the final deadly blow. He had hit her once more for good measure—she killed Peg. He had every right.

Carefully, he let Peg's head rest on the carpet. Bending down, he kissed her cheek and wiped some sticky stuff from her rubber lip. Mom had told him before not to touch Peg or to make the nasty in her mouth, but he

couldn't help it. He loved her too much just to leave her be. If Mom found out he was doing the nasty then she would take Peg away, like before—he would have to find her too.

As Teddy went back to Angie's body he stopped for a moment to marvel at her nudity. He had always watched her dress from the closet, but he had never seen her thing up close. He was fascinated by the dark tuft of hair between her legs—Peg didn't have that. Cautiously he touched her thigh, and jerked away as if her flesh were hot. It wasn't, though. In fact, she was starting to get cold. It had been four hours.

"I hate you," he informed her cadaver eyes.

Again he touched her thigh, but this time he didn't pull away. Gently, he ran his fingertips up her hip and toward her crotch. With the other hand, he pulled her muscled legs apart. Between them was a puddle of urine the size of a pancake. He gave her genitals a curious poke. She was much softer than Peg, and wait—although her body was cold and pallid, she was warm inside. He was getting excited by her macabre sexual divinity.

He had to stop—Mother would be upset if he was doing the nasty. She hated the nasty; Dad had found that out the hard way. All she liked was sewing and watching *Family Feud*. She loved that Richard Dawson guy.

But she was so yielding, so doughy. Peg's skin was hard and waxy inside—he'd had her for ten years (when he was eighteen he ordered her from a dirty magazine). Angie was only five then, and now she had matured into a beautiful young woman. He really didn't hate her that much but she shouldn't have killed Peg. He was only watching her shower. It was nothing new. But she would have told Mother, Mother couldn't stand for that kind of filth in her house. That's why he had to hide Peg in the first place. Mother was so old-fashioned; he had to hide a lot from Mother.

Going to the garage, he fetched a spade and began digging in the garden. He had to finish before she got home.

The soil was tender, and it took but a half hour to make the grave.

Time was precious so he went in and cleaned up. He grabbed a towel and went to Angie's room. Grabbing both her arms, he pulled her back a few feet—the puddle had soaked into the carpet, leaving a dark stain. He carefully sopped it up and threw the towel in her closet.

As he dragged her through the living room, he considered an idea. It was the best idea he had ever had. If Mother had liked the nasty, she would have been proud of his idea.

He dropped Angie's arms and went back to his room. It pained him to look at Peg's wasted body; the gash in her chest seemed bigger and painful. But she was old, he thought. Maybe it was best she had died.

Teddy tossed the knife and carried the rubber doll's limp torso through the kitchen into the back yard. "I'm sorry Peg," he told her painted face. He wouldn't bury her just yet—first he wanted to try out his idea. If it worked, then he would cover her up.

It was almost time, he would have to hurry. Back in his sister's room, he took off his jeans and knelt beside the corpse. The smell of death was pungent and sickening, but life was too frightening for him to handle. He was more of a watcher. But it was too late for watching and she would be perfect. He could hide her. Just like Peg.

As Teddy mounted his sister in a fumbling, incestuous act of necrophilia, Mother's car pulled into the cracked driveway. She saw through the grimy windshield the rotting bags of trash piled among the weeds near the porch. That damnable Teddy. Just like his father.

Merely four strokes within her, Teddy finished shamefully; he stayed inside for a few moments—he liked the slimy grip on his flesh. He was embarrassed, but he liked the nasty stuff so much. Why couldn't Mother understand his needs?

"Teddy, didn't I tell you to take out the trash?" she hollered as the front door opened, slamming into the wall. She grimaced as a rat scuttled from somewhere to anywhere. A catalog of punishments befuddled her mind as she crossed the living room.

Teddy froze. How could he explain this to Mother? He would have to hide Angie; if Mother saw what—

"Teddy."

As Mother hobbled into the hall, he looked up from his disgraceful position.

She stood above him, ancient and leviathan from his angle. Her cane loomed over him like a tree trunk.

Teddy's frozen panic melted and he leapt up and hurriedly cupped his naughty parts, hiding them from Mother.

"Teddy, why didn't you take out the garbage?"

"Huh?" He was confused by her displaced question, her banal motherliness.

"Oh, never mind." She poked her cane at Angie with simple curiosity. "Put on your drawers."

"Mother, it wasn't my fault, she killed—" He quickly shut his mouth—Mother couldn't know about Peg. She hated Peg.

"She's dead, huh?"

"Mother, I didn't mean to kill her." That was a lie.

"You were watching her again," Mother beamed.

"No Mother. I never ever watched her. I promise I didn't."

"You did. She tells me."

"No Mother." That bitch, she had told. He wished he could kill her again; she suffered too little.

"I told you not to do the nasty. And now I catch you doin' it on your sister. What can I do with such a disrespectful boy?"

Her rhetoric frightened him. What if she took away the television? What if she made him take those pills again—what had she called them? Saltpeter? He could fix that though. He was good at hiding them under his tongue and then throwing them out his window.

Although Teddy was taller than Mother, she overwhelmed him with her presence. She stepped over Angie and raised her cane to his head; she was varicose in her elegance.

"Bad boys have to be punished. That's how we keep a family together."

Sharply, and with surprising force, she bludgeoned his head repeatedly until he collapsed, limp and denigrated on the carpet.

When Teddy awoke, he winced at the tugging pain at his eyelids—they wouldn't open no matter how hard he strained. Atop his naked groin he felt the cold security of Peg, and beneath him the gritty soil. Damn Mother and her sewing. He touched his eyelids and knew he would find the tiny knotted stitches binding his vision.

"Teddy," she called from above. "You've been a bad boy. You won't be looking at Angie anymore though, I've seen to that. Just like your father you are. I had to teach him a lesson too."

He heard an earthy scrape from above and pleaded for forgiveness. "Mother please, I didn't mean to look. I'm sorry. Please, Mother—"

A scoop of dirt landed on his face, covering his nose and mouth; his arms were squeezed too tightly into the grave to protest.

"Got to keep the family together."

Mother continued to fill in the grave as Teddy struggled to free himself; he wanted to spit but his mouthful of dirt prohibited any such action. Above, Mother babbled about discipline and Teddy's punishment led to suffocation as his eyes seeped tears of blood.

March 15, 1988

*Night Terrors Magazine*
1007 Union Street
Schenectady, NY 12308

Brian Warner
3450 Banks Rd. #207
Margate, FL 33063

Hey Brian,

Thank you for "All in the Family." I like the idea, but I prefer something a little more involved. However, you write very well and very convincingly, and I'm anxious to see another submission from you. But, Brian, I would first urge you to acquaint yourself with the unique type of fiction we publish by purchasing a subscription to *NT*. I can send you the next four issues for only $12 for your first year and $16 each year afterwards. I hope you'll take advantage of this savings—more than 35% off the cover price—and join our bloody little gang. If you're serious about selling your work to *NT*— payment is two and a half cents per word—then getting to know the mag is your key to a quick sale.

Till then,
John Glazer
Editor

March 28, 1988

Brian Warner
3450 Banks Rd. #207
Margate, FL 33063

John Glazer, Editor
*Night Terrors Magazine*
1007 Union Street
Schenectady, NY 12308

Dear John Glazer,

Thank you very much for your encouraging response. Enclosed is a check for four issues of *NT*. I am eager to receive my first copies. In the meantime, I am sending you three new poems I wrote, "Piece de Resistance," "Stained Glass" and "Hotel Hallucinogen." I hope that you'll find them more to your taste.

Thank you for considering these submissions, and I'm looking forward to receiving my subscription to *Night Terrors Magazine.*

Sincerely,
Brian Warner

## PIECE DE RESISTANCE

When the fork eats the spoon,
and the knife stabs
the face reflected in the plate,
dinner is over.

## STAINED GLASS

In the wooden silence
genuflecting fornicators
seek penance and
false-toothed idealists
throw grubsteaks on the offering plate.

light a candle for the sinners
light a fire

Self-pronounced prophet, parable-speaking Protestant
preaches his diatonic dogma,
disemboweling indiscreetly.

supplicate
congregate
the world looks better through stained glass

light a candle for the sinners
set the world on fire

Falsities
Falsities
Falsified factualities;
All sitting like eager sponges,
soaking up the tertiary realities of life.

## HOTEL HALLUCINOGEN

Lying in bed contemplating
tomorrow, simply meditating,
I stare into a single empty

spot, and I notice a penetrating
of two eyes looking up and
down and at various odd angles
secretly inspecting me; and I
feel my stare tugged away
from the blank screen in
front of my eyes and directed
at the eight empty beer cans
forming an unintentional pyramid.

And I close my lids to think—
How many hours have passed
since I constructed such an
immaculate edifice of tin?
Or did I create it all?
Was it the watchers?

I open my eyes and return my stare to the pyramid.
But the pyramid has now
become a flaming pyre, and
the face within is my own.
What is this prophecy that
comes to me like a delivery boy,
cold and uncaring of its message,
asking only for recognition?
But I will not fall prey
to this revelation of irrelevance
I will not recognize this perversion
of thought.

I will not.

I hurl my pillow at the
infernal grave, as if to save my
eyes from horrific understanding,
and I hear the hollow clang
of seven empty beer cans,
not eight—
Was it fate that left
one to stand?
Why does this solitary tin soldier
stand in defiance to my
pillow talk of annihilation?

Then, for some odd, idiotic,
most definitely enigmatic reason
the can begins to erupt in a barrage of
whimpering cries.
Does he lament because his
friends and family are gone
or that he has no one
with which to spawn?
They were gone. . .

But no, that's not the reason.
It is a baby's cry of his mother's
treason.
The screaming fear of abandonment.
And this wailing, screaming, whining
causes the dead cans to rise
and I can't believe my eyes,
that this concession of
beverage containers is chanting
in a cacophony of shallow rebellion
to my Doctrine of Annihilation
that was discussed in my
Summit of the Pillow (which is now
lost among the stamping feet of the
aluminum-alloy anarchists).

I am afraid, afraid of these
cans, these nihilistic rebels.
As the one approaches—the baby cryer,
I suppose my fear now
escalates, constructing a wall
around my bed, trying to shut
everything out
but without a doubt
the cryer casually climbs what
I thought was a Great Wall
not unlike the one in Berlin.

He begins to speak.

His words flow cryptically from
the hole in his head

like funeral music: deep, resonant,
and sorrowful.

He says to me: "You must
surrender to your dreams it's just.
We sit all day planning for your attendance
and upon arrival you
very impolitely
ignore us."

In awe, I nod involuntarily
and he closes my eyes.

No.

He gives me a pair of aphrodisiac sunglasses,
and I fall asleep in the shade.

Asleep in a field of hyacinth and jade.

When I crawl out of my sleep
I get up,
my hair a tangled mess of golden locks.
I enter the kitchen,
and go to the icebox.
I pull out a single can of beer,
and as I begin to drink
I hear

The weeping of an abandoned infant.

June 5, 1988

Brian Warner
3450 Banks Rd. #207
Margate, FL 33063

John Glazer, Editor
*Night Terrors Magazine*
1007 Union Street
Schenectady, NY 12308

Dear John Glazer,

I received my first copy of *Night Terrors* in the mail two
weeks ago, and have now read the entire issue. I enjoyed it,
particularly the story by Clive Barker. I haven't heard from
you, and wonder whether you received the poems that were
included with my subscription request. I am more eager now
than before to be published in *Night Terrors Magazine*. I
feel that it is the perfect place for my work. Please
respond soon and let me know if you received my last
submission, or if you'd like me to send it again.

                              Sincerely,
                              Brian Warner

---

July 8, 1988

*Night Terrors Magazine*
1007 Union Street
Schenectady, NY 12308

Brian Warner
3450 Banks Rd. #207
Margate, FL 33063

Hey Brian,
Nice to hear from you. Thanks for the nice words about *NT*; yes, I read
your poems, and enjoyed them, but did not think they were right for *NT*.
I'm sorry; I must've forgotten to respond to them. But please submit again
soon; I'm really enjoying your work.

                              Till then,
                              John Glazer
                              Editor

**⑤**

*i wasn't born with enough middle fingers*

C'MON BABIES GREASE YOUR LIPS
PUT ON YOUR HATS AND SWING YOUR HIPS
DON'T FORGET TO BRING YOUR WHIPS
WE'RE GOIN' TO THE FREAKER'S BALL.
—*Dr. Hook and the Medicine Show,*
*"Freaker's Ball"*

# WHEN you have friends, you form a band.

When you're lonely, you write. So that's how I spent my first months in Fort Lauderdale. As my father worked at Levitz Furniture, supposedly a big opportunity for him, I sat alone at home and brought my most twisted fantasies to life in poems, stories and novellas. I sent them everywhere from *Penthouse* to *The Horror Show* to *The American Atheist*. Every morning I rushed to the door as soon as I heard the mailman. But all he carried in his bag was disappointment: either nothing or a rejection letter. Only one story, "Moon on the Water," about an alcoholic writer with a cat named Jimi Hendrix and a well that swallows everyone he loves, was ever published—in a small journal called *The Writer's Block*.

Disappointment followed me like a ball and chain that first year in Florida. The more work I did, the less it paid off. I was leading a pathetic life: living with my parents and attending Broward Community College, where I studied journalism and theater because it was all that interested me. For extra money, I became the night manager of a local Spec's, a record chain where I soon found an opportunity to revert to the type of behavior that had gotten me into trouble in Christian school.

There were two cute girls who worked at the store. The one that liked me, of course, was heavily medicated and obsessed with killing herself. The one I liked was Eden, named after the garden of earthly delights, but she refused to share any of those earthly delights with me. In a callow attempt to be cool, I made a deal with them: They could smoke pot in the back of the store if they agreed to steal cassettes for me. Since there was a security guard who searched our bags whenever we left the premises, I bought the girls sixteen-ounce soft-drink cups from Sbarro's and instructed them to fill the containers with as many cassettes by the Cramps, the Cure, Skinny Puppy and so on as would fit. The week Jane's Addiction's *Nothing's Shocking* came out, I had Eden steal it and then unsuccessfully tried to coax her into coming with me to their concert at Woody's on the Beach.

My first article in my college newspaper, *The Observer*, was a review of that show, headlined "Jane's Addiction Returns to Shock Crowd at Woody's." Little did I know that there was a word in that headline that would go on to be used several thousand times to describe my music, and it wasn't "woody." Even more unforseeable was the fact that many years later I would be in a Los Angeles hotel room trying to keep Jane's Addiction's guitarist, Dave Navarro, from

giving me a blow job as we sniffed drugs together. (If memory serves me correctly, Dave ended up hanging out in the room of my bassist, Twiggy Ramirez, who had ordered two expensive prostitutes and was busy fucking them to the beat of ZZ Top's *Eliminator*.)

What I regretted most when I was fired from the record store for general job-shirking (they didn't catch me stealing) was that I would never get to go out with Eden. Once again, however, time and fame were on my side, and a year and a half later I ran into her after a Marilyn Manson and the Spooky Kids concert. She didn't even know I was in the band until she saw me on stage, and then all of a sudden she wanted to go out with me. So you can believe that I fucked her—and didn't call her afterwards.

After getting fired, I delved into rock criticism, working for a local freebie entertainment guide called *Tonight Today*. The newsprint magazine was run by a creepy, burned-out hippie named Richard Kent, who never paid me a cent. He was completely bald except for a patch of gray hair he kept in a ponytail and he wore thick black glasses. He constantly walked around the office with his neck bobbing back and forth, as if he were a fat parrot in search of something to say. Whenever I asked him a question about an article or a deadline, he'd stare blankly at me for minutes. I never knew what he was thinking, but I always hoped it wasn't about molesting me.

I soon conned my way into a glossy start-up magazine, *25th Parallel*, by telling the owners, two lovers named Paul and Richard, that I had a degree in journalism and had written for numerous national publications. They bought my lies and hired me as a senior editor. I always tried to picture Paul and Richard having sex, but it was an impossible image to conjure. Paul, a small, chubby Italian from New York, looked like a fun-house mirror version of Richard, who was gaunt and tall with terrible acne and monstrous teeth that looked like they were part of a Halloween costume. One of the things that creeped me out most about them was a picture Paul kept over his desk of Slash passed out naked in a bathtub. I always wondered about the circumstances under which the photo had been taken.

Paul and Richard were a hopeless pair. They would sit around the office depressed, destitute and in tears. The only reason the magazine came out month after month was because they made money selling the records they received for free in the mail. Like most people who don't pay for their music, they didn't appreciate it. I wrote nonstop for the entertainment section, but the piece that I was happiest with wasn't about rock. It was about a subject that combined my aspirations in journalism and horror writing.

## 25TH PARALLEL, APRIL, 1990
## WE ALWAYS HURT THE ONES WE LOVE
### (A TRIP INTO THE WORLD OF B AND D)

#### by Brian Warner

The cloying scent of stale sex and leather instantly accosts my senses as I stumble into Mistress Barbara's dungeon. After being blindfolded and escorted here by her personal slave, I spend a few moments adjusting my vision to the dim lighting in this living-room-gone-torture chamber; carelessly, I stuff the adhesive eye patches in my shirt pocket. Once I finally focus, the carnal coexistence of this Fort Lauderdale apartment becomes quite apparent.

The short, corpulent woman who calls herself Mistress Barbara is, in fact, a B and D (that's bondage and discipline for those of you who

## "Whatever someone's fantasy is, I fulfill it."

thought that the missionary position was still the standard) specialist and her house of ill repute is closer than you might think.

"Whatever someone's fantasy is, I fulfill it," she asserts, gesturing to a roomful of painful, though prurient, blue movie props and other pornographic paraphernalia. "In commercial sessions I use instruments of torture on people. I do [genital] torture, body piercing and bondage—I tie them in positions

that are *extremely* uncomfortable and I leave them there for long periods of time. If it's a good session and they've been a responsive slave, I will allow them to masturbate afterwards."

On the wall opposite the door is a row of full-length mirrors and to either side of them are her *work tools*. I follow her to the rack on the right where she points out two jockey helmets, riding gear, electric shock equipment used for dog training, several flea collars, a pair of spurs and metal cuffs designed for shackling legs, wrists and thumbs.

"I don't always apply them to wrists, ankles and thumbs, however," she laughs.

Continuing down the wall are a plethora of clamps and accompanying weights that are used for stretching the more *tender* parts of the body. Below that she identifies a set of familiar-looking utensils as "escargot tongs."

"These are *wonderful* for [genital] torture," she beams, picking up the tongs fondly and snapping them in the air like some metallic lobster. "And besides, when somebody eats those snails again, they always think of me." (Reader warning: *25th Parallel* recommends that

you do not try this at home, or at Joe's Stone Crab for that matter.)

Below that are 30 or so rubber, leather and metal hoops ranging in size from one to four inches in diameter. Apparently, these were invented by the Chinese to promote sexual endurance. I think they look like pirate earrings myself, but hey, what does an average-sex-life-with-a-little-Jell-O-on-holidays kinda guy like me know?

Farther down, she shows me a small leather and chain parachute. It looks like something for a child's action figure; I can imagine it now—authentic bondage accessory for Teenage Pervert Ninja Turtles. She explains that this device is used to "stretch the genitals." I don't think you will find this one at Toys "R" Us.

Stranger still, there is a magnifying glass below the Freudian-nightmare-paratrooper gear. She pulls it from its peg and quips, "This is so the males I deal with can get a good look at [what] they have and they can see with their eyes how they view it *mentally.*"

Stashed at the bottom of the wall are a collection of spiked slave collars, leather bras, masks, gags and nipple/penis tassels. She picks up the latter and points out, "I make the men dance with these on and the tassels all have to swing in the same direction." In addition to that treasury of ribald playthings there is

also a horse's tail (complete with fastening "butt plug" for the Mr. Ed aficionado) and a real ball and chain which she claims to have purchased at a garage sale.

Across the room, on the other wall, is where Mistress Barbara keeps her more dangerous weapons, so to speak. Of course, there is a slew of chains as well as an English birch cane, several paddles (wicker, oak, rubber, leather and plastic), a yardstick, a ruler, a Dutch Boy paint stirrer, a medieval spiked flail that she has nicknamed "ball breaker," a few cat-o'-nine-tails and enough whips to make Indiana Jones salivate uncontrollably. Furthermore, the

## *"On birthdays and the Fourth of July I put one of these in the end of their penis and light it."*

drawers that line the floorboard contain things like electronic muscle stimulators, disposable enemas, candles, rubber gloves, condoms (she uses both Traditional Dry and Naturalube Trojans), fake blood, plaster of Paris, Saran Wrap, a soldering iron, plastic garbage ties, Icy Hot, feathers, furs, brushes, baby powder, vitamin E lotion, Vaseline, an entire drawer full of marital aids (in various colors, shapes and sizes), more lingerie than Victoria's Secret and Frederick's of Hollywood combined, and a box of sparklers. Being

the naïve layman that I am, I ask what the sparklers are used for—I wish I hadn't.

"On birthdays and the Fourth of July I put one of these in the end of their penis and light it," she confesses without a hint of sarcasm. "Most of these things are props but most men love to dress up like women. They come here to be feminine."

Carefully, I find a seat on the black fur comforter that covers her full-size platform bed. Below it, where most normal folks might stash, oh say, a Monopoly game or maybe even their KISS dolls, I notice a caged sleeping cell.

Although Mistress Barbara has only been practicing bondage and discipline commercially (that's not commercial as we know it; this practice is very illegal) for three years, she has been doing it privately for 45 of her 57 years. Her introduction to the whip-me-beat-me-jab-safety-pins-through-my-sex-organ world of B and D came at the ripe and uncertain age of 12.

"I was living in California and there was a man who was 21 that came to my house all the time," she recalls, lighting a cigarette. "One day he was teasing me with his bull-whip and he made me mad. So, I took the bullwhip from him and made him take off his clothes and drive back to town naked."

From that day on, she has been abusing men for their pleasure. However, she never actually lost her virginity until she was 16. Thereafter she continued to practice her trade privately, moving to Florida in 1980. Finally, she realized that if she advertised, she could do the same things to strangers for more money. Now, at $200 a session (which can last anywhere from 12 minutes to 13 hours), she earns roughly $25,000 a year, tax-free.

Her customers, who are between 19 and 74, locate her through a personal ad that reads: "Sincere, mature, dominant woman has slave quarters available for short- and long-term stays." Generally, her clientele are businessmen with families, she claims. "I believe the higher the executive, the higher the pressure and the more they do these things," she decides. "I see faces and I recognize them from campaign posters. I find that it's not unusual that I've had firemen, police officers, attorneys, judges, airline pilots and football

# "So, I took the bullwhip from him and made him take off his clothes and drive back to town naked."

players." Laughing, she adds, "I get most of my calls after the three-day holidays when these men are at home with their wives and they're not accustomed to spending that much time with their families. So I get some pretty frantic calls that they've been 'bad boys' and that they need to be spanked."

Not only does she provide services for sexually depraved clients, her personal live-in slaves give her everything they own. Presently, the peon of this V-girl's bawdy house is a gaunt, middle-aged gentleman named Stan. Despite the fact that he is a good two feet taller than Mistress Barbara, her tyrannical demeanor causes him to cower beneath her like a maimed cat. As my photographer, Marc Serota, prepares some additional lighting, she orders Stan to undress for the picture; the slave scuttles out of the room obediently. Turning back to me, she explains, "You can't be a good dominatrix without understanding submission. The game that we play is—I play as though I am in control and I'm forcing them to do these things. But in reality it's what they want to receive.

"They make no decisions. Not even what to wear or when to speak. I totally control their lives. I am everything to them. These are people who have not been able to run their lives. They've made such a mess of their lives and have never been satisfied with any woman. So I just take everything over, they don't even have to think."

Apparently, men like Stan live with her and cater to her every desire whether it is sexual or otherwise. In return for her care, he gives her a nominal amount of money each week that she uses to pay his bills. She becomes a mother of sorts. What they don't know is that she saves most of their cash and returns it to them when they decide to move on; she likes to give them a fresh start.

Stan finally returns. I am a little more than surprised by his appearance. Aside from the fact that he is totally naked, his body hair has been shaved entirely and he is wearing four or five (I don't get close enough to get an exact count) of those attractive metal hoops that I described some 27 paragraphs ago; they jangle as he walks into the room. Sheepishly, he crawls onto Mistress Barbara's black leather chiropractor's chair, where she proceeds to crucify him against the wall. After he is secured at the neck, wrists and ankles, she casually applies surgical hemostats to his nipples.

"Does that hurt?" she asks coyly.

## *"Does that hurt?"*

"Well …" he begins, but before he can finish she grabs his denigrated genitals and squeezes with the ease of any Publix produce shopper.

"Get a little more uncomfortable," she commands and her

battered boy toy responds quickly, stretching his leg sideways at an awkward angle.

As pancake-size red welts form around Stan's mangled breasts, I ask him how he feels. Slowly and carefully he mumbles, "Restrained . . . I feel something but it's hard to pin a certain emotion on it."

"Stan is not an articulate person and he always understates everything," the groin-gouging guru interjects. "I've always treated men in this fashion. I've always felt that men should be kept in cages and stables like dogs and horses and taken out only when you want to play with them. It's very convenient."

The camera begins to flash and Stan winces for the paparazzi as Mistress Barbara answers the door. It's Bob, her part-time slave. He carries in a large box that she says is filled with black market transvestite videos. Bob is a retired grandfather who serves Mistress Barbara with his wife's reluctant permission.

"My wife accepts this but she's not into it," Bob explains while fidgeting with the change in his pocket. "She knows it's a big fantasy of mine and I enjoy it. As long as she knows where I'm at and that the people are sane and discreet, it's okay. I would never lie to or cheat on my wife. I don't go with other women, and there's no real hanky panky going on here."

Whether it's with Bob, Stan or any of the others, Mistress Barbara leads a hedonistic life. She spends her free time sailing, flying, or diving. She eats when and where she wants and she never has to worry about sexual satisfaction; she has them trained for that. "Stan's not allowed to have an erection unless I say. He has learned to function on command."

She represents everything a woman is about while at the same time contradicting what we believe is normal behavior. Besides that, she has never been arrested and she makes a hell of a lot of money.

I decide that it's time to head back into apple-pie-and-no-sex-until-marriage America, so I don my adhesive eye patches and follow her into the humid afternoon sunlight. As we trod forward by Braille, in search of the car, she concludes by whispering, "They think I'm wonderful. Somebody else might think I'm the biggest jerk. So why not be where you have adoration?"

I soon met a woman who would torture me in ways much more subtle and painful than anything Mistress Barbara could devise with her hellish instruments of sadism. Her name was Rachelle. I was nineteen and she was twenty-two when we met at Reunion Room, a local club that, though I was underage, let me in because I was a journalist. She was so beautiful she was painful to look at because I knew I could never have her. She was a model, with red hair in a Bettie Page cut, a gently curving body and a face stretched perfectly over well-defined cheekbones.

As we talked, Rachelle explained that she had just broken up with her boyfriend, who was still living with her but trying to find his own place. Once I realized she was on the rebound, a slow flush of confidence began to creep over me. She was leaving for Paris for the entire summer in a month, which gave me just enough time to pursue and miraculously catch her. The letters we exchanged across the Atlantic were as steamy as they were inspirational. I was smitten. When she returned, our relationship resumed even more passionately than before. In desperate need of her affection (or just to get laid) one night, I paged her. My phone rang minutes later, and I picked it up.

"Why are you paging this number?" asked a hostile man's voice.

"This is my girlfriend's number," I told him belligerently.

"It's also my fiancee's number," he fired back, and at that moment I felt my heart freeze and shatter, each shard dropping painfully through my insides.

"Did you know," I stammered, "that she's been sleeping with me?"

He didn't get angry or threaten to kill me. He was in shock, like I was. I walked around for months in a heartbroken daze. Just as I was beginning to pull myself back together, she called.

"I don't know how to tell you this," she said, "but I'm pregnant."

"Why are you telling me?" I asked as coldly as I could.

"I don't know if it's yours or his."

"Well, I guess we're just going to have to assume that it's his," I snapped back, hanging up before she could say anything else.

Two years later, I ran into her in a local diner. She looked the same—drop-dead gorgeous—but modeling hadn't worked out for her. She had become a police officer, and looked like every man's fantasy dominatrix in her blue uniform, cap and nightstick.

"You should meet my son," she said. "He looks just like you."

My face blanched and my jaw dropped open in the process of trying to exclaim, "What?!" I pictured child support payments, weekends spent baby-sitting and a husband plotting brutal revenge.

After savoring my shock, she pulled her dagger out of my chest

just as swiftly and cruelly as she had plunged it in. "But I know it's not yours. I had a blood test."

As a result of discovering that Rachelle had betrayed me and was engaged to someone else, I promised myself that I would try to close myself off emotionally to the world and trust no one. I didn't want to get carried away by my feelings again; I needed to stop being victimized by my own weaknesses and insecurities about other people, especially women. Rachelle left me with a scar deeper than any I've since inflicted on myself. It was partly out of anger and revenge that I wanted to get famous and make her regret dumping me. Another reason was that I was frustrated with music journalism. The problem wasn't the magazines or my writing, but the musicians themselves. Each successive interview I did, the more disillusioned I became. Nobody had anything to say. I felt like I should be answering the questions instead of asking them. I wanted to be on the other side of the pen.

I interviewed Debbie Harry, Malcolm McLaren and the Red Hot Chili Peppers. I wrote promotional biographies for Yngwie Malmsteen and other metal assholes. I even published an article on Trent Reznor of Nine Inch Nails with no premonition that we were about to begin a relationship that, like a long stay in Mistress Barbara's dungeon, would be strewn with unforseeable peaks of pleasure and pain.

When I first saw Trent, he was sulking in the corner during soundcheck as his dreadlocked tour manager, Sean Beavan, hovered protectively over him. Once we started talking, he thawed and became affable. But I was just another journalist. Talking to me was as good a way as any for him to kill time before a show in a city where he knew no one.

The next time Trent Reznor came to town, I was his opening act.

*deformography*

PART

II.

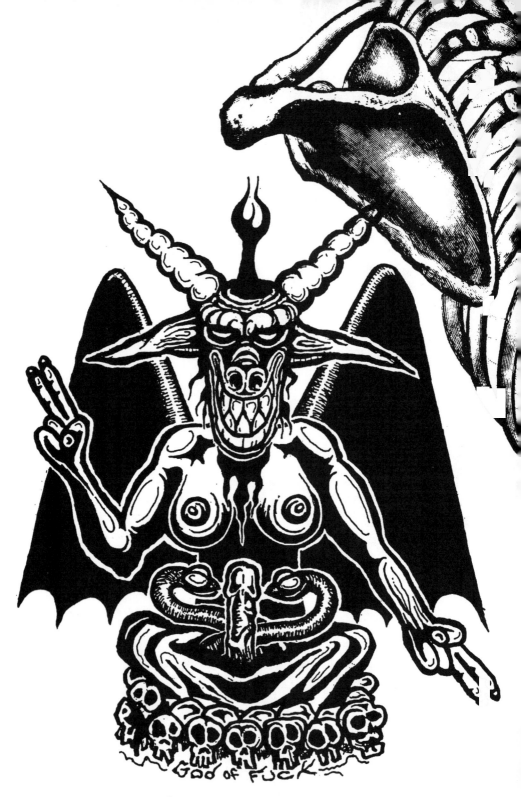

**ONE OF MY EARLY ILLUSTRATIONS**

# ⑥

## *the spooky kids*

# MARILYN Manson was the

perfect story protagonist for a frustrated writer like myself. He was a character who, because of his contempt for the world around him and, more so, himself, does everything he can to trick people into liking him. And then, once he wins their confidence, he uses it to destroy them.

He would have been in a longish short story, about sixty pages. The title would have been "The Payback," and it would have been rejected by seventeen magazines. Today, it would be in the garage of my parent's house in Florida, faded and mildewed with all the other stories.

But it was too good an idea to rot. The year was 1989 and Miami's 2 Live Crew were beginning to make headlines because store owners across the country were getting arrested for selling their album—classified as obscenity—to minors. Pundits and celebrities were rushing to aid the band, to prove that their lyrics were not titillation but art. A culturally significant chain of events had been set in motion simply because of dirty nursery rhymes like: "Little Miss Muffet sat on a tuffet with her legs gapped open wide/Up came a spider, looked up inside her and said, 'That pussy's wide.'"

At the time I was reading books about philosophy, hypnosis, criminal psychology and mass psychology (along with a few occult and true crime paperbacks). On top of that, I was completely bored, sitting around watching *Wonder Years* reruns and talk shows and realizing how stupid Americans were. All of this inspired me to create my own science project and see if a white band that wasn't rap could get away with acts far more offensive and illicit than 2 Live Crew's dirty rhymes. As a performer, I wanted to be the loudest, most persistent alarm clock I could be, because there didn't seem like any other way to snap society out of its Christianity- and media-induced coma.

## CIRCLE SIX - HERETICS

Since nobody was publishing my poetry, I convinced Jack Kearnie, the owner of Squeeze, a small club in the middle of a mall, to start an open-mike night. This way, I could at least get some exposure for my writing. Every Monday, I stood awkward and vulnerable behind the microphone on the small stage and recited a handful of poems and prose pieces to a meager crowd. All the bizarre characters who attended told me my poetry sucked, but I had a good voice and should start a band. I told them to fuck off. But inside I knew that no one really likes poetry anyway and that their advice was right—if only because no one else I interviewed or listened to was writing songs with any intelligence. I had always dreamt of making music because it was such an important part of my life, but until then I never had the confidence or the faith in my abilities to pursue it seriously. All I needed were a few resilient souls to go through hell with me.

The Kitchen Club was the epicenter of South Beach Miami's burgeoning underground industrial scene and a regular haunt of mine from the time it opened that year, tucked inside a sleazy hotel populated by prostitutes, drug addicts and vagrants. There was a pool in the back with water filthy from being used as a combination bathtub-

Laundromat by alcoholics who had pissed and shat themselves. I would go to the hotel on Friday night, rent a room and by the end of the weekend find myself alone and miserable, puking in the bathtub from ingesting too much trucker speed and too many screwdrivers.

One Friday I arrived at the club with a friend from theater class, Brian Tutunick. I was decked out in a navy blue trench coat with "Jesus Saves" painted on the back, striped stockings and combat boots. At the time I thought I looked cool, but in retrospect I looked like an asshole. ("Jesus Saves"?) As we walked in, we noticed a blond guy leaning against a pillar with a Flock of Seagulls haircut hanging in his face. He was smoking a cigarette and laughing. I thought he was laughing at me, but when I passed by he didn't even turn his head. He was just staring into space, cackling like a madman.

As Laibach's Yugoslavian military march version of "Life Is Life" blasted out of the sound system, I spotted a girl with black hair and huge breasts (which, when they were on a Goth girl like her, we called Dracula biscuits). Shouting over the music, I explained to her that I had a hotel room and tried to convince her to come up with me. But, for the ninety-ninth time that summer, I was denied because she had come to the club with a date, which turned out to be laughing boy. She brought me to his pillar, and I asked him what he was laughing about. His response came in the form of a tutorial on the proper ways to commit suicide, which included essential details like the exact angle to hold the shotgun at and what type of ammunition to use. The whole time he had a strange way of laughing at everything he said. He'd just start cackling, and within that cackle he'd repeat what he had just said—a word like *twelve-gauge* or *cerebral cortex*—so that both you and he knew what was so funny.

His name was Stephen, but, he explained in the ensuing seminar, if anyone called him Steve, it pissed him off. If anyone spelled his name with a *v* instead of a *ph*, it pissed him off too. The subject of names didn't change until Ministry's "Stigmata" came on and the Goths and pseudo-punks stopped dancing and started violently slamming. Much of the commotion was instigated by an effeminate, Crispin Glover-looking guy with purple hair, a mini-skirt and a leopard-skin leotard. He would eventually become our second bassist. Completely oblivious to the activity around him, Stephen told me that if I liked Ministry, I should listen to Big Black. He then delved into a detailed analysis of Steve Albini's guitar playing—the techniques he used and the tones he produced—followed by a dissertation on Albini's methods of production and the lyrical content of his album *Songs About Fucking*.

I didn't get laid that night, which pissed me off, though it was nothing new. But I did exchange numbers with Stephen. He called me the next week and said he wanted to make me a cassette of *Songs About Fucking* and bring me something else he thought I'd be extremely interested in. He wouldn't say what it was. He just wanted to come over and give it to me.

Instead of Big Black, he brought me a tape of a band called Rapeman, and he spent several hours extemporizing on the lineage between the two bands, rocking back and forth autistically all the while. I later learned he had a problem with hyperactivity as a child, which his parents had treated with Ritalin. Now that he wasn't on medication, he often turned into a babbling blur that was dizzying to watch. His mystery surprise was a rusty can of spiced sardines that had expired in June 1986. He never offered an explanation for it, and I never figured one out. Maybe he thought I was going to pull an Andy Warhol and make silk screens of it.

We began spending a lot of time together, hanging out at my poetry readings and going to concerts by shitty South Florida bands that I thought were halfway decent at the time. After a show one night, we came back to my house and pawed through poems I wanted to turn into songs and lyrical scraps I had written. I was hoping he played an instrument since he seemed to know everything there was to know about all things electrical, mechanical, and pharmaceutical. So I asked. The answer came in the form of a long-winded monologue about how his brother was a jazz musician and played a variety of reed, keyboard and percussion instruments.

Eventually, he confessed, "I can play drums—heh, heh, heh, drums, heh, heh—sort of—heh, heh, sort of, heh."

But my vision didn't include drums. I wanted to start a rock band that used a drum machine, which seemed somewhat novel at the time since only industrial, dance and hip-hop bands used drum machines. "Just buy a keyboard and we'll start a band," I told him.

Stephen didn't end up in the first incarnation of the group. Neither did the next person I found that I liked. I was at a record store in Coral Square Mall buying Judas Priest and Mission U.K. tapes as birthday presents for my cousin Chad. A well-tanned store employee who looked like an exotic Middle Eastern skeleton with an afro bigger than Brian May's walked over and tried to foist Love and Rockets albums on me. His nametag identified him as Jeordie White. One of his coworkers, a girl named Lynn, had given blow jobs and much more to most of the South Florida scene, excluding me but including Jeordie (though he denies it to this day). Almost a year later,

Jeordie and I would form a joke band called Mrs. Scabtree and perform a song about Lynn's legacy to the music scene. It was called "Herpes." Jeordie sang it dressed like Diana Ross and I played drums using a chamberpot as a stool. Jeordie would go on to play in my band as Twiggy Ramirez. But for now, Jeordie was just a friendly freak in a Bauhaus T-shirt trying to find someone who understood him.

The next time I ran into Jeordie at the mall, he was playing bass in a death metal outfit called Amboog-A-Lard. So I didn't even bother trying persuade him to quit. I just asked if he could recommend a good bass player, but he insisted that there weren't any in South Florida. And he was right. I ended up talking Brian Tutunick, my friend from theater class, into playing bass with us. I knew this was wrong from the start because he had been talking about forming his own band for some time, and had no intention of including me. He may have thought he was doing me a favor when he joined Marilyn Manson and the Spooky Kids as part of the rhythm section instead of as the frontman that he wanted to be, but it wasn't much of a favor because he was a bad bassist, a fat hairdresser, a wanna-be vegetarian and a devotee of Boy George, which placed him at the bottom end of the aggressivity meter. He lasted two shows before we kicked him out. He wound up forming Collapsing Lungs, a bad, watered-down industrial metal band with songs like "Who Put a Hole in My Rubber?" They thought they were God's gift to South Florida, especially after they got signed to Atlantic Records. But I cursed them. Now they're God's gift to the unemployment line, though I can't entirely take credit for their downfall. Bad musicianship and industrial metal songs about saving sea turtles didn't help their career any.

I found the next piece of the band at a drunken house party. An intoxicated, pie-faced twit with greasy brown hair and long monkey arms flopped onto the couch next to me, pretending he was gay and talking about the drapes. He introduced himself as Scott Putesky. He seemed to know a lot of technical information about music-making and, even better, he owned a four-track cassette recorder. I had a concept but no musical skills whatsoever, and I was easily impressed. Scott was the first real "musician" I had come in contact with, so I asked him to join the band and later rechristened him Daisy Berkowitz. He immediately proved to be a fuck-up when I called him the day after the party and his abrasive mother rasped nasally at me, "Sorry, Scott isn't here. He's in jail." I thought she was kidding, but it turned out he had been picked up for drunk driving on the way home from the party.

Scott had been in several local rock and new wave bands before, and almost everyone he worked with wanted to kill him because he was very pretentious and had deluded himself into thinking that he was much more talented than he actually was. Some people talk better than they play, but Scott did neither well. He always knew just what to do to annoy people. He'd tell girls, "You look great from the waist down," and think it was a compliment.

I would have performed using my own name, but I needed a secret identity in order to write about my music in *25th Parallel*. So I carefully chose a pseudonym, a moniker with a magical ring to it like *hocus-pocus* or *abracadabra*. The words *Marilyn Manson* seemed like an apt symbol for modern-day America, and the minute I wrote it on paper for the first time I knew that it was what I wanted to become. All the hypocrites in my life from Ms. Price to Mary Beth Kroger had helped me to realize that everybody has a light and a dark side, and neither can exist without the other. I remember reading *Paradise Lost* in high school and being struck by the fact that after Satan and his angel companions rebelled against heaven, God reacted to the outrage by creating man so that He could have a less powerful creature companion in his image. In other words, in John Milton's opinion at least, man's existence is not just a result of God's benevolence but also of Satan's evil.

As a bipedal animal, man by nature (whether you call it instinct or original sin) gravitates toward his evil side, which may be one of the reasons people always ask me about the darker half of my name but never about Marilyn Monroe. Although she remains a symbol of beauty and glamor, Marilyn Monroe had a dark side just as Charles Manson has a good, intelligent side. The balance between good and evil, and the choices we make between them, are probably the single

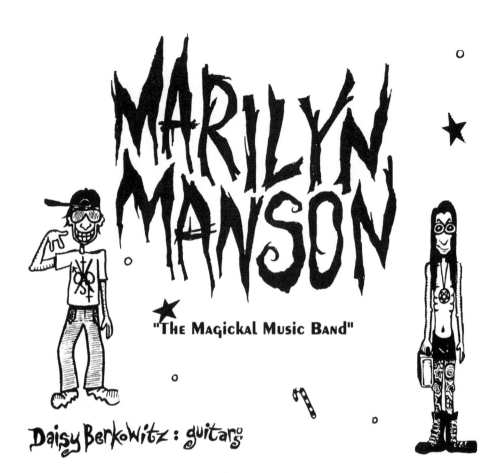

# MARILYN MANSON

★ "The Magickal Music Band"

Daisy Berkowitz : guitar

mr. manson: voice

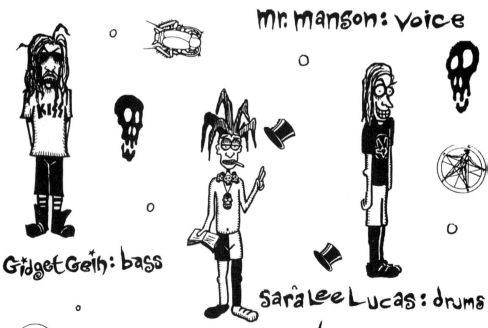

Gidget Gein: bass

sara lee Lucas: drums

Maddnna Wayne Gacy: Keys

most important aspects shaping our personalities and humanity. I could elaborate further, but it's all on the Internet (try the alt.life's-only-worth-living-if-you-can-post-it-online-later newsgroup). All I'll add is that the first article written on Marilyn Manson was by Brian Warner. And he completely misunderstood what I was trying to do.

At the time, Charles Manson had been resurrected as a news item and television special in the name of Nielsen ratings. In high school I had bought his *Lie* album, which featured him singing bizarre, almost comical original songs like "Garbage Dump" and "Mechanical Man," which I incorporated into one of my own poems, "My Monkey." "I had a little monkey/I sent him to the country and I fed him on gingerbread/Along came a choo-choo, knocked my monkey coo-coo/And now my monkey's dead/At least he looks that way, but then again don't we all/(What I make is what I am, I can't be forever.)"

"Mechanical Man" was the beginning of my identification with Manson. He was a gifted philosopher, more powerful intellectually than those who condemned him. But at the same time, his intelligence (perhaps even more so than the actions he had others carry out for him) made him seem eccentric and crazy, because extremes—whether good or bad—don't fit into society's definition of normality. Though "Mechanical Man" was a nursery rhyme on the surface, it also worked as a metaphor for AIDS, the latest manifestation of man's age-old habit of destroying himself with his own ignorance, be it of science, religion, sex or drugs.

After we turned four or five of my poems and ideas into songs, we felt we were ready for South Florida to see our ugly faces, which we strategically covered with makeup. Unfortunately, Stephen still hadn't bought a keyboard, so we found an acne-faced nerd named Perry to fill in.

Another problem was that among the many neuroses that Christian school had instilled in me was a crippling stage fright. In fourth grade, the drama teacher chose me to portray Jesus in a school play. For the crucifixion scene, he wanted me to wear a loincloth. Forgetting the cruelty kids were capable of, I borrowed an old, frayed terrycloth towel from my father and wore it without underwear. After dying on the cross, I walked backstage, where several older kids yanked the towel off me, started whipping me with it, and chased me through the hall. It was your classic preteen nightmare come to life: running down a corridor naked in front of all the girls you like and all the boys who hate you. Oddly, I got over my fear of exposing myself on stage, but I never got over my resentment of Jesus for traumatizing me.

Our first show was at Churchill's Hideaway in Miami. Twenty people showed up, though now that we're famous at least twenty-one claim to have been there. Brian the fat hairdresser (name changed to our trademark starlet–serial killer combination of Olivia Newton-Bundy) played bass; Perry the pimplehead (who renamed himself Zsa Zsa Speck without realizing the pun on his speckled complexion) played keyboards; and Scott the fascist of the four-track (Daisy Berkowitz) played guitar. We used Scott's Yamaha RX-8 drum machine (which, like Scott, would one day leave us, although the drum machine was never heard from again).

Being very literal-minded, I wore a Marilyn Monroe T-shirt, but I added a Manson-style swastika to her forehead. Droplets of blood had leaked through the shirt, staining Marilyn Monroe's left eye, a result of my having had a potentially cancerous mole recently removed from beneath my nipple in the same spot where Jesus was wounded. Although the doctor warned me not to touch the area around the incision, as soon as I returned home I stretched the skin around it as tautly as I could. The results were my first new hobbies as Marilyn Manson: scarification and body modification, which I

 **CIRCLE SEVEN - THE VIOLENT - AGAINST THEMSELVES**

furthur pursued with a plastic surgeon, who clipped my drooping earlobes down to human size.

The stage at Churchill's consisted of several pieces of plywood over rows of bricks, and the P.A. was basically a pair of Walkman headphones snapped apart and scotch-taped to the wall on either side of the stage. We opened with one of my favorite poems, "The Telephone."

"I am awakened by the incessant ringing of the telephone," I began, my croak turning to a growl as I wondered whether there was enough chaos on stage to hold the audience's attention. "I still have dreams caked in the corners of my eyes and my mouth is dry and tastes shitty.

"Again—the ringing. Slowly, I bustle out of bed. The remnants of an erection still lingering in my shorts like a bothersome guest.

"Again the ringing. Carefully, I abscond to the bathroom so as to not display my manhood to others. There, I make the perfunctory morning faces, which always seem to precede my daily contribution to the once-blue toilet water that I always enjoy making green.

"Again the ringing. I shake twice like most others, as I am annoyed by the dribble that always seems to remain, causing a small

acreage of wetness on the front of my briefs. I slowly, languidly, lazily, crazily stumble into the den where my father smokes all the time. Cigars in his easy chair.

"Oh, the stench!"

The song went on, the concert went on, and I lost track of what I was doing until afterward, when I rushed into the club bathroom and threw up in the toilet. I thought it had been a terrible show for watcher and performer alike. But a funny thing happened as I leaned over my putrid amalgamation of pizza, beer and pills. I heard applause, and suddenly I felt something rise inside me that wasn't vomit. It was a sense of pride, accomplishment and self-satisfaction strong enough to eclipse my withering self-image and my punching-bag past. It was the first time in my life I felt that way. And I wanted to feel like that again. I wanted to be applauded, I wanted to be hissed, I wanted to make people pissed.

Few stories in my life are without an anticlimax, and this one came as I was driving back to Fort Lauderdale at three A.M. that night in my mom's red Fiero. On the overpass arching above the crime-ridden ghetto of Little Havana, the digital radio blinked out in my car. I pulled over to the shoulder to see what was wrong, and discovered that I couldn't restart the car. The alternator belt had snapped, and, less than an hour after having found my true calling, I was stuck foraging for a phone by myself in Little Havana, where the chances of a makeup-streaked clown named Marilyn Manson not getting beat up were pretty slim. The only good that came out of the experience was that, since the tow truck didn't arrive until ten A.M., I got used to not sleeping after a concert early in my career.

Our first real show took place at the Reunion Room. I booked it by telling the manager and DJ, Tim, "Listen, I got this band and we're going to play here and we want $500." Normally bands were paid $50 to $150, but Tim agreed to my price. That was lesson number one in music-industry manipulation: If you act like a rock star, you will be treated like one. After the show, we kicked pimplehead and the fat guy out of the band and they no doubt went off to make sandwiches, squeeze zits and star in the sitcom *Pimplehead and the Fat Guy*, which lasted for two episodes.

We then lured Brad Stewart, the Crispin Glover look-alike from the Kitchen Club, away from a rival band, Insanity Assassin, which featured Joey Vomit on bass and on vocals Nick Rage, a short, stubby guy who had somehow tricked himself into thinking he was a tall, skinny, attractive guy. It wasn't hard to convince Brad to play bass with us (even though he had played guitar with Insanity Assassin)

since we had similar musical goals—and better stage names. He became Gidget Gein. We let Stephen join the band as Madonna Wayne Gacy, even though he didn't have a keyboard. Instead, he played with toy soldiers onstage.

For better but ultimately for worse, one more character ended up in our freak show. Her name was Nancy, and she was psychotic in all the wrong ways. She knew my girlfriend Teresa, who was one of the first people I met after Rachelle had made a fool of me. I was seeking a motherly figure instead of a model's figure, and I found it at a Saigon Kick concert at the Button South. Teresa came from the same factory as Tina Potts, Jennifer and most of the other girls I ended up with in Ohio. She had a slight overbite, tiny hands and a blond bob not unlike Stephen's. The two were perpetually mistaken for twins.

I had seen Nancy once before when I worked at the record store, a hippo Goth looking foolish in a black wedding gown. When Teresa introduced me to her a year later, Nancy had lost fifty pounds and had an I'm-skinny-and-I'm-gonna-pay-back-the-world-for-all-the-times-when-I-was-fat-and-didn't-get-fucked attitude. She had shoulder-length black curly hair, floppy tits that hung out of a slutty tank top,

Hispanic features, a pale face, and a permanent stench that was half flowery, half noxious. Once I told her about the performance art ideas I had for future shows, there was no escaping her: She pushed herself into the band like a tick working its way under an elephant's skin. Any idea I had that involved a girl—no matter how extreme or humiliating—she immediately volunteered for. Because she was willing and I was desperate—and also since she seemed like somebody other people would dislike as much as they disliked me—I gave in.

Our antics quickly grew from tame to depraved. The first time we performed together, I sang while holding her on a leash the whole time—to make a point about our patriarchal society, of course, not because it turned me on to drag a scantily clad woman around the stage by a leather leash. Soon afterward, Nancy asked me to punch her in the face, so I began giving her progressively crueler beatings each show.

 ## CIRCLE SEVEN · THE VIOLENT · AGAINST THEIR NEIGHBORS

It must have caused some brain damage because she began to fall in love with me—even though I was going out with Teresa, who was good friends with Nancy's boyfriend, Carl, a tall, goofy, well-meaning klutz with big hips and a soft, girlish figure. This lame *Real World* situation was made even worse when Nancy and I began to explore sexuality as well as pain and dominance onstage. I made out with her and sucked her tits, and she got on her knees and caressed whatever she found down there. Without fucking, we took it as far as we could without getting in trouble with my girlfriend, her boyfriend or the law.

During one concert we put her in a cage, and, as the band played "People Who Died" by the Jim Carroll Band, I revved up a chain saw and tried to grind through the metal. But the chain flew off the blade, smacked me across the eyes and made a huge gash in my forehead, sending blood streaking down my face. I barely made it through the rest of the show because all I could see was red.

Like any good performance art, there was a message behind the violence. Most of the time, I wasn't interested in inflicting pain on myself and others unless it was in a way that would make people think about the way they act, the society they live in or the things they take for granted. Sometimes, as a concrete lesson in making assumptions, I'd toss into the audience dozens of ziploc bags—half of them filled with chocolate chip cookies, the other half with cat turds.

*deformography*

I was also interested in the danger and menace of seemingly inno-
cent children's movies, books and objects, like metal lunchboxes,
which were banned in Florida because the state was worried kids
would use them to beat each other senseless. During "Lunchbox," I
regularly set a metal lunchbox on fire, took off all my clothes and
danced around it, trying to exorcise its demons. In an attempt to reit-
erate the lesson of *Willy Wonka* in my own style during other shows,
I hung a donkey piñata over the crowd and put a stick on the edge of
the stage. Then I would warn, "Please, don't break this open. I beg
you not to." Human psychology being what it is, kids in the crowd
would invariably grab the stick and smash the piñata apart, forcing
everyone to suffer the consequence, which in this case was a shower
of cow brains, chicken livers and pig intestines from a disemboweled
donkey. People would slam-dance and slip on this mass of now-
spoiled meat, cracking their heads open in a total intestinal freak-out.
The outrageous stunts, however, came later, after a disastrous trip to
Manhattan during which I wrote my first real song.

A girl with a pretentious name like Asia, who I had met while she
was working at a McDonald's in Fort Lauderdale, was spending the
summer in New York and offered to fly me up for a weekend.
Although I was going out with Teresa, I accepted—mainly because I
didn't like Asia and just wanted a free trip to New York. I thought
that maybe I could find a record executive to sign our band, so I
brought along a crude demo tape. I was never happy with our demos,
which Scott always recorded, because we sounded like a tinny
industrial band and I imagined us playing rawer, more immediate
punk rock.

Manhattan turned out to be a disaster. I discovered that Asia had
lied to me about her name and age. She had used her sister's ID to get
a job at McDonald's because she was too young. I got pissed—it
wasn't that big a deal, but it was another case of a girl deceiving me—

and stormed out of her apartment. In the street, by a coincidence or not, I ran into two club rats from South Florida, Andrew and Suzie, a couple of dubious sexuality. I always thought they looked sharp and stylish in clubs, but seeing them for the first time in daylight that afternoon I realized that they used makeup and darkness to practice Gothic deception. In the afternoon sun, they looked like decomposing corpses and seemed at least ten years older than me.

In their hotel room, the cable system had public-access channels, a completely new phenomenon to me. I spent hours flipping through the stations, watching Pat Robertson preach about society's evils and then ask people to call him with their credit card number. On the adjacent channel, a guy was greasing up his cock with Vaseline and asking people to call and give him their credit card number. I grabbed the hotel notepad and started writing down phrases: "Cash in hand and dick on screen, who said God was ever clean?" I imagined Pat Robertson finishing his more-righteous-than-thou patter, then calling 1-900-VASELINE. "Bible-belt 'round Anglo-waste, putting sinners in their place/Yeah, right, great, if you're so good explain the shit stains on your face." Thus "Cake and Sodomy" was born.

I had written other songs I thought were good, but "Cake and Sodomy" was more than just a good song. As an anthem for a hypocritical America slobbering on the tit of Christianity, it was a blueprint for our future message. If televangelists were going to make the world seem so wicked, I was going to give them something real to cry about. And years later, they did. The same person who inspired "Cake and Sodomy," Pat Robertson, went on to quote the song's lyrics and misinterpret them for his flock on *The 700 Club*.

When I came back from New York, my real troubles began. Teresa was supposed to pick me up at the airport, but she never showed up and nobody answered the phone at her house. So I called Carl and Nancy, since they lived near the airport.

"Do you know where the fuck Teresa is?" I asked. "I had a shitty time in New York, I'm stuck at the airport with no fucking money and all I wanna do is go home and go to sleep."

"Teresa's out with Carl," Nancy said, the cold tone of her voice betraying a hint of the jealousy that I also felt.

Nancy offered to pick me up and drive me home. When we arrived, she followed me inside. I just wanted to pass out, but I didn't want to be mean after she had rescued me. I collapsed onto the bed, and she collapsed on top of me, coming on to me heavier (all puns intended) than she ever had before. She rammed her tongue down my throat and grabbed my dick. I was very apprehensive, mostly because

I didn't want to get caught. By now, I had begun to feel removed from the everyday world of morality. Guilt had become more a fear of getting caught than any sense of right or wrong.

I ended up letting her give me a blow job, because Teresa never went down on me. But, as onstage, I wouldn't let her fuck me. When Teresa and Carl showed up at my house less than fifteen minutes later, we were sitting on the bed innocently watching television. Carl instinctively walked up to Nancy and kissed her on the mouth, unaware that minutes ago that very orifice had received several million of my sperm.

At the time I thought it was funny and appropriately vengeful, but I didn't realize that this solitary act of fellatio would be the beginning of a six-month reign of full-on Gothic terror.

INGUINAL CANAL
(OPENED)

PENIS

URETHRA

SPERMATIC CORD

PERSISTENT SEROUS
CAVITY AROUND
CORD—EXCEPTIONAL

CREMASTERIC MUSCLE
AND FASCIA
INTERCOLUMNAR
FASCIA

DARTOS

TUNICA VAGINALIS—
PARIETAL LAYER
INFUNDIBULIFORM
FASCIA
SESSILE
HYDATID

RIGHT HALF OF SCROTUM SKIN        LEFT HALF OF SCROTUM

⑦

*dirty rock star*

**THE URGE TOWARDS LOVE, PUSHED TO ITS LIMIT,
IS AN URGE TOWARDS DEATH.**
*—Marquis de Sade*

T**HE** place is Fort Lauderdale, Florida. The date is July 4, 1990. The thing in the palm of a hand stretched out in front of me is a tab of acid, and in a moment it will obliterate all these facts.

Teresa, my girlfriend, has done acid before. Nancy, the psycho, has done it. I haven't. I let it sit in my mouth until it annoys me, then swallow it and return to packing up the remains of Marilyn Manson and the Spooky Kids' first backyard performance, confident that my will power is stronger than whatever this tiny square of paper has in store for me. Andrew and Suzie, the couple who gave me the tab, smile conspiratorially. I wink back, unsure of what they're trying to communicate.

Minutes pass, and nothing happens. I lie in the grass and focus on figuring out whether the acid is working—if my body seems different, if my perception has changed, if my thoughts are warping. "Do you feel it yet?" comes a voice, breathing sticky and sickly on my ear. I open my eyes to see Nancy grinning masochistically through her black hair.

"No, I don't," I say briskly, trying to get rid of her, especially since my girlfriend is around.

"I need to talk to you," she insists.

"Fine."

"I'm just starting to realize some things. About us. I mean, Teresa's my friend and Carl, I don't care about Carl anymore. But we need to tell them how we feel about each other. Because I love you. And I know you love me, even if you don't know it. It doesn't have to be forever. I know how you are about things like that. I don't want this to get in the way of our band"—our band—"and the chemistry we have onstage. But we can try it. I mean, love . . . "

As soon as she says love that last time, her face appears lit up against the grassy background, like a billboard advertising self-deception. The word love seems to hang suspended in the air for that moment, masking the rest of her sentence. It's all very subtle. But I realize then that I'm going on a trip, and there's no way back.

"Did you feel that—the difference?" I ask, confused.

"Yes, of course," she says eagerly, as if we're on the same wavelength. I do need somebody on my wavelength because I think I'm about to freak out. But I don't want it to be her. Oh, God, I don't want it to be her.

I stand up and start to look for Teresa, walking through the house slightly disoriented. Everyone is huddled in corners talking in small

groups, each cluster of people smiling at me and beckoning me to join them. I keep walking. The house seems endless. I explore about a hundred rooms, not sure whether they're all the same one or not, before giving up, confident that my girlfriend is having a good time somewhere that I'm not. I reemerge in the backyard. But it's not the same backyard. It's dark, it's empty and something feels wrong. I'm not sure how long I've been inside.

I step outside and wander around. Intricate designs, like sketchy pencil drawings, appear in the air, only to be erased moments later. I trip out on them for a while before I realize it's raining. It doesn't really matter. I feel so light and uncorporeal that the rain seems to be dropping through me, penetrating the layers of light my body is emanating. Nancy comes up to me and tries to touch me and understand. Now I'm definitely freaking out.

With Nancy in tow, filling the air with the store-bought scent of dead flowers, I walk downhill to a small, man-made creek. Everywhere there are gray-skinned toads, jumping on the rocks and in the grass. Each step I take, I squish several of them, squeezing out gray-blue blood. Their entrails stick to my shoe, discolored, dead and yellow like blades of grass trapped under the metal rails of lawn furniture. I'm driving myself crazy trying not to kill these things, who have kids and parents and lives to get back to. Nancy is trying to relate to me and I'm trying to pretend like I'm paying attention. But all I can think about are the dead toads. I feel pretty confident that this is what a bad trip feels like—because if this is a good trip, then Timothy Leary has a lot of explaining to do.

I sit down on a rock and try to collect myself, to tell myself that this is all just a drug thinking for me, that the real Marilyn Manson will be back in a moment. Or is this right now the real Marilyn Manson, and the other one just a shallow representation?

My mind is spinning like the wheel of a slot machine around my consciousness. Some images I recognize—the creepy stairs to my old basement room, Nancy playing dead in a cage, Ms. Price's flash cards. Others I don't—a leering police officer wearing a Baptist church cap, photographs of a blood-drenched pussy, a scab-covered woman tortously tied up, a mob of kids tearing up an American flag. Suddenly, the wheel stops on one image. It bobbles up and down blurrily in my mind several times before I can make it out. It's a face, large and expressionless. Its skin is pasty and yellowish, as if jaundiced from hepatitis. Its lips are completely black, and around each eye a thick black figure, like a rune, has been drawn. Slowly, it dawns on me that the face is mine.

*deformography*

My face is lying on a table near a bed. I reach to touch it, and notice that my arms are stippled with the tattoos I've been thinking about getting. My face is paper, it is on the cover of a big, important magazine, and that is why the phone is ringing. I pick it up, and notice that I am not anywhere I recognize. Someone who identifies herself as Traci is trying to tell me that she saw the magazine with my face and it makes her excited. I am supposed to know this person, because she apologizes for not having been in touch for so long. She wants to see me perform tonight at a big auditorium I've never heard of. I tell her I'll take care of it because I am glad that she wants to come but disappointed it is only because she saw my paper face. Then I roll over in a bed that is not mine and go to sleep.

"The cops are here!"

Someone is yelling at me, and I open my eyes. I hope that maybe it's morning and this is over, but I'm still sitting on a rock surrounded by dead toads, Nancy and a guy shouting that the police are busting the party. I can't figure out which of these things is worse.

I've always been paranoid about the police, because even when I'm not doing anything illegal I'm thinking about doing something illegal. So whenever I'm around a cop, I get uncomfortable and nervous, worried that I'm going to say the wrong thing or look so guilty that they'll arrest me anyway. Being completely out of my mind on drugs doesn't help the situation any.

We start running away. The rain has stopped and everything is wet and soft under my feet, so I feel like I'm sinking into the ground instead of running. Utterly acid-addled, the situation grows to enormous proportions in my mind, and I feel like I'm fleeing for my life. My entire future depends on not getting caught. We arrive and stop dead in front of a Chevrolet covered from hood to trunk with fresh, dripping blood. I'm in too deep.

"What the fuck is going on?" I ask everyone around me. "What is this? What's happening? Somebody!"

Nancy reaches out to me, and I push her away and find Teresa. She takes me into her car—dark, factory-scented and claustrophobic—and tries to soothe me, telling me that the other car is just painted red, and the red looks like blood because of the wet rain on it. But I'm completely paranoid: dead toads, cops, a bloody car. I see the connection. Everyone's against me. I can hear myself screaming, but I don't know what I'm saying. I try to get out of the car. I do it by punching the windshield, putting my fist through the supposedly shatter-proof glass. The cracks in the glass spiderweb around my hand, and my bleeding knuckles look like a row of open sewer pipes gushing waste.

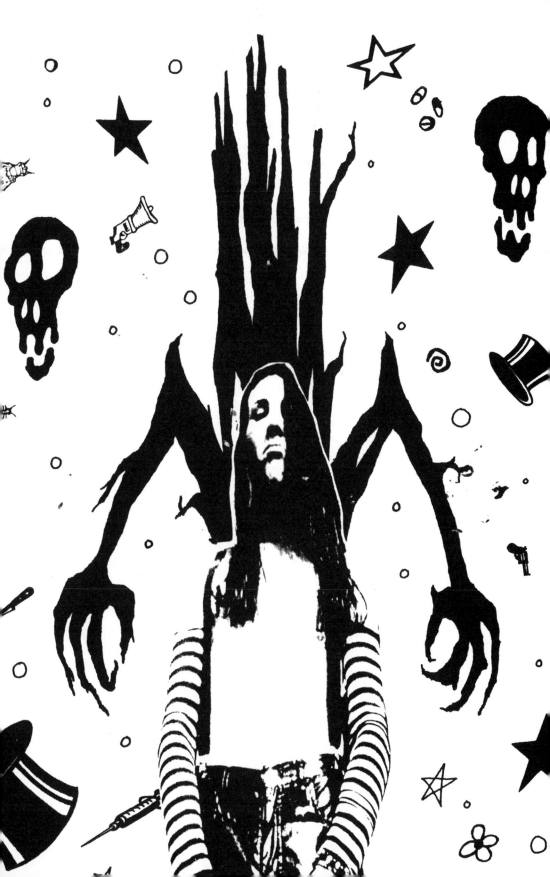

Then we sit, and Teresa whispers things in my ear and tells me she knows what I'm feeling. I believe her, and I think she believes herself too. We enter that acid mind-meld where we don't have to talk anymore to know what each other is thinking, and I begin to calm down.

We return to the party. People are still there, though there are less of them, and there's no evidence that the cops have ever been there. Just as I'm beginning to cross the border from bad drug experience to tolerable one, someone—not realizing I'm tripping my balls off—tries to push me in the pool as a joke. It doesn't take a math major to figure out that acid plus swimming pool equals certain death. So I panic and start flailing. Soon, we're locked in a fistfight, and I'm tearing at him like he's a doll I'm trying to mutilate. I punch him in the face with my raw, skinless knuckles and don't even feel the pain.

After he stumbles out of range, I notice everyone staring at me slack-jawed. "Listen, let's just go over to my house," I say to the people around me. We pile into the car—it's me, my girlfriend, Nancy and her boyfriend—the exact four ingredients necessary in a recipe for personal misery. Back at my parents' town house, we make our way to my room, where we find Stephen, my keyboardless keyboardist, lying on the bed like gasoline waiting for a match. He tries to interest us in the video he is watching, *Slaughterhouse Five*, the kind of strange, disconnected head-trip film you don't want to think about when you're on acid.

Carl instantly gets engrossed in the movie, the television glow playing on his open, drooling jaw. Without saying a word, Nancy stands up hastily—annoyingly—and marches to the bathroom. I'm sitting on the bed with my girlfriend, my mind flashing in the same way the movie is flickering on Carl. Stephen is babbling about how the special effects in the movie were done. From the bathroom, I hear a spastic scratching sound, like the claws of dozens of rats skittering around the bathtub. In a rare moment of lucidity, I realize that the sound is of a pencil writing furiously on paper. The sound grows louder and louder, drowning out the TV, Stephen and everything else in the room, and I know that Nancy is writing something that is going to completely make me miserable and ruin my life. The louder the sound surges, the more crazy and twisted I imagine the words getting.

Nancy emerges from the bathroom in a blaze of vindictive glory and hands me the note. No one else seems to notice. This is between us. I look into the television to gather my strength. I'm staring at it so hard that I can't even focus on the picture anymore. In fact, it doesn't even look like a TV. It looks like a strobe light. I turn away, and look at Nancy. But I don't see Nancy. I see a beautiful, pouty woman with

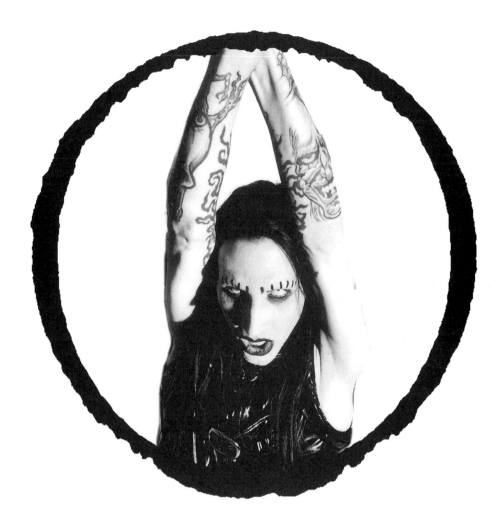

long, blow-dried blond hair and an Alien Sex Fiend T-shirt hiding her curves. It must be the woman from the telephone . . . Traci.

Instead of pencil scratching, I hear David Bowie: "I. I will be king. And you. You will be queen."

I have Traci's fingers in one hand and a bottle of Jack Daniel's in the other. We're standing on a balcony at a party, which seems to be in my honor. "I never knew you were all this," she purrs, apologizing for something in the past I'm unaware of. "I thought you were something different."

There are lights and flashbulbs, Bowie is singing "We could be heroes just for one day," and everybody is smiling ingratiatingly at us. She seems to be as famous as I seem to be.

"I spent my adolescence masturbating to that bitch," a roadie—mine?—cackles in my face.

"Who?" I ask.

"That."

"What's that?"

"Traci Lords, you lucky fucker."

On the floor beneath us there is a tall, slouched man with long black hair and a face painted white. He is wearing platform boots, torn fishnet stockings, black leather shorts and a shredded black T-shirt. He looks just like me, or a parody of me. I wonder if he is me.

A fat girl with metal rods and hoops stuck through half of her face and lipstick smeared over the rest notices me staring at the tall man. She comes upstairs, pushes past a stocky bodyguard—mine?—and, as her face strobes grotesquely in the light, explains, "You wanna know who that guy is? Nobody really knows his name. He's totally homeless. He makes his money hooking, and then spends it trying to look like you. He always comes in here and dances to your records."

I listen to the music again. The DJ has put on "Sweet Dreams" by the Eurythmics. But it's slower, darker, meaner. And the voice singing is mine. I need to get away from this surreal scene, away from all these people who are treating me like I'm some sort of star they can suck a little brightness out of. Traci takes my hand and leads me away, moving like mercury through the admiring rubble. We step behind a white, gauzy curtain to an empty VIP room full of untouched deli sandwiches and sit down. There is something in my hands . . . a piece of paper. I try to focus on the thick, smudged lines. "Dear, Lovely Brian," it begins. "I want to kick my boyfriend out, and I want you to move in with me. You said last week that you weren't happy with the way things were going with Teresa"—fuck, it's from Nancy—"I will make you so happy. I know I can. No one will take care of you like I will. No one will fuck you like I will. I have so much to give you."

I put it down. I can't deal with it right now, not while I'm on this trip. Will I ever get off this trip? Nancy is standing in the bathroom doorway looking at me, her bare midriff slightly distended below her tight, navy T-shirt. Her thumb is thrust into the waistband of her jeans and she is biting her lower lip. She doesn't look sexy. She looks freakish and misshapen, like a Joel-Peter Witkin photograph. I stand up and walk over to her. Teresa and Carl sit on my bed watching the movie, completely oblivious to us and Stephen's freakish chatter.

The breeze blows in cool and logical from the open window of my bathroom, which is pitch black, though the lights in my head strobe on. I grope for the porcelain edge of the bathtub and sit down, trying

to still my spinning head and remember what I was going to say to Nancy. I can hear music now, far too big and loud for my bathroom. I feel myself blacking out and try to fight it.

The music grows louder in my head. "This is not my beautiful house! This is not my beautiful wife!"

The music is not just in my head anymore. It's the Talking Heads, "Once in a Lifetime," and it's all over me, vibrating against my back. I'm lying on the floor, blinking open my eyes and trying to regain consciousness.

"And you may ask yourself, 'Well, how did I get here?'"

She—Traci—is leaning over me, pulling my shirt over butterflied lacerations I never knew I had. Her other hand is working on the buttons of my pants. Her mouth is hot and syrupy, and I can taste cigarettes and Jack Daniel's. She begins to do things with that mouth and those tiny hands and pomegranate red nails that millions of men have watched on second-generation videotapes for years—films I was never interested in, despite my fascination with her life. She lowers my pants and, with arms perfectly crossed, pulls off her top. She hikes up her skirt, not to remove it but to show me she's not wearing any underwear. I'm transfixed. She doesn't seem dirty, as if she's playing a role in a porno movie, even when she's giving me head. She is delicate, protective and angelic, a feather suspended in midair above an inferno of debasement and carnography. I'm drunk and, for that split second, I'm also in love. Through the thin lace curtain separating our tangle of tongue, fingernail and flesh from the rest of the club, I can see the bodyguard silhouetted against the strobing light, guarding the gate like St. Peter.

"Once in a lifetime . . . '"

I am thrusting into her now, and she screams. I grab her hair, but instead of long tresses of yellow, I get something short, clumped and stiff that tears out in my hands. My arms are shorn of tattoos, and the moans, muffled by my hand, reverberate against the silence. Shit, I'm fucking Nancy. What am I doing? This is not the kind of mistake you can get away with. Fucking a psycho is as good as killing one. There are consequences, repercussions, prices to pay. In strobing flashes, I see Nancy's face gazing up at me as she sits on the bathtub, her legs opening and squeezing shut, foaming wet like the jaws of a ravenous dog. With every flash, her face grows more and more distorted, more twisted and inhuman, more . . . demonic. That's the right word. My body keeps moving, fucking her hard, but my mind is screaming for it to stop.

This is it. I'm fucked. I'm screwing the devil. I've sold my soul.

"And you may ask yourself, 'Where does that highway go?'"

Someone bites the cartilage of my ear. I think it is Traci, because I like it. She grabs my choker and pulls my head toward hers. Her breath, hot and moist on my ear, whispers: "I want you to come inside me."

The music stops, the flashing stops and I come inside Nancy like a bouquet of milk white lilies exploding in a funeral hole. Her face is dead and emotionless. Her eyes are like burned out flash bulbs. Is that where the flashing was coming from?

"And you may ask yourself, 'Am I right? Am I wrong?' And you may tell yourself, 'My God! What have I done?'"

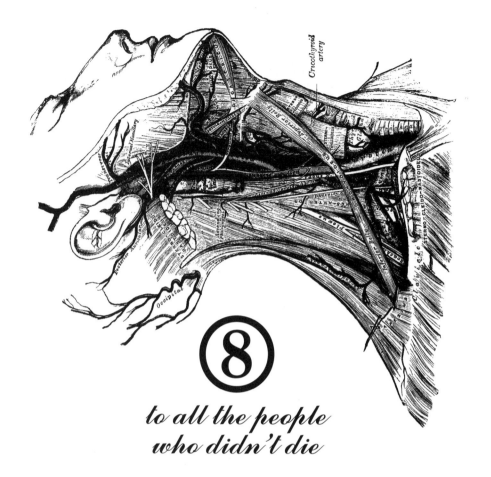

# ⑧

## *to all the people who didn't die*

MALDOROR WAS VIRTUOUS DURING HIS FIRST YEARS, VIRTUOUS AND HAPPY. LATER HE BECAME AWARE THAT HE WAS BORN EVIL. STRANGE FATALITY! HE CONCEALED HIS CHARACTER AS BEST HE COULD FOR MANY YEARS; BUT IN THE END, BECAUSE SUCH CONCENTRATION WAS UNUSUAL TO HIM, EVERY DAY THE BLOOD WOULD MOUNT TO HIS HEAD UNTIL THE STRAIN REACHED A POINT WHERE HE COULD NO LONGER BEAR TO LIVE SUCH A LIFE AND HE GAVE HIMSELF OVER RESOLUTELY TO A CAREER OF EVIL . . . SWEET ATMOSPHERE! WHO COULD HAVE REALIZED THAT WHENEVER HE EMBRACED A YOUNG CHILD WITH ROSY CHEEKS HE LONGED TO SLICE OFF THOSE CHEEKS WITH A RAZOR, AND HE WOULD HAVE DONE IT MANY TIMES HAD HE NOT BEEN RESTRAINED BY THE THOUGHT OF JUSTICE WITH HIS LONG FUNERAL PROCESSION OF PUNISHMENTS.
— *Comte de Lautréamont, Maldoror*

# FOR weeks after the trip, I was depressed and terror-

ized, stalked and successfully captured by Nancy. I let her make cre-
ative decisions for the band and, even worse, fucked her all the time
behind Teresa's back. The sex was good, but I didn't want it.
Somehow, every direction I turned, she was there. And every time she
was there, she wanted to get naked. I was completely possessed. She
had me doing things I knew I shouldn't, like taking acid again. This
time it was before a performance.

I had gotten a call from Bob Slade, a punk-rock DJ in Miami with
a Monkees-style bowl haircut. We didn't have a manager at the time,
so I was mishandling our business affairs.

"Listen," he said in his nasal, obnoxious radio voice. "We need
you guys to open up for Nine Inch Nails at Club Nu." Club Nu was a
guido bar in Miami that we all hated.

Though we only had seven songs, Brad was still learning to play
bass and Stephen hadn't bought a keyboard yet, I agreed. It was too
good an opportunity to pass up just because we sucked. Before the
show, Nancy handed me a tab of acid. As if the fourth of July had just
been a bad dream that had nothing to do with drugs, I stuck it under
my tongue without a second thought—until afterwards.

On stage, I wore a short, orange dress and dragged Nancy around
by her usual leash and collar. For some reason, I didn't freak out on
the acid: Nancy did. She cried and screamed throughout the show,
begging me to beat her harder and harder, until welts rose up on her
pale, anemic back. I was frightened by what I saw myself doing, but
excited too, mainly because the crowd seemed to be getting so much
enjoyment out of our psychedelic sadomasochistic drama.

After the show, which I don't even think Trent Reznor watched, I
ran into him backstage.

"Remember me?" I asked, trying to pretend like I wasn't tripping,
though my ultradilated eyes probably gave it away. "I interviewed
you for *25th Parallel.*"

He politely pretended he remembered me, and I gave him a tape
and scurried away before I could say anything too stupid. Crazed on
drugs and still under the spell of Nancy, I stumbled to a backstage
hospitality area—most likely Nine Inch Nails's dressing room—where
I found her waiting for me. We had sex, and I saw the devil in her eyes
again. But I wasn't scared. We were already well acquainted by then.

When we were finished, we lowered our dresses and walked into
the hall, where we ran into Nancy's boyfriend, Carl, and my girl-

friend, Teresa. It was a strange moment of recognition that seemed frozen in time. We stared at them and felt like they looked guilty. They stared at us and felt like we looked guilty. Nobody said anything about it. We all just knew, or thought we knew.

Something had been bothering me about Teresa anyway. From the beginning of our relationship, there was an element of mystery about her, as if there was a skeleton she kept locked in the dark closet of her mind. She lived in a tiny house with her mother, who slept on a couch in the living room, and her brother, a walking contradiction. He was a perpetually drunk pickup-truck-driving redneck who was also into hip-hop and b-boy culture. Theoretically, this meant he should be beating himself up.

It was never much fun sleeping over at Teresa's, because her brother used to get violent and punch holes in her door, and her dog had fleas so I'd stay up half the night itching. Although it would have been better for both of us if we had just broken up, I was too insecure and too afraid of standing up on my own without using her as a crutch. It wasn't about sex, it was about support—she paid for everything, gave me advice, treated me like a child, and tolerated my mental abuse. She was sweet, plain and nurturing, which was what I was looking for after my experience with Rachelle, who was cold-hearted, gorgeous and manipulative.

But when I visited Teresa at her home on Mother's Day, her eyes, which were always ringed with darkness, looked blacker and more clouded than usual. I asked her what was wrong, and, after trying to circumvent the question, she admitted that she had gotten pregnant in high school, carried the child to term and then put him up for adoption. After she said this, I started looking at her differently, noticing the stretch marks on her hips and the maternal way she treated everyone. I felt like I was fucking my own mother when I slept with her. Though I was deceiving her about Nancy, I still couldn't help being hypocritical and feeling spiteful that, like every woman I had gone out with to that point—from pretentious Asia to two-timing Rachelle—Teresa had lied to me and betrayed me. To this day I still have a complex that every girl I meet has a kid or is going to try to have a kid with me. Usually, I'm right.

I also started noticing that Teresa and Nancy were connected by some sort of balance that kept their collective weight in equilibrium. As Teresa grew fatter, Nancy kept getting skinnier. Part of the reason I fell under the influence of Nancy's spell was that she saw the holes spreading in my armor and worked her way inside like the corrosive rust that she was.

When I came down off the acid that morning after the Nine Inch Nails show, I also came down off Nancy's spell. It was as if I had been on one long trip since the fourth of July. I fell asleep angry and confused, trying to figure out what had been wrong with me for the past few months. She called me up late that afternoon—just after I had woken up with the chorus of the worst song I would ever write, "She is not my girlfriend/I'm not who you think I am," in my head—and gave me her usual shit about kicking Carl out of the house and moving me in. But this time I didn't take it.

"No, there's no way," I exploded. "You know, this is total bullshit. First of all, this whole thing with the band isn't going to work out. I want you out."

"But it's my band, too," she insisted.

"No, it's my band. It never was your band. You aren't even in the band. You're an extra, a prop, and I appreciate what you've done for us on stage, but it's time to move on."

"But what about us? I mean, will we still . . . "

"No. That's over too. Whatever we had, it was a mistake and I want to end it right now. Teresa is and will remain my girlfriend. I'm sorry if I sound like an asshole, I'm just trying to be final about this."

That's when she flipped out, worse than when she was tripping the night before. She screamed and cried herself hoarse, threatening me with everything she had. The conversation ended with me trying to convince her not to tell Teresa or Carl about us. She agreed. But hours later, Teresa called.

"Listen to this," she said, putting the receiver next to her answering machine. There was a message from Nancy, but she was yelling so frantically into the receiver that it was difficult to make it all out. It went something like: "You bitch . . . what the fuck did you . . . I told you . . . never . . . fucking kill you . . . if I see you . . . limb . . . spread your ugly . . . fucking . . . blood all over the walls (click)."

From there, all hell broke loose. Nancy called clubs and canceled Marilyn Manson and the Spooky Kids shows; she showed up at our concerts, threatened people in the audience, and even climbed onstage and attacked the girl who replaced her, Missi. She called every person I knew and told them what an asshole I was, and she started leaving obscene messages and packages for me. One morning I found a necklace she had borrowed from me lying on my doorstep. But it had been smashed to bits, covered with something resembling blood and sealed ritualistically in a Mason jar with some kind of hair. It was like a curse that John Crowell's brother would have attempted.

Never in my life had anyone ever made me so violently angry

before. She was ruining my life when we were sleeping together, and now that we weren't, she was destroying it even more thoroughly. Every night when I came home there was a new death threat waiting for me. I already had so many strong feelings about Nancy: repugnance, fear, lust, annoyance, exasperation and the knowledge that any girl who likes me must be crazy. But now they were all superseded by deep, dark, vitriolic hate, which throbbed scaldingly through my veins every time her name came up. I finally called her and laid it on the line: "Not only are you not going to be in the band anymore, but if you don't leave town I'm going to have you killed." I wasn't exaggerating. I was infuriated, I had nothing to lose and I was so emotionally wrapped up in the situation that I had no perspective. It wasn't just Nancy who was like John Crowell, it was me, because I was losing my own identity in my hatred for the people I thought were trying to destroy it.

My respect for human life had long since dulled. I had realized this just weeks before when I was leaving the Reunion Room and witnessed a head-on collision as I was crossing the street. A middle-aged man stumbled out of one car, a blue Chevrolet Celebrity, with his hand on his forehead screaming for help. He staggered around the street, disoriented and in shock, and then let go of his forehead. The flap of skin covering the top of his head fell over his face, and he collapsed in a growing pool of his own blood, trembling and convulsing as death seized and finally stilled him. When I walked to the other side of the street, where the other car had crashed, there was a woman whose skull had been split open. She was clearly in pain, but she was calm and lucid, as if she had accepted the fact that her world was about to end. As I walked by, she slowly turned her head toward me and begged for me to hold her. "Please, somebody hold me," she pleaded, shivering. "Where am I? Don't tell my sister. . . . Somebody, please. Hold me." I could see the humanity and desperation well up in her brown eyes. She just wanted some kind of physical, nurturing contact as she died. But I kept walking. I wasn't part of it and didn't want to be part of it. I felt disconnected, as if I were watching a movie. I knew I was being an asshole, but I wondered, would she—or anybody—have stopped for me? Or would they have been too concerned with themselves—worried that I'd bleed on their clothes, make them late to a meeting or infect them with HIV, hepatitis or something worse.

With Nancy, while I didn't think it was right to take a human life, I didn't think it was right to deny myself the chance of causing someone to die either, especially someone whose existence meant so little to

the world and to herself. At the time, taking someone's life seemed like a necessary growing and learning experience, like losing your virginity or having a child. I began mapping out different ways I could carry out my threat to Nancy with the least possible risk to myself. Was there someone I knew who was so desperate that they'd kill her for fifty dollars? Or could I do it myself, perhaps push her in a lake and pretend it was an accident? Maybe I could sneak into her apartment and poison her food? This was the first time I had ever seriously considered murder. I wasn't sure what to do. So I called the one person who I knew was an expert: Stephen, our keyboardist, who we had started calling Pogo at this point because neither Madonna nor Gacy seemed to fit his personality and Pogo was John Wayne Gacy's clown nickname.

I asked Pogo everything there was to know about murder and the disposal of bodies. I wasn't going to accept any other alternative. She had to die. In my mind, I built her into a symbol, a representation of everyone who had ever tried to possess me or control my mind, whether it be through Christianity or sex, and I wanted revenge—compensation—for the boy they had warped and destroyed. Pogo and I went about this task very meticulously. We plotted the perfect murder, with not only no evidence that we had been involved but no evidence that there had even been a murder. We followed her, cased out her house and figured out her routine before coming up with the solution: arson.

That Thursday night, Pogo and I put on all black (which wasn't that much different from how we usually dressed); filled a shoulder bag with kerosene, matches and rags; and drank some courage at Squeeze. Before leaving the club, I phoned Nancy to make sure she was home. As soon as she answered, I hung up. We were on.

She lived in an area of town called New River, underneath a bridge that sheltered much of Fort Lauderdale's homeless population. As Pogo and I neared her house, a black vagrant chased after us. "Hey, what is this, Halloween?" he yelled as he approached, the fetid stench of his breath signaling his arrival. He had a large gold-colored ring across

POGO

his knuckles that spelled out his name, Hollywood, and he kept telling us about the drugs he had for sale. The fact that he looked like Frog, the kid who had beaten me up at the roller-skating rink, only served to compound the hate I felt at that moment and add to my determination to kill this girl.

But Hollywood kept following us, all the way to Nancy's door. Pogo and I looked at each other. We didn't anticipate there being a witness in this deserted neighborhood. The look we gave each other was a question mark: Do we kill him, too? Or do we abandon the plan for tonight?

We decided to walk around the block and pretend Nancy's building wasn't our destination. But he kept trailing us and trying to get us to buy crack. If I had known better at the time, I probably would have taken him up on the offer.

As we neared Nancy's house a second time, we heard sirens. Two fire engines whizzed by, followed by a police car and an ambulance. We were so tightly wound that we fled in the opposite direction, leaving Hollywood, Nancy and New River alive and unscathed.

I'll always wonder if Hollywood was some kind of messenger, a portent of the better things I had to accomplish. Because after that night, I became too paranoid to kill Nancy, too scared of getting caught and sent to prison. I woke up to the fact that I had told too many people of my hatred for her, and even the best plan Pogo and I could come up with wasn't good enough to protect us from chance events like passing police cars. So I set about harming Nancy in a way that could never be traced back to me. In every malicious moment of my waking day, I visualized her destruction, her misery, her disappearance from Fort Lauderdale and my life. I walked down the streets enveloped in a cloud of hatred. For a curse, Satan and *The Necronomicon* weren't necessary; the power was within me. And the next afternoon, after telling Carl (the only friend she had left) that she was breaking up with him, Nancy disappeared.

Instead of holding this against me, Carl began emulating me. Perhaps it was his way of denying I had been sleeping with his girlfriend. Teresa stupidly forgave me because she knew how crazy Nancy was. It would have been a happy ending, but I started feeling uncomfortable about the amount of time Teresa and Carl were spending together.

One afternoon I showed Teresa a demo tape cover I had designed with a gnarled, twisting tree that looked like something from *The Wizard of Oz*. Days later, a concert poster Carl drew for another band appeared plastered all over town with the exact same tree on it.

I was furious with Teresa for giving my idea away to Carl (exacerbated by the fact that I was just bored with her in general), and disgusted by Carl's sycophantic behavior. I made sure they were both at our next concert and performed a song about Carl, "Thingmaker," one long rant about how I was sick of his trying to look and act like me, and especially sick of his stealing from me. But the stealing didn't stop there, because he and Teresa soon started dating, an abomination which continues to this day. Frustrated and betrayed on the day I turned twenty-one, I went to get my first tattoos—a goat's head on one arm and, on the other, the same tree he had plagiarized from me. It was my way of copyrighting it.

Though I heard rumors about Nancy, I didn't see her again until four years later at Squeeze. At first, I thought about making peace with her. She was alone, and every time she passed me, she'd slam her body against mine violently without saying a word. My jealous girlfriend, who was probably in elementary school when everything with Nancy had happened, got upset. "I'm going to fucking kick her ass if she does that again," she said after Nancy rammed into us for the fourth time that night.

When Nancy passed by again, my girlfriend blocked her path and yelled in her face, "What's your problem, you ugly bitch?" Nancy took a bottle and smashed it over her head. My girlfriend must have had experience in the matter, because without even seeming dazed she grabbed my claw ring off my finger and punched Nancy in the face five times with it, fucking her up so badly that I'd be surprised if she didn't have permanent damage. Because I had some kind of clout at that point, the bouncers kicked Nancy out of the club. The old hatred welled up again, and I wanted to do something heinous and more permanent to her, but I couldn't find out where she lived.

\*   \*   \*

Nancy's replacement, Missi, not only filled in the gap Nancy left onstage, but the gap Nancy was trying to fill in my life. I met Missi in the midst of the Nancy psychodrama, outside an Amboog-A-Lard concert at Button South, a heavy metal palace where it's probably still cool to like Slaughter and Skid Row. Brad and I were passing out fly-

**MISSI**

ers promoting a show of ours. It was a good way to meet girls, because if they liked you, they knew where to find you. But that's not what happened with Missi. We exchanged phone numbers right away, and two nights later we were sitting on the beach drinking forty-ounce bottles of Colt 45. I talked about my aspirations for the band. She listened patiently, as she would for years to come.

I was too insecure to break up with Teresa at first, and Missi and I became friends. I didn't have a car, a job, or much of a life, so she would pick me up at home and we'd see a matinee while Teresa was still at the restaurant where she worked.

As our friendship began to grow into a relationship that winter, I asked Missi if she wanted to be in a show. From our earliest concerts, we had named the back corner of the stage Pogo's Playhouse, and there he had all kinds of homemade gadgets, contraptions and instruments of torture—most notably a large rectangular lion's cage that he used as a stand for the keyboard he had mastered playing in less time

than it took for him to save up to buy it. For Missi's debut, we put her in the cage and filled it with chickens. She looked great: a pale, topless eighteen-year-old with long black hair in white underpants camouflaged by the flying feathers of half a dozen chickens.

 **CIRCLE EIGHT · FRAUD · PANDERS AND SEDUCERS**

When people realized that Nancy had left the band, freaks from all over Florida wanted to get in on the act. So we let them. Sometimes we enlisted them merely as part of a provocative (and hopefully discomforting) spectacle, like when, inspired by the John Waters movie *Pink Flamingos*, we had two naked fat ladies making out in a playpen. Other times we made sure that the spectacle came attached to an idea. During one concert, we had a girl on stage with rollers in her hair and a pillow stuffed under her shirt to make her look pregnant. She stood in front of an ironing board, and as we sang she pressed the wrinkles out of a Nazi flag. As the show progressed, she sat spread-eagled on the ironing board and pretended to perform an abortion on herself. Then she wrapped a fake fetus in the swastika flag and offered it ritualistically to a glowing television set in front of her. If we didn't drive home our point about the fascism of television and the way the American nuclear family sacrifices its children to this cheap, mind-numbing baby-sitter, at least we looked good trying.

Not every show went according to plan. For one of our first performances in Tampa, we bought a giant canister filled with some 500 crickets that I wanted to cover myself with. But when I opened the can, they had all died. The stench was one of the most rancid things I had ever inhaled, and the odor clung to my hands as strongly as the smell of Tina Potts's pussy had. I threw up instantly, and in response half a dozen people in the audience, including our future bassist, Jeordie White, did the same. Even if I hadn't begun the concert with a message in mind, I ended with one: Disgust is contagious.

Animal rights activists hounded us as incessantly then as they do now, but, outside of that accidental cricket massacre, we never killed any animals—only effigies of animals. In one of our more cartoonish moments, we spent a week building a giant life-sized cow out of papier-mâché and chicken wire. In a cross between *Willy Wonka*, *Apocalypse Now* and one of my grandfather's bestiality magazines, I stuck my fist up the cow's ass and pulled out gallons of chocolate syrup, covering the crowd with it as Pogo played a sample of Marlon Brando ranting, from *Last Tango in Paris*, "Until you go right up into

the ass of death, right up in his ass, do you find the womb of fear. And then, maybe . . . " To antagonize the animal rights people even more, we'd buy mechanical cats and pigs that move in response to sound and hang garbage bags filled with intestines over the stage, so that once the toys started moving spastic and lifelike in response to the music and the gore came tumbling down, activists thought we were committing acts of cruelty to animals when, in fact, we were committing acts of cruelty to the activists themselves. Only human rights were violated during our shows—against ourselves, against the girls we caged, and against the fans—but nobody seemed to care about that.

Each concert was a new adventure in performance art. Since clubs liked to book us on holidays, we always tried to do something special those nights. For our first set on New Year's Eve, I wore a tuxedo and a top hat. For the second set, a girl named Terri disguised herself as me, wearing a black wig, a tuxedo, a top hat and a very realistic strap-on dildo. When she walked on stage, everybody thought it was me with my dick hanging out of my pants, which was nothing new by that point. As the band began its version of "Cake and Sodomy," I crept around her and gave her a blow job, so that it seemed like I was sucking my own dick. Maybe that's where the rumor that I surgically removed my ribs so that I could give myself fellatio started.

On February 14, Missi and I tried to get arrested at a local club so we could spend Valentine's Day together in jail. The club was owned by a mafia type who was perpetually slouched under the weight of his gold jewelry and whose employees had police records longer than our set list. There were cops all over the club that night, so I brought Missi out topless in a mask. This time, I was on the receiving end of a blow job. I taunted the cops, challenging them to arrest me, as she violated several Florida laws. But we weren't arrested. The palms of the police were greased too well.

Offstage, Missi continued to be a perfect collaborator. (She would go on to become the girl who punched out Nancy at Squeeze.) We had begun going out in December, and I was determined to turn over a new leaf and be faithful for once, especially since, unlike every other relationship I had up to that point, this one began with the stable foundation of a friendship. In addition, I was older and felt obliged to raise her and mold her as if she were a protégé.

*deformography*

Our relationship began around the time of the Gainesville murders, when eight college students were stabbed, so I took a bunch of photos of Missi lying naked covered in blood, as if she had been brutally butchered. We shot Polaroids of her tits, her pussy, her mouth—all carved up, drenched in blood and jaundiced. Sometimes I covered her head with a black plastic bag to make it look like she had been asphyxiated, or concealed her head with a black cloth and put gory makeup on her neck so that she seemed decapitated. We left our photographs in restaurants and on buses where people could find them and do whatever their consciences dictated.

The only problem was that we were never able to see the results of our hard work. So we came up with a new prank when we noticed that people were setting up nativity scenes on their lawns for Christmas. Despite my animosity toward organized religion, I've always liked Christmas, probably because my parents raised me in a very secular household (the most religious thing they ever did was send me to Christian school) and I never associated Christmas with the birth of Christ. It just meant hanging shit on a tree, getting presents and watching the streets grow chaotic with lights and decorations. But just because I liked the holiday didn't mean I'd let it get in the way of a good joke.

Several days before Christmas, Missi and I drove to Albertson's grocery store, which between the hours of one A.M. and three A.M. was frequented chiefly by teenagers looking for supplies for various pranks. Though I could afford whatever I wanted, I stole things anyway because I felt the need to show my superiority over the uptight assholes working there. Besides, I've always believed that shoplifting should be punishable by the death penalty, because it's so easy that if you're stupid enough to get caught, you deserve to die.

That night we ripped off a handful of wire clippers and flashlights. In Missi's hatchback car, we drove around the neighborhood, stopping in front of every lawn with a nativity scene and stealing two things: baby Jesus and the black wise man. Our intention was to sabotage so many nativity scenes in a single neighborhood that people would think it was a conspiracy. Then we planned to send a ransom note from a phony black militant group to each house, declaring, "We feel that America has falsely illuminated and plasticized the wisdom of the black man with its racist propaganda about his so-called 'white Christmas.'" The only kink in our plan was that nobody paid attention. There wasn't a word about it in the newspapers.

The following Christmas we decided to do something more blasphemous and bought a bunch of big, salted hams at Albertson's.

Unfortunately, they were too big to steal, but I've always been prepared to pay a price for my art. We unwrapped them and returned to the same homes, replacing the baby Jesuses with the spoiling meat. It made for a beautiful image, especially when, with our remaining hams, we sabotaged nativity scenes at local churches and, as a symbolic *coup de grâce*, left pig meat in the manger of the precinct police station.

Few enterprises in South Florida were free from our pranks, especially places frequented by children, like Toys "R" Us and Disney World. One day, Missi, Jeordie and I were at Disney World with some new toys we had bought at a magic shop—a fireball shooter that propelled flames from our palms and a razor blade attached to a tube filled with blood, so that we could create fake wounds. We were all tripping on acid and hallucinating that everyone in the amusement park was affiliated with the Secret Service. They all seemed to be talking into their wrists, reporting our every movement to headquarters, though in actuality they were probably trying to steer their kids away from us. We were convinced they all knew we were on LSD, which was confirmed (in our minds) when we went on the haunted house ride and, in the middle, the cars stalled and a voice announced, "Please make sure there are no spooks in your doom buggy," a seemingly deliberate reference to the Marilyn Manson and the Spooky Kids song "Dune Buggy." When the buggy jolted to a start again, they said or we imagined the announcement, "Enjoy the rest of your trip." Afterwards, we stopped at a petting zoo and, while Jeordie tried to communicate with the chickens, I stared fascinated for a full hour into a giant, mud-covered, pulsating pink pig pussy, not unlike the one I would ride years later in the "Sweet Dreams" video.

In one of the park's plastic fantasy worlds, there were a dozen families sitting around picnic tables, happy and content as they gnawed on giant turkey legs. It was a barbaric celebration of carnivorousness given an ironic twist by the fact that there were pigeons and seagulls flying overhead, oblivious to the carnage being perpetrated against their fellow fowl. I'm not a vegetarian, but the whole gleefully brutal spectacle seemed wrong and disgusting. So I walked over to a set of twins who were dressed alike, looking like something out of *Children of the Damned*. As they sat there tearing at their turkey bones, I stood in front of them, raised my sunglasses to reveal my mismatched eyes, gave them as baneful a grin as I could muster in my state, and pulled out my razor and sliced my arm. I let the blood run off my wrist and drip down onto the discarded ticket stubs and popcorn kernels on the ground. They dropped their meat and ran away

screaming as I walked away exhilarated by my success, because there's nothing like the feeling of knowing that you've made a difference in someone's life, even if that difference is a lifetime of nightmares and a fortune in therapy bills.

Driving back to Fort Lauderdale the next day, we passed the Reunion Room and, on the same corner where I had seen the car crash, there was a prolife demonstrator, a skeletal, gray-haired man in a short-sleeved work shirt with a wife beater underneath and blue work pants. Every afternoon he marched up and down the block like an old factory worker on strike, but instead of a sign demanding more health benefits his was emblazoned with pictures of aborted fetuses. Anyone who would listen was given a long, loud sermon on how we're all going to hell for killing the unborn.

Still flushed with mischief from the day before and looking as hideous, pale and unclean as corpses, we pulled up near him and called him to the car. Excited that maybe he'd actually found someone to discuss his views on damnation with, he approached us. When he was close enough to see through the open window clearly, I held out my hand. "I talked to the devil today, and he told me to tell you hello," I growled, shooting a fireball in his direction. It burst in his face, and he let out an ungodly scream, threw his sign in the air and ran. I didn't see him on the corner much after that. But I think I actually did him a favor since he probably became a folk hero at his local church; everyone knows that, like Job, you have to be pretty fucking holy and righteous to merit the devil's attention.

Jeordie and I had grown close by then, though he still wasn't a member of the band. The bond that united us was music, a love of havoc-wreaking and a mutual obsession with old kids toys, particularly *Star Wars*, *Charlie's Angels* and Kiss paraphernalia. I had spoken to Jeordie a few times at the mall, but we first became friends when I was at a concert with Pogo. I was carrying one of the metal lunchboxes from my collection, and Jeordie scampered over and said, "I know someone who has more of those. If you want, I'll take you to him. He's got tons of lunchboxes." We exchanged phone numbers, and the next day he drove me to a store run by a corpulent cutthroat named John Jacobas. It was a paradise of *Star Wars* figures, Muhammad Ali dolls, rusty wind-up monkeys with clapping cymbals, and, in particular, Nazi World War II paraphernalia, which was probably what he made most of his money from. He just looked at you, assessed the degree of desperation in your eyes and then offered you the highest price he knew you'd accept. He was a professional, and he lured me back to the store every week with the promise that he would

bring in his treasure trove of lunchboxes, which, like the end of a rainbow, he was never able to find, if it existed at all.

Jeordie and I also discovered that we had a crush on the same girl, a hot brunette who looked like the kind of person who should be working at the mall. And, in fact, she did—at the piercing pagoda. But she wouldn't even acknowledge our humanity, no matter what part of our body we asked her to pierce. So I fell back on my usual deviant way of getting a girl's attention: malicious, asinine behavior. Every day for nearly a month, Jeordie and I met at a pay phone around the corner from the pagoda, where we could see her but she couldn't see us. At first, the calls were harmless. But they quickly grew meaner. "We're watching you," we'd threaten her at the height of our spite-masked lust. "You better not leave work tonight, because we're going to rape you in the parking lot and then crush you underneath your own car." I knew what she must have felt like, because Nancy used to leave similar messages for me.

## CIRCLE EIGHT - FRAUD - HYPOCRITES

Jeordie was miserable in Amboog-A-Lard because he was the only one in the band with any stage presence or any ambition to be more than just a heavier version of Metallica. I always told him I wanted him to be a Spooky Kid, and he always said he was more into what my band was doing than what his was. But I had all the musicians I needed and he was stuck in Amboog-A-Lard, whose members had started to turn against him because he was too much like us. So we had to content ourselves with side projects like Satan on Fire, a fake Christian death metal act with songs like "Mosh for Jesus." Our goal was to infiltrate the Christian community (a fantasy I still harbor) but the local Christian club would never book us.

Perhaps because he couldn't be in Marilyn Manson and the Spooky Kids, Jeordie ended up instigating the mayhem at our most notorious shows. We played at a club called Weekends in Boca Raton, the Florida equivalent of Beverly Hills, and the show was filled with rich Boca girls, conservative jocks and a rebel faction of lame surfer types. While we were playing, Jeordie clambered on stage and pulled down his pants, which was normal behavior for him. Though he didn't mind that all his life people had told him he looked like a girl, sometimes he felt the need to prove that he wasn't. The only strange thing was that he didn't try to light his pubic hair on fire, as he usually does when his pants are down in public and he's not having sex.

Since he was standing next to me and I had a free hand, I started jacking him off. The Boca snobs were aghast, and from that day on there was a rumor that we were gay lovers. It was a rumor we did our best to encourage and spread.

Jeordie brought his ten-year-old brother to another show, and, in order to sneak him into the club, we pretended he was part of the band and stuck him in Pogo's keyboard cage. Behind him, Missi was tied to a cross, wearing only a black mask and a pint of blood. I thought of the scene as a painting depicting the idea that it was only through such horror and brutality that mankind could be born with any hope of innocence and redemption. Christianity's crucifixion seemed no different than the pagan sacrifice, in which people thought they could better their own condition by shedding someone else's blood, a concept that particularly appealed to me in the aftermath of my Nancy death wish. At the end of the show, Jeordie's brother was so overcome by the desire to try his own hand at performance art that he ran out of the cage and mooned the crowd. That show started another legend that has persisted to this day, that we have naked kids on stage.

On a more helpful day, Jeordie introduced us to our first manager, John Tovar, who also mishandled Amboog-A-Lard. He was a huge, sweaty, cigar-chomping Cuban constantly clad in a black suit and black tie with cheap cologne drowning his body odor. He looked like a cross between Fidel Castro and Jabba the Hutt. As if nature hadn't already short-changed him, he was also a narcoleptic and would fall asleep during soundcheck directly in front of the speaker. We took advantage of the opportunity to conduct valuable medical research and experiment with different words to wake him, yelling in his ear that he was a piece of shit or the building was on fire. But he wouldn't stop snoring and heaving his mountainous gut. Only the words "vanilla milkshake" and "Lou Gramm" would rouse him—and he'd open his thick, heavy-veined eyelids, slowly roll his medicine ball eyes skyward and snap back to normal. Then he'd usually pull me aside and whisper some kind of well-meaning advice, like, "You guys need to, you know, tone it down a little bit so we can play at the Slammy awards. Maybe you can do a show with Amboog-A-Lard, the boogie boys." (The Slammies were Florida's hard-rock awards.)

The closest we got to satisfying his wish was shortening our name to Marilyn Manson, retiring our drum machine and holding auditions for a human drummer. The only person who showed up to try out was a hobbling little guy named Freddy Streithorst, and our guitarist, Scott Putesky, insisted that we hire him since they had played together

in a sissy-pop band called India Loves You. Like most everyone in our band, Freddy soon had several nicknames. On stage, he was known as Sara Lee Lucas. But we called him Freddy the Wheel. The name came from one of our first groupies, Jessicka, who went on to form Jack and Jill, a band that I renamed Jack Off Jill and took under my wing briefly, performing with them a few times. When Freddy was a teenager, he had an accident and, while he was in the hospital, the muscles in his leg atrophied to the point where the limb deformed. As part of his rehabilitation, he learned to play drums.

Freddy was a good guy and I never treated him any differently than anyone else. But I always felt bad pushing him to play better—he was a shitty drummer and everyone knew it except Scott. Jessicka, however, didn't have any qualms about mocking him. She decided that Freddy had a wheel for a foot and should henceforth be known as Freddy the Wheel. She realized this, of course, after having had sex with him, so she was in no position to mock anyone because she had bowed down before the Wheel and, in fact, gotten caught beneath it.

In the end, Freddy wound up going out with Shana, a Siouxsie Sioux–wannabe I had dated briefly before meeting Teresa. Our relationship didn't last long because I had the flu, and she'd come over to take care of me and have sex. Daylight was not a good time to get intimate with her because she was among South Florida's many practitioners of Gothic deception. It wasn't just that the makeup hiding the potholes on her face flaked away in the sun, I also noticed a mysterious white ring around her vagina. I was never able to decide whether it was a venereal disease, some form of mucus, a yeast infection, the skin from the top of a pudding or a glazed donut that someone may have accidentally left there after intercourse. Discovering it was as appalling and disturbing an experience as my childhood run-in with Lisa's snot, and I stopped seeing her. Scott Putesky, a pussy vulture who had already tried to prey on Teresa, went on to fall in love with her, but was denied when Freddy stole her away like a little hobbit and indeed went on to become Lord of the Ring.

\*     \*     \*

Like a used car that keeps breaking down with new problems every time an old one is fixed, the band was beginning to come together when we started having problems with our bassist, Brad. The longer he played with us, the more people came up to me and complained,

"That guy's a fucking junkie." I always stuck up for him because I was completely naive and had never done any drugs besides pills, pot, acid and maybe glue. Brad was insecure to begin with and was always trying to impress everyone around him. So whenever he mentioned drugs I just thought he was trying to be cool.

Brad was stupid and, unlike Scott, knew it. I liked him, so I usually ended up loaning him money and baby-sitting him. Eventually, I found someone to mother him, a rich, older lawyer named Jeanine. I had slept with her a few times and, even though she bought me anything I wanted, decided that Brad needed her more than I did.

Within two months, they were living together. But whenever I stopped by in the afternoon to visit him while Jeanine was at work, he seemed uneasy, as if he didn't want me there. One afternoon he was acting stranger than usual, trying to get me out of the apartment. Naturally, I didn't want to leave because I was curious about what he was hiding. After I spent fifteen minutes watching him play uncomfortably with his green and purple dreadlocks, two black girls emerged giggling from the closet in a cloud of smoke and carrying short glass tubes. As they talked, it dawned on me that the tubes were crack pipes, the girls were prostitutes and Brad was a junkie. Here was another person I thought I knew but later realized had a secret life.

Once I was aware that he was a heroin addict, the signs were obvious. He looked like shit, went through wild mood swings, was incredibly paranoid, drank heavily, missed shows, lost weight daily, showed up late for practice, never had any energy, and always borrowed money. He and his previous girlfriend, Trish, thought they were Sid and Nancy, but I never understood that their tribute went that far. Every time I looked at him now, all I felt was hatred and disgust. My entire message and everything I'd begun striving to be as a person ran in direct opposition to Brad. I wanted to be strong and independent, to think for myself and help other people think for themselves. I couldn't (and still can't) tolerate someone who's a fucking weakling living out of a spoon and a needle.

One night Jeanine called and woke me up. "Brad's dead!" she kept screaming. "I should have stopped him. He's dead! He's finally done it to himself. He's dead! What should I do? Help me!"

I rushed to the house, but I was too late. An ambulance was already leaving. Jeanine was on the phone with her lawyers because whenever someone overdoses and medics find hypodermic needles and drug paraphernalia, they're obligated to call the police. I stayed with Jeanine that night until we found out Brad had been resuscitated and then promptly arrested. We talked for hours about it. I felt sorry

for Brad because he was a creative, good-natured guy and I loved writing songs with him. But he was also a junkie and a fuck-up. A part of me wished he really had fatally overdosed, for his own and our peace of mind. By then his life was heroin. Playing bass was just a way of killing time between shots.

When I saw Brad again, I sat him down and, for the first time, realized how important this band really was to me and how much I would not tolerate anyone fucking it up. This was not a game anymore. "Listen," I told him. "You've had your final chance. Clean up your act or you're out of the band."

Brad broke down and started crying, apologizing in broken sobs for his behavior and promising not to shoot dope anymore. Because I didn't have any previous experience with junkies, I believed him. I believed him the second and the third times too. He hit the one weak spot still left in my cold black heart: pity, a word that over the course of the arduous year to come would be excised from my vocabulary.

Months later, we drove to Orlando for an important showcase for several record labels interested in signing us. The night before I had gotten another panicked phone call from Jeanine, who was scared because Brad was on heroin again and had sucked some guy's dick that night. I confronted Brad, and he was in denial about his drug use but he wouldn't stop bragging about how he had finally fulfilled his fantasy of sucking a guy off, a promiscuous shampoo boy who worked at the salon where he went to get his hair dyed (which was somewhat ironic since Brad's dreadlocks were always dirty and smelly).

Onstage, Brad seemed out of it, but I had more important things on my mind than his track-marked arms. After the show, he disappeared, but again I had more important things on my mind because we were staying with these cute girls. Normally I would have been concerned, but I was sick of baby-sitting him.

At three in the morning, he burst into the house with three strippers who none of us knew. He was still wearing his outfit from the show—a sleeveless purple seventies shirt with silver stars on it, small glittering women's shorts over red tights with guns on them and combat boots—and he was beyond wasted. His eyes were darting from side to side so quickly that they were a blur and he was fidgeting manically with his lip ring as he babbled incoherently about something that seemed important to him. Up close, the strippers had bruised and discolored legs, arms and necks, as if they were running out of veins to shoot up into. Their teeth were gapped and gnarled in their mouth like melting white candles on a stale fudge cake. As they teetered nastily around the room, offering everyone heroin, Valium and whatever

else was collecting lint in their pockets, Brad seemed to be collapsing into himself, shriveling on the couch and becoming so disoriented that he didn't even know his own name. Sweat was dripping off his face and landing in droplets on his clothes. For a second, he seemed to come to his senses. He looked me straight in the eye, then toppled onto the floor, passed out. His face was pale green from the hair dye that had seeped with his sweat into the oily creases of his forehead and his unpainted fingernails were now swirled purple and blue.

The strippers, probably used to this situation, fled the house. At first, I tried to wake Brad up—helping everyone roll him around, slap him and dump buckets of water on him. But what I really wanted to do was kick him in the ribs. I was overwhelmed by hatred for him and the cliché his life had become. I had once loved Brad like a little brother, which made it easier to hate him. Not only are love and hate such closely related emotions, but it's a lot easier to hate someone you've cared about than someone you never have.

We stepped away from his motionless, rainbow body and talked—not about how we could help him, but about how we could hurt him. I suggested turning him over and letting him choke on his own puke. If the coroner couldn't tell he had been moved, Brad's death would be attributed to his own stupidity. We sat locked in debate, trying to determine whether we would get arrested and charged with manslaughter. Though I still felt a tinge of pity, I thought of his death as an assisted suicide. In actual fact, I felt as if he had already committed suicide, because the Brad I met at the Kitchen Club when I first conceived of the band years ago was dead, a stranger to both of us.

But I didn't want him to jeopardize the band in death as he had in life. In the end, it was only the fear of being caught that kept us from killing him. It was a monstrous way of thinking, but I couldn't help it. I was becoming the cold, emotionally crippled monster I always wanted to be, and I wasn't so sure I liked it. But it was too late. The metamorphosis was already well under way.

The next day I called the studio where Jeordie was working on Amboog-A-Lard's first independent album. It was a big move for Jeordie, because he was playing bass and guitar as well as producing. But I also knew he wanted to join Marilyn Manson so badly that he had actually befriended Brad and had been taking him out to drink and do drugs after Brad had been warned to clean up. I always wondered whether this was a deliberate act of sabotage on Jeordie's part or not. If it was, it was pretty clever.

"Do you want to be in our band?" I asked.

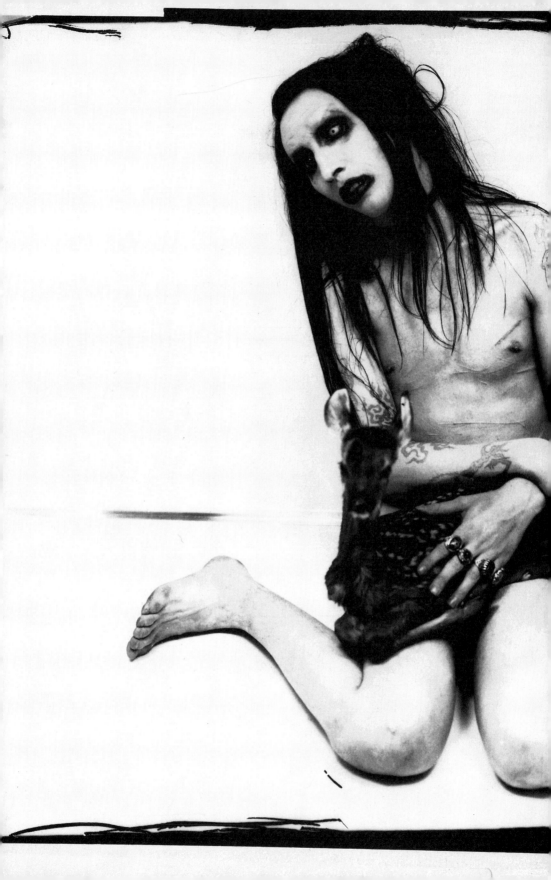

"Well, I'm in the middle of making this record." Jeordie sighed.

"You've always belonged in our band."

"Yeah, I know."

"And your band hates your fucking guts and wants to kick the shit out of you."

"I'll call you right back," he said, and I knew that I got him.

**CIRCLE EIGHT - FRAUD - THIEVES**

Brad was as good as dead, Nancy was as good as dead and my morality was as good as dead. Marilyn Manson was finally on its way to becoming the band I wanted it to be.

Sp;enium

Pia

Corpus Callosum

septum pellucidum

Third ventricle

Cerebral pedicle

Genu

Rostrum

Anterior commissure

Lamina terminalis

Optic recess

Optic chiasma

Infundibulum

Corpus mamillare

Oculomotor nerve

Cerebral aqueduct

Pons

Cerebellum

Medulla oblongata

Choroid plexus

Fourth ventricle

# ⑨

## *the rules*

**DO WHAT THOU WILT SHALL BE THE WHOLE OF THE LAW.**
*—Aleister Crowley, Diary of a Drug Fiend*

 **CIRCLE EIGHT · FRAUD · FRAUDULENT COUNSELORS**

# PEOPLE always want to know about

my religious and philosophical beliefs. But few people ever ask me
about my everyday ethics—the rules I use when dealing with day-to-
day society. Here are a few of them. Feel free to cut them out and post
them on the door of your mother's refrigerator for easy reference.

# DRUGS

There is a stereotype among people who have never gotten high that anyone who has ever done drugs, no matter what that drug is, is an addict. The truth is that addiction has little to do with what drugs you use or how often you use them. There are other factors, like the extent to which you let them run your life and your ability to function normally without them. I make no secret of my drug use. But at the same time I have nothing but utter contempt for anyone who is addicted to drugs. It is the people who abuse drugs that make the people who use them look bad. Here are a few simple rules to help you determine whether you are a user or an abuser of cocaine, pot and other substances. Consider yourself an addict if . . .

1     ...YOU ACTUALLY PAY FOR DRUGS.

2     ...YOU USE A STRAW AS OPPOSED TO A ROLLED-UP DOLLAR BILL.

3     ...YOU USE THE WORD *blow*.

4     ...YOU'RE A GUY AND YOU'RE BACKSTAGE AT A MARILYN MANSON CONCERT (UNLESS YOU'RE A DEALER OR A POLICE OFFICER).

5     ...YOU OWN MORE THAN ONE PINK FLOYD RECORD.

6     ...YOU DO COCAINE DURING A SHOW. (IF YOU DO IT AFTER A SHOW, YOU'RE OKAY. IF IT'S BEFORE, YOU'RE TEETERING ON THE BRINK.)

7     ...THE MERE MENTION OF COCAINE MAKES YOU PASS GAS OR THE SIGHT OF IT MAKES YOU WANT TO TAKE A SHIT.

8     ...YOU'VE WRITTEN MORE THAN TWO SONGS THAT REFER TO DRUGS.

9     ...YOU GET KICKED OUT OF A BAND FOR BEING A DRUG ADDICT.

10     ...YOU'RE FRIENDS WITH A MODEL.

11     ...YOU LIVE IN NEW ORLEANS.

12     ...YOU PAY FOR YOUR GROCERIES WITH ROLLED-UP DOLLAR BILLS.

13     ...YOU'VE EVER BEEN IN DR. HOOK OR KNOWN THE LYRICS TO A DR. HOOK SONG.

14 ...THE EMBOSSED NUMBERS, PARTICULARLY THE 0'S,
   6'S AND 9'S, ON YOUR CORPORATE CREDIT CARD ARE
   FILLED IN WITH A MYSTERIOUS WHITE POWDER.

15 ...YOU'RE ALONE IN YOUR HOTEL ROOM ON TOUR AND
   YOU DO DRUGS.

16 ...YOU DO DRUGS BEFORE 6 P.M. OR AFTER 6 A.M.

17 ...YOU HATE EVERYBODY. (IF YOU LIKE EVERYBODY,
   YOU'RE ON ECSTASY AND I'M AGAINST YOU.)

18 ...YOU KNOW THE NAME FOR THE FLESHY CREVICE BETWEEN
   YOUR THUMB AND INDEX FINGER.

19 ...YOU'VE EVER SAID, "THIS IS MY LAST LINE" OR,
   CONVERSELY, "WHICH LINE IS THE BIGGEST?"

20 ...YOU INVITE PEOPLE TO STAY AT YOUR HOME WHILE
   YOU'RE ON DRUGS.

21 ...YOU TELL ANYBODY ABOUT YOUR CHILDHOOD WHILE
   YOU'RE ON DRUGS.

22 ...YOU'RE NOT THINKING ABOUT TITS RIGHT NOW.

23 ...YOU SAY, "I ONLY DO THIS WHEN I'M WITH YOU."

24 ...YOU HAVE YOUR BODYGUARD WATCH THE DOOR WHEN
   YOU GO TO THE BATHROOM.

25 ...YOU'RE A GUY AND YOU TALK TO A GIRL WHO HAS A
   BOYFRIEND FOR MORE THAN FIVE MINUTES BECAUSE SHE
   HAS DRUGS.

26 ...YOU'RE A CHILD ACTOR.

27 ...IF YOU MAKE THIS BOOK INTO A GAME AND DO A LINE
   EVERY TIME DRUGS ARE MENTIONED, THEN NOT ONLY ARE
   YOU AN ADDICT BUT YOU MAY BE DEAD.

RULES I'VE BROKEN: 1, 4 (but that doesn't count), 5, 6 (and I came back on stage with the dollar bill hanging from my nose), 7, 8 (I've written dozens), 12, 13, 14 (unless I've cleaned it out because I'm crossing a border), 15, 16, 17, 19, 20, 21 (but only for this book), 24, 25.

## HOMOSEXUALITY

My philosophy about sexuality is that I don't have a problem with anything anyone does in any way. All I ask is that you know the rules. I've sucked the dicks of several men, which a lot of straight guys won't admit to having done or wanting to do. But just like kissing a girl can't get her pregnant, sucking a guy's dick doesn't make you gay (unless you break rule #3). It's not that I'm against being gay—I just want to clarify what makes you gay. Please note that this list only pertains to guys: All women are by nature lesbians. So let's get things straight (no pun intended)—if you meet any of the qualifications below, you are gay.

1   IF YOU GET SOMEONE ELSE'S SPERM ON YOU.

2   IF YOU'VE EVER OWNED A SMITHS ALBUM.

3   IF YOU GET HARD WHILE SUCKING ANOTHER GUY'S DICK. IF YOU DON'T, YOU'RE STRAIGHT—UNLESS HE GETS SPERM ON YOU.

4   IF MICHAEL STIPE IS IN THE ROOM WITH YOU AND YOU'RE HAVING SEX WITH A WOMAN, YOU'RE BISEXUAL.

5   IF YOU'RE AT A GAY BAR, YOU'RE NOT GAY. BUT IF YOU'RE AT A STRAIGHT BAR AND YOU TALK TO ANOTHER GUY LONGER THAN YOU TALK TO A GIRL, YOU'RE GAY.

6   IF YOU TAP YOUR FEET TO A SMITHS SONG.

7   IF YOU DISCUSS ART FOR MORE THAN 45 MINUTES.

8   IF YOU'VE EVER WORN A BERET.

9   IF YOU KISS A GUY AND HE HAS A HARD-ON, YOU'RE NOT GAY UNLESS YOU HAVE A HARD-ON TOO.

10  IF YOU HAVE ANY KIND OF SEX—WITH A MALE OR A FEMALE—TO THE SMITHS, YOU'RE GAY.

11  IF YOUR ONLY PURPOSE IN LIFE IS TO GET GIRLS PREGNANT SO THEY CAN HAVE MORE GIRLS TO HAVE LESBIAN SEX TOGETHER.

12  IF YOU JACK OFF AND YOU GET CUM ON YOURSELF

13  IF YOU GET A BONER WATCHING *Gilligan's Island.*

14  IF YOU DON'T GET A BONER WATCHING *Bewitched.*

15  IF THERE'S A SMITHS SONG ON IN A BAR AND YOU'RE IN THE BATHROOM WITH YOUR DICK IN YOUR HAND.

16  IF YOUR NAME IS RICHARD AND YOU GO BY DICK.

17  IF YOU'RE FRIENDS WITH ANYONE NAMED DICK.

18 **IF YOU DON'T CHEAT ON YOUR WIFE, YOU'RE ONLY USING HER AS A PROP TO MAKE PEOPLE THINK YOU'RE NOT GAY.**

19 **IF YOU'RE FRIENDS WITH A MODEL.**

20 **IF YOU FUCK A GIRL WHO LIKES THE SMITHS.**

21 **IF YOU DON'T EAT MEAT BECAUSE THE SMITHS ALBUM *Meat Is Murder* HAD AN IMPACT ON YOUR LIFE.**

22 **IF YOU DO ANYTHING SPIRITUAL.**

23 **IF YOU FUCK A PREGNANT WOMAN AND SHE'S CARRYING A BOY, YOU'RE GAY. IF YOU GET SPERM ON THE AMNIOTIC SAC, THE BABY WILL GROW UP TO BE GAY TOO.**

24 **IF YOU'VE EVER HAD A HAIRCUT LIKE MORRISSEY.**

25 **IF YOU'VE EVER HAD A HAIRCUT WHILE A MORRISSEY OR SMITHS ALBUM WAS PLAYING IN THE ROOM.**

26 **IF YOU'VE EVER TALKED ABOUT OR OWNED A CRYSTAL— ESPECIALLY IF IT'S CRYSTAL METH.**

27 **IF YOU'VE EVER PUT BAND-AIDS ON YOUR NIPPLES AS A FASHION STATEMENT.**

28 **IF YOU'VE EVER SPENT MORE THAN A WEEK ON SOUTH BEACH.**

29 **IF YOU'RE NOT THINKING ABOUT TITS RIGHT NOW.**

30 **IF YOU STILL LIKED JUDAS PRIEST AFTER YOU HEARD THE RUMOR THAT ROB HALFORD WAS GAY.**

31 **IF YOU GET A HARD-ON WHILE TAKING A SHIT.**

32 **IF YOU KNOW WHAT SPERM TASTES LIKE (ESPECIALLY IF IT'S YOUR OWN).**

33 **IF YOU KISS A GIRL WITH TONGUE AFTER SHE'S SWALLOWED YOUR CUM.**

34 **IF YOU GET HARD WHILE READING THIS.**

35 **IF YOU KNOW THE NAMES OF ANYONE WHO'S EVER BEEN IN THE SMITHS BESIDES MORRISSEY AND JOHNNY MARR.**

36 **IF YOU'RE A MALE MODEL.**

37 **IF YOU GET CHOKED UP LISTENING TO "BOYS DON'T CRY" BY THE CURE.**

38 **IF YOU'RE A CLOTHING DESIGNER.**

39 **IF YOUR FIRST, LAST, MIDDLE OR ONLY NAME IS MORRISSEY.**

RULES I'VE BROKEN: 1, 2, 12 (this probably makes us all gay), 20 (most likely unintentionally), 26, 30, 33, 38 (I design my own clothes).

# CHEATING

Though we have a reputation as flagrant plunderers of all the free and expensive tits that come with being a rock star, the truth is that we are all completely faithful to our girlfriends. I can honestly say that I have never cheated on my girlfriend. And that's because I play by the rules, which are listed below for your use and edification.

1   YOU CAN SQUEEZE FAKE TITS BECAUSE THEY'RE NOT ACTUALLY REAL, SO YOU'RE NOT CHEATING.

2   IF YOU DON'T REMEMBER THEIR NAME IT DOESN'T COUNT.

3   IF YOU DON'T CALL THEM AFTERWARD IT DOESN'T COUNT.

4   BLOW JOBS DON'T COUNT – THEY'RE LIKE HANDSHAKES AND AUTOGRAPHS.

5   IF YOU CUDDLE, YOU'RE CHEATING.

6   IF YOU ARE IN A TIME ZONE THAT IS AHEAD OF THE TIME ZONE YOUR GIRLFRIEND IS IN, USE THE FOLLOWING EQUATION TO DETERMINE WHETHER OR NOT YOU'VE CHEATED: LET $X$ BE THE TIME DIFFERENCE BETWEEN THE TWO COUNTRIES AND LET $Y$ BE THE NUMBER OF HOURS THAT HAVE ELAPSED SINCE YOU SLEPT WITH ANOTHER WOMAN. IF YOU TALK TO YOUR GIRLFRIEND AND $Y<X$, THEN YOU HAVEN'T CHEATED BECAUSE IT HASN'T HAPPENED YET. IF $Y>X$, YOU CHEATED.

7   IF YOU ARE IN EUROPE, CANADA, SOUTH AMERICA OR JAPAN, YOUR MARRIAGE LICENSE IS NOT VALID. SO YOU CAN SLEEP WITH ANYONE YOU WANT.

8   IF YOU FUCK SOMEONE THE NIGHT BEFORE SEEING YOUR GIRLFRIEND, IT'S OKAY BECAUSE IT'S JUST PRACTICE TO MAKE SURE YOU DON'T PREMATURELY EJACULATE WITH YOUR GIRLFRIEND.

9   IF IT WAS PART OF A PUBLIC PERFORMANCE, IT DOESN'T COUNT.

10    IF YOU'RE DOING IT TO HELP YOUR CAREER, IT DOESN'T COUNT. BUT IF SHE THINKS YOU CAN HELP HER CAREER, THEN YOU'RE CHEATING.

11    IF YOU REMEMBER THE NAME OF A GIRL THAT SOMEONE ELSE HAD A ONE-NIGHT STAND WITH, THEN YOU CHEATED BECAUSE YOU THOUGHT ABOUT IT MORE THAN THE PERSON WHO GOT LAID DID. IF YOU DON'T HAVE A GIRLFRIEND, THIS JUST MAKES YOU DESPERATE AND COUNTS AS ONE CHEAT AGAINST YOUR FUTURE GIRLFRIEND.

12    IF IT'S SOMEONE'S BIRTHDAY, IT DOESN'T COUNT (ESPECIALLY IF IT'S YOUR OWN).

13    IF THE GIRL HAS A TATTOO WITH YOUR NAME ON IT, THEN IT'S JUST COMMON COURTESY TO HAVE SEX WITH HER.

14    IF YOU HAVE ANAL SEX WITH SOMEONE ELSE IT DOESN'T COUNT BECAUSE IT'S NOT COITUS (UNLESS YOU'RE DATING MORRISSEY).

15    IF SHE HAS THE SAME NAME AS YOUR GIRLFRIEND, IT'S NOT CHEATING—OR IF THE FIRST LETTER OF HER NAME IS THE SAME. IF NEITHER OF THESE APPLY, SPRITZ HER WITH YOUR GIRLFRIEND'S FAVORITE SCENT BEFORE HAVING SEX AND YOU'RE ALL RIGHT.

16    IF YOU TELL THEM YOU RESPECT THEM IN THE MORNING AND MEAN IT, YOU'RE GAY.

RULES I'VE BROKEN: None.

## 10

### all for nothing

I saw that [he] was a genius of suffering and that in the meaning of many sayings of Nietzsche he had created within himself with positive genius a boundless and frightening capacity for pain. I saw at the same time that the root of his pessimism was not world-contempt but self-contempt; for however mercilessly he might annihilate institutions and persons in his talk he never spared himself. It was always at himself first and foremost that he aimed the shaft, himself first and foremost whom he hated and despised.
—Herman Hesse, Steppenwolf

## THE KING OF FILTH COMES CLEAN:
## PART ONE OF A TWO-PART STORY
### by Sarah Fim
### Empyrean Magazine, 1995 [1]

Images of naked boys and rotting corpses flicker on the TV screen in Marilyn Manson's hotel room as he removes his sunglasses and settles down on the couch. Photographs, clothing and papers are scattered across the floor, the debris of a busy year for Manson, the leader of the controversial shock-rock band of the same name. Practically overnight, the quintet has catapulted from a local Florida band to an arena act thanks to a contract with Nothing Records, the label owned by Trent Reznor of Nine Inch Nails. Since then, Manson, whose real name is Brian Warner, has been arrested, banned and beaten. He's been accused of torturing women, killing animals and setting his drummer on fire. Today, for the first time, he has agreed to talk candidly and on the record about the events of the past two years. To make sure he doesn't back out on that promise, we've filled him with liquor and drugs and rented one of his favorite movies, Alejandro Jodorowsky's hallucinogenic spaghetti western *El Topo*.

Lying across the glass table directly in front of him is Judas Priest's *British Steel* CD, the one with the razor blade on the cover. It is an appropriate image because lined up in long white strips across it is some of the finest cocaine the editors of *Empyrean* could afford. Manson rolls up a $20 and snorts half of a line up his right nostril. He tilts his head back and shakes out his long black hair, then lowers his head and inhales the remainder of the line up the other nostril. In music, as in life, Marilyn Manson doesn't play favorites. He likes to destroy everything in equal measure.

**EMPYREAN: You look exhausted.**

**MANSON:** Yeah. I woke up at seven o'clock this morning, and I was trying to find someone to express my ideas to but I couldn't. I was walking around like a fucking madman. Then I called Missi [his girlfriend]. There has to be something wrong with anybody who is capable of liking me, because I'm not a likable person.

---

[1]This series of articles was originally written for *Empyrean Magazine*, vol. 7, nos. 2 and 3, issue dates May and June, 1995. It was never published due to content objections on the part of *Empyrean's* publisher, Centaur Enterprises, which believed that the magazine had followed unethical interview procedures in order to extract information from Mr. Manson. The magazine folded soon afterward.

**Maybe you should do a line.**
I could do one line, and then . . .

**. . . see if you need another?**
Well, you never need one in the first place.

**But you always need another.**
Yeah, because once you have that one, you need the rest for maintenance [*snorting sounds*].

**Let's talk about how you finally broke out of Fort Lauderdale.**
Right, what happened was at the time I shortened the name of the band to Marilyn Manson, which is what people always called us anyway. The band had become less cartoonish and taken on a more serious tone. Several labels were interested in us. Epic Records had us come to New York to showcase for them. We were being courted by this guy Michael Goldstone who at the time had just signed Pearl Jam. Their album hadn't come out yet and I got to hear it, and I thought it was very mediocre. At the same time I was idealistic about our music and its success. So it wasn't very good for my ego when Epic ended up not liking us. It was a huge disappointment because we spent about three grand of our own money getting to New York.

**So how did you end up working with Trent Reznor?**
It began when we returned home practically broke. Missi and I went by the record store where I used to work and bought Nine Inch Nails' *Broken*, which had come out that day. I was thinking that I hadn't heard from Trent in a while because every now and then he would call just to say hi and keep in touch. As I was listening to it, I got a call from Trent's manager asking for a copy of our demo tape. (These kinds of coincidences always happen to me, and have led me to believe that everything happens for a purpose.) I didn't know why he wanted a copy of our demo tape. Maybe he just wanted to listen to it.

A few days later I got a phone call: "Hey, it's Trent."

And I'm like, "Hey, what's going on."

And he said, "Well, you'll never believe where I'm at. I'm living at the Sharon Tate house." It was funny because when I first met him I told him that one of my dreams was to record "My Monkey," our revision of a Charles Manson song, at the house where Sharon Tate had lived. I liked the irony of it. And lo and behold, Trent was there now.

He said, "Why don't you come out? We're shooting a video for one of my songs, and I want you to play guitar in it."

I told him, "Well, I don't really play guitar." But I went out there anyway and pretended to play guitar in a video that was never actually released. It was a song called "Gave Up."

**Then he signed you to Nothing?**

Actually, I still didn't know that Trent was starting a label. We just hung out and had a great time, and that's when we really became close and established our friendship.

**Can you remember anything more specific about that time?**

I remember one night Trent ditched his girlfriend, a rich teenaged bitch who had become so obsessed with him that she tattooed his initials on her butt, and we went to a bar in L.A. called Smalls, where we met some girls that today I wouldn't even let take out my garbage. But at the time they seemed like people worth wasting my efforts trying to fuck because I didn't know any better.

Actually, we weren't really interested in sex. We were more interested in having fun because we had this new friendship. So we invited these two terrible individuals back to his house, and I remember one of their names was Kelly, which I found interesting because, like her face, it could have belonged to a man or a woman. We went on to make a videotape which I've since lost. But it was known only as "Kelly's Cornhole." You can imagine why.

**No, I can't. Please tell me.**

Well, what we did was we pulled a trick that I've become quite famous for. It is pouring a large glass of tequila for your adversary, or your victim, and then pouring a large glass of beer for yourself and pretending that yours is tequila also. You convince them to drink down their large glass until they vomit and pass out and are left to be tormented. A similar trick had been done to me when I was young.

So the trick worked, as it always does, and Kelly and her friend were drunk and running around the lawn where Sharon Tate's friends had been murdered. They jumped in the pool and somehow I was convinced to join them. That's something I don't like to do because I don't know how to swim. So I was in the pool with this sea bass, I suppose you could call her. By smell she was some sort of porpoise fish-woman, and by sight she looked like a water behemoth. Trying to create some sort of entertainment for everybody, I

said, "Why don't we play Guess Who's Touching You? We'll put a blindfold on you and try to figure out whose hands are on you." So Trent and I take this sea bass back into his living room. The other girl had since passed out and was hopefully drowning in her vomit.

We blindfolded the sea creature. No, I think we just wrapped a towel around her head, which also covered up her face and made us both feel better. Not that her body was any greater than her face. It was all terrible. I grow ashamed of myself right now as we speak of this.

So we started squeezing her nipples and prodding around her genitals and what-have-you. We were laughing because we were both drunk, though not nearly as drunk as she was. In the background a Ween album was playing, "Push the little daisies and make 'em come up . . ." as me and the young Trent Reznor poked our fingers into the birth cavity of a bizarre fish lady in search of some sort of caviar. But what we ended up finding was a mysterious nodule—maybe it was white fuzz or a piece of corn—that she had on the outer region of her rectum. It horrified us and we looked at each other with disgust and shock. But we knew that we must continue with our debasement of this poor unsuspecting person. So I found a cigarette lighter, and I started to burn her pubic hair. Though it didn't hurt her, it didn't help things smell any better than they already did.

Unfortunately, there isn't any real climax to this story other than I think that she wanted to cuddle with someone and we both ran.

### Did she catch you?

I have a feeling that Trent may have ended up cuddling with her because he has a soft spot for shitty women. Not that we all don't all have a penchant for taking ugly girls under our wings in the hopes that they'll be better in the morning. But they're always worse.

So I went to sleep and hoped that it all would go away. The next day it did and we felt a lot closer to each other of course. He told me that he was starting his own label through Interscope Records called Nothing, and he wanted Marilyn Manson to be the first band on it. I thought it was the best label to be on because Trent was so upset about his experiences with his old label, TVT, that one of his biggest goals was never to deceive or mistreat the bands on Nothing.

Trent said he was particularly impressed with the demo that we had out at the time, called *Live as Hell*. It was recorded on a

Tampa Bay radio station and it was dreadful sounding. It was with our then-drummer, Freddy the Wheel [Sara Lee Lucas], whose time-keeping was about as impressive as Kelly's cornhole was.

**Tell me about the recording of your first album, *Portrait of an American Family*, which was actually number one in our reader's poll last year.**

It was a disaster at first. We went to record in Hollywood, Florida, at Criteria Studios, which is owned by the Bee Gees. The guy we were working with was Roli Mossiman, who was a weird charac-ter. I forget if he's Swiss or German—some country where they've never discovered the toothbrush. He had about six—maybe eight—teeth in his head. And while we were in the studio recording he lost two of them. They were just falling out of his head, rotten, and he smoked all the time. Do you know how I feel about that?

**Your manager told me you despise it.**

Right, and Roli would roll into the studio smoking at about two o'clock and would want to quit a few hours later. He spent all his time talking about when he used to be in the Swans, which was one of the reasons why we picked him. But he only worked maybe five or six minutes a day.

When we were finally finished, Roli had done the opposite of what I'd expected. I thought he was going to bring out some sort of darker element. But he was trying to polish all the rough edges and make us more of a rock band, a pop band, which at the time I wasn't interested in at all. I thought the record we did with him came out bland and lifeless. Trent thought the same thing so he volunteered to help us repair what had been damaged.

**So then the band went out to Los Angeles?**

No, I went out there by myself at first to try and remix the tracks I thought were still salvageable. A funny thing happened when I was done. I called home to Florida to talk to Daisy [Berkowitz, guitarist] and ended up talking to Pogo [keyboardist Madonna Wayne Gacy]. He told me they were at Squeeze and they got really fucked up. Daisy couldn't handle his alcohol, and all of a sudden passed out while he was walking and fell right on his face. He split his chin open and lost his memory. He didn't know who he was when he woke up, and he kept saying, "Where's my car? Where's my car?" He thought he had been in a car accident. I called him, and he sounded like another person. I couldn't communicate with him. He didn't understand anything I was trying to say and

probably didn't even know who I was. The doctors told him he had a bubble in his brain.

**Was there any tension or hostility in the band at that point?**

I had early impressions from Trent that there were problems with the band. He and everyone he worked with knew Freddy the Wheel was a weak link. And Brad Stewart [former bassist Gidget Gein] was also still in the band, and I knew that he was an even weaker link because at that point he had already OD'd three or four times. I was on the verge of kicking him out and replacing him with Twiggy Ramirez.

I also got the impression from a lot of people that Daisy was not only disliked as a person because his personality was abrasive but that no one was particularly impressed by his guitar playing—though I thought he was all right and didn't have a problem getting along with him. I knew that we had a foot in the door but I was not satisfied. Marilyn Manson wasn't the band that it could have been. I knew I'd have to go through hell to get the band to where I wanted it. And I'm still going through hell. You know, the only way to get out is to go through all the way, to the very bottom.

**I'm sorry. Have another line.**

Sniff the dust? Okay [*Cutting and clicking sounds. Sniffing sounds*]. Where were we?

**We were talking about Daisy.**

So when Daisy got out of the hospital, we told him, "Fly out. Come hear the mixes. Let's work on fixing these other songs." The day that he was supposed to leave, he missed his flight and showed up late. He walked in the studio, and Trent had never met him face to face before. Trent said hi to him and Daisy was kind of abrasive and greasy. He always seemed to have baby oil dumped on his face and on his hair. The kid needed some Stridex. So he came in, and he was like this angry greasy pimple guy with cigarettes coming out of every orifice of his body, and Trent's like, "You wanna hear the mixes?"

And Daisy says, "No, I wanna go smoke a cigarette." He was a dick right off the bat, which made me feel uncomfortable because I had to defend him. When Daisy eventually did listen to the mixes, he didn't even pay attention or make a comment. He just kept bragging about the musical shit that he could do.

*deformography*

We spent the next month or so trying to re-record songs and fix things up, and everyone learned early on that Daisy was not someone who was easy to work with. He was stubborn and he never had a song or the album in mind. He just had his personal agenda as a musician. He wanted to display his idea of what his talents were. Sometimes it got frustrating making that record. But most of the time it was fun. It was new. Life still seemed like something to be enjoyed.

As we were working on *Portrait*, Trent was starting his album *The Downward Spiral*, and we had some good times working together. I thought that was what making music was about. Everyone was pretty sober except for maybe having drinks at the end of the night, and I can't recall anybody doing drugs except Brad Stewart being passed out on heroin. All I had to be pissed off about was the rest of the world, the things that weren't a part of my life, the way I saw everybody else's life. So it was still okay to be idealistic. I hadn't been scarred by the bad sex, drugs and touring that came afterward.

**Can you recall any of those good times?**

Well, the studio had a large window where you could view the live room, and one night we wanted to have someone entertain all of us. So we taped $150 to the inside door of the studio—Trent and I each put in seventy-five dollars. In order to win that money and get in all our good graces, the challenge was to go outside the studio, which was on Santa Monica Boulevard where all the transvestite and transsexual prostitutes come out after dark like little hermaphroditic cockroaches, and pick up one of them and bring him–her–it back.

**CIRCLE EIGHT · FRAUD · SIMONISTS**

At first, all of us went and walked around. There were lots of people driving by and they seemed to be having an easy time picking these people up. But the prostitutes were clearly afraid of us, and we came back frustrated and ate dinner.

Pogo, who was a skinhead with a long goatee then, went into the bathroom and shaved his head. He always carried around clown makeup because at random times he liked to go out dressed up like a clown. He made up his face Gene Simmons–style and went out by himself. We were starting to record some tracks when all of a sudden Pogo walks in with some she-male and takes her

into the live room. All we had to do was turn on the microphones that were recording the drums and we could hear their conversation. Apparently this person's name was Marie, and from far away it looked pretty much like a woman, and not that unattractive, at least for a prostitute. But upon closer inspection we could see that underneath her fishnets there were some open sores on her legs that looked like they came either from being burned with giant cigars or the first stages of something that we didn't want to know about.

What ended up happening was that she was smarter than we thought. She knew we were watching and wanted to charge extra. We weren't really into it that much so Pogo went into the other room and, to the best of our knowledge, he jacked off on a man's tits—and I'm not sure what that makes him, other than depraved, of course.

### Was it scary working in the Sharon Tate house?

One strange thing that happened was we were mixing the song "Wrapped in Plastic," which is about how the typical American family will wrap its couch in plastic and the question, "Will it keep the dirt out or will it keep the dirt in?" Sometimes the people who seem the most clean are really the dirtiest. We were using a computer because we had a lot of samples and sequencing. While we were working on that song the Charles Manson samples from "My Monkey" started appearing in the mix. All of a sudden, we'd hear in the song, "Why does a child reach up and kill his mom and dad?" And we couldn't figure out what was going on. The chorus of "Wrapped in Plastic" is, "Come into our home/Hope you stay?" And we're in the Sharon Tate house, just me and Sean Beavan [the record's assistant producer]. We totally got scared and we're like, "We are done for the night." We came back the next day and it was fine. The Charles Manson samples weren't even on the tape anymore. There's no real logical or technological explanation for why they appeared. It was a truly supernatural moment that freaked me out.

### Why do you think it's become so trendy for musicians to make references to Charles Manson in their music?

That pisses me off. Axl Rose was in a hellstorm because he recorded a Manson song, and I'll tell you how he got that idea in a minute. Meanwhile Trent was living at the Sharon Tate house, so I end up looking like I'm this Marilyn Manson guy that's riding Trent Reznor's wagon, which is kind of funny. But I never got a chip on my

shoulder. I never minded because otherwise I would never have gotten to record there and sleep there and get freaked out by the ghosts there.

**That's a good attitude. Why don't you do another line?**
Okay, but this is the last one [*sucking sounds*].

So what happened with Guns N' Roses was that Trent took me to a U2 concert one night and backstage I met Axl Rose. He was very neurotic and was telling me all about his psychological problems, his split personalities, and I felt like, "This guy's a total fucking flake." Being the overzealous type, I started telling him about my band anyway. And I said, "You know we do this song 'My Monkey' and it's an adaptation of a Charles Manson song off his album *Lie*."

And he's like, "I never heard of that before."

I told him, "You should check out the album, it's cool." And lo and behold six months later Guns N' Roses put out *The Spaghetti Incident* and Axl Rose covers "Look at Your Game, Girl" from the *Lie* album.

Then he started getting all that heat from Sharon Tate's sister and everybody. When our album was finished after that, we had the song "My Monkey" on it but I had this five-year-old kid Robert Pierce sing on it. That was the great irony: Here's a kid that's singing a song that to him is an innocuous nursery rhyme but to everybody else is this horrible thing.

After we turned the album in, I got this call from Trent and John Malm, who's Trent's manager and runs Nothing Records. And they're like, "Listen, are you willing to put out your album without the song 'My Monkey' on it?"

I asked, "Why?!"

And they said, "Well, Interscope is having problems because of the shit that Axl Rose has got. He's had to donate the proceeds of the song to the victims' families."

I said, "Well I don't have a problem with that. Just explain to me what's going to happen." (The entire song wasn't Charles Manson's song. I just borrowed a few lyrics and the rest were my own.)

In the end, Interscope insisted that we take the song off. I said, "No." So they told us they weren't going to put the album out.

All of a sudden we went from being South Florida's brave new hope, from being the only band that will ever make it out of there, to being like an unsigned local band again. And it sucked. It was the most soul-destroying period in my life because we had an album done and everyone was expecting it to be in stores.

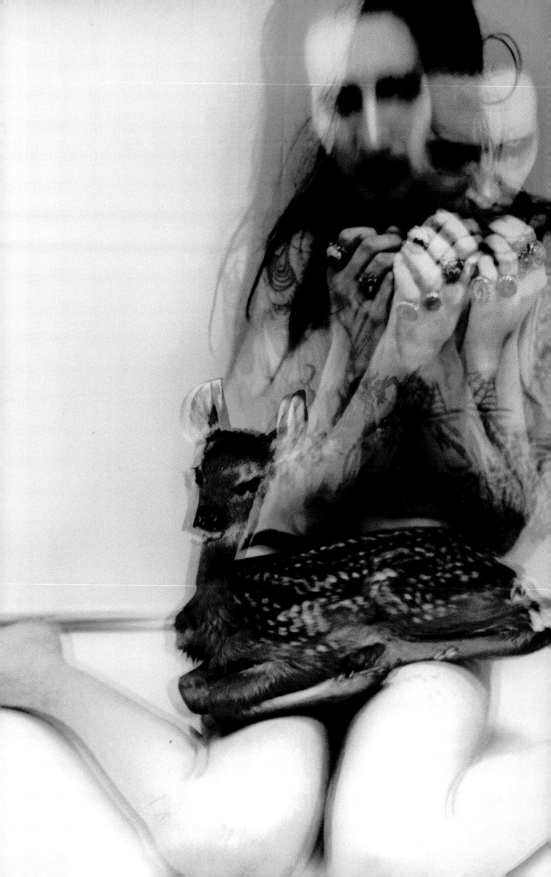

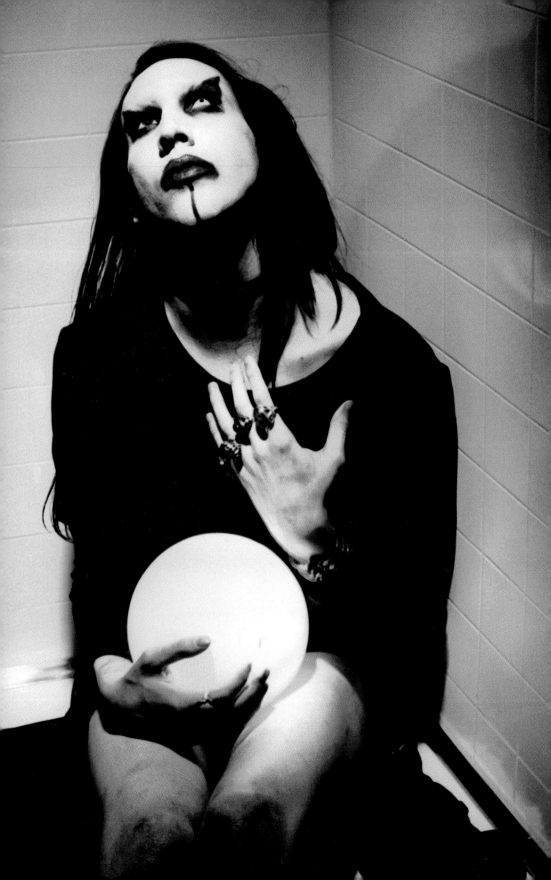

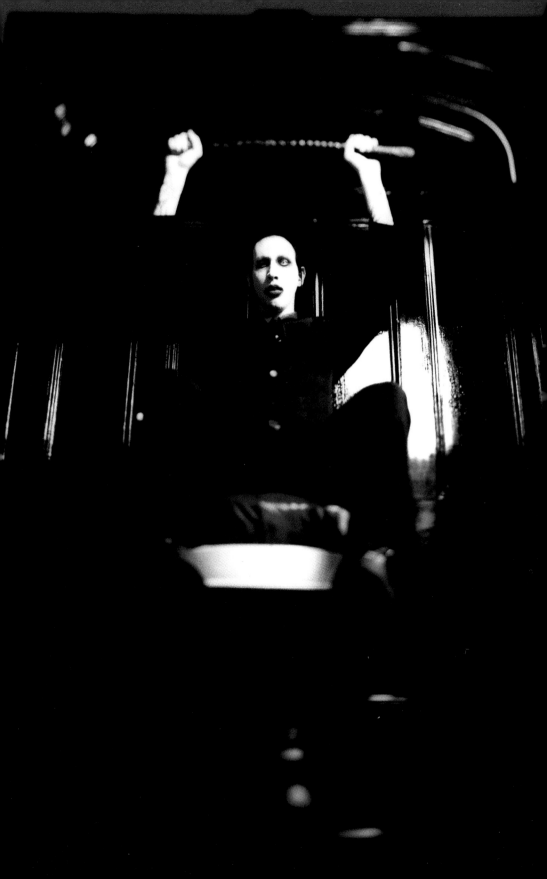

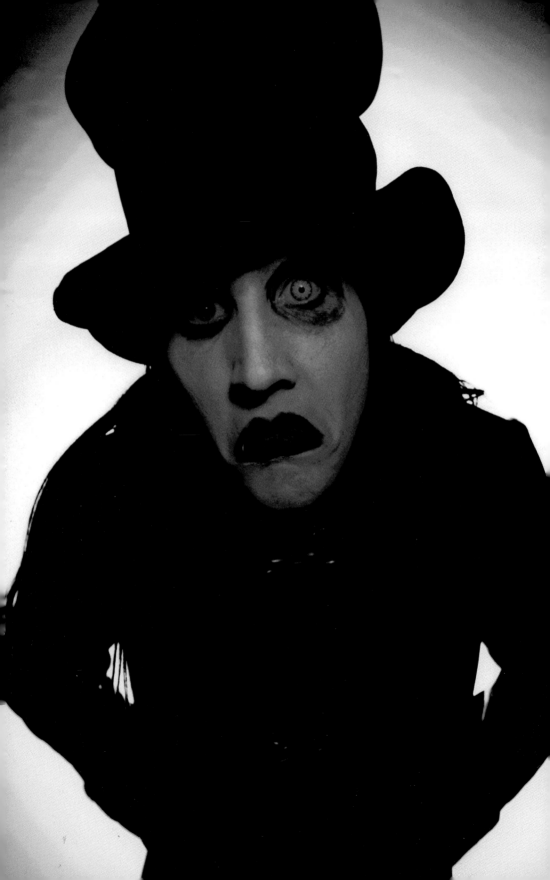

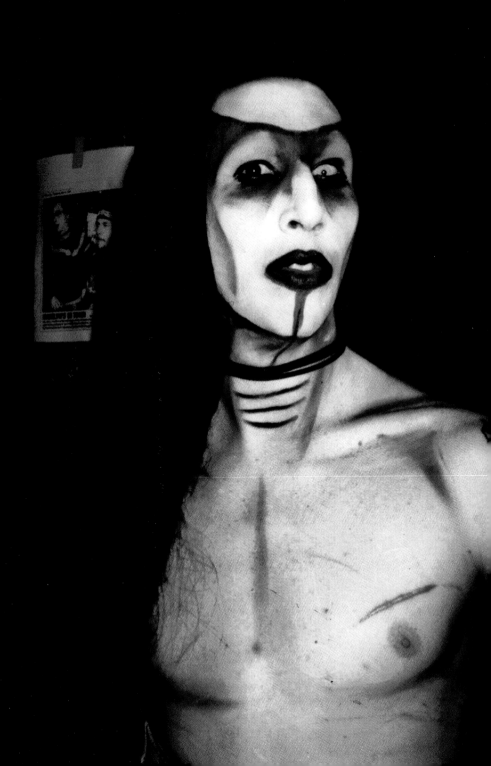

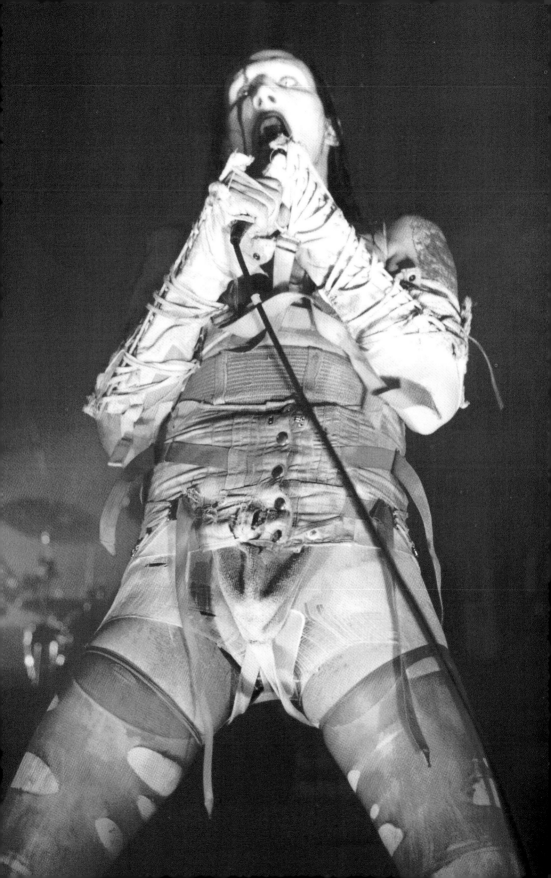

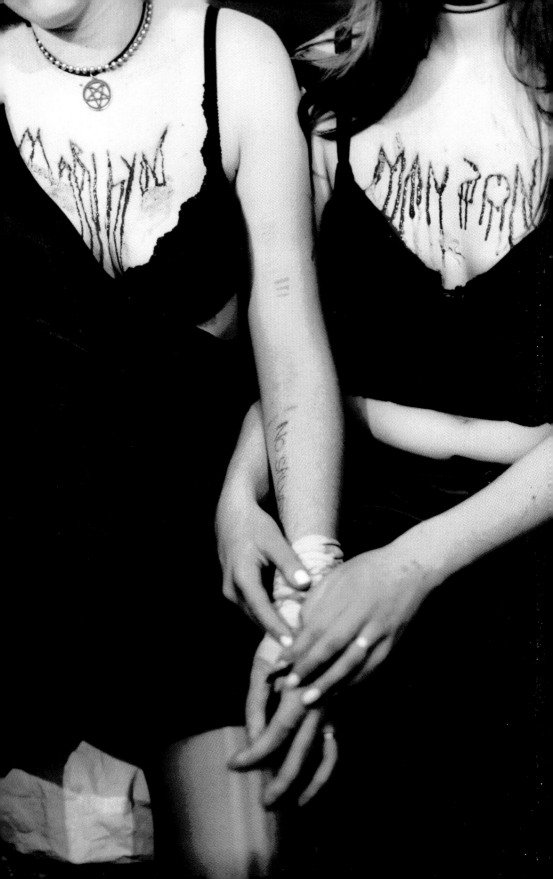

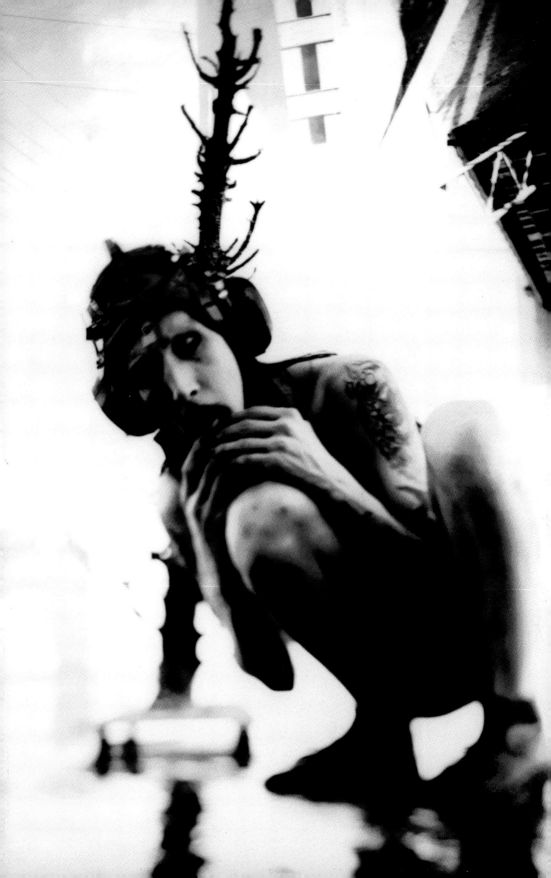

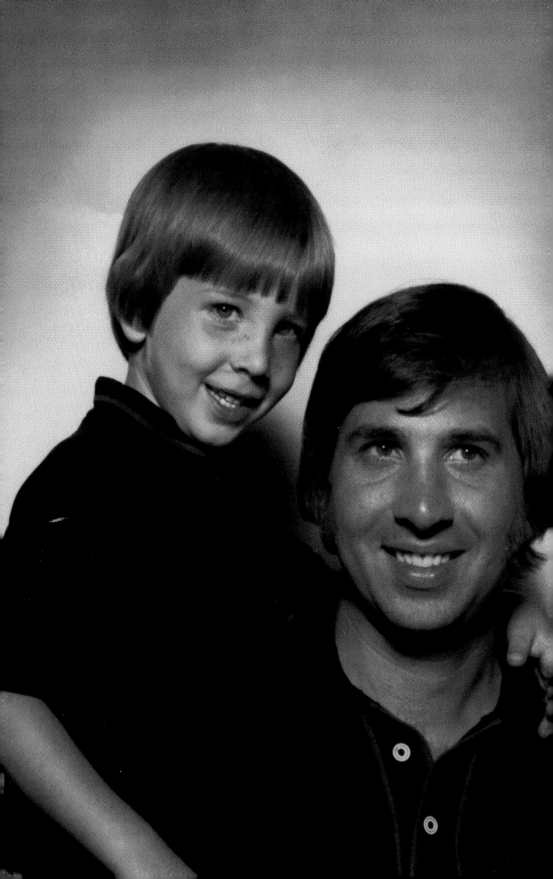

OFFICE OF THE
SHERIFF
4 JAX., FLA.

OFFICE OF THE
SHERIFF
94 JAX., FLA.

· 4 7 1 · 0 6 1 2 28 94 ·

4 4 7 1 0 6 1 2 2 89

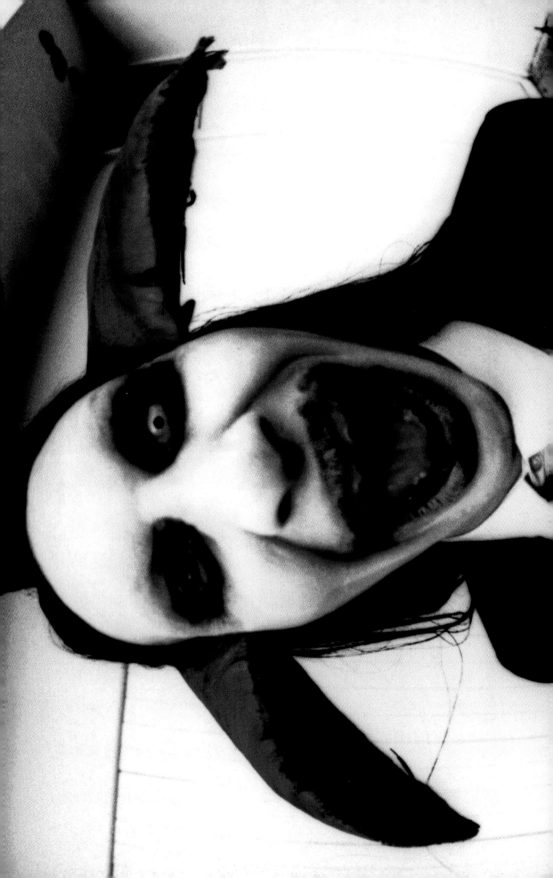

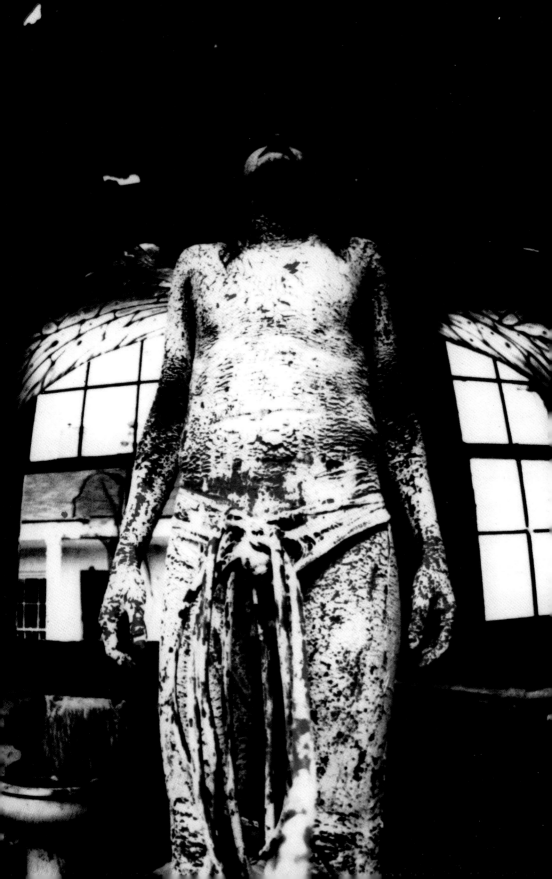

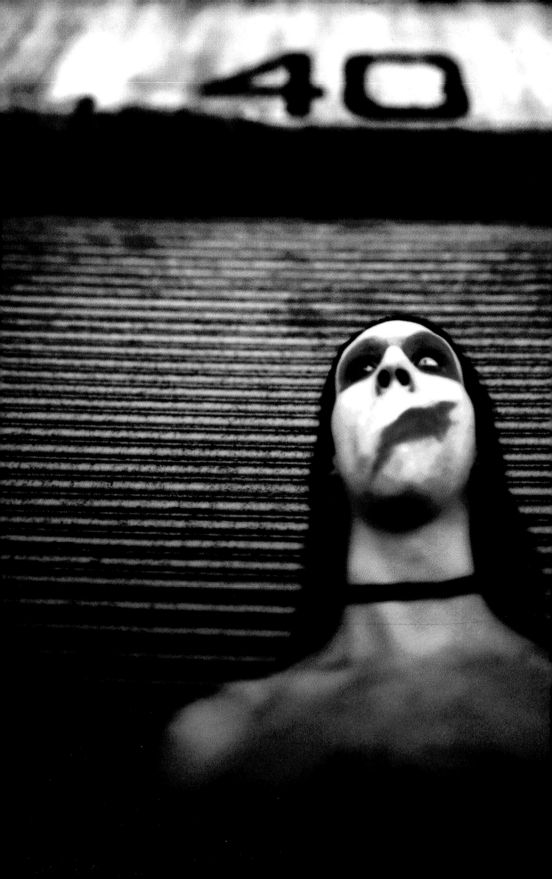

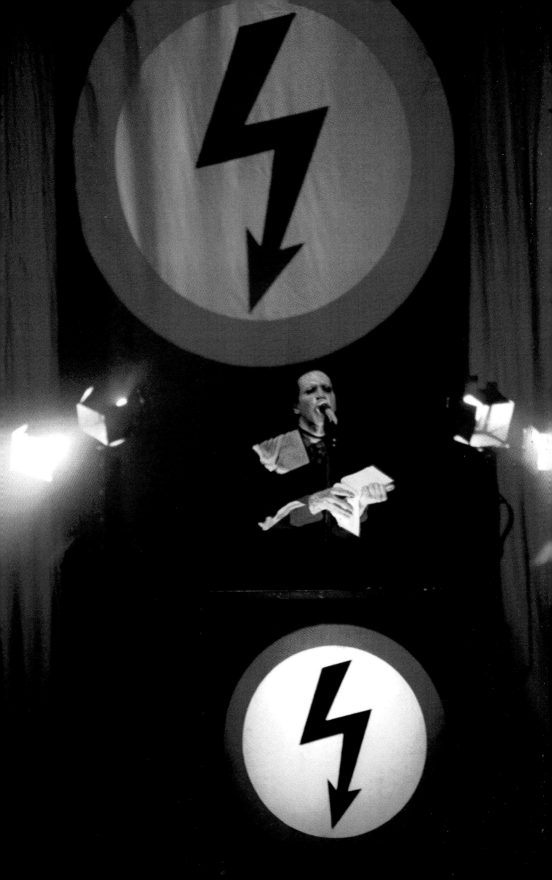

Meanwhile, my original bass player [Brian Tutunick, a.k.a Olivia Newton-Bundy], had started his own band called Collapsing Lungs and they got signed to Atlantic and had a total attitude toward us because they thought they were going to be big fucking rock stars. And now his replacement, Brad, was getting so fucked up on heroin that we had to kick him out of the band because we were spending more time taking care of him than rehearsing. So there was a real period there where I felt defeated. I wanted to give up. I thought it was over and my ideas were too strong for people. I thought about trying another medium, but I knew in my head that a year or two from then would be a better time for my music.

**How did Interscope come crawling back?**
While everything was in the air, Trent backed us up and stood behind us. He told us not to worry because he had an option to put out a record with any other label as part of his contract with Interscope, even though it technically owned Nothing. So we had Guy Oseary from Maverick Records [Madonna's label] down to see us and he brought Freddy DeMann, Madonna's manager. The funniest thing about those guys was that the first thing they asked me after the show was over was, "Aren't you guys Jewish?" And our keyboard player said, "Yeah I'm Jewish, but I'm not religious, I don't practice it," And they said, "Yeah, okay, that's cool. We gotta stick together."

We had this whole bonding thing. Then they went back to New York and our manager got a call like two days later. They said, "We don't really have a problem with Manson's image, the tattoos, the association with the occult and Satanism. But there's something we need to know: Does Manson have any swastikas tattooed on him?" And he's like, "No. What are you talking about?"

They said, "Well, we just wanted to check because if there's any sort of anti-Semitic message then it's not something we want to be involved in." Everything I was doing was so much about sticking up for the underdog that I couldn't understand how they could misassociate what I was doing like that. It was weird. After my tattoos checked out, they actually offered us a deal. It must have lit a fire under Interscope's ass because all of a sudden Interscope came back and said, "Listen, we're willing to put out the record and we'll even pay for it." We agreed because we had always wanted Interscope from the beginning, I had faith in that label. I still do. They had a deal with Time Warner, who were the ones causing the problems.

**So Interscope let you put "My Monkey" back on the album?**

They did, but we continued to have other problems. I wanted to use a photo in the album's booklet of me naked on a couch when I was a kid. When you hold up something to people, usually what they see in it is what's inside them in the first place. And that's what happened because the lawyers at Interscope said, "First off, that picture's going to be considered child pornography, and not only will no stores carry the album but we're subject to legal retribution from it." They said if a judge were to look at it, the law states that if a photograph of a minor elicits sexual excitement then it's considered child pornography. I said, "That's exactly my point. This is a photograph that was taken by my mother, and it's extremely innocent and very normal. But if you see it as pornography, why am I the guilty person? You're the person who's got a hard-on. Why aren't you punished?" That's still a point I'd like to make. People's morality is so ridiculous: If they get excited by it, then it's wrong.

[*Manson rummages through his bags and pulls out the original album booklet, which has a reproduction of a painting of a clown face on the cover, with no text.*]

You see, we also had a John Wayne Gacy painting of a clown on the cover, and look at the other photograph on the inside. It's one of my favorite photographs and I've never gotten to use it. It's a picture of one of those dolls from the '60s and you pull a string on the back of it and the eyes get really big and they change colors. Around it is this like circle of wisdom teeth, and candy corns, and peppermints, and these Polaroid photographs of a completely mutilated girl. But it was something I had faked. It wasn't real but it looked very authentic. So they called again and said, "Listen. First of all we won't print this kind of photo, and second of all we couldn't do it because unless you provide us with a name and a written affidavit from the person in the photo we're gonna get arrested for distributing it." They still thought it was real, so I told them it was okay not to use it. In the end I thought it was cooler for them to think it was real. It's always been a game of not compromising but also knowing your limits and doing the best you can within those limits.

**So you're not bitter about your early experiences with Interscope?**

Well, there was always a real chip on our shoulder that the album never really got the push from the record label that we thought it deserved. It was all about us touring our fucking asses off. We toured for two solid years, opening up for Nine Inch Nails for

a year and then doing our own club tour. It was all just about perseverance.

**Looking back on it, are you happy with the album?**
Well, the whole point of the album was that I wanted to say a lot of the things I've said in interviews. But now I feel like I fell short, like I didn't say it right. Maybe I was too vague or maybe the songs weren't good enough, or whatever. But I wanted to address the hypocrisy of talk show America, how morals are worn as a badge to make you look good and how it's so much easier to talk about your beliefs than to live up to them.

I was very much wrapped up in the concept that as kids growing up, a lot of the things that we're presented with have deeper meanings than our parents would like us to see, like Willy Wonka and the Brothers Grimm. So what I was trying to point out was that when our parents hide the truth from us, it's more damaging than if they were to expose us to things like Marilyn Manson in the first place. My point was that in this way I'm an anti-hero. I think I'll be able to say it better on the next album.

## AMERICA, MEET MARILYN MANSON: PART TWO OF A TWO-PART STORY
### by Sarah Fim
### Empyrean Magazine, 1995

When we last left Marilyn Manson, he was in his hotel room snorting coke and giving *Empyrean* an exclusive on the whirlwind

events of the past year. The time now is four A.M. that same night and just as he is preparing to launch into the carnage tales of his tours with Nine Inch Nails (with the Jim Rose Circus Sideshow and, later, Hole as opening acts), there is a knock on the door. He hides his drug-covered Judas Priest CD behind a cardboard box and stands up, smoothing out his Adam Ant *Friend or Foe* T-shirt. He looks cautiously through the peephole, half expecting to see the psychotic runaways that slavishly follow his every movement and sleep with his crew (and occasionally very desperate band members) to find out his latest whereabouts.

But the sight facing him when he opens the door is a much more horrid one: it's Twiggy Ramirez, the band's bassist, with a bottle of wine in his hand and an expression of pure, abject horror on his face. He complains about how miserable he is because he's snorted too much cocaine. Then he snorts another line and sits on an armchair in the corner of the room, curling his knees up to his red-and-white button-down shirt. Instead of making him talkative, the cocaine is bringing him down. To every question he is asked, all he responds is "whiskey and speed."

I wonder if his presence will keep Manson from opening up and being honest, but Manson says not to worry as he pours himself a large glass of wine.

**EMPYREAN: Snort some of that and then we'll get started again.**
**MANSON:** This is good talking powder. [*Big snorts.*] Eek. [*He is startled by a scene on the video of handicapped people being massacred.*]

**When did you start doing cocaine anyway?**
Not that long ago. The first time was on the Nine Inch Nails tour. We had just played in Chicago, and one of the roadies called me and Twiggy into Trent's dressing room. He was there with someone else in the band. The room was destroyed. There was food everywhere. Shit was crushed into the floor. Dirty clothes were strewn all over. And everything was covered in flour because those guys used to pour flour all over themselves.

In the middle of the wreckage there was a strange, gray-haired, pock-marked hippie who had bribed his way backstage with drugs and carved out something like thirty lines on a stainless steel counter in the bathroom. It was some ridiculous rock star amount of drugs, something insane like an ounce. He was like, "Do you want some?" And we were like, "We've never done this before."

And he said, "Try it." So we did, and we were wired out of our minds. We were doing lines like crazy.

I was wearing rubber underwear that had been built only with an opening for your dick; I wore them all the time on that tour. And there were these two girls who were hanging out backstage. One was a blond and one was a redhead, and they were both pretty cute. One was studying to be a psychiatrist, and the other one was just a slut. I remember being really high and really confused and still having my pants on because I never took them off until I went to bed. And I was fucking both of them in the back lounge with this underwear on like I was some kind of debased version of Superman. My skin never touched them. It was like wearing a body condom.

**Were you afraid your heart would stop on the cocaine?**

It didn't really bother me at the time. We thought it was really funny because it was such a cliché. Only stupid people get carried away with drugs. Like John Belushi and Corey Feldman.

**That whole tour must have been amazing. All of a sudden you went from nothing to living this rock star life on the arena circuit!**

No one had heard of us, and our album wasn't even out yet. There were just rumors about us from the small amount of press that we had gotten from our publicist, Sioux Z., who was very excited about taking on this project even though she probably didn't understand it. I always wanted something more. That was my problem: I always wanted more. And when I came across that way to my publicist or my record company or my producer I was always told to be patient and not expect too much or get my hopes up. Even Trent and his manager, when they signed us they said something like, "Someday I think you guys could sell as many records as Ministry."

**That's like 200,000 records.**

Exactly. And always in my head it felt defeating. I want to be bigger than Kiss. I don't want to be some fucking dispensable thing. I probably shouldn't say this, but what the fuck, nobody reads your magazine. [*He straightens out a line and snorts half of it.*]

Anyway, I felt there was always a competition from the beginning. Not from my end but from them. It made me feel defeated because I was always ahead of myself. I was always thinking of the big picture, and nobody else was. It was very disappointing all the

time. What nobody understood then is this: The only way that you achieve what you want and fulfill your dreams and become great is by demanding that sort of attention. You have to make it happen. And I think nobody saw that back then but me and my band, or at least the core of the band, which was Pogo, Twiggy and myself.

**Let's get back to the tour.**

Yeah, okay. We had a lot of interesting things that happened with Jim Rose [leader of a traveling troupe of freaks and contortionists called the Jim Rose Circus Sideshow]. He was always a great thrill to be around because he instigated a lot of interesting scenarios. There was one girl that had followed us around to most of the cities, and she was sort of overweight but cute, like a koala bear with Gothic udders, I suppose. Somehow one night she was talked into standing naked and bent over as everybody took turns trying to spit in her asshole, a game that even I found crude and couldn't take part in.

**You're just saying that for my benefit.**

No, that's true. For a moment I thought, "Well, maybe." But I was uncomfortable because I felt a little sorry for her. She seemed like the type of person that just really wanted to be accepted. She was basically being exploited for her anxiousness and her neediness, and I have a soft spot for people like that because I'm so used to wanting to be accepted that I've let people exploit me. There are actually certain lines I will draw as far as what I do. I'm not trying to be self-righteous: I thought it was entertaining. I just didn't participate.

There were things I took part in, though. The most memorable was toward the very end of Jim Rose's time on the tour when we were getting really rowdy. What happened was Jim Rose had gathered together quite an assortment of people this time. He had really done some work. He had about ten girls, very nubile and ready to get fucked. Unfortunately that's not what happened to them. I'm sure they were all disappointed.

Instead, he devised a bowel movement contest to see who could receive an enema and hold it in the longest. The person who shit it out first lost. Three girls agreed to compete, and they were all rather attractive for people who would participate in such an event. I ended up giving the enemas, and also holding a bowl of Fruit Loops underneath each of their asses. The first girl shot right away—sprayed out some brown water that wasn't even really shit.

It was sort of a Yoo-Hoo colored liquid. And Mr. Lifto, who is the strongman of the Jim Rose show except he uses his dick instead of his biceps, ate the bowl of cereal. The girl who ended up winning didn't even spray or shit at all.

**Was she rewarded?**
She was rewarded with our respect and admiration.

**Did you feel vindicated coming back to Fort Lauderdale as a rock star?**
Actually, our first big homecoming show was in Miami, and everyone was in the audience. My parents, every girl I had ever slept with, every girl I had ever wanted to sleep with, and everyone I had kicked out of the band. But what happened was while we were performing, Robin [Finck], the guitarist in Nine Inch Nails, ran out on stage in a G-string with some kind of powdered confectionery item he planned to dump on me for whatever reason. In the midst of this sabotage attempt, I grabbed him and pulled his pants down and placed his limp, salty penis in my mouth and sort of, uh, teethed on it for a few moments, but not long enough to really constitute it being a blow job. It should be noted that I didn't have a hard-on, which should relieve me of any accusations of being gay. Afterwards, he ran off stage sort of embarrassed and I had to flee from the cops when the show ended. They came backstage looking for me, and I hid in the bathroom where, conveniently, some drugs had been stashed. Luckily, they never issued a warrant for my arrest or prosecuted me for that particular incident.

We staged a private encore several days after the original incident. We were retelling the anecdote for the twentieth time at a Nine Inch Nails after-show party filled with a cast of characters that Jim Rose had hand picked—mildly attractive girls who seemed foolish enough to do anything he suggested. And I was asked to make a repeat performance, so I went ahead and did it again just to prove that it was not only for art, it was for pleasure as well. This time I did a better job and once again did not get a hard-on, although I believe that he may have had one.

**What else happened on that tour?**
I think my first real experience in the rock and roll world came in Cleveland the day that Hole joined the tour. The lineup was actually Marilyn Manson, Hole and Nine Inch Nails. Courtney showed up late. She had flown in and was completely wrecked when she got to the concert. She went on to play probably one of the worst

shows in her life, and I'm sure she would admit this. She took off her top, said something sarcastic speculating whether Trent Reznor was a top or bottom to piss off the audience, and then dove into the crowd. A lot of people tried to grope her breasts and tear off the rest of her clothes.

After she finished, she decided to come into our dressing room because we had adjoining ones. She was pretty much just in her underpants and her bra, and lying around sprawled out, high or drunk. I'm not sure which, probably a combination of both. I was kind of confused by the situation because—other than Trent—she was one of the first infamous (rather than famous) people I had come across. So I kept my distance. I'm not sure if I was scared of her or if I just didn't want to get involved.

She was trying on everyone's clothes, and I remember Daisy was pissing me off because, in particularly bad taste, he was trying to trade some of his clothes to get her to send him one of Kurt Cobain's guitars. She was very cool about it and didn't take any offense.

**Do you want any more wine?**
Sure. I need to go to sleep eventually. [*He refills his glass.*]

**Now, Courtney has always said that she had some kind of relationship with Trent but Trent has always denied it. What's the truth?**
I probably shouldn't talk about that. All I'll say is that it seemed

that Trent had picked Hole to be on the tour as a bit of a novelty. He seemed to dislike her greatly, and I think he wanted her on tour either to make a fool out of her or just to study her. But as the tour progressed I noticed that Trent and Courtney were hanging around a lot together, and it was a part of the tour where he wasn't talking to us too much. He had disappeared into his own world—or hers.

**So you didn't really know whether they were sleeping together?**
Well, things started to get weird a month or so down the road as the tour was ending. Courtney showed up at Trent's bungalow trying to break down the door and doing some other stuff that I

forgot about because I was drunk. But it was some sort of outburst that comes from a girl only if you fuck her. So I could tell that there was something going on that Trent wasn't telling us about, especially since he was stumbling around her hotel room at certain hours of the night that were very suspicious. Still to this day he won't admit to any of us what happened. So you can make your own judgment.

**I thought this interview was to tell the truth about everything that happened in the past year.**

I'm telling the truth, but Twiggy can probably tell you more because he had an undocumented, undisclosed relationship with her afterwards.

**Is that true, Twiggy?**

**TWIGGY:** It's true that I need whiskey and speed.

**MANSON:** What happened was that after the leg of the tour with Hole was over, for some reason we kept running into Courtney. Whenever she would pop up, it would cause great amounts of stress for Trent. He's a nonconfrontational person so rather than dealing with it he would let it torment him.

There was a night that we were all partying. I think it was in Houston, and Trent was working on the *Natural Born Killers* soundtrack. Twiggy and I went out to a bar and some guy gave us drugs. We had one of our very first nights of terror where I felt like I was gonna die, and I wanted to call everybody I knew and tell them that I loved them and that I was afraid. In the midst of the terror, Twiggy disappeared because he had gotten some frantic phone call in the middle of the night. Apparently Courtney was in town and told him, "Come over. I'm freaking out!"

He didn't come back until about seven o'clock the next morning. I asked him what happened, and he pulled up his shirt and had these giant red claw marks on his back. He kind of sheepishly admitted to doing some very graphic and very obscene sexual acts. Very exciting. I'll leave it up to your imagination.

So they continued to have this secret relationship, probably because Twiggy wasn't famous enough at the time for Courtney to admit that she was having sex with him.

**Do you think she was manipulating him to get to Trent?**
**MANSON:** I don't know, but Trent seemed to think so. And it worked. Because not long afterwards we got a call from John Malm, the president of Nothing. During the tour, we had fired our management from Florida, which was too busy taking care of that country band the Mavericks to really care, and let Nothing take over. So now John Malm, our new manager, was telling us, "Listen, you can't hang out with Courtney because she's trying to find out where Trent's staying and she's gonna use you to do it."

**So which did you choose, Twiggy, Trent's peace of mind or your budding relationship with Courtney?**
**TWIGGY:** Whiskey and speed.
**MANSON:** He kept seeing her, but not to rebel against any-one. He was just into her. I think he was also starstruck by Courtney because he had never had a relationship with anyone of her stature. At the time I didn't really understand Courtney and was siding with Trent. I sympathized with him and believed his side of the story. I felt like Courtney was a bad thing and I didn't want any part of it. [*Twiggy suddenly stands up from his chair, slightly flushed.*]
**TWIGGY:** Everyone was accusing me of being used when at the time it was genuine. It meant something. I learned a lot from that relationship, more than any other one. It was inspiring. But the closer we got to each other, the more pressure there was to stay away. I think there was also this idea at the beginning that I was discrediting Trent's trophy. [*He collapses back into the chair.*] I guess the timing was wrong.

**Is there anything else you want to add, Twiggy?**
**TWIGGY:** Whiskey and speed.
**MANSON:** I never really ever had a conversation with Courtney until just recently, when I found out that she is a very smart person and more in control than most people think. We were playing somewhere on the West Coast and there was a knock on our tour bus door. I heard this drunken, raspy voice screaming, "Jeordie! Jeordie! Where the fuck's Jeordie?" And Courtney came limping on the bus because apparently the night before she had fallen and hurt her leg. She saw a girl sitting there and immediately

started telling her, "You don't need to be on this bus. You should get a keyboard and start your own band. Then these guys'll be on your bus."

Then she looked at us and asked, "You got any donuts?" I had just gotten a dozen glazed donuts and she took four and devoured them before I even saw her mouth open. Then she whipped off her bandage and winged it at our tour manager, who started freaking out because getting blood on him, whether it belongs to someone famous or not, was not in his contract. When Twiggy came out from the back of the bus, no doubt hiding the several teenage girls he had back there, he seemed semi-embarrassed and semi-entertained by the whole situation. It was at that point that I started to like Courtney and gain a bizarre respect for her because she made me laugh and I thought she was cool.

**I'm told that on the last night of the tour, Nine Inch Nails got their revenge on you. Is this true?**

It wasn't revenge exactly. Traditionally on the last night of the tour the opening act expects to get fucked with by the main act. So on the last show of the tour in Philadelphia I was leaving the bathroom backstage before our show when I saw two naked girls making out and touching each other all over. Next to them there was some weird naked bisexual guy. Everybody from our band and from Nine Inch Nails was standing there watching. So the guy goes to me, "I've heard you say that if anyone has the guts, you'll fist-fuck them backstage. I'd like to know if I could take you up on that offer."

Nine Inch Nails thought that they were gonna pull one over on me because I had made a habit of saying onstage, "Who's gonna come backstage and let me stick my fist up their ass?" They thought, "Oh, we'll show him. We're gonna bring someone back and he'll chicken out." But, more to destroy their plans than to keep from being a hypocrite, I said, "Okay. No problem." I put on a big rubber glove that came up to my wrist, and there wasn't any sort of lubrication nearby other than margarine. So I wiped that all over my fist and then tried my hardest to get most of my hand, probably up past my knuckles, into this guy's anxious, pouting rectum.

I thought that was all. But when I went to go on stage five minutes later, Nine Inch Nails ambushed us and covered us with every disgusting substance they could find backstage—flour, salsa, Vaseline, guacamole, ketchup, baby powder. So we had to go on stage covered in all this shit, and as we were performing five male strippers ran on stage and started dancing. I felt like maybe this had gone too far because now they were messing with our perfor-

mance, and I didn't want the crowd to think that I would be responsible for something so stupid.

We walked offstage ready to kick the shit out of Trent and his band to pay them back for a joke that had gone too far, but it wasn't over. I was wearing just a pair of leather shorts and wet socks, and we were all covered with beer, sweat, lipstick and every backstage condiment imaginable. Before we could even reach the safety of our dressing room, we were ambushed again and smothered in whipped cream. A bunch of security guards grabbed us and handcuffed our hands behind our backs, led us out the backstage door and threw us into a pickup truck.

They closed the doors and drove off, and at this point it had gone beyond a joke. In retrospect I'm impressed by the planning that went into it. But at the time I was scared shitless because they drove us for half an hour. We ended up in downtown Philly, where they pulled us off the truck and threw the keys to the handcuffs into a trash can. They crumpled up a dollar bill, threw it on the ground and laughed, "That's to help you get back to the concert."

It was about twenty-five degrees and we were practically naked and freezing, especially because we were drenched from the filth of the night. We looked so scary, pathetic and degenerate that nobody would even walk on the same side of the street as us. We ended up begging some college kids to drive us back to the arena.

**Did you have any hard feelings?**
No. If I can dish it out, I've got to be prepared to take it. I wasn't so calm at the time, but now I see it as a good prank, definitely more elaborate and crueler than anything I could have come up with. That kind of symbolized the ending of our freshman year so to speak. We graduated to the next level.

**But not without a little bloodshed along the way, like your drummer and several chickens, right?**
Okay, I'd better address this. Some people think we killed a chicken during a show in Texas; some people say that it didn't die. The truth is that after we left the Nine Inch Nails tour, we did some shows on our own before going to New Orleans to work on the EP we're making now, *Smells Like Children*. I put in our tour rider as a joke that we had to have a live chicken. I guess in Texas it's pretty commonplace to have chickens running around because in the midst of our celery and Jack Daniel's backstage at one of our shows there we found a chicken sitting around clucking in a cage. I

named him Jebediah, and I was particularly attached to him. I didn't want to kill him at all. But our stage set looked like a strange cross between *Ziggy Stardust* and *The Texas Chainsaw Massacre*, and I thought that visually the chicken added something to what we were trying to present. So we let him tour with us, and sometimes I even miked the chicken and let him sing along. But during a show at Trees in Dallas, somehow the chicken cage got kicked open and the chicken flew into the crowd. They tossed him around, but he didn't die. He went back on the farm, although he's probably Chicken McNuggets right now. Heaven forbid I kill a chicken, but it's okay for Ronald McDonald.

From then on, "kill the chicken" became a euphemism for either getting high or going all the way. If we were getting ready to do a show, instead of giving each other a high five or saying "Let's rock," we'd say, "Let's kill the chicken."

**There's one more line left. Who wants it?**

I think I need to get to sleep soon. What I could really use is some Valium. [*He opens a hidden compartment on a ring on his left index finger and takes out a blue pill, which he washes down with a sip of wine.*]

**Before I let you go to sleep, what happened with Freddy?**

On the last day of that tour, we were playing at a gay bar in South Carolina. There weren't many people in the audience so we thought we would do something different. Twiggy put on a suit, and I put on a black cowboy hat, a long black coat, and painted a black line from my forehead all the way down to my dick. Pogo was shirtless and he was wearing my underwear with the dick hole and a giant studded leather belt that said *Hate* in red letters. He looked like a big creepy hairy baby man with a bald fetal head, a giant bushy chest, some kind of steroid Olympics wrestling belt, a flaccid dick encased in black vinyl and combat boots. He was definitely the gayest looking person in the place. I tried to get Daisy to do something different and enjoy himself more, and he said something ridiculous like [*speaking in a slow, dumb drawl*], "Oh, I get it. I should become more the character of Daisy Berkowitz."

Everybody knew that Freddy was going to be fired except for Freddy because just a week before, while Freddy the Wheel was polishing his spokes or something, we auditioned a quiet, older drummer from Las Vegas named Kenny Wilson and asked him to join the band as Ginger Fish. He actually rode the tour bus with us

one night and we told Freddy that he was just a friend of our tour manager. He bought it.

We didn't want to be cruel to Freddy because we liked him as a person. We just felt obliged to make his last show with the band a memorable one. Twiggy and I had shaved our eyebrows off, but he still had his as well as a goatee and a hairstyle that was just black bangs in front of an otherwise shaven head. I think he did this because he was starting to go bald in back. He was a very self-conscious person. But somehow we convinced him to shave his entire head and his face, and he ended up looking like this weird cancer patient version of Uncle Fester from *The Addams Family*. We thought it was the coolest he had ever looked, and wished for a second that he was still going to be in the band.

So we took the stage and immediately we weren't having a good time because the crew had decided that, as their way of ending the tour with a memorable prank, they were going to put raw chicken feet all over the stage. So I slipped and fell on a beer bottle, and it shattered. I was so pissed I took it and fucking slashed my chest from one side to the other. And that was my first real act of self-mutilation in front of people. We sacrificed Freddy by setting his bass drum on fire, but the whole drum kit burst into flames, followed by Freddy. As Freddy escaped backstage to find a fire extinguisher we started smashing everything. So that last day of the tour was really the chrysalis of a new stage of development for us, a sort of ritual bloodletting followed by a sacrifice to what we are in the process of becoming, which I can't entirely explain right now because I don't fully understand it myself.

**You never actually fired Freddy?**
No. We didn't tell him he'd been fired and he didn't tell us he quit. I think he knew that he'd been sacrificed because the next day he just got on a plane and went home. I never got to say goodbye to him, and I haven't said a word to him since. He was very peaceful about it, and I respect him for that. So if he sues me now, I'll break his kneecaps.

# we're off to see the wizard

AS FAR AS I KNOW, THERE IS NOT ONE WORD IN THE
GOSPELS IN PRAISE OF INTELLIGENCE.
—*Bertrand Russell,*
*"Has Religion Made Useful Contributions to Civilization?"*

I had written, I had called, I had pleaded. Finally, I was granted an appointment. During a day off on the '94 Nine Inch Nails tour in San Francisco in October, the hotel phone rang.

"The doctor wants to meet you," came a woman's voice, stern and husky.

I asked her if the doctor would care to see our show the following night. I knew everything there was to know about the doctor but he knew very little about me.

"The doctor never leaves his house," she replied icily.

"Okay, when do you want me to come over? I'm in town for a few days."

"The doctor really wants to meet you," she replied. "Can you come between one and two tonight?"

No matter what time the doctor called for me and where he summoned me to, I planned to be there. I admired and respected him. We had a lot of things in common: We had experience as extravagant showmen, successfully placed curses on people, studied criminology and serial killers, found a kindred spirit in the writings of Nietzsche, and constructed a philosophy against repression and in support of nonconformity. In short, we had both dedicated the better part of our lives to toppling Christianity with the weight of its own hypocrisy, and as a result been used as scapegoats to justify Christianity's existence.

"Oh," the caller added before she hung up. "Make sure you come alone."

The doctor was the preferred name of Anton Szandor LaVey, founder and high priest of the Church of Satan. What nearly everybody in my life—from John Crowell to Ms. Price—had misunderstood about Satanism was that it is not about ritual sacrifices, digging up graves and worshipping the devil. The devil doesn't exist. Satanism is about worshipping yourself, because you are responsible for your own good and evil. Christianity's war against the devil has always been a fight against man's most natural instincts—for sex, for violence, for self-gratification—and a denial of man's membership in the animal kingdom. The idea of heaven is just Christianity's way of creating a hell on earth.

I'm not and have never been a spokesperson for Satanism. It's simply part of what I believe in, along with Dr. Seuss, Dr. Hook, Nietzsche and the Bible, which I also believe in. I just have my own interpretation.

That night in San Francisco, I didn't tell anybody where I was

going. I took a cab to LaVey's house on one of the city's main thoroughfares. He lived in an inconspicuous black building collared by a high, brutal-looking barbed wire fence. After paying the cab driver, I walked to the gate and noticed that there was no bell. As I contemplated turning back, the gate creaked open. I was as nervous as I was excited, because, unlike most experiences where you meet someone you idolize, I could already tell this one would not be a letdown.

I timidly entered the house and saw no one until I was halfway up the stairs. A fat man in a suit with a sweep of greasy black hair covering his bald spot stood at the top. Without saying a word, he motioned for me to follow him. In the times I visited LaVey since, the fat man has never introduced himself or spoke.

He brought me into a hallway and swung shut a heavy door, blotting out the light entirely. I couldn't even see the fat man to follow him anymore. Just as I felt myself panicking, he grabbed my arm and pulled me the rest of the way. As we followed the curve of the corridor, my hipbone collided with a doorknob, causing it to turn slightly. Angered, the fat man pulled me away. Whatever was behind there was off limits to guests.

He finally pulled open a door, and left me alone in a dimly lit study. Beside the door there was a lavishly detailed portrait of LaVey standing next to the lion he used to keep as a house pet. The opposite wall was covered with books—a mix of biographies of Hitler and Stalin, horror by Bram Stoker and Mary Shelley, philosophy by Nietzsche and Hegel and manuals on hypnosis and mind control. The majority of the space was taken up by an ornate couch, over which hung several macabre paintings that looked like they were taken from Rod Serling's *Night Gallery*. The oddest things about the room were the oversized playpen in the corner and the television set, which seemed out of place, a token of disposable consumerism in a world of contemplation and contempt.

To some people, this would all seem corny. To others, it would be terrifying. To me, it was exciting. Several years before I had read LaVey's biography by Blanche Barton and was impressed by how smart he seemed. (In retrospect, I think the book may have been slightly biased since the author is also the mother of one of his children.) All the power LaVey wielded he gained through fear—the public's fear of a word: *Satan*. By telling people he was a Satanist, LaVey became Satan in their eyes—which is not unlike my attitude toward becoming a rock star. "One hates what one fears," LaVey had written. "I have acquired power without conscious effort, by simply being." Those lines could have just as easily have been something I

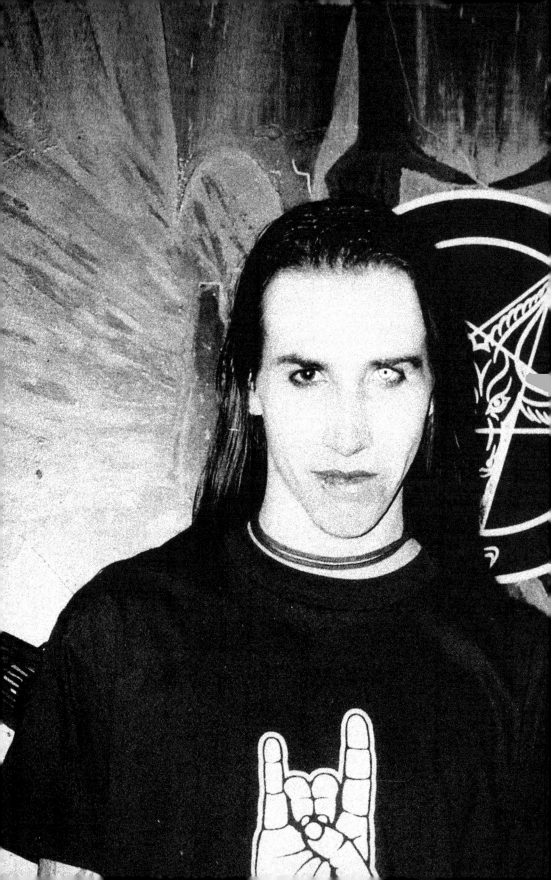

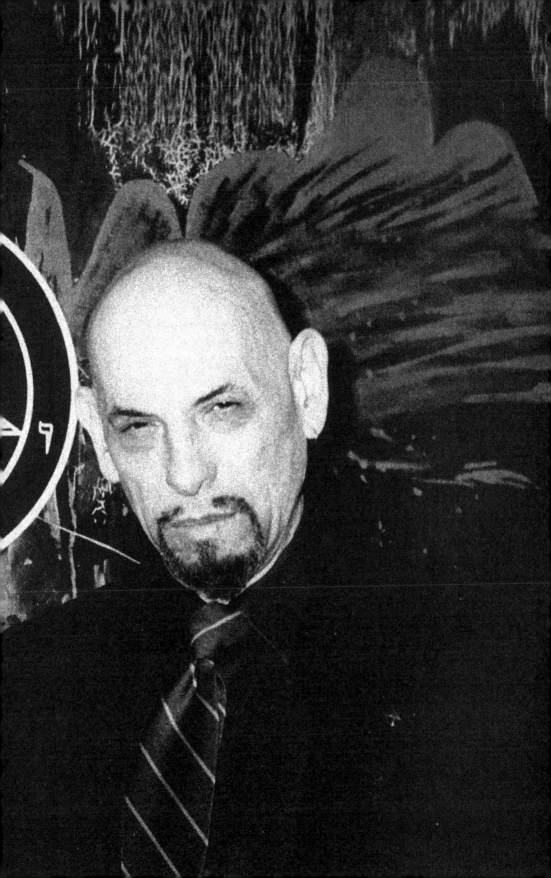

had written. As important, humor, which has no place in Christian dogma, is essential to Satanism as a valid reaction to a grotesque, misshapen world dominated by a race of cretins.

LaVey had been accused of being a Nazi and a racist, but his whole trip was elitism, which is the basic principle behind misanthropy. In a way, his kind of intellectual elitism (and mine) is actually politically correct because it doesn't judge people by race or creed but by the attainable, equal opportunity criterion of intelligence. The biggest sin in Satanism is not murder, nor is it kindness. It is stupidity. I had originally written LaVey not to talk about human nature but to ask if he'd play theremin on *Portrait of an American Family*, because I had heard he was the only registered union theremin musician in America. He never acknowledged the request directly.

After sitting in the room by myself for several minutes, a woman walked in. She had gaudy blue eyeliner, an unnatural coif of blow-dried bleach-blond hair, and pink lipstick smeared on like a kid drawing outside the lines in a coloring book. She wore a tight baby-blue cashmere sweater, a miniskirt and skin-toned hose with a forties garter belt and high heels. Following her was a small child, Xerxes Satan LaVey, who ran up to me and tried to remove my rings.

"I hope you're well," Blanche said stiffly and formally. "I'm Blanche, the woman you spoke to on the phone. Hail Satan."

I knew that I was supposed to respond with some kind of mannered phrase that ended with "hail Satan," but I couldn't bring myself to do so. It seemed too empty and ritualistic, like wearing a uniform in Christian school. Instead, I just looked at the boy and said, "He has his father's eyes," a line from *Rosemary's Baby* that I was all too sure she was familiar with.

As she left, no doubt disappointed by my manners, Blanche informed me, "The doctor will be out in a minute."

The formalities I had seen so far, combined with everything I knew about LaVey's past—as a circus animal trainer, magician's assistant, police photographer, burlesque hall pianist and all-around hustler—led me to expect a grand entrance. I was not disappointed.

LaVey didn't walk into the room—he appeared. All that was missing was the sound of an explosion and a puff of smoke. He wore a black sailor's cap, a tailored black suit and dark sunglasses, even though he was indoors at 2:30 A.M. He moved toward me, shook my hand and said right off the bat in his rasping voice, "I appreciate the name Marilyn Manson because it's about putting different extremes together, which is what Satanism is about. But I can't call you Marilyn. Can I call you Brian?"

"Sure, whatever you feel comfortable with," I replied.

"Because of my relationship with Marilyn in the sixties, I feel uncomfortable because she has a special place in my heart," LaVey said, closing his eyes gently as he spoke. He went on to talk about a sexual relationship he had with Monroe that began when he was the organist in a club where she was a stripper. In our conversation, he planted the seed that his association with her made her career flower. Taking credit for such things was part of LaVey's style, but he never did it arrogantly. It was always done naturally, as if it were a well-known fact.

He removed the sunglasses from his goateed gargoyle head, familiar to thousands of teen dabblers from the back cover of *The Satanic Bible,* and instantly we were enmeshed in an intense conversation. I had just met Traci Lords backstage after a show at the Universal Amphitheater in Los Angeles, and she had invited me to a party with her the next night. Nothing sexual happened, but it was an overwhelming experience because she was like a girl version of me—very bossy and constantly playing mind games. Since LaVey had a relationship with another sex symbol, I thought that maybe he could give me some advice on what to do about Traci, whom I was both confused and captivated by.

The advice that ensued was very cryptic, which was no doubt another way for him to maintain power. The less people understand you, the smarter they think you are. "I feel like you both belong together, and I think something very important is going to happen with your relationship," he concluded. It sounded more like the result of fifty dollars and five minutes spent calling the Psychic Friends Network than something I expected LaVey to say. But I pretended like I was grateful and impressed, because LaVey was not someone you could criticize.

## CIRCLE EIGHT · FRAUD · FLATTERERS

He continued by sharing sordid details about his sex life with Jayne Mansfield and said that after all this time he still felt responsible for her death in a car crash because he had put a curse on her manager and boyfriend, Sam Brody, after a dispute with him. Unfortunately for Jayne Mansfield, she happened to be with him that night in New Orleans when a mosquito-spray tanker crashed into his car, brutally killing them both. Although I was suspicious about some of LaVey's claims, his rhetoric and confidence were convincing. He had a mesmerizing voice, perhaps from his experience as a hypnotist.

The most valuable thing he did that day was to help me understand and come to terms with the deadness, hardness and apathy I was feeling about myself and the world around me, explaining that it was all necessary, a middle step in an evolution from an innocent child to an intelligent, powerful being capable of making a mark on the world.

One aspect of LaVey's carny personality was that he liked to align himself with stars like Jayne Mansfield, Sammy Davis Jr., and Tina Louise of *Gilligan's Island,* who were all members of the Church of Satan. So it wasn't surprising that as I left he encouraged me to bring Traci to visit him.

The next day, Traci happened to be flying in from Los Angeles for our show in Oakland. I was badly bruised and banged up after the concert, so she came back to the hotel, where she bathed and mothered me. But, once again, I didn't sleep with her because I was still determined to remain faithful to Missi, though Traci was the first person I had met who seemed capable of melting my resolve. I told her about my meeting with LaVey, and she gave me the whole Deepak Chopra, *Celestine Prophecy,* healing crystal, New Age rap about destiny, resurrection and the afterlife. She didn't seem to understand what he was about, so I tried to clue her in as I sunk into restless sleep: "This guy's got an interesting point of view. You should listen to him."

When I brought her to his house the next day, she was a lot more cynical and self-righteous than I had been—at first. She walked in with the attitude that he was a hoax and full of shit, so she debated him whenever she disagreed even slightly with something. But when he said that a louse has more right to live than a human or that natural disasters are good for humanity or that the concept of equality is horseshit, he was prepared to back it up intelligently. She left the house in silence with dozens of new ideas swirling in her head.

On that visit, LaVey showed me a little more of the house—the bathroom, which was strewn with real or fake cobwebs, and the kitchen, which was infested with snakes, vintage electronic instruments and coffee mugs with pentagrams on them. Like any good showman, LaVey only let you know what he was about in small pieces and revelations, and the more information he gave you the more you realized how little you really knew about him. Near the end of our visit, he said, "I want to make you a Reverend," and gave me a crimson card certifying me as a minister in the Church of Satan. Little did I know that accepting that card would be one of the most controversial things I had done to that point; it seemed then (and it still does) that my ordainment was simply a gesture of respect. It was like an honorary degree from a university.

It was also LaVey's way of passing down the torch, because he was semiretired and tired of spending so many years advancing the same argument. No mainstream rock musician has advocated Satanism in any lucid, intelligent, accessible way since perhaps the Rolling Stones, who in "Monkey Man" came up with a line that could have been my credo, "Well I hope we're not too messianic/Or a trifle too satanic." As I left, LaVey put a bony hand on my shoulder, and, as it lay there coldly, he said, "You're gonna make a big dent. You're going to make an impression on the world."

LaVey's prophecies and predictions soon came true. Something important happened in my relationship with Traci, and I began making a bigger dent in the world.

The day I became a Satanist also happened to be the day the allied forces of Christianity and conservatism began mobilizing against me. Just after our meeting, I was told that the Delta Center, where we were to play in Salt Lake City, would not allow us on the bill with Nine Inch Nails. We were offered, for the first but not the last time, money not to play—in this case, $10,000. Although we were removed from the bill, Trent Reznor brought me out as a guest, and I condensed my entire set to a single gesture, repeating "He loves me, he loves me not" as I tore pages out of the Book of Mormon.

Ever since mankind created its first laws and codes of communal conduct, those who would break them have had one simple avoidance technique at their disposal: running. And that's what we did after the show, fleeing to the tour bus and escaping a night of lockdown in the Salt Lake City penitentiary. We never got our $10,000, but the statement seemed more valuable than the money.

We had made a similar escape earlier in the tour in one of Florida's most conservative cities, Jacksonville, where the Baptists who ran the town had threatened to arrest me after the concert. But when we returned to perform in Jacksonville for our first headlining dates after the Nine Inch Nails tour, I wasn't so lucky.

Beneath my pants I wore my black rubber underwear with the dick hole, which by now had accrued its fair share of blood, spit and semen stains. As usual, halfway through the show I stripped down to the underwear, doused myself with water and convulsed violently, whipping my hair and body back and forth and sending droplets of water flying across the stage. No unseemly body part was ever exposed because my dick was tucked safely inside its rubber casing. But the vice squad, stationed at each exit of Club Five, saw what it wanted to see, which was me jacking off with a strap-on dildo (which I didn't even have) and urinating on the crowd.

Near the end of our shows I used to smear my face with red lipstick and, if there were girls near the front of the stage I wanted to meet, I'd grab them and make out with them, leaving on their faces the mark of the beast, which served as an entrance ticket to the hell that was and always will be backstage.

After the performance, I walked offstage and up the stairs leading to the dressing room. Running after me, however, was Frankie, our tour manager. He was either a drug abuser or an ex-abuser, depending on who you happened to be talking to. He looked like Vince Neil from Mötley Crüe, only with big dark circles under his eyes.

"The cops are here," he blurted in a panic. "And they're coming to arrest you!"

I ran upstairs and made a futile attempt to look respectable, which meant taking off my rubber underwear and putting on a pair of jeans and a long-sleeved black T-shirt. There was a commotion in the hall, and two undercover policemen burst in and yelled, "You're under arrest in violation of the Adult Entertainment Code," a phrase that sounded like "a tart in a tan mint coat" over the disco music the club was now blaring. They handcuffed me behind my back, escorted me out of the club and sped me to the police station. I wasn't worried because they didn't seem to have a grudge or any malevolent feelings toward me. They were just doing their job. But all that changed when we arrived at the police station, and I was introduced to several burly rednecks in police uniforms who looked like they wanted to do more than just their job.

One in particular, with a thick black mustache, a stocky build and a cap that said FIRST BAPTIST CHURCH OF JACKSONVILLE, seemed to have it in for me. He and his cop friends made numerous ignorant jokes at my expense, and then posed with me for Polaroid photographs, probably so they could show their wives the monkey they had played with at work. It was a slow night, and I was clearly the entertainment.

Still I had no complaints. After all, I am an entertainer. But then in walked a black colossus, possibly the biggest person I had ever seen in my life. His hands seemed to cast a shadow over my entire body and each vein bulging in his neck was probably as thick as my own neck. He shoved me into a small cell with a mysterious stainless steel contraption that was supposed to be a combination toilet, sink and drinking fountain. As I was trying to figure out which part was the toilet and which was the sink, the colossus ordered me to wash the makeup off my face. All I had was water and a paper towel, which were useless. After watching me struggle, he opened

the door and boomed, "Use this," throwing a plastic container of pink floor cleaner at me.

With my face scrubbed raw and pink, I sat in the cell dejected and abandoned, waiting for help from the outside world. The colossus returned, slamming the door behind him. "All right," he ordered in a drill sergeant voice that rattled the room. "You're going to have to take off all your clothes."

No matter how much of an exhibitionist you are, when you stand naked before someone several times your size with the power to do anything they want to you and get away with it, you suddenly learn to appreciate rayon, cotton, polyester and all the wonderful fabrics that protect your body from direct physical contact. Slowly, thoroughly and with the constant threat of violence in his oafish, callused hands, he searched me up, down and inside.

When he left, a quarrel broke out on the other side of my cell door. The colossus was arguing with two other officers. In my mind, I tried to work out what they were debating because I knew the outcome of their argument would determine my fate in jail. I finally decided that either someone wanted to release me on grounds of lack of evidence or someone wanted to be my new boyfriend.

Fig. 313. TALISMAN FOR DELIVERANCE
FROM PRISON

The argument died down and the colossus returned and asked as curtly as possible, though I could tell he actually felt embarrassed, "Where's the dildo?" Before I could keep my smart-ass instincts in check, I asked coquettishly, "What do you want a dildo for?" And that was when all hell broke loose.

His face turned as red as if it had been scalded with an iron, his chest expanded like the Incredible Hulk's, and he threw my naked, pale, trembling body against the wall. The other cop, the Baptist shit-kicker, pressed his face against mine and, puffing hot pig breath down my throat, interrogated me. We had a confrontation as long as the concert over the existence of the dildo I had supposedly committed lewd and obscene acts with. After a while, they seemed to relent, and once more started arguing amongst themselves, trying to figure out if they had made a mistake.

When they finished, the colossus ordered me to get dressed and threw me into a holding tank with half a dozen people who wouldn't even sit on the same bench as me because my appearance frightened them. My only companion was a guy with the face and mental capacity of an eight-year-old boy and the body of a fat, lonely child molester. He looked like how I imagined Lenny in *Of Mice and Men*. He told me that his mom, whom he still lived with, had turned him in for forging a check in her name. I wanted to ask him if he was apprehended passing the check at Dunkin' Donuts, but this time restraint and good sense got the better of me. Our conversation reminded me of when I first met Pogo, because Lenny started sharing handy, time-saving tips on the disposal of dead bodies. The only difference was that this guy had actually killed someone, and his method of disposing of her was the same one Pogo and I had dreamed up for Nancy: fire.

For the ensuing nine hours, Lenny courted and wooed me, regularly interrupted by the cops, who kept marching me through the station to show off their prize catch. After the eighth parade of the night, they didn't return me to the holding cell. Instead, they said I was being transferred to general population. On the way, they handed me over to a nurse, who gave me a psychological test. Any smart psycho knows how to deal with a test like this: There are normal person answers, there are crazy person answers and there are trick questions in which they try to trap crazy people to see if they're just pretending to be normal. I looked over the questions— "How do you feel about authority?" "Do you believe in God?" "Is it okay to hurt someone if they hurt you first?"—and gave them the answers they wanted, thus avoiding a short vacation in the psychiatric ward.

 **CIRCLE EIGHT - FRAUD - FALSIFIERS OF METAL, PERSONS, COINS, WORDS**

Having been deemed a normal, I was brought to a doctor for a physical. The first thing he did was bring out a pair of pliers. "You're going to have to take that out," he said, gesturing to my lip ring.

"It doesn't really come out."

"If we don't take it out, someone will rip it out for you when you get beat up in general population," he said in measured tones, the corners of his mouth creeping upward in a sadistic smile he could barely restrain.

They cut off the lipring and led me into a corridor. There were two routes to general population: One was past a herd of huge ox-men working out with weights and looking for someone with long hair to sodomize. The other was past the flotsam of society—drunks, vagrants and junkies. For some reason, the cops leading me broke their unspoken code of sadism and sent me down the easy path. Nobody tried to fuck with me and, relieved, I fell asleep instantly.

I was awoken an indeterminable amount of time later to find a plate of wilted lettuce sprinkled with watered-down vinegar, a piece of stale bread, and, for dessert, the news that someone had posted bail for me. I was told that I had been in prison for sixteen hours. The worst part about it was that my manager had posted bail the minute I was imprisoned. But that kind of information travels slowly when you're someone the police hate. Normally, the shittiness of an event like this would be offset by the free publicity afterward, something we desperately needed at the time. But it never made the papers because, as a precaution, the judge made a deal with my lawyers that if I talked to the press or publicized the incident, they would come down harder on me. Since the police had no evidence, the charges were eventually dropped anyway.

When I next met with LaVey a year and a half later on our *Antichrist Superstar* tour in 1996, we had a lot to discuss. I had seen the enemies I was up against, and not only were they capable of stopping shows and making unreasonable demands on our performances, but they were capable of, for no reason at all, taking away the one thing LaVey and I both stand for: personal freedom. Like LaVey, I had also discovered what happens when you say something powerful that makes people think. They become afraid of you, and they neutralize your message by giving you a label that is not open to interpretation—as a fascist, a devil worshipper or an advocate of rape and violence.

On this visit to LaVey's house, I brought Twiggy with me. We were allowed to enter one of the only rooms in his thirteen-chamber house I hadn't been in. It was behind the door his fat steward had

jerked me away from when I first visited the house. The room was a private museum of arcana. The entrance was a giant Egyptian sarcophagus that had been propped up against the doorway. There was a rocking chair that had supposedly belonged to Rasputin, Aleister Crowley's pipe, a satanic altar with a giant pentagram above it, and a couch lined with the fur of some endangered species. We sat at an old wooden dining table (probably something Aleister Crowley used to snort heroin off of) and ate steak.

We spoke of religion, and how much of it is just a custom preserving practical codes of health, morality and justice that are no longer necessary for group survival (like not eating animals with cloven hooves). It makes a lot more sense to follow *The Satanic Bible,* written with twentieth-century humanity in mind, than a book that was written as a companion to a culture long since defunct. Who's to say that a hundred years from now some idiot isn't going to find a Marilyn Manson T-shirt—or a Collapsing Lungs baseball cap for that matter—nail it to a wall and decide to pray to it.

As we discussed this, every ten minutes LaVey would leave the room. I had the feeling then that he was watching us through the eyes of one of his oil paintings, so I consciously kept quiet when he wasn't around.

We also discussed Traci Lords because LaVey asked me what had happened with her. I told him that she had blown me off and his optimistic prediction about our relationship was wrong. But after our show the next day, I found out she had been trying to hunt me down all along. Since by then I had a top-ten album and had been on the cover of *Rolling Stone*, our relationship had flipped on its axis, as LaVey said it would. When I first met Traci the fact that she was a star made her seem distant and unattainable. It crushed me, which made me stronger, filling me with the desire—the need—to become more of a fucking rock star. Now I had become one. This time around I was in charge, and I didn't give a shit because I only wanted her when I couldn't have her.

A few days after Halloween the following year, I got a call at four A.M. telling me that LaVey had died. I was surprised by how sad I felt, because he had actually become a father figure to me and I never got the chance to say good-bye to him or even to thank him for his inspiration. But at the same time I knew that even though the world had lost a great philosopher, Hell had gained a new leader.

# 12

## *abuse, parts one and two*

**I FIND TERRIBLE THE NOTION THAT OTHERS CAN DO TO ME
WHAT I DO TO THEM.**
*— Duran Duran, Barbarella*

### ABUSE: GIVEN

One hundred and ninety-four pounds of abused flesh, atrophied muscle and hard bone, Tony Wiggins was a vacuum cleaner for sin. His blue eyes shone with the light of a perpetual party and his cyanotic lips curled and uncurled in threatening invitation. Only his redneck charm, emanating from a blond ponytail and Colonel Sanders goatee, hinted at any semblance of manners, decency or morality. No matter where he was at what hour—the smaller the town and the more unlikely the circumstance the better—Tony Wiggins managed to suck the filth, corruption and decadence off the streets and bring it back to us.

We met Tony Wiggins at the right time, when we were weak and vulnerable. That first year on the road had taken its toll, not just on our health and sanity but on our friendships and relationships. In the meantime, all our singles had failed, our music wasn't on the radio and nobody knew us except for a small cult of Nine Inch Nails fans and a few stray freaks. We had a new drummer, Ginger Fish, and were ready to go back into the studio, give it another shot and, if our next singles flopped, see if Collapsing Lungs needed any backup singers. We didn't want to be an underground band all our lives. We knew we were better than that.

But, just as we were preparing to record new songs in New Orleans, we were invited to join Danzig's Spring 1995 tour as an opening act. It was an invitation we couldn't refuse because the record label considered it a big break and an excellent opportunity to promote *Portrait of an American Family,* an album that, as far as we were concerned, was dead. So we began the Danzig tour reluctant, resentful and pissed off. The fact that during our warm-up show in Nevada some girl fed me crystal meth (telling me it was coke) didn't help any. I vomited through the entire show and couldn't sleep on the daylong bus ride to our first show with Danzig in San Francisco.

I walked onstage that first night wearing a hospital smock from a mental ward, a black jock strap and boots. My eyes were red and bleary from three sleepless nights. Right away, I felt something cold and hard hit my face. I thought it was the microphone, but it clattered to the floor and smashed, sending shards of glass splintering into my leg. It was a bottle from the audience. By our second song, there were bottles and refuse all over the stage and a muscled, tattooed fraternity reject in the front row was challenging me to a fight. I was so enraged at this point that I grabbed a beer bottle off the stage, smashed it on the drum kit and stopped the song. "If you want to fight me, come up onstage, you pussy," I screamed. Then I took the jagged half-bottle and plunged it into the side of my chest, dragging it across my skin until it reached the other side and creating one of the deepest and biggest scars on the latticework that is my torso.

Gushing blood, I dove into the crowd and landed on frathead. When security threw me back onstage, I was completely naked and nearly everyone in the front rows was stained with blood. I grabbed the microphone stand and sent it hurtling through Ginger's bass drum, destroying it. He looked up at me, angry and confused—it was only his second concert with us since replacing Freddy the Wheel— but quickly caught on, punching through his snare. Twiggy raised his bass over his head and brought it splintering down onto the monitor.

Daisy raised his ax and dropped it on his foot. We destroyed everything on stage short of each other.

As we walked off after our fourteen-minute show, we passed Glenn Danzig, who is at most half of my height (though with ten times the muscle mass). I smiled wickedly at him, as if to say, "You asked for us, and now you're going to pay for it."

We didn't want to be onstage playing music. So every night we didn't. The shows continued to be short exercises in brutality and nihilism, and the road map across my chest began to expand with scars, bruises and welts. We had all become wretched, exhausted, empty containers—*Westworld* automatons gone berserk. But just when even our own violence was beginning to bore us and I was deep in the cavity of misery because Missi had called and said she wanted to end our relationship—the first relationship that meant anything to me—because I was never around, we met Tony Wiggins.

He emerged off Danzig's tour bus in black jeans, a black T-shirt and a pair of slick black wraparound sunglasses. He looked like the kind of guy who would pummel you mercilessly and then apologize afterward. I complimented him on his sunglasses. He tore them off his head and, without even hesitating, said, "Here, they're yours."

From that day on, we weren't on tour with Danzig anymore. We were on tour with Tony Wiggins, their bus driver. Every morning he knocked on our bus or hotel room door and woke us up with a bottle of Jagermeister and a handful of drugs. When his hair was in a ponytail, which was rarely, it meant that he was doing his job and driving Danzig's bus. When his hair was down, he was tending to us, making sure our self-destruction wasn't limited to the stage. One night at a cheap, decrepit motel in Norfolk, Virginia, he burst into the room, carved up a couple lines right onto the dust and roach-powder-covered floor and snorted them. "Get on my back," he ordered. Twiggy grabbed a bottle of Jack Daniel's off the floor and complied. I ignored them because I was busy writing the lyrics to a song called "The Beautiful People." They ambled out the door, a drunk, double-assed beast that would hereafter be referred to as "Twiggins," and headed toward the outside stairwell. Suddenly there was a clattering and a string of obscenities. At the bottom of the stairs, I found Twiggy face down in a puddle of rainwater and blood. We rushed him to the emergency room, but we looked so demented—dripping makeup, rainwater and blood—that we were ignored. Instead of complaining, Wiggins just grabbed a metal doctor's tray and cut up several more lines. That was how nights with Wiggins usually ended. He would stir things up and wouldn't leave them alone until someone was dead,

in the hospital or passed out in their own vomit. If that someone wasn't himself, he wouldn't stop partying until it was.

Eventually Wiggins, Twiggy and I realized there were ways we could make the best of our situation and try educating ourselves and accumulating valuable knowledge while on the road. We began conducting various psychological experiments, like walking up to a couple and giving only the girl a backstage pass to test their relationship.

## CIRCLE EIGHT - FRAUD - SOWERS OF SCANDAL AND SCHISM

Gradually, the tenor of the tour began to change from miserable to memorable. On tour with Nine Inch Nails and Jim Rose, I had refrained from some of the stupider human tricks they indulged in, but now I didn't care anymore. As we sat atop a twenty-foot-high steel tower outside a club called Sloss Furnaces in Biloxi, Mississippi, warming up for a show with Jagermeister and drugs, Wiggins, Twiggy and I swore to stop exploiting and humiliating girls backstage. Instead, we decided to perform a therapeutic service for them. To carry out our new plans, all we needed was a video camera and some girls willing to confess their deepest, most intimate sins. Little did we know just how dark and disturbing the lives of our fans really were.

While we performed that night, Wiggins did the prep work. Underneath the club, he found a network of dark catacombs with metal grates, dripping water and the general atmosphere of a set from *A Nightmare on Elm Street*. I raced to meet him there after the show, not only because I was excited but also because I needed to hide from the cops, who wanted to arrest me for indecent exposure. As our tour manager detained them, Wiggins took us to the catacombs, where he had two prospective patients waiting. We didn't know whether our plan to extract confessions would really work, and at the time didn't really understand what it meant to actually be burdened with the weight of someone's darkest secrets. People don't necessarily confide in one another to get something off their chest. They want something: reassurance, which is a hard gift to give convincingly.

Under a relentless and probing fusillade of questions from Wiggins, the first girl broke down and disclosed that when she was eleven, several boys in the neighborhood would regularly pick on her. One night she awoke to find her window open and four of them standing in her room. Without a word, they pulled down her bedsheets, tore off her pajamas and raped her one by one. When she told

her father the next day, he was indifferent. Within a year, he was sexually molesting her as well. As she told us this, she was kneeling on the floor, staring at the damp ground. When she finished, she looked up at me expectantly with wet eyes, the tracks of her tears tattooed by runny black mascara. I was supposed to do something, to say something, to help her somehow. With my music and in interviews, I never had any problem telling people about the lives they should be leading and the independence they should demand. But that was when I was talking to an aggregate, a mass, an undifferentiated group of people. Now that I was one-on-one and actually had the opportunity to change someone's life, I froze momentarily. Then I told her that the fact that she was here and could talk about it proved she was strong enough to live through it and accept it.

I wonder still whether anything I went on to say meant anything to her, or if they were just the same clichés she had heard all her life. She told me that she wanted to trade clothes with me and took off her T-shirt, which was emblazoned with Nietzsche's "God Is Dead" slogan followed by God's response, "Nietzsche Is Dead." I still take that shirt with me everywhere I go.

The first story was so harrowing that I still can't remember what the second girl confessed to. All I remember was that she was a beautiful blond girl with the word *failure* carved into her arm.

With each show, Wiggins refined his inquisition methodology. His art was brutal and sophisticated, and, some in the field of psychoanalysis may say, unethical. He arrived at a point so advanced that in order to proceed with his work, he had to invent his own investigative apparatus. He unveiled it after a show in Indiana.

Backstage after Danzig's set, we discovered our crew videotaping a tiny but full-bodied girl with white hair and pale skin. A boy who seemed to be her brother or boyfriend, about nineteen and skinny and effeminate with red hair in a bowl cut, a light smattering of freckles and a discolored bruise around his cheekbone, stood on the side, anxiously picking at an unlit cigarette in his hands. The smell of fresh shaving cream was in the air, and they had coaxed the girl into shaving herself and committing other unspeakable acts. It seemed like the kind of traditional exploitation that Wiggins and I were trying to avoid.

As soon as they saw me, the girl and the boy dropped to their knees. "The gods have answered our prayers," she cried.

"I just wanted to meet you," he told me. "That's why we're here." So, naturally, Wiggins and I asked them if they had anything to confess, besides the atrocities the girl had just taken part in with our road

crew. Instantly, the girl looked over at the boy, and he bowed his head in shame or sadness. We knew we had found the perfect person to test out Tony's new invention.

Wiggins asked the boy if he minded being tied up and restrained, then brought him into the back room of the dressing area, requesting several minutes to set up. When I walked in, he was hog-tied with his hands behind his back in an apparatus that forced him to keep his legs spread at a ninety degree angle and his hands behind his back. The device was intended for women, but it looked even more disturbing to see a naked guy spread-eagled there. If he moved any limb from that position, the rope around his neck would tighten and begin to choke him. In order to keep from strangling himself, he had to work to keep himself in this awkward, vulnerable position. Tony stood over him with a video camera, capturing his struggle from every angle.

"Is there anything you'd like to confess?" Wiggins began in a genteel Southern accent with an undercurrent of menace. Outside the door, Metallica's "Master of Puppets" provided a soundtrack to our mock-priestly endeavor.

He hesitated, and tried to squirm into a comfortable position, which was impossible. With a free hand, Tony lifted his chin up towards the video camera, and he started talking. "My sister and I, we ran away from home like two years ago. So to . . . " His words shortened and fragmented as he struggled with the ropes.

"Is that your sister out there?" Wiggins asked. He never let anyone get away with vagueness.

"No. Just a friend. She begs in the street with me."

"Why did you run away?"

"Abuse, really. Just abuse. Our stepfather, mostly. So, anyway, we needed to get money for tickets. To see the concert. And for some other things. So we hitched a ride out to a sort of rest station–truck stop. I wanted to sell her. Her body."

"What was she wearing?" Wiggins's inquiring mind wanted to know.

"Just high heel shoes we had found. A tube top. Jeans. Some makeup we stole. But it wasn't for sex. Just blow jobs."

"Was that the first time you pimped her?"

"Sort of."

"Yes or no?" Wiggins was a master.

"For money, yes."

"Then what happened?"

"This trucker." The boy began crying, and his face turned crimson

from a combination of emotion and the fact that the rope was tightening around his neck. He flexed his freckled thighs to keep from choking. "This trucker, he took her inside. His truck. And I heard her yelling, so I climbed up. To the window. But before I could . . . " He gagged for a moment, then regained his equilibrium. "He hit me. He hit me. And." He was crying, and his legs were trembling. "And I don't know where she is . . . "

"You mean he drove away with her?" Wiggins asked incredulously. He wasn't even paying attention to the camera anymore. I'd never seen him surprised by anything before and I haven't since. We both knew we were in over our heads and we were scared the boy wouldn't be able to hold his own against the ropes.

Suddenly, the music outside the door stopped and we heard several voices barking out orders. I opened the door a crack and spied into the dressing room, where two cops were looking through our make-up bags and examining the driver's licenses of several girls there. I closed the door, locked it and looked around in a panic. I had drugs in my pocket, a naked runaway tied up in a bondage apparatus and a video camera documenting the whole thing as evidence. We quickly untied him, and he rolled onto his side, curling into a fetal position. As he caught his breath and reoriented himself, we quietly and awkwardly put him into the rest of his clothes. I listened at the door. People were laughing again, a sure sign that the police had left. Through some stroke of luck, they didn't know there was a back room. They were looking for the daughter of some prominent local politician. The boy seemed to want our help but, since the police were still in the club, we urged our new friend to find them and tell them his story, which continues to haunt me.

Compared to a lot of my fans, I've had an easy life. One person who helped me realize this was Zepp, who we met at an earlier show in Philadelphia. As we were walking to our bus after the show, a short, stocky long-haired guy with a square jaw and an Anton LaVey beard beckoned to us from outside the parking lot, promising to give us a canister of nitrous oxide if we signed something for him. Since I'd never inhaled laughing gas before, I agreed. He introduced himself as Zepp, after an old, regrettable Led Zeppelin tattoo on his right shoulder. At our next dozen or so shows, Zepp showed up backstage afterward toting nitrous oxide or pizza or photographs of teenage girls. Eventually, we decided that since he was with us so much, he might as well work for us. I gave him a video camera, paid him and he began touring with us. I knew he would fit in the day I opened the door to

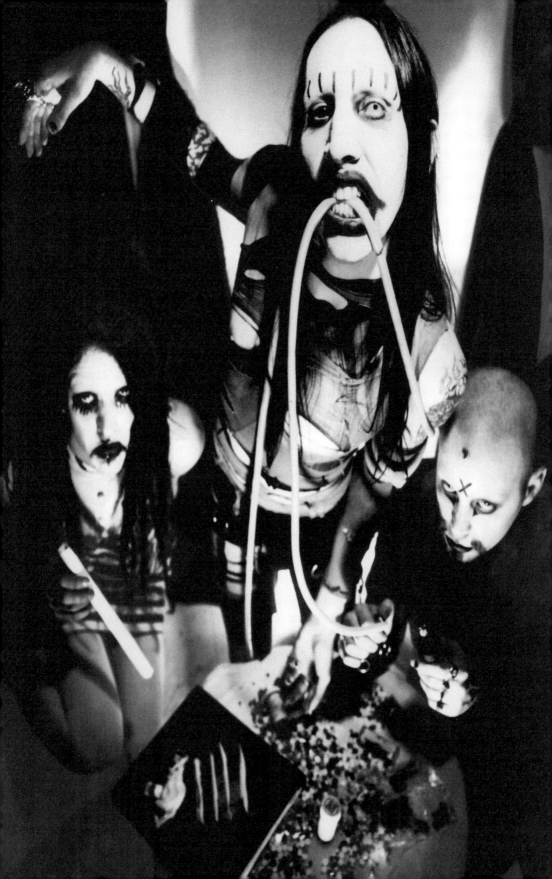

the rear lounge of the tour bus and found him filming Twiggy and Pogo, who were having sex with a plastic blow-up doll I had bought as a joke. Pogo had his dick up its ass, Twiggy had his dick in its mouth, and I forgot to check to see whether Zepp had his dick in his hand.

Gradually, we learned that Zepp wasn't just a regular guy from Pennsylvania. He claimed to have fucked three hundred girls in his hometown, and one day we opened up the luggage bay of the bus to find him in there on top of girl number 301. He used to inject speed with his aunt, and told us some exotic stories about how at the height of their insane addiction they would shoot up sludge from a mud puddle or whiskey. It was a small miracle he was still alive, and a fortunate one, too, since it was Zepp who introduced us to the slashers, two girls who followed us around the country. They reminded me of the Charles Manson girls from 1969, because they both looked like classic, suburban, all-American teenagers with something gone slightly wrong. In this case, it was the fact that one, an innocent-looking, flush-faced girl with white eyebrows named Jeanette, liked to carve the word *Marilyn* into her chest before each show and the other, a quiet girl with long brown hair and half a dozen lip rings named Alison, liked to carve the word *Manson* into her chest, with the *S* cut in backwards. At nearly every show since, I've seen them singing along in front with fresh self-inflicted wounds dripping blood down the front of their dresses or tank tops.

Between Zepp, Tony Wiggins and my own encroaching madness, the tour became one of the most chaotic, turbulent and decadent periods of my life. One of the most unsettling incidents took place after a show in Boston. I was in the dressing room drinking Jack Daniel's with the rest of the band when Wiggins motioned to me through the door.

"I've got someone who wants to tell you something," he whispered slyly.

He walked me to an out-of-the-way room where a girl in white underpants, a white bra and pink socks was waiting for me, bound and trussed in Wiggins's sin-sucking device. She would have been attractive, but all over her body, particularly on the back of her neck and the backs of her legs, there were red splotches with raised islands of pale white flesh in the middle. It was an uncomfortable sight because, before she even confessed a word, I already felt sorry for her. Despite myself, I was also somewhat turned on because she looked like a beauty who had been mauled by a beast. And few things are more of a turn-on than beauty disfigured. Stranger still,

she looked familiar, as if I had seen her somewhere before.

"What happened to you?" I asked. It was my turn to be inter-rogator.

"I have a skin disease. Nothing contagious."

"Is that what you have to confess?"

"No," she said, pausing to gather strength for what she was about to say. "What I have to confess has something to do with you."

"Fantasies don't count."

"No. It's from when I met you in person. A year ago. When you were on tour with Nine Inch Nails." She stopped and struggled with the apparatus. She was puny and weak.

"Go ahead," I said, knowing that if I had done anything unspeak-able to her I definitely would have remembered those splotches.

"I was backstage and you said hi to me. I was the girl that went back to the hotel with Trent that night."

"Okay, I remember," I said, and I did.

"What happened was that I was going out with someone at the

TONY WIGGINS

time, and he was angry at me because I wanted to go backstage and sleep with Trent. But I did it anyway."

"So he broke up with you?"

"Yes. But that's not what I . . . what I'm trying to say. The next day, my stomach started to ache and I started to have all these pains. I went to the doctor and he told me that I was several months pregnant. But," and she broke down in tears, "I would never have the baby. I had miscarried from having sex."

I don't know if I believed what she said, but she seemed to. Her last word, "sex," escaped from her throat like a dart out of a blow-gun. She had become so overwhelmed by the memory that she released the pressure on her hands and legs and allowed Wiggins's contraption to snap tightly around her neck. Her head hit the floor, unconscious. Still shocked by her confession, I bent down in a daze and began fumbling with the knots and rope, unable to do a thing as her face swelled from red to purple. Wiggins pulled an army knife out of his pocket and sliced through the cord trailing from her neck, releasing the tension. But she didn't wake up. We slapped her, screamed at her, dumped water on her. Nothing worked. This was bad. I didn't want to be the first rock-and-roller to have actually killed a girl due to backstage hedonism.

After three minutes, she groaned and blinked her eyes open. That was probably the last time she ever wanted to go backstage again.

\* \* \*

## ABUSE: RECEIVED

When we returned to New Orleans to start recording after the tour, we thought life would return to normal. But just as Wiggins had shown us the true meaning of indulgence, a word we only thought we understood up till then, New Orleans taught us about hate, depression and frustration. People like to think of hate and misanthropy as protective shells built up against the world. But in my case, they came not from a hardness but from an emptiness, from the fact that my humanity was draining away like the blood from all the wounds I had inflicted on myself. In order to feel anything—pleasure or pain—I had to chase after experiences that were more than normal and more than human. New Orleans, where the only thing to do was laugh about how depressing it was, had to be the worst possible place to search for meaning and humanity. It was like trying to find warmth in a hooker's embrace. If touring had extinguished what little was left of my morality, New Orleans devoured my soul.

The longer you stayed in New Orleans, the uglier you became. And the people we hung out with were the ugliest. They were drug dealers, cripples and scumbags. The only attractive people in the city were either coming from the airport or on their way there. Our stomping grounds were dives like the Vault, a Gothic industrial bar the size of a hotel room. The floor was covered with a slime of congealed urine, beer and general condensation from the humid, fetid climate of the city. Solely used for the ingestion of class one substances, the bathrooms didn't even have toilets. We spent many nights at the club sniffing drugs with the disc jockey and convincing him to play Iron Maiden's *Number of the Beast* in its entirety so we could watch the Goth kids try to dance to it. At dawn, we would return to our apartment, a miserable two-room flat in a shitty neighborhood where two cops had recently been shot in the face. We all slept in the same squalid room, inhaling the stench of dirty clothes and fending off bugs and rats. When it all got to be too much, we hired a Guatemalan cleaning lady, who cleared away the debris for ten dollars an hour.

Everybody treated us like shit in New Orleans, and we despised them all and in turn treated them like shit. One girl kept hounding after us trying to interview us for her fanzine, and one night I broke down, took her minicassette recorder and brought it around the room, asking people what they thought of Iron Maiden. Then I pissed into the microphone and threw it at her. More and more, our nights were becoming long strings of nihilistic acts.

Another girl who stalked us was someone Trent had introduced me to while we were on tour with him. She was known as Big Darla, and she lived up to the name. She belonged to the class of vampires who hover around me in bars, waiting to make eye contact so they can come over and suck the life out of me. On our first night in New Orleans, she came to the door wearing an old, obscure Marilyn Manson T-shirt with a box of New Orleans delicacies that looked like flattened cow turds topped with olives, mustard and cat urine. Throughout the rest of our stay in New Orleans, she and her sandwiches followed us everywhere, a constant annoyance.

On Trent Reznor's birthday, we were walking along the banks of the Mississippi River trying to figure out what to get for him, because he has everything and usually tosses gifts in a corner and never looks at them again, when I spotted a panhandler with one leg and hit upon the idea of obtaining his prosthetic limb as a present. As I was trying to convince him to part with it, a cute, scrawny girl passed by, and I started talking to her. I asked if she knew the music of Nine Inch

Nails, and she said she did. Then she showed me a cut she had on her arm, as if I would be able to relate.

"It's Trent Reznor's birthday today," I told her. "Do you want to come and like create some kind of funny surprise?"

She looked like she was ten, though she had to be much older. It turned out she was a stripper, and I thought about fucking her when we brought her back to the apartment to get changed for dinner. But she started talking about crack and alluding to prostitution, and scared me away. So we took her to Brennan's, one of the most expensive restaurants in the city. Trent assumed she was my date, and we didn't say a word about his birthday. After dinner, as Trent was talking, she nonchalantly climbed on the table, taking off all her clothes and outraging (yet titillating) the rich patrons of this high-class restaurant. She looked like Brooke Shields in *Pretty Baby*, and she succeeded in embarrassing everyone because she made us look like a ring of child pornographers. That got the shenanigans rolling, and we got drunk, we got high, and we talked to people we would never normally talk to unless we were drunk and high. As a fitting finale to a fucked-up night, we returned home and pushed open the doors only to find ourselves confronted with the broad, naked expanse of Big Darla's back. Smashed underneath her were two skinny legs sticking out feetfirst toward the door. They were Scott's, and she seemed to be more embarrassed at being caught in the act than he was. Like high-school kids who have just caught a classmate masturbating in the bathroom, Trent and I bonded over the spectacle, adding the memory to our growing list of inside jokes—though Trent was reluctant to make fun of either Scott or Big Darla because he had a soft spot for both of them, for whatever reason.

In the studio, life wasn't any less bizarre. The chaos of the Tony Wiggins tour and the corruption of New Orleans had sent us on a writing binge, and Twiggy and I churned out thirteen songs, working so closely and so in synch that we didn't even have to talk to each other to communicate ideas. When we put all the songs together on a demo tape, we saw that we had created one giant metaphor for our past, our present and our future. It was about a dark, twisted, vitiated creature's evolution from a childhood spent living in fear to an adulthood spent sowing fear, from a weakling to a megalomaniac, from a shit-eater to a shit-kicker, from a worm to a world-destroyer. We had a vision, we had a concept and, even if no one else believed in the music, we knew we had at least several of our best songs. We were ready to start synthesizing our lives into a fully realized record.

But when we played the rough, four-track demos to Trent to ask

his opinion, he seemed primarily concerned with the fact Scott didn't play guitar on it. "Listen," I explained. "We don't even know if we can work with this guy. He doesn't understand the direction we're going in at all."

"He's the backbone behind Marilyn Manson," Trent warned. "Marilyn Manson is known for his guitar style." John Malm, our manager and label head, agreed.

A wave of frustration surged through my body. I dug a fingernail into my side to keep it in check. "I've read a hundred articles and not one person has ever even mentioned guitars," I said, pissed off. "In fact, nobody even talks about the songs. I want to write good songs that people are gonna fucking talk about."

I offered to show them the lyrics, to tighten the songs, to add extra melodies, but nobody had any faith in the project. Besides, everybody thought we should still be promoting *Portrait of an American Family*. In many ways, I was my own worst enemy because I still didn't trust myself. I was so new at this that I looked up to and believed publicists, lawyers and label heads. I followed their instincts instead of mine, so I forgot about the songs we had written and, for the first but soon to be last time, compromised. We began working on an EP of remixes, cover songs and audio experiments to encapsulate our mind-set at the time, which was dark, chaotic and drug-addled.

Whatever flaws I found in *Portrait* paled in comparison to the disaster that this EP turned out to be. It was like stitching together an elaborate outfit for a party but catching the hem on a nail when leaving the house and watching helplessly as it unraveled and fell apart. The nail, in this case, was Time Warner, Interscope/Nothing's parent company.

The album we turned in to the label began with one of the most harrowing tape recordings I had ever made. Naturally, Tony Wiggins was involved. It was of a girl he had brought backstage early in the Danzig tour. She begged to be humiliated and abused. Wiggins began teasingly, cutting off her pubic hair, lightly whipping her and wrapping a chain ominously around her neck. But she kept asking for more and more abuse until, finally, she screamed that her life was worthless and begged to be killed on the spot. The tape snippet had Wiggins worrying that he had gone too far. "You're okay, aren't you?" he asked as she let loose a flurry of screams that no longer differentiated between pleasure and pain. "You know I'm not going to kill you," he tried to soothe her.

"I don't fucking care," she told him. "This feels so fucking good."

It was the only time I saw Wiggins exercise restraint.

On the album, as soon as she said her life didn't matter and begged to be killed there was a loud, ambiguous, cataclysmic crash and then the bassline of "Diary of a Dope Fiend" slowly kicked in. It was a perfect preface to an album about abuse: sexual abuse, domestic abuse, drug abuse, psychological abuse. Midway through the record, we included one of the taped confessions we had gathered, from a girl who had molested her seven-year-old male cousin. It underscored the subplot of the album, about the most common target of abuse: innocence. I've always liked the Peter Pan idea of being a kid in mind if not in body, and *Smells Like Children* was supposed to be a children's record for someone who's no longer a child, someone who, like myself, wants their innocence back now that they're corrupted enough to appreciate it. Having recently had our own innocence abused by our road manager, Frankie, who we fired when we discovered he had run up $20,000 in expenses he couldn't account for, we felt justified in adding a song about him called "Fuck Frankie."

The glue holding all of this together was dialogue from *Willy Wonka and the Chocolate Factory* that had been taken out of context to sound like sexual double entendres. And the centerpiece was our recasting of the Eurythmics's "Sweet Dreams," which we had been performing on the road. In a single lyric, it summed up not only the album but the mentality of nearly everyone I had met since forming the band: "Some of them want to abuse you/Some of them want to be abused." The record label fell into the first category of abuse. They had us excise the *Willy Wonka* samples because they didn't think we would be able to get permission to use them and—I should have learned my lesson by now—said that we needed written affidavits from the people in the Tony Wiggins recordings. Most record labels probably would have come to the same conclusion, which is one reason why art and commerce are in essence incompatible.

But then, out of the blue, Nothing came to a decision that went strictly against commercial instincts. They didn't want to release "Sweet Dreams" as a single, which I knew would be a song that even people who disliked our band would like. The label wanted to release our version of Screamin' Jay Hawkins's "I Put a Spell on You," which was far too dark, sprawling and esoteric even for some of our fans. We battled the label this time, and learned that we could win. The other thing I learned was to stick with my instincts, which usually end up serving me better than someone else's. It was a disheartening experience but it didn't hurt half as much as the fact that no one at the label ever congratulated us on the success of the song. What began as a very disturbing record had become a record that disturbed only me.

The only solace was that through some unfortunate error some-one at the record pressing plant made several thousand copies of our original version of the album, thinking it was the new one. Without even listening to them, the record company sent them out as promo-tional copies to radio stations and journalists before realizing their mistake. Now, they are available to anyone who wants to hear them on the Internet. Though someone at the label actually accused me of plotting it, I wish I was that resourceful. God, however irrelevant he may be to me, works in mysterious ways.

Another saving grace was that, despite having to remove the recordings we made on tour, we were able to include Tony Wiggins on the lawyer-approved version of the album. The result was one of the record's more surprising and ironic moments, an acoustic version of "Cake and Sodomy." Since the song critiques southern, Christian white trash, we thought there was no better way to remix it than to have Wiggins strum and twang a redneck version.

During our entire stay in New Orleans we had exactly one good time. And we had Tony Wiggins to thank for it.

Narcotics were so plentiful there that we became bored with just doing drugs. To entertain ourselves, we had to add special games, rit-uals and scenarios to drug experiences. On Twiggy's birthday, a pug-faced, inbred-looking bartender who worked at a dive in the French Quarter came by with a friend, a one-armed musician who played slap-bass with a hook. Since his primary source of sustenance was drug-dealing, he brought us several eight-balls of cocaine. But we didn't just want drugs. We wanted the combination of drugs, ritual and the situations that Wiggins was capable of getting us into.

On a notepad, Twiggy and I sketched Wiggins in pencil and red crayon, depicting him dying saint-like on the cross, presiding over a Last Supper of maggots and blood, and descending to earth in the guise of the Angel of Death. On a tray on the floor, we arranged sev-eral lines of cocaine next to several shots of Jagermeister and chicken in a biscuit (to represent the alleged killing of the chicken and the con-firmed torching of our drummer on tour). Behind them, we propped up a battered doll of Huggy Bear, the pimp from *Starsky and Hutch,* which was missing a leg. Inside that empty plastic socket was where we hid our drugs throughout the Tony Wiggins tour. Whenever we ingested the contents of that extra orifice, we referred to it in code as "dancing with the one-legged pimp." And the night of Twiggy's birth-day, we had our dance cards out and ready to be punched. I was naked except for a blond wig, a rooster mask with flashing eyes and a homemade red paper crown. Twiggy was wearing a blue plaid dress

that looked like a tablecloth, brown pantyhose, an auburn wig, and a cowboy hat. He looked like a slatternly zombie housewife from Texas.

We called Wiggins on his portable phone and, as soon as he answered, conducted our own Communion, attempting to transubstantiate the body and blood of Tony Wiggins into our meal of intoxicants. We snorted a line, licked the head of Huggy Bear, dipped the doll in the remains of the coke and rubbed it on our gums. Then we downed a shot of Jagermeister, and placed the chicken wafer in our mouths. It took no more than forty-five seconds for Twiggy and me each to complete this sacred obstacle course. Wiggins recognized us right away.

## CIRCLE EIGHT -
## FRAUD - DIVINERS, ASTROLOGERS & MAGICIANS

As if having eaten the fruit of knowledge, I realized I had to cover my nakedness. So I took the cardboard tube from a roll of paper towels and duct-taped it around my dick. In an attempt to turn it into a crude jockstrap, I drunkenly tore the television out of the wall and wrapped the cable around my waist like a belt. We tried to get Pogo to do or wear something to amuse us, but our efforts were in vain. We watched for an hour as a drunk hag of a girl with scabs on her legs knelt over his face with her panties around her knees, trying to get over her performance anxiety about dripping urine into his eager mouth. Then we dared Pogo to cut his wrist with a knife, which he did several times, and spray EZ-Cheez on his genitals and masturbate, which he also did but failed to arouse either himself or our interest.

It was a typical night: We had taken too many drugs and begun driving ourselves crazy with nervous energy until well after the sun had risen. Twiggy grabbed his acoustic guitar and shoved a minicassette recorder set to high-speed into the sound hole, causing the instrument to emit weird Chipmunks-like songs. Since it wasn't very funny without an audience (or very funny at all to anyone who wasn't high), we ran screaming into the streets in our homemade ensembles, tripping over a homeless guy sleeping on the sidewalk. "Hey man, what the fuck are you doing?" Twiggy asked, trying to be friendly. But the guy was either too scared to reply or just wanted to be left alone.

Knowing that intoxicants are the quickest way to a man's heart, we gave him a bottle of vodka. Now that we were on the same wave-

length, we thought maybe he would join our traveling circus. So we urged him to put on a wig, dance around and sing songs with us. We felt like we were four years old again, and it felt good.

"Hey Joe," Twiggy sang to urge the gentleman to action. "Hey Joe, what are you doing today? Do you think you could be heading our way?" But Joe didn't dance or head anywhere. He pissed himself, wetting our bare feet with his 120 proof urine.

We were so taken aback by this unexpected performance art statement that we didn't notice the sirens wailing behind us. Someone must have called the police. On the Danzig tour, I actually had a tolerable run-in with the cops when they arrested me for exposing my ass on stage and, instead of humiliating me at the station, gave me a ticket, apologized for the inconvenience and then one of them asked if he could take a Polaroid picture with me because he was a fan. But I knew it was just luck, not a trend. I wasn't about to take my chances in New Orleans, especially while wearing nothing but a cardboard penis sheath.

"Stop what you're doing and put your hands against the wall," crackled a loudspeaker atop one of the cop cars. I looked at Twiggy. Twiggy looked at Pogo. Pogo looked at Joe. Joe wet himself again.

Then we did what every self-respecting citizen does in the face of a greater authority. We ran, and never looked back. After a brief intermission that consisted of all of us passing out for several hours we continued our adventures.

Along with a clichéd over-pierced and over-tattooed couple, we drove to a cemetery just outside of town where we were told bones sprouted out of the ground like flowers. Instead of the statues, sepulchers and upright rows of tombstones we expected, the place looked like a nineteenth-century dumping ground for corpses. There were teeth mixed in with the dirt and pebbles, and broken leg and arm bones jutted into the air like tire-flattening spokes at a parking lot. We wandered around for half an hour filling a plastic grocery bag with bones. I suppose we thought they'd make good presents for loved ones or party favors for Twiggy's next birthday.

Twiggy, drunk again, wanted to take some headstones as well, which I disapproved of. Not out of respect for the dead—I had lost the ability to respect anyone living, let alone dead—but because they were too heavy to carry. We brought them back to the apartment anyway and stored them in the mop closet in the hallway. That probably had something to do with the strange behavior of our cleaning lady the following day, who mysteriously quit, leaving her rosary hanging on the mop closet doorknob.

Throughout our *Smells Like Children* tour, Twiggy lugged the bones from city to city, telling anyone who asked that they were the remnants of our former drummer Freddy, who we had burned alive. Freddy, as the bag of bones was now called, ended up on fire again in Los Angeles. As usual, Tony Wiggins was involved.

When we indulged ourselves, it was usually in tribute to Wiggins, because he had shown us that there are no limits. And every so often, he would hear our call and, when we were most miserable or bored, come flying to us like a sybaritic poltergeist. As the tour was winding down, he materialized backstage before a concert at the Palace in Los Angeles. He was drunk and riled up on some kind of speed. Proving that he can take abuse as well as he can dispense it, he insisted that I cut him. Since I had never used anyone's body other than my own as a canvas for scarification before, I complied, giving him a temporary tattoo in the shape of a star. He spent the entirety of the show on the side of the stage, bleeding and trying to pour whiskey down our throats whenever we walked past. It was the type of behavior we had come to expect from him.

Afterward, we went to a party in Wiggins's hotel room on Sunset Boulevard. The entire toilet seat was ringed with cocaine and the room was filled with pretentious L.A. scenesters who were name-dropping like it was going out of style. At the same time, they were mentally taking notes so that they could name-drop Marilyn Manson in another hotel room on another night.

We ran out of beer, which resulted in a fruitless expedition to Ralphs supermarket that involved Wiggins offering several cops $500 to buy beer for him. Back at the hotel, he donated the money to Twiggy and everything was fine again—until we ran out of drugs. All night, Twiggy and I had wanted nothing more than to make these very cool and with-it L.A. types smoke Freddy's bones like they were the latest brand of French cigarettes. Now was our chance. We took one of Freddy's ribs, chipped off a few pieces, and dropped them into a pipe. We lit it up and each took a drag, letting our lungs fill with the

fumes of this unknown dead body. Though the room quickly took on the foul stench of a burning corpse, we convinced two annoying girls to take a hit. They both got sick and left the room, which was what we wanted in the first place. Twiggy ended his night in the bathroom vomiting; I ended mine dreaming that I was possessed by an old Baptist minister from turn-of-the-century Louisiana.

In retrospect, the experience was not nearly as bad as some of the encounters I had with normal plant drugs. When we were hanging out with Nine Inch Nails shortly before the bone-smoking incident, they offered me one of the only narcotics I hadn't tried before: mushrooms. Pogo, Twiggy, most of the Nine Inch Nails and I ingested several caps as we left for a place called the Mars Bar. It was supposed to be nearby, but the drive took an hour. On the way, we drank short, wide-mouth cans of Budweiser. But no matter how much we drank we couldn't empty a single one. Either someone at Budweiser was a genius or the mushrooms had kicked in.

The Mars Bar was exactly the wrong place to be in our state of mind. It was in a creepy abandoned mall on the waterfront, and the only way to get there was to take a rickety elevator flooded in black light. Someone came up with the bad idea to play molecule, and started spinning around and bashing into everyone. One of the people we were with was Bill Kennedy, a notorious heavy-metal producer, and as he knocked into me he transformed into a demon with flaming hair, corn husks for teeth and writhing snakes around his waist. When he cackled, cigarette butts flew in and out of his mouth like popcorn bouncing around the inside of a popping machine. It was a nightmare, and reminded me too late why I should never do psychedelic drugs.

When the elevator door finally opened, it was into a room full of brown skeletons. Everyone was skinny and tan and, in the black light, they looked an otherworldly brown. The furniture was all undersized like something out of *Alice in Wonderland*. And the music kept changing: The songs they were playing would have new sections I had never noticed before, or all I'd be able to hear was the hi-hat. We were led by club management to some kind of holding pen and petting zoo, where everyone could stare at us and reach in and touch us. There was nothing to do but sit and be gawked at. I was going crazy. I looked at Pogo and he had a red light shining down on him like he was about to be beamed up by aliens. "Are you alright?" I asked. He just smiled at me and answered, "I'm gonna kill somebody." And he meant it, which terrified me.

An exit was conveniently and temporarily provided for me when a friendly looking guy walked up and said he knew me. I remembered

him vaguely as a bartender at the Reunion Room, where we had played some of our earliest shows. "This is my club," he said. "I run this place."

"Great," I replied. "Is there somewhere you could take me to get away from all this? I'm freaking out."

He led me to the back of the club and opened the door to a giant cooler. I walked in and he followed me, closing the door behind him. "You know," he said, "you used to go out with one of my ex-girlfriends."

It was a cruel thing to do to someone in my precarious mental state. I felt set up. I tried to tune him out and stared at the walls, out of which grotesque gargoyles were leering back threateningly at me. I tried to think about something else, and all I could imagine was that Pogo was probably killing someone right now, and I was going to have to talk to the cops. I didn't care who he was killing or whether he was going to fry for it; I just didn't want to face the police while I was on mushrooms.

Suddenly, the door of the cooler heaved open and a dozen people piled in who had been scouring the club for me. "Are you okay?" someone asked, concerned. I couldn't speak. I was scared, I was confused, I had to piss, I had to shit, I had to do something. Twiggy was with them, but all he could do was talk nonsense about stealing a paddleboat and escaping into the harbor.

I fled to another room and found an alcove under the stairs that, for some reason, was stuffed with pillows. I lay on them and enjoyed the solitude. I could hear everybody else outside, particularly Twiggy, who was trying to jump in the water in search of a paddleboat. I kept worrying that he'd drown and I'd have to talk to the cops. That was my main concern: I didn't care who died or was killed. I just didn't want to deal with the cops and have to tell them I was tripping.

When the sun came up, I began to grow more lucid. I stumbled into the hot, humid morning air and about fourteen of us piled in a minivan built for ten. On the way home, Trent suggested stopping at a McDonald's drive-through, where he ordered enough Egg McMuffins, hash browns, orange juices, large cokes, coffees and sausage biscuits to feed the entire Jacksonville penitentiary.

Before we had time to eat, Trent, who like myself is an instigator, tossed a soggy hash brown at Twiggy. Wiping potato from his face, Twiggy grabbed an Egg McMuffin, picked it apart and threw it at Trent layer by layer. Soon meat, eggs, drinks, bread, syrup and food morsels in various states of digestion were being tossed and spit all over the crowded van. It was an all out McWar, but with ketchup

everywhere instead of blood. Meanwhile, the car was swerving recklessly from lane to lane as our driver, who was sober, tried to keep from barreling over the median.

If Trent is an instigator, Twiggy is an accelerator, always adding an extra veneer of mischief, recklessness or decadence to a situation. He threw up all over his lap several times. Robin, the guitarist from Nine Inch Nails whose dick I sucked on stage, was sitting next to him. He did what anyone in his situation would have done: he picked up the vomit and threw it at me. I flung it at someone else, and soon we were in the midst not of a food fight, but of a postfood fight. Twiggy at this point was actually throwing up into Robin's hands, who was sharing the bounty with all of us. By the time we returned to the hotel, those of us who hadn't thrown up were ready to. At great expense to royalties from "Head Like a Hole," we left the contents of the van to bake and dry in the heat.

The first thing we saw upon stepping outside was a drag queen coming out of a club, a black Mr. Clean with a bald head, a tutu and gold gloves. "Hey, baby," he greeted us. "Hey, Mr. Queen," someone said, and invited him back to our room to do drugs with us.

Once inside, the first thing I did was call Missi, who had decided to go out with me again. Relationships never break cleanly. Like a valuable vase, they are smashed and then glued back together, smashed and glued, smashed and glued until the pieces just don't fit together anymore. I was covered with hash browns and vomit, I had a bag of bones under the bed, I had a Huggy Bear doll on the table filled with cocaine, and I had just come to the realization that I didn't care whether anyone I knew died so long as I didn't have to deal with it. On top of all that, there was a transvestite in a tutu smoking crack on the bed next to me. I didn't tell Missi all that. I just told her that I was freaking out.

"You know what?" she answered. "You gotta think about how you're living your life."

It was the last thing I wanted to hear at that particular moment.

THE LONG HARD ROAD OUT OF HELL

# ⑬

## *meating the fans*
## *meat and greet*

[STEAK] IS AT THE HEART OF MEAT, IT IS MEAT IN ITS
PURE STATE; AND WHOEVER PARTAKES OF IT ASSIMILATES A
BULL-LIKE STRENGTH. THE PRESTIGE OF STEAK EVIDENTLY DERIVES
FROM ITS QUASI-RAWNESS. IN IT, BLOOD IS VISIBLE, NATURAL,
DENSE, AT ONCE COMPACT AND SECTILE. ONE CAN WELL IMAGINE
THE AMBROSIA OF THE ANCIENTS AS THIS KIND OF HEAVY
SUBSTANCE WHICH DWINDLES UNDER ONE'S TEETH IN SUCH A
WAY AS TO MAKE ONE KEENLY AWARE AT THE SAME TIME OF ITS
ORIGINAL STRENGTH AND OF ITS APTITUDE TO FLOW INTO
THE VERY BLOOD OF MAN.
— *Roland Barthes, Mythologies*

8

9

10

11

12

13

14

15

5

6

7

**Q: Do you want to talk about the meat incident today?**

A: Okay. So, the first time I met Alyssa was at the last show that Brad Stewart played in our band and it was the showcase that we had for Freddy DeMann at Maverick Records. She came backstage and she was a short girl with blond hair. Cute. She had a pretty face, but most notably she was big-breasted. Just huge tits. A girl that you'd probably see at a Warrant concert by the way that she dressed and the way that she acted. I immediately realized that she was deaf because of the way her voice sounded. She told me that she could feel the music when she's close to the stage and that's how she gets her enjoyment from it. And she sort of came on to me and wanted to have sex or something. But I wasn't really interested at the time. I think probably because my girlfriend was on the other side of the door. Maybe if she wasn't there, I would have been interested.

A year later, when we went to record the B-side to the "Lunchbox" single, we were in South Beach Studios in Miami. And it was me and my band, Trent [Reznor], Sean Beavan [our assistant producer] and Jonathan, who had been hired by Nine Inch Nails as their video documentarian. I guess I became the instigator or director of photography. Or the Chief Executive Officer of Filth.

I went outside to get something to eat and I ran into Alyssa. So I said, "Come by the studio." I thought it would be entertaining to introduce her to everybody else. And it was ironic because just that day, Pogo was saying that one of his fantasies was to have sex with a deaf girl because then he could say whatever he wanted without upsetting her or feeling embarrassed. So I brought her into the studio and introduced her to everybody. To break the ice, I usually say whatever is on my mind in the hopes that it will make everyone laugh or that someone will actually follow through with it. So I said, "Why don't you take off all your clothes?" And she laughed and she took off all her clothes, and she only had her boots on. We were all shocked and amazed that we were commanding that much sexual power and that there was a naked deaf girl in the studio.

**Q: How was she able to understand what you were saying?**

A: She was a flawless lip-reader, a skill she had obviously accumulated from years spent in the front row of heavy metal concerts learning the lyrics to shitty songs like "Fuck Like a Beast," which brings us

to the meat at hand since I was with the author of the recent heavy metal refrain, "I want to fuck you like an animal."

Earlier that day we had collected a wide variety of meats. Big round pieces of meat that had the bone in the center, hot dogs, cheese dogs, salami, sausage, bacon, chitlins, pig's feet, chicken feet, chicken legs, chicken breasts, chicken wings, chicken gizzards. All uncooked meats. So we constructed a meat helmet made out of a large ham with pieces of bacon, sausage links and things like that suspended from it. A meat mobile. We crowned her with the meat helmet, and I took some pimento loaf to cover her nipples. And we put several slices of bologna on her back. That day we all definitely earned backstage passes in hell.

Before all this began, I had put on yellow latex gloves, basically because I didn't want to handle the salami. No other reason.

We had one half hour of pure meat cavorting. Meat handling. Working with meat. Meat cuddling. Meat shenanigans.

**Q: We could call this chapter "Meating the Fans."**

A: I was also thinking of "Meat and Greet."

**Q: That's good. So go on.**

A: We documented this in all sorts of ways. Pencil sketches, photography, videotape, whatever way we could capture this great moment in art history. At this point, I didn't think it was very sexual. It was more of a living meat sculpture. What happened next was the result of me always trying to escalate everything to the next level. I asked Twiggy and Pogo to scotch tape their penises together to see if she could put two penises in her mouth at the same time. But it turned out that they couldn't stand next to each other to create that, so they had to face their dicks front to front, and it became like a penis tug-of-war. She sort of licked it like some sort of dick harmonica. Some giant dick harmonica. That's when all the trouble started to break out. Because that was when we decided that Pogo should get to live out his fantasy and have sex with the deaf girl.

So, he put on a condom . . .

**Q: Hold on. How did he separate himself from Twiggy?**

A: She gnawed through the tape like a rat looking for a piece of cheese. And then Pogo put this condom on, which made his dick look like a chitlin. And he started to fuck her from behind, which was

appropriate because she had a dog leash on at the time and he was holding the leash. So, he's shouting all these obscenities at her . . .

I should mention that I do not feel that she was being exploited by any means because, despite however many cameras, street musicians, and sketch artists were in the room clapping and dancing around to Slayer or whatever was playing at the time, she was very excited to be a part of it. I think she, too, found it to be art and was having a good time. Everybody was having a good time—except for the guys in Nine Inch Nails, who were keeping their distance.

While all this was happening, Pogo said something, and we might not want to mention it because it's pretty offensive.

**Q: Go ahead. We can always take it out of the book later if we want.**

A: He shouted, "I'm going to come in your useless ear canal," and it seemed to echo through the room as maybe one of the darkest things we had ever heard. At that point, I felt that what I did with the baby Jesuses paled in comparision.

Then what happened was that Alyssa wanted to take a shower because she was covered in meat slime and assorted body fluids from the act of filth. So, since she was going in the shower anyways, I asked, "Can we urinate on you?" What she said next was probably darker and more profound than what Pogo had said. She said, "Just not on my boots." And we all looked at each other, like how you just looked at me: "Wow." At least she had some sort of morals. And then, adding icing to the cake—or dressing to the meat, in this case— she told us, "And don't get it in my eyes. It burns." Obviously she had experience in these matters.

So she got into the shower stall, and the camera crew watched while Twiggy and I put one leg on the stall and one leg on the toilet and hosed her down with urine. She just kind of sat there delighted and splashing her breasts as pieces of meat flaked away from the pressure of the urine.

Then what happened was that Twiggy's aim went in the wrong course and hit her in the face, and that was when everyone else in the room completely shut down and realized things had gone too far.

 **CIRCLE NINE - TREACHERY - TRAITORS TO GUESTS**

Sean Beavan said something that completely captured the moment. We kept repeating it all the time on tour afterwards. But I can't remember what it was right now. Maybe Twiggy knows.

*[Picks up phone, dials, waits.]*

He's not there. It'll come back to me.

Now, as the urine was dripping off her chin, the Sexual Janitor [Daisy Berkowitz] came in and went, "What's going on? What are you doing?"

And we were like, "Alyssa is taking a shower." We didn't feel the duty to tell him everything that had gone on before because he was the Sexual Janitor and we thought it would be amusing. So, we were like, "Alyssa is in the shower and would like you to get in with her."

I think the fact that he had very little experience with girls, good looking or ugly, made him get into the shower. So, Daisy took off his clothes right in front of us—he didn't even care—and jumped into the shower with her. The water hadn't really rinsed her off yet, and he started making out with her where urine had just been on her lips. And we were freaking out. Of course, he thought we were freaking out because we thought he was this sexual madman and dynamo and we were impressed with his dick size. If he knew that she was covered in urine, he probably wouldn't have cared anyway.

We finished off that little cinematic episode by taking the last final piece of meat that hadn't fit into the program—a big raw salmon, head and eyes and scales and all—and throwing it into the shower and blocking the door. That was the end.

**Q: Do you remember what it was that Sean Beavan said?**

A: Yeah, he said, "This is so wrong." Make sure you accentuate the *so* when you write that with a lot of *o*'s.

*how i got my wings*

PART
III.

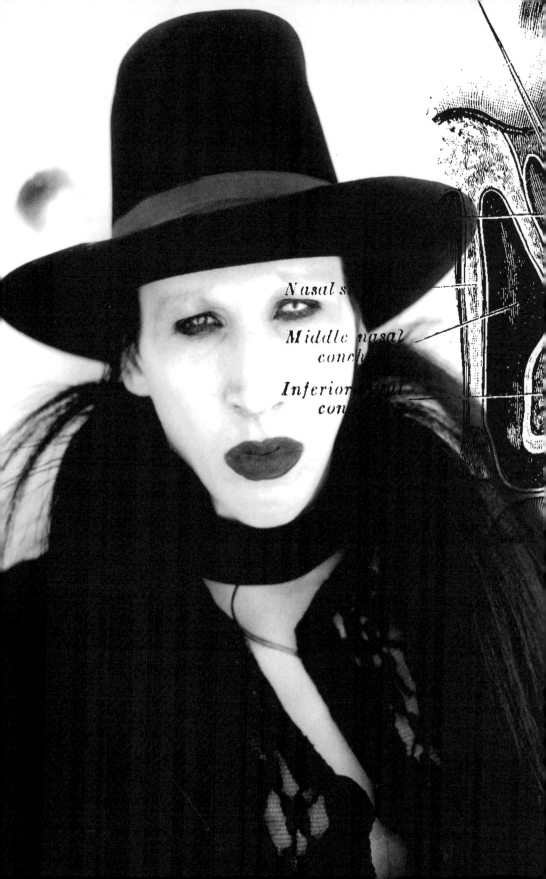

Nasal s

Middle nasal conch

Inferior nasal con

Levator palpeb
superioris
Inferior lacrimal
gland
Conjunctiva

Puncta lacrimalia

Nasolacrimal duct

Maxillary air-sinus

## (14)

### *the reflecting god*
### [DREAMS]

As I walked through the wilderness of the world,
I lighted on a certain place, where was a den; and I
laid me down in that place to sleep: and as I slept I
dreamed a dream. I dreamed, and behold I saw a man
clothed with rags, standing in a certain place, with his
face from his own house, a book in his hand, and a great
burden upon his back. I looked, and saw him open the book,
and read therein; and as he read, he wept and
trembled: and not being able longer to contain, he brake
out with a lamentable cry; saying, "What shall I do?"
—*John Bunyan, The Pilgrim's Progress*

This isn't me! I'm someone else! This isn't me!
—*Marilyn Manson to his bodyguard,
Aaron Dilks, during an alcohol blackout
en route from Leipzig to Berlin*

# THERE'S something I've never told

anyone. I didn't even remember it until recently, when I went to the chiropractor and he snapped my neck, causing me to black out for less than a second. In that time, I traveled back in my mind to Canton, Ohio. I was speeding down Thirty-fifth Street in my old neighborhood and there were hundreds of decaying corpses in the road trying to stop me. Their skin was yellow, and the wind was blowing their loose, nacreous teeth back and forth in their mouths. I kept plowing into them, and the instant the car touched them, they disintegrated into dust. Missi was in the car, and I was trying to save her because the corpses were trying to pull her away from me. I stopped the car and stepped out to try and help her, but there were large, mottled, sinewy dogs everywhere, jumping at me in slow motion with bared fangs. At the end of the street, I saw a group moving toward me, like a tribe. Their leader was Traci Lords. Her skin was even more yellowed than those of the corpses and she had a neon pink cross painted across her face. Her motions seemed animatronic. Her eyes were moving mechanically back and forth in their sockets and her mouth kept snapping open and shut like she was a ventriloquist's dummy.

In my dreams, I always return to Canton, Ohio. Usually I am in my bedroom in the basement, which, like my grandfather's basement, terrified me. Except the horror was not in anything tangible, but in my mind. As a child, I used to get scared down there for no specific reason and run upstairs, not just at night but also in the middle of the day. I never felt comfortable alone in my room and always slept with the television on to cover up the sounds I imagined hearing. If there is one ghost in my past, one skeleton still in a closet I've never been able to unlock, it involves that old basement. At night my mind struggles desperately to take me back there, to make me feel as if I've never left there, as if my whole life has unfolded in that basement. It places people I've met since then and will meet in the future in that room, and once there, they twist and contort, become monstrous and malevolent. Then my mind blocks the exit, making the crooked wooden staircase impassable. I try to run up the stairs but never make it to the top because hands are grabbing my legs through the slats between steps.

In another recurring dream, I can't leave the basement because some kind of invisible force or person keeps pushing me back against the wall and trying to trap me there. Or because my cat, O.J., an

orange tabby I found on the steps of Christian school, attacks me whenever I make a move to escape. There's another dream I often have in which the lightbulb in the basement burns out and I try to change it as quickly as possible because I'm afraid to be alone there in the dark. But each new lightbulb I screw in burns out, and I'm stuck perpetually running to change it to keep the room from going dark forever.

There are simple psychological explanations for these dreams, but none of them ever satisfies me. In only one dream can I remember making it to the top of the stairs. This time the basement floor isn't carpeted, as it usually is, with the motley green scraps my father brought home from work. It's cement, and I walk to the side I was always afraid of as a kid, where the washer and dryer sit in the shadow of the low ceiling. I'm rifling through mildewed, cobweb-covered boxes that contain my old belongings, and I'm nervous that some kind of animal—a spider, a rat, a snake, or even a lion, because it seems like anything can happen—is going to bite me. In one small box, I find a Curious George doll. But as I try to pick it up, something moves across the room—an indescribable, incorporeal warm weight that feels white for some reason. It pins me against the wall as the Curious George doll comes to life and runs around, knocking things off shelves and lighting one of the boxes on fire. I try to put it out and, when I can't, I run. I try to escape up the stairs, but the weight is holding me back. I push harder and harder, and finally get to the top. I tear the door open, and there's a woman at the top. She looks partly like my mom and partly like the girl who gave me crabs in high school. She has things written all over her arms in lipstick or paint or Magic Marker, and I try to read them but I can't.

In another dream, I'm in the basement with my mother and we find a box and pry the lid open. Inside are dozens of different types of bugs, but I can't make out what kind most of them are. We remove the lid completely and a praying mantis jumps out, flying into the rafters over my head. We look inside the box again and see a spider made of crystal. It is completely transparent: Its legs are like icicles and its organs are all visible. I ask my mother to get some bug spray to kill it before it jumps out and attacks me. But as I spray it, it turns into a woman. She is wearing all black, and she chases me through the basement to a beach covered with rocks. Inside each rock there is a different spider trying to escape.

That same night—I often have long strings of nightmares in a row, which I dread as much as I look forward to—I find my grandmother, on my mother's side, in my room. She is lying on a hospital bed cov-

ered with tubes that stick out of nearly every part of her body, which is crisscrossed with wires held in place by duct tape. A round flexible canister on the side of the bed is pumping air into her and the equipment keeping her alive is making whirring noises and electronic pulses. I hear a crash in the closet, and the door opens to reveal my dad lying in a bed. He's only thirty, his hair is messed up, and he seems to have gone mad. I talk to my grandmother, and she keeps reassuring me that everything is okay, that I did good in life, and that she isn't mad at me. She has a big bandage over her eye, and it falls open. Inside is yellow pus, which runs over her face and soaks into the pillow, staining it yellow. I bend over her to find out that she has no eye.

I believe in dreams. I believe that every night on the planet everything that is, was and can be is dreamt. I believe that what happens in dreams is no different and no less important than what happens in the waking world. I believe that dreams are the closest equivalent present-

day mankind has to time travel. I believe you can visit your past, present and future in dreams. I believe I've dreamt half of my life that hasn't happened yet.

I don't believe in chance, accidents or coincidences. I believe in the Delusional Self, which is to say that I believe that the things I talk and think about change the world around me and result in events that appear to be coincidental. I believe that my life is so important that it affects the lives of everyone else. I believe I am God. I believe everyone is their own God. I dreamt I was the Antichrist, and I believe it.

 **CIRCLE NINE - TREACHERY - TRAITORS TO HOMELAND**

I've thought about being the Antichrist ever since the word was first taught to me at Christian school. In the Bible, the word *antichrist* is only used as a description of people who don't believe in the teachings of Jesus of Nazareth. He is not described as one satanic entity—as the beast of Revelation which many people believe—but as a person, any person, who deviates from the Christian orthodoxy. But through years of myth-making and fear-sowing, Christianity metamorphosed antichrists into a single Antichrist, an apocalyptic villain and Christian bogeyman used to scare people much as Santa Claus is used to regulate children's behavior. After years of studying the concept, I began to realize that the Antichrist is a character—a metaphor—who exists in nearly all religions under different names, and maybe there is some truth in it, a need for such a person. But from another perspective, this person could be seen not as a villain but a final hero to save people from their own ignorance. The apocalypse doesn't have to be fire and brimstone. It could happen on a personal level. If you believe you're the center of your own universe and you want to see the universe destroyed, it only takes one bullet.

When my dreams about the Antichrist began occurring more frequently later in life, I knew I was that figure. When I dreamt as a child I'd be performing in front of thousands of people, it seemed just as improbable at the time. Now I doubt nothing. After all, the beasts and dragons of the apocalypse were all born in a dream, a dream of John the Apostle's now known as Revelation and taught as fact. In one of my own revelations—we all have them—it was the last day of the world, Judgment Day, and there was a giant tickertape parade in New York. Except instead of paper, people were throwing vegetables and rotten meat. I was on a giant crucifix strapped to a huge float made from human and animal skin. We were nearing Times Square,

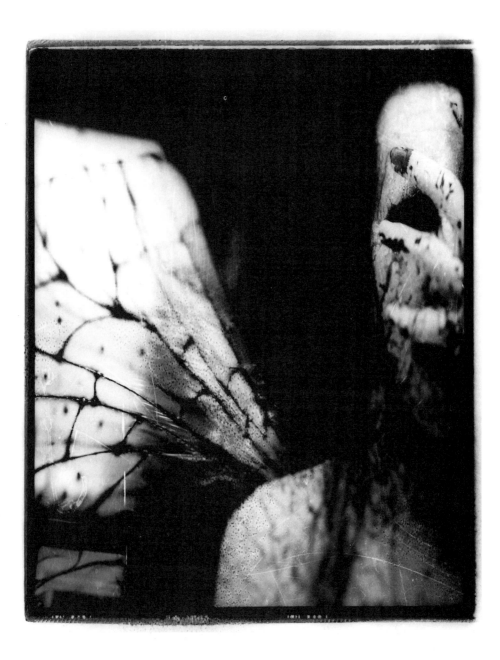

the sky was a deep black streaked with jagged stripes of orange, yellow, red and purple, and everyone was celebrating. They were happy that they were finally going to die.

Another took place in the future in Florida. Most of the human race had been turned into zombies for the entertainment of a small elite. There was a strip club where they had reanimated female corpses and made them dance naked in cages made of thick metal bars. Their flesh was covered in boils and gnarled veins, and their hair was falling out in clumps. Their jaws had been wired shut so that they wouldn't bite off the dicks of the guys around them masturbating. The world had degenerated to such a Sodom and Gomorrah state of sin that it seemed clear that the appearance of the Antichrist and the Second Coming were imminent.

I dreamt of little girls strip-dancing as little boys (or dwarves) hit them with rubber snakes, Tonka trucks and lollipops instead of throwing money. And I dreamt of taking my own hair and teeth, saved from when I was a small child, and very ritualistically creating an artificial companion out of them. And all these things became the album *Antichrist Superstar*. Now I can't tell which is more real: my dreams or my music.

I will leave you with one more dream, from last night. It was with the slashers, the fans who slice the band's name into their chests. In my nightmare, I'm in bed with Jeanette, the cherubic looking one. She has *Marilyn* cut into her, and each letter is dripping like wet paint over her breasts, staining her white tank top. I'm fucking her and we're both laughing because it seems like something that we shouldn't be doing. Her friend, Alison, is sitting next to her, with the word *Manson* bleeding on her chest. One of her eyebrows is bleached white, her lip rings are clattering against each other, and she's wearing a black dress, thigh-high hose, and black boots to the knees. She seems mad at me because I shouldn't be doing this with her friend and she's upset at her friend because she's laughing about it.

When we finish, they want to take me to eat. We walk downstairs to a damp, stone-walled, cavernous place, like a dungeon. It could be my parents' old basement, but it's also a restaurant. Water is dripping off the ceiling although there's a hole over our heads with sunlight streaming in. The waiter is a tall, skinny, Aryan-looking gay guy. He brings us big black metal bowls and each one has a live bird in it. They look like crows, but they're not. They're just black birds covered with a shiny film of grease. Another blond guy comes to the table and takes a pair of giant clippers, like the kind used to cut bike locks, and snips their heads off and peels the skin back so all that's left is meat

on a skeleton. The birds, though, are still alive. The guy takes one of the bird heads and drinks the blood, then he tells me to take a bite of the skin. I don't want to because I'm scared of getting some kind of weird disease, but I do it anyway. I drink all the blood out of the bird. When I'm finished, I feel a pain in the back of my neck. I turn around, and the waiter is trying to use the clippers on me for a table of customers sitting on high chairs above me. Except they don't look like clippers anymore. They're like a cross between a bird's beak and a crocodile's jaws. I try to protest, and then I realize that it's useless, because I am watching everything upside down as one of them puts my open neck to his mouth and drinks my blood.

I've seen my own death in dreams like this and it's helped me appreciate life more. I've also seen my own life in dreams and it's helped me appreciate death more.

*Amnion*

*Umbilical cord*

*Yolk-sac*

(15)

*antichrist superstar*

IN MY OPINION THE APOCALYPSE . . .
MUST BE PRIMARILY AN INTERNAL, SPIRITUAL EVENT, AND
ONLY IN A SECONDARY WAY AN EXTERNAL CATASTROPHE.
THE GATES OF THE WATCHTOWERS . . . ARE MENTAL
CONSTRUCTIONS. WHEN THEY ARE OPENED, THEY WILL
ADMIT [SATAN] NOT INTO THE PHYSICAL WORLD BUT INTO
OUR SUBCONSCIOUS MINDS. . . . THE APOCALYPSE IS A
MENTAL TRANSFORMATION THAT WILL OCCUR, OR IS
PRESENTLY OCCURRING, WITHIN THE
COLLECTIVE UNCONSCIOUS OF THE HUMAN RACE.
—*Donald Tyson, "The Enochian Apocalypse"*

# "THIS man is deceased."

A male voice was speaking somewhere above my body. His words were the first sounds I had heard for hours, maybe days. I didn't know how long I'd been lying there. I didn't even know where I was, or if I was alive. I struggled to move, but I couldn't. My left arm tingled. Everything else was numb and impotent, like wooden limbs hanging from the severed strings of a discarded marionette. I tried to open my eyes, to command them to raise, but they wouldn't respond. I needed to wake up, to tell them I wasn't dead. I was still alive. It wasn't my time to die. I had too much left to accomplish.

My eyelids fluttered open, leaving behind a greasy, blurry film obstructing my vision. All I could make out was a blinding white light shining on me, penetrating my being, or what was left of it. It wasn't my time to die. I knew it.

The back of a hand, bony and varicose, rubbed my forehead. I wondered if it had been there all along. A hideous shadow, ancient, corpulent and redolent of sour cheese and wet wood, blocked the light. It spoke: "God still loves you." The speaker was a woman, who coughed phlegm into her palm and shook her crumpled nun's habit then continued stroking my forehead with the back of the hand she had just spit into.

I could feel my chest now. It was tight and constricted, crushing my heart. There was a small commotion nearby. An old, emaciated man, his body covered with sores either from the mattress, old age or the bones pushing against his skin, had died in the bed next to me.

A softer hand gripped my jaw and pulled it open. "This is going to give you a headache, but it will make your heart feel better." She placed something under my tongue, which bubbled, fizzed and tickled, then switched off the bright lights over my bed. My body sank deeper into the bed, and a warm, enveloping wave of blood raced toward my head and rocked me back to sleep.

When I awoke again, it was dark and the room was empty. My temples throbbed against my skin and my left arm still felt numb, but my strength seemed to be returning. I was wearing just a green, open-backed hospital gown. My clothes sat in a neat black pile on the floor and on the bedside table slouched a tall, lemon-yellow kitchen garbage bag. I tried to remember what had brought me here.

I reached for the table, and a jolt of pain shot through my ribcage.

Inside the bag was a toothbrush, toothpaste, a pen, a makeup case and a black composition notebook—my journal.

I turned to the first page and tried to focus my eyes on the wavy blue lines and smudged black ink.

> *I can't even stand to watch people in restaurants laughing, having fun, enjoying life. Their pitiful happiness sickens me. And on TV, do people really live like this? Is this all a joke? Do we raise kids to believe in* Baywatch, *canned laughter,* Jenny Jones? *Stupid fish-white housewives straining their flabby legs together with Suzanne Somers's Thighmaster? She helped create the dumb blonde stereotype and now she's a fucking infomercial folk hero hawking a worthless contraption that sounds like a porno movie or an Aerosmith song. Fuck blind consumerism. Stupid people deserve what they get. They'd buy shirts that say "I'm fucking stupid" if Cindy Crawford told them it was cool. I'd love to kill all of them, but I'd be doing them a favor. The worst punishment I can give them is to let them wake up every morning and lead their stupid fucking lives, let them raise their stupid fucking children in their stupid fucking homes, and, of course, make a record called* Antichrist Superstar, *which will annoy and destroy each and every one of them. Fuck you America. Fuck me. The world spreads its legs for another fucking star . . .*

I had written those words the day I arrived in New Orleans, four months ago. I remembered it as if it were yesterday, because every day since had steadily grown worse, until, ravaged by drugs, exhaustion, paranoia and depression, my body had finally given out on me, landed me here in this fetid, white-walled hospital. I was optimistic after fulfilling my obligation to promote *Smells Like Children.* I thought I had shed my skin of self-doubt, watched it peel away inch by inch over the course of two years of touring. What seemed to be emerging from this cocoon was hard and soulless, smooth and terrifying, scarred and numb, a malefic gargoyle about to spread its scabrous wings. My plan then was to write an album about the transformation I had endured during my twenty-seven years, but I had no idea that I was about to undergo my most painful one as I sat writing in my journal in Missi's car as she turned onto Decatur Street on a wet February afternoon.

In the back seat was our only "child," a black and white dalmatian–boxer hybrid named Lydia. She barked with excitement or fear as I stepped out of the car and kissed Missi goodbye.

"Don't wait up," I assured her. "This is going to be a long day."

I opened the wrought-iron gate, pressed the buzzer, and waited for the studio manager to let me in. The first thing that greeted me— that greeted anybody who came to the studio—was a menagerie of dogs, which belonged to the studio's owner, Trent Reznor. They barked, jumping and fighting with each other, and then decided what to tear up next or where to shit.

"Everyone seems to have a dog this summer," I thought. "Maybe that's because they know our secrets and, despite that, don't judge us."

I sat down on a black leather sofa in the lobby. A big-screen TV filled the room with light and noise from the Alien Trilogy video game that Dave Ogilvie, the engineer hired to coproduce the album with Trent Reznor, knelt in front of, as if praying to the screen. He was a short Canadian with glasses, the kind of guy who looked like he got beat up a lot at school, not unlike Corey Haim in the movie *Lucas*, but he was also childish in a way that I enjoyed. As we killed time waiting for Trent—he was always the last to arrive—I faded out the xenomorphs and barking dogs, and thought about why I was here and what I was about to embark on. My nightmares still hadn't gone away. In fact, the move to New Orleans had only increased their intensity, a backlash from the dark, secret history that squirmed through the belly of the city like a tapeworm. Life was sucked in and decomposed. Nothing seemed to grow from here.

I had come to accept the fact that the acquisition of too much knowledge had led me to drug use, but it was through that very same drug use that I had acquired my knowledge. As a band, we had agreed that party time was over. There would be no more chasing after drugs, women, and adventure. We were in New Orleans to work. I wanted to focus my hatred and sharpen my contempt, even if I harbored both of those feelings for myself the most.

A black BMW skidded into the garage and a door slammed shut, announcing the arrival of Trent, who breezed into the room, nodding to me and Dave like men do at malls or at stoplights as he headed into the kitchen. The rest of the band soon arrived at the studio and began setting up their equipment: Twiggy Ramirez, a restless, mischievous child in the body of a silent psychopath; Daisy Berkowitz, a purveyor of leftover food, equipment and girls; Ginger Fish, the quietest and most dangerous of us all, a ticking time bomb gingerly awaiting a cat-

aclysmic explosion; and Pogo, a genius too mad to use his intelligence in any constructive way. He always reminded me of the professor on *Gilligan's Island*: he was smart enough to build a TV out of coconuts, but he could never fix the boat to take everyone home. If dared to, Pogo would gladly do anything, even drink his own urine; however, he would fall deathly ill if anyone did anything as trifling as putting mayonnaise on his food.

As Trent and Dave played video games, we sat and stared at each other. We had so many ideas, and so much at stake, that we didn't know where to begin. Only Daisy spoke. He was excited and agitated because he thought he finally understood the album, which he explained was a musical about Jesus Christ going on a rock tour. He even brought along a demo tape of six songs he had recorded, but his concept couldn't have been further from the execrable truth. Hearing it only depressed us further.

I left the room and climbed the wide staircase—spacious enough to fit the coffins that were once carried through this former mortuary—to the office and picked up the phone. I knew Casey's number by heart: I had dialed it so much last time we were in New Orleans. Before I had time to roll up a twenty-dollar bill, Casey had arrived, a starstruck leech who sold drugs not for profit but because he wanted to be around musicians and celebrities. Some people become roadies, writers and A&R scouts to accomplish this same goal: Casey had simply become a dealer. The walls of Casey's apartment were lined with gold and platinum records, each one a testament to the addiction and desperation of a different rock star who had exchanged his trophy for narcotics.

Casey cut up a long, snaking line across the office's fake wooden desk and invited me to help myself. I called for Twiggy to join me. I wasn't doing this alone, and I felt like maybe we should celebrate our reunion in New Orleans. Snorting it also seemed like a way to counter the insecurity and intimidation of setting out on a big project, a cop out that would be used to rationalize drug taking in the months to come just as often as the excuse of a reunion would.

We returned to the studio's live room and prepared to record the title song. Dave, however, was back at the console of the Playstation, wrapped up in Alien Trilogy. Out of respect, since he was practically a member of Skinny Puppy, a band much older than ours, we waited for him to die. By the time he rejoined us, Twiggy had disappeared upstairs to snort another line. Then Pogo had to leave to get some air, having bypassed cocaine for his own personal supply of exotic pot, which he smoked out of a crushed Coke can with holes in the side.

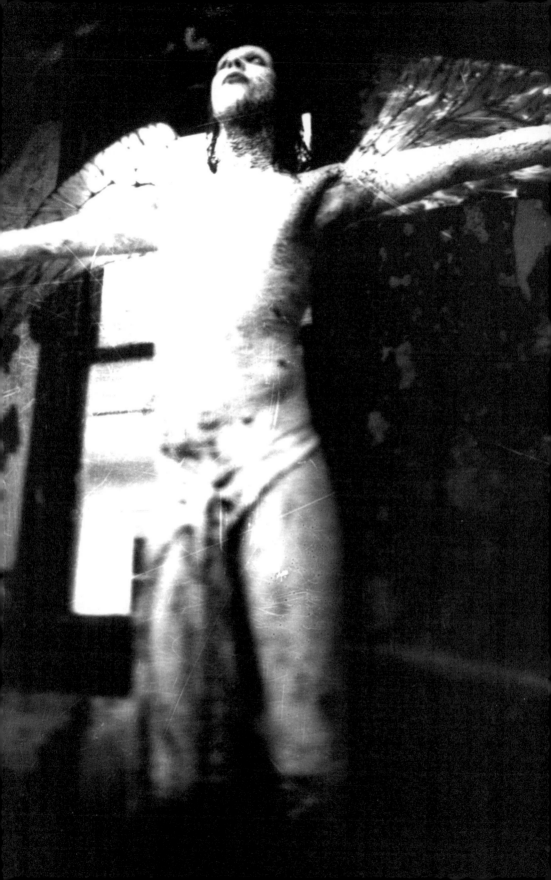

Then Daisy vanished into the foyer to play guitar into his four-track. When we were finally all together again, Dave had abandoned us to watch a Toronto Maple Leafs hockey game he was looking forward to. We were done for the night.

Days passed, weeks passed, and enthusiasm faded to annoyance as we began to realize that our first day in the studio was not a warm-up exercise but a pattern of inactivity. Every time inspiration struck, no one was around or too many drugs were around, and, like a spark without oxygen, our inspiration dissipated each time.

It could have been any night in the months that followed when I lay in bed staring at the high ceilings, wide awake from all the cocaine still coursing through my desecrated bloodstream. Missi was stretched out next to me, fast asleep, unaware that the reason we hadn't had sex these past few weeks was not because I was too busy thinking about work but because I was on drugs. Like just about everyone else in the band, I had been spending more time getting high and talking about making music than actually making music.

I eased out of bed as quietly as I could and creaked barefoot on the dusty wooden floor to the living room, careful not to trip over the buckets of red and black paint. I was living in a large, traditional New Orleans house in the Garden District rented through Trent's real estate agent, a stern, frumpy woman. I had recently obtained her permission to repaint the drab living room. But ever since I had begun working on it, the phone had been ringing off the hook—with record-label executives, managers, real estate agents and pencil pushers I didn't know telling me I wasn't allowed to alter the house. Just the other day, I had received a call from Dave, a half-witted stage carpenter with a lazy eye who had managed to keep himself on the Nine Inch Nails payroll even though their tour had been over for a year. Although Dave's new job was to solicit companies to give the band free swag—T-shirts, shoes, bongs, video games—his job duties that day had come to include the honor of calling me and informing me that I'd have to pay the building's owners $5,000 to return the room to its original colors.

Every time I saw the half-finished deep red walls and shiny black borders, my mind clouded with hate for everyone who had told me one thing when they meant something else, everyone who had lied intentionally knowing that they would later be caught, everyone who managed to crawl through life unscathed as they left a trail of duplicity and betrayal coagulating behind them. New Orleans was a city populated by two-faced men who were all smiles in your presence but knives and daggers behind your back. Most of the world's problems could be avoided if people just said what they fucking meant.

I climbed into the cracked red leather seat of a metal barber's chair in the living room that served as a womb, protection from a studio that had become a nemesis and a city that had turned against me. I often imagined that it was a pilot's chair gutted from a helicopter, like the one my father flew in Vietnam. I closed my eyes and focused on my heart, beating triple time against my chest. I let the pulse, the rhythm, the warmth spread through me, then concentrated on lifting that enveloping, warm essence up out of the scarred, abused container of my body, as I had read about in so many books on astral projection. I let myself be carried upwards, higher and higher into the night, until I was immersed in a radiant, consuming white. I felt myself growing, a body wrapping around me now, wings spreading from my back, ribs jutting through my skin like serrated knives, face deforming into the monster I knew I had become. I heard myself laugh an ugly, reboant laugh, my mouth widening in a malevolent sneer large enough to engulf the spinning ball of earth below, a world of petty lives with petty problems and even pettier joys. I could swallow it if I wanted to, dispose of it once and for all. It's what they had been praying for. It's what I had been sinning for. "Pray now, motherfuckers," I heard myself bellow, the sound rattling the firmament. "Pray your life was just a dream." And the earth answered back with a loud, clattering scream that resounded so loudly in my head that I had to press my palms against my temples to keep my sanity, or insanity.

It was the phone ringing. I picked it up groggily.

"Hey, what's going on?" came a voice I didn't recognize.

"Who's this?"

"It's me, Chad." He seemed insulted that I didn't recognize him—after all, we were cousins and were once best friends—but a lot had happened since then. "Did you get my invitation?"

"What invitation, you fruitcake?"

"To my wedding. I'm getting married in September, and it would mean a lot to me if you came."

"I'm in the middle of working on my album right now, but maybe I can get away. I'll try, okay?"

"Yeah, it would mean a lot to me."

I felt insincere on the phone, like all the duplicitous, smiling assholes I had hated as a kid, but I didn't know what to say. I didn't want to go back to Canton, Ohio, and see the normal shitty married life I could be leading right now. I might be tempted—because life in New Orleans fucking sucked.

When Missi woke up, we drove to the studio. Working there had begun to feel like trying to escape from a Chinese finger cuff: the

harder we tried, the tighter the resistance became. No sooner did I enter the foyer then Twiggy, who was becoming more a puppet of Casey's each day, came swooping out of the back room with a wooden-framed photograph in his hands, yelling, "Captain Larry Paul is ready for takeoff!" Captain Larry Paul was the nickname Twiggy had given a photograph of a fan's pencil sketch of Trent. Twiggy thought it looked like a goofy manager he once worked under at a record store in Florida where, like myself, he used to steal CDs. The picture had become a portable surface for the cutting and sniffing of drugs, ritualistically dug out of its hiding place in an old closet full of air-conditioning ducts, water heaters, and a musty, miasmal smell reminiscent of my grandfather's basement.

A meeting with Captain Larry Paul had become the typical initiation to a day of worklessness in the studio. Never in a life of prodigious drug use had I ever filled my nostrils with so much white powder. Every day, we would get so wired that we wouldn't be able to focus on recording anything, a situation that would antagonize us so greatly that we would grow even more paranoid and useless.

By now, everybody in the studio seemed to have given up on the album. Trent was beginning to feel resentful because he needed to be writing and recording a follow-up to *The Downward Spiral,* and Dave never seemed to be around when there was work that needed to be done. Ginger was hardly part of the band anymore, because he was too busy trying to amuse a foul harem of strippers he had picked up near the studio. And Daisy was rarely in the control room. Instead, he spent most of his time in the lobby of the studio with his headphones on, playing hackneyed hard-rock licks into his four-track tape recorder. He had never listened to heavy metal as a teenager, so he constantly mistook his clichés for originality. He used an old Jaguar guitar—like the one Kurt Cobain had used—not because it sounded good but because he had refinished it himself. The guitar was supposed to have been destroyed during the "Sweet Dreams" video shoot, but Daisy had proudly saved it from the scrap pile. "So what if it keeps feeding back," he would explain. "I put so much time into finishing it that it would be a waste not to use it."

So excited was Daisy by the progress he was making on his four-track recorder that he wanted to actually get something done and record a few riffs on the album, maybe on "Wormboy," the song that most incorporated his musical ideas. He walked into the live room, excited to find Trent seated there. The rest of us hung out by the mixing console, monitoring the live room through two closed-circuit television cameras. On screen, we could see Daisy excitedly showing off

his refurbished guitar to Trent, who actually seemed interested. We watched as Trent reached for the guitar, crooked it under his arm, strummed the strings a few times and then mercilessly smashed it over the amplifier, consigning it to the fate that was meant for it half a year ago. Trent casually left the room, and Daisy stood there aghast for several seconds before storming out of the studio, giving himself the rest of the day off to try and comprehend what had just happened.

We had turned a new corner in our work on *Antichrist Superstar*. Now, not only were we not productive, we were destructive. In the days that followed, our band's first drum machine would be thrown out of a second-story window, Trent's walls would be punched through, Twiggy's equipment would be smashed and Daisy's four-track recorder would be placed in a microwave set to high, frying its circuit board beyond repair.

On July fourth, the day in the studio consisted of everybody getting drunk as Trent and I lit fireworks, threw them into the microwave, and tossed the whole radiated mess into the street. This was followed by the destruction of my collection of Spawn toys along with a Venom action figure, a villain from Spider Man comic books taken off the market because it said, "I wanna eat your brains," much like the drugs were now doing to most of us. The only common thread holding the night together was the constant barrage of bottles thrown at Ginger—not out of good-natured fun, but out of resentment because he had managed to find some semblance of happiness in his shallow strip dancers. The only company the rest of us could find was misery. By sunrise, Twiggy was looking for marshmallows to roast over the mixing console that Trent was planning to set on fire. It wasn't just destruction: it was a very violent form of procrastination.

The state of our equipment was a lot like the state of the band: demolished. Within weeks, Daisy had left the group. The sissy had made the first manly move of his life and called a meeting and quit. The meeting went surprisingly well. In some ways, I actually respected him for staying true to what he wanted to do instead of remaining with us. At the time, I treated it as a joke, telling everyone that the only thing I would miss was watching Daisy, the Sexual Janitor, pick up used condoms as he dusted and mopped behind the band and the crew, buying chocolate and flowers in an attempt to seduce girls we had all slept with. But the truth was that I felt worse than ever. Every single person I had formed the band with was gone, and everyone who was left was beginning to side against me. I was the only one with a girlfriend in New Orleans and the only one who

seemed to want to work. Even Twiggy was becoming a stranger, controlled on one hand by Casey's drugs and on the other by Trent, to whom he was growing so close it seemed like he was more interested in being a member of Nine Inch Nails than Marilyn Manson. He had begun to call me Arch Deluxe, after the McDonald's hamburger marketed to adults, and everyone soon joined in. I constantly felt like a father figure, hated for trying to make everyone do their homework.

Whenever I wanted to talk about the books I was reading on the apocalypse, numerology, the Antichrist, and the Kabbalah, no one gave a shit. When I finished recording something, everyone invariably hated it and wanted to make it noisier and harsher—or even to use a drum machine instead of a live drummer. Was this production or sabotage? I didn't know what to think anymore. The only time anyone agreed with me was when I suggested we call Casey.

Outside of the studio, New Orleans was a cesspool. All the places where we had hung out the summer before were now filled with Goth tourists. The city had changed from a place where no one knew us to one where we were walking clichés, parodies of ourselves. Every night I drank, swallowed and snorted what I could to escape. One night, Missi and I ended up at a bar called the Hideout, which, the previous year, had been a biker hangout with three or four customers and a jukebox that played Whitesnake and Styx. We liked to drink there because it was empty, it was a joke and the bathrooms had doors that locked.

When Missi and I returned to the Hideout, the place had become a happening nightspot. Everyone there was cold and indifferent, as if they were too cool to recognize us, even though the only reason they were there was because they knew we would be there. In the midst of the black clothes, eyeliner and hair dye, I saw a beacon of silver—a human disco ball—a brown-haired girl covered in glitter with metallic eye shadow and lipstick. She stood in the middle of the room like a big neon sign bearing testimony to my infidelity—she had sucked my dick the summer before. Whatever special radar girls have, Missi's was on high that night, and instantly she picked up on the tension between me and the Liberace disco ball. The drunker we got, the more volatile the situation became. Missi kept asking me who she was and if I had slept with her, and I kept denying it. In the meantime, the girl was hitting on me as if Missi were a ghost, which in some ways she had become.

When I stood up to go to the bathroom, the girl squeezed in as I was closing the door. I was drunk and dizzy, and stuck with this filthy

girl in this filthy room, its white tiled floor caked with congealing, pubic hair–encrusted urine. The first thing the filthy girl did was sit on the toilet and take a piss. I tried not to look or care, but she called to me. "Look at this," she said, gesturing to a ring stuck through the hood of her clitoris and another in the crevice where her thigh met her crotch. "I got these when I was fifteen."

"That's great," I said, disgusted by the reddened, infected skin around both the piercings as well as the raw, irritated flesh surrounding her entire genital area, which had recently been shaved. I didn't know if I was supposed to lick her, finger her or fuck her, so I just stood there dumbly, telling her I was going to get caught. Instead of leaving, she pulled up her pants and reached into her pocket, producing a tiny ziploc bag. I've always wondered who makes those minuscule ziploc bags. What sandwich is going to fit in one of those?

"All of my boyfriends are either dead or in jail," she informed me as she crushed out a line of coke on the lid of the tank in the back of the toilet. As soon as I snorted it, my nose began burning, followed by my eyes, which welled with tears. Her drugs were definitely cut with speed or glass or Pop Rocks or something. As I sat there reeling from the alcohol and bad drugs, she grabbed my face and started making out with me, covering me with incriminating glitter. My pants were half off and she pulled on my flaccid cock. I wasn't thinking about getting caught anymore: All I could think about was urine. I seemed to have inhaled some, because it was all I could smell, and I still had to pee. The stench filled my head and permeated my body. I felt like I was going to vomit. I thrust my hand down her pants and violently yanked the ring on the hood of her clitoris, making her yell in pain, surprise or delight. Then I thrust my thumb inside her, bending my middle finger around her and ramming it up her asshole. "Why am I doing this?" I thought to myself. I wasn't trying to turn her or myself on. I was just trying to be dirty. The situation seemed to call for it. I could have just as easily stuck my hand in a garbage can and accomplished the same thing.

I pulled my fingers out as quickly as I had inserted them, urinated and left the bathroom to find Missi. But she had left, no doubt stormed off in a rage, leaving me stuck with the disco queen and so pissed at Missi that I was determined to plunge deeper into the sordid trench I had begun digging for myself. As I was asking if anyone knew where Missi had gone, a short, fat girl with a bag of stomach flesh hanging over her too-tight jeans and a white tank top dampened from sweat, revealing saggy, bra-less breasts, walked directly up to me, thrust her face inches away from mine and just stared at me.

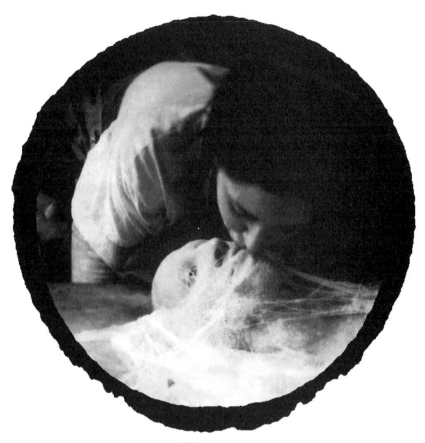

**MISSI AND ME**

"What?" I asked, annoyed and uncomfortable.

She responded by throwing her drink in my face—not just the liquid, but the glass as well. I whipped my bottle of beer at her, and soon I was covered with hands trying to restrain me and pull me out of the bar. She followed me out and began yelling something unintelligible, most likely a reference to me selling out or sucking or being too cool for her. She seemed to be suffering from some delusion that her existence was important enough for me to pretend not to acknowledge it.

With the disco ball still rolling along behind me, I ran drunkenly and dizzyingly into a nearby alley alongside a large white Spanish church and hid in the corner. A house of worship was probably the last place the cops would look for me. I had stuck the ziploc bag in my compact, so I brought it out and we snorted a few bumps off my house keys. I don't know why I did more of that girl's coke other than

the fact that it was there. But as soon as I did, I regretted it. My heart began to feel like it was going to explode. I ran away, leaving the girl behind like the decade she seemed to belong to, and hailed a cab. The driver, a white ox in a wife beater with a big brown mustache and greasy hair, instantly struck up a conversation.

"Have you ever seen *Planet of the Apes*?" he asked. "Isn't this just like *Planet of the Apes*? All these fucking niggers everywhere."

"What the fuck are you talking about?"

"Well, look around you."

"The South can be so charming," I said with an air of disgust, evidently visible to him.

"Are you a queer or something?" he fired back maliciously.

I don't remember exactly what I said next, but no doubt it contained one of the following—"fuck off," "asshole" or "suck my dick"—because he screeched to a halt in the middle of the street, smashed his hairy monkey fist into me through the divider and told me to get the fuck out of his cab.

As I walked the quarter mile left to my house with a bloody nose and a pounding head and heart, a combination of bad drugs and a good punch, all I could think of was Charlton Heston saying, "Get your dirty paws off me, you filthy ape." When I opened my front door, all hell broke loose. My records were strewn all over the apartment and the tops of them were scratched, courtesy of Polly, Missi's white cat, which looked exactly like the familiar that belonged to John Crowell's brother, except one of its eyes was blue and the other was green. I placed the keys on the table, and Polly lunged for my hand, tearing away the flesh over my tendon. I grabbed her violently by the neck. Missi was on the phone complaining to a girlfriend and ignoring me, but when, out of the corner of her eye, she saw me go on to throw her cat against the wall, she slammed the receiver down and began screaming at me. It only got worse when she saw the glitter, now mingled with the blood, on my face.

Everyone in the house was against me. Even the dog had, as usual, managed to find the exact book I was reading (*Tetragrammaton*) and tear it to shreds. My heart kept speeding up and swelling against my chest, and I ran into the bathroom and locked the door. From outside, Missi could hear me vomiting messily into the toilet, and her attack softened and turned into the sympathy I definitely didn't deserve. Blows of panic upon panic were hitting me because the more you get worried about being too high, the worse your situation becomes because the stress only makes your heart beat faster. To make matters even more dire, all I could think about was the fact that, like my dad,

I had Wolff–Parkinson–White syndrome—an erratic, rapid heart-beat—and probably wouldn't make it through the night without the help of a doctor.

I tried to relax and lay down on the ground and drink water, but my heart was clenched too tight to let me calm down. I could literally see it pounding against my lacerated chest. I wasn't worried about dying. My overwhelming concern was my usual fear of getting arrested or having to talk to the cops. As Missi tried to make some sort of arrangement to get me to the hospital without a press or police incident, I flushed the empty ziploc bag down the toilet and cleaned off my credit cards. Then I bent over the toilet, dry heaving and spitting, before unlocking the door. I walked to my closet and put on neat, respectable clothes and asked Missi to drive me to the hospital. I was detached from myself as I did this, as if I were watching someone else make these preparations. From that vantage point, I was impressed with how rationally I was acting for someone whose head was reeling from alcohol and whose heart was hammering so fast and heavy that cardiac arrest seemed imminent. My left arm was tingling, and I flashed back to years ago when someone had told me that this was a warning sign of a heart attack.

I woke up in that hospital bed next to a dead man, confused. I remembered the night before as if it were a series of photographs. At first I could only see a few snapshots, but slowly they began multiply-ing until they formed a complete moving picture. The only missing chunk was arriving at the hospital: I remembered a fat black woman who admitted me, I remembered a metal tube draining my blood for chemical analysis, and I remembered thinking, "Now I know how Brad Stewart felt."

As I regained consciousness in the hospital bed that night, I tried to figure out what I had meant by that. Brad Stewart—not the person, but the addict—was despicable to me, a creature so much the oppo-site of what I wanted to be. He was someone who had let something else control his life. I thought I was different, because I could stop. But why hadn't I? Why did I need drugs to work, to play, to go to sleep, to do anything? I had always told myself that doing a drug is okay, but needing a drug isn't.

As I lay in the bed, however, I managed to convince myself that I was not Brad Stewart, that I was still in control: this overdose would not be an epiphany or a wake-up call to straighten up. It was simply a mistake. There was too much going wrong with my life to just blame it all on drugs. That would be too easy. Drugs weren't the root of the problem, they were a symptom. *Antichrist Superstar* had become a

figment of our imagination, a fairy tale that had no other function than to scare us, like the bogeyman or Corey Feldman. Not only was nothing getting done, but everyone was telling me that it was weak, poorly executed and simply a repeat of what Trent had already done with *The Downward Spiral*. And maybe they were right. Maybe I had placed too much confidence in the concept of *Antichrist Superstar*. Maybe everyone was trying to save me from myself.

But maybe they had never really taken the time to listen to and understand the idea. Maybe the album they had in mind for Marilyn Manson was not the one I had in mind. It seemed like Trent and I wanted to make different records. I saw *Antichrist Superstar* essentially as a pop album—albeit an intelligent, complex and dark one. I wanted to make something as classic as the records I had grown up on. Trent seemed to have his heart set on breaking new ground as a producer and recording something experimental, an ambition that often ran in opposition to the tunefulness, coherence and scope I insisted on. I had always relied on Trent's opinion in the studio, but what was I supposed to do now that our opinions differed? No matter what anyone said, I knew that *Antichrist Superstar* was not the same as *The Downward Spiral*, which was about Trent's descent into an inner, solipsistic world of self-torment and wretchedness. *Antichrist Superstar* was about using your power, not your misery, and watching that power destroy you and everyone else around you. What was happening to me now seemed to be some kind of perverse combination of both types of self-destruction. It had been nearly four months now—four months—and all we had to show for ourselves was five half-finished songs, sore nostrils and a hospital bill. Nobody seemed to realize that the band was falling apart.

At the same time, Trent seemed to be growing more distant as a friend and as a producer each day, perhaps because we were taking up so much of his time on a project that he was rapidly losing faith in. He had said offhandedly in a conversation when we first started recording that it was impossible to make a great album without losing any friends, and I hadn't thought much about it at the time. Now it was all I could think about, because I was losing the three people who mattered to me most: Missi, Trent and Twiggy. All I had left was my family.

\*     \*     \*

After checking out of the hospital, I booked a flight to Canton, Ohio, to attend Chad's wedding. I always felt responsible for Chad, like I had somehow knocked him off his path to becoming an actor or

comedian. There was no specific reason why I thought this, except maybe guilt that I had escaped Canton while his life was stagnating there. He had nailed himself into the all-American coffin: he'd gone to college, gotten his girlfriend pregnant, and now he was going to marry her and be miserable or, worse still, content.

Talking to Chad, whose buck-toothed, freckled face hadn't changed except for a goatee, I couldn't relate to him anymore. How could he understand being on stage in front of thousands of people yelling his name? Staying up for three nights doing drugs and watching people piss, shit, whip and fist fuck one another for sheer amusement? Trying to go to sleep at night with a chest still bleeding from broken glass and a head gashed open by a microphone stand? We could only talk on a superficial level, discussing the strangeness of his getting married, his wife's wedding gown and the unfathomable concept of actually having children.

The wedding was the first time I had been in a church since I was a kid, and I felt uncomfortable throughout the long service. I wore my black suit with a red shirt, a black tie and sunglasses. Everybody seemed to be staring at me disapprovingly. Not only was the priest giving me dirty looks, but so was the rest of my family. As they all piously recited their prayers and sang hymn after hymn, I studied each and every one of them coldly. I imagined walking down the aisle in Chad's place, but marrying a black woman or a gay man and watching the confusion and anger that would result. I imagined responding to the priest's question, "Do you take this woman to be your lawfully wedded wife, till death do you part?" by dousing myself in gasoline and lighting it. I couldn't figure out why I had turned out different than everybody else. I had the same education, the same advantages, the same disadvantages. It was then that I came up with the lyric that would end the album, "The boy that you loved is the man that you fear."

Afterwards, I walked up to Chad's brother and mother, who explained that they were upset that I'd mentioned my grandfather in the press. "Why do you feel the need to tell family secrets," his mother scolded me.

"No one believes what I say anyway," I replied curtly. My grandfather had died the previous Thanksgiving, and the fact that I decided not to attend the funeral seemed to have resulted in a tacitly agreed pact among my relatives to excommunicate me.

**CIRCLE NINE - TREACHERY - TRAITORS TO KIN**

Everyone I talked to asked if I was gay or a drug addict or a devil worshipper. No one had anything nice to say, and no one understood anything about me. I wasn't Brian Warner anymore, I was some kind of inexplicable and repulsive slime that had trickled out of a sewer and filthied their manicured lives. Chad seemed too young and too intelligent to be falling into this trap, and all I could think was that I didn't want to grow up and have to tolerate this life that everyone thinks they're supposed to live. On the other hand, my life was no better. There had to be something else.

After the reception, we drove back to my grandmother's. As everyone sat in the living room drinking wine, eating crackers and struggling to say something interesting. I stole away and walked downstairs to my grandfather's basement. It looked almost exactly the same, but the train set and the enema bag were gone and someone had emptied the white medicine cabinet. I reached behind the mirror on the ceiling, and the pornography had been removed. I opened up one of the paint cans, and the 16-millimeter films were actually still there. I picked up the top one and held it up to the dusty beam of yellow light streaming in through the window, revealing a black man making love to a fat white blond. I removed another reel of film, and stuffed them both into the waistband of my my pants.

I didn't feel small and scared in the basement anymore. In fact, I felt at home for the first time since I had returned to Canton. I had much more in common with my grandfather now than with the innocent kid who used to explore his basement, which was an upsetting realization in light of the fact that moments ago I had been sitting in church promising myself that I would never grow up. I even wore women's lingerie, like my grandfather did, and had engaged in sexual acts far more perverse than the ones in his *Watersports* and *Anal Only* magazines. My grandfather had been the ugliest, darkest, foulest, most depraved figure of my childhood, more beast than human, and I had grown up to be him, locked in the basement with my secrets as the rest of the family reveled in the petty and ordinary upstairs. Down there, I saw my black, ancient, ineluctable core exposed, like a crab forced out of its shell—dirty, vulnerable, and obscene. For the first time in my life, I was truly alone.

\* \* \*

The first weeks back in New Orleans served to prove that the situation was even worse than I had imagined. Taking a break had knocked out the one last support I still thought I had under me, and returning to

find myself in the exact same pointless, self-destructive studio situation that I had left only compounded it all. I went on drug binges that lasted for days, resulting in blackouts, fights, and the destruction of most everything I owned and used to love. My life was falling apart, my band was falling apart and the record was falling apart. I was a rock and roll cliché, and I hadn't even really made it yet.

Sitting in the live room with Twiggy preparing to record "The Minute of Decay," I felt the weight of the futility of this project crush me. I had somehow thought that in my absence, everything would work itself out. But the fact was that we had talked ourselves a great album, but recorded a shitty one. I was preparing to sing into a guitar amp, use a drum machine hooked into a boom box, and let Twiggy play bass through a cheap little amp. The most expensive thing in the room was the half-decimated pile of cocaine in front of us. Like a fly on a fishing pole, no matter how much I flapped, wriggled, and struggled, there was no way to escape. I was dangling from a line I had no way of cutting. I had worked so hard these last few years only to be strung up here, doubting my own artistry and my own existence. At least I knew—I had always known—that there was an exit. But I didn't want to think about that. The truth is that I was too selfish to kill myself and let them—not just everyone in the studio, but my family, my teachers, my enemies, the world—know they had won.

I began to sing. "There's not much left to love." I reflexively took a sniff of the cocaine in front of my face. "Too tired today to hate." The drug didn't even affect me anymore. "I feel the empty." Something wet splashed in the middle of the pile of white powder. "I feel the minute of decay." It was a tear. "I'm on my way down now." I was crying. "I'd like to take you with me." I couldn't even remember the last time I had cried—even felt—like this. "I'm on my way down." I completely broke down.

"Could you come up to the control room?" crackled a voice over the P.A. system.

"All right," Trent said when I arrived, "we think you're overdoing it."

"I think you're laying on the emotion a little too thick there," Dave added. "We'll let you do it one more time, but lay off the theater. This isn't Shakespeare."

"I don't think you really . . . ," I began but stopped myself. I didn't think it would accomplish anything to tell them that if they were my friends, as I had once thought, they would have understood that my desolation was real.

I should have gone straight home then—I would tell myself that a

thousand times later—but I didn't. Instead, I punished myself with liquor, pills and drugs as I had with increasing frequency and quantity since returning from Canton. But this night was different. Some semblance of humanity had returned to me in the studio, and it scared me. It was unfamiliar and I wanted to push it away. Near dawn, Trent dropped me off at home and I crept inside, fearful of waking Missi. But the bedroom light was on, and Missi was lying on her back on top of the bed, with no covers. She was shivering, but her skin was stippled with sweat, which had soaked into the sheets around her. She didn't even acknowledge my presence: her eyes were rolled into the back of her head.

I shook her and talked to her, placing a hand over her burning forehead. But she didn't show any sign of consciousness. I cursed myself for not having come home sooner, for not having paid attention when Missi said earlier in the day she thought she was coming down with the flu, for not even bringing home the medicine she wanted, for all the times I had fought with her and cursed her existence in the past six months. And then I wondered if my own self-centered indulgence had killed her.

She was the only person left for whom I was capable of feeling any love, and to lose her would be to destroy my only chance of returning to the normal human world of feelings, sentiments and passion—to destroy, in essence, myself.

I panicked. Not only was I too fucked up to drive but even if I wanted to, I couldn't because Missi's car was a stick shift. Despite our recent differences, Trent was still the only person I could count on in New Orleans. I called his cell phone and, together, we rushed Missi to the hospital, the same one she had taken me to when I had overdosed. The nurses wheeled her into the emergency room and shot her with adrenaline to keep her alive. Her temperature was nearly 107 degrees, high enough to scramble the brains of most people. Several hours later, as the sun rose to signal the passing of another punishing day, two doctors brought Missi to the waiting room, where I sat with Trent still by my side. Trent didn't need to be there: it wasn't his responsibility. But there he was. Perhaps I had been wrong about Trent's friendship lately. After all, in a lot of ways, over the past three years Trent had become the brother I never had.

The doctors explained that Missi was three months pregnant and, if she decided to have an abortion, she would have to wait until her flu went away. I knew that during the course of our long relationship I had deformed her personality to suit my own. Now I realized that I had deformed her body as well.

The next night, as I sat alone in the studio's control room, I played back the rough mixes we had recorded of "Tourniquet," a song inspired by one of my many apocalyptic nightmares. I thought I was listening to it to try and determine if it should be redone, but in reality I was trying to find myself in the song, to see if I could discover some clue, some answer, some solution, some way out of the mess my life and career had become. I listened to it again and again until I was numb to it, no longer able to tell if the song was good or bad, or even if it was my own or someone else's. In a daze, I picked up the microphone plugged into the computer, beginning to feel one of the blackouts I had been experiencing more frequently coming on. Very slowly and firmly I drummed my left hand on the table as if tapping an S.O.S. into a telegraph and whispered into the microphone: "This . . . is . . . my . . . most . . . vulnerable . . . moment." I flipped the waveform around, so that it was backwards, and added it to the beginning of the song, a distress call heard by no one but myself.

I collapsed into the swivel chair and tried to clear my head. The words came from a place inside me as pink and sensitive as the head of a newborn baby. I wondered if the debased, demoralized, degraded monstrosity that I had become was dying (or being murdered), making way, as Anton LaVey had predicted over a year ago, for something new, for something confident, for something emotional, for something terrible and beautiful and powerful, for Antichrist Superstar—a world redeemer no one would allow to be born. What neither I nor anyone else around me realized was that the same corrosive that had stripped away my humanity was also responsible for trying to kill Antichrist Superstar in the womb: betrayal. It was a word that rattled around my mind like a rusty tin blade every time something went wrong. From my grandparents to Chad to my teachers at Christian school to my first girlfriends, no one had lived up to the roles they acted out in public. They wasted their years trying to live the lies that they had created for themselves. Only in private could they really be the demons, hypocrites and sinners that they really were, and woe betide anyone who caught them at their game, because the only thing worse than a lie is a lie exposed. I thought I had learned to protect myself from betrayal by trusting and placing faith in no one. But in the weeks that followed, I was to experience more betrayal in less time than I ever thought possible. Each one was like a hammer driving a stake deeper and deeper into my chest.

It began with my decision to do something about the predicament we were in. I called a meeting with the band, Trent and John Malm, and we discussed what could be done to save the album and our-

selves. In the end, it was agreed that we needed someone other than Dave to help produce the album, something Trent had been trying to tell us for a month. We needed someone who would help us work, and Dave seemed to have fallen in with our lethargic self-destruction. Like everyone else, he just wanted to get the album over with; but he didn't want to have to stop playing video games or watching ice hockey to accomplish this goal. In the end, we agreed that we'd all meet with Dave the following afternoon and let him go.

But the next day when I showed up at the studio for the meeting, I found myself alone with Dave. No one else had shown up. I was used to looking like a villain to parents and Christians, but not to musicians whom I used to respect, especially when that musician wasn't even technically working for me. The meeting, which took place in the office, went as badly as expected and ended with Dave storming out of the room, his final words, "This doesn't surprise me—this is how everyone in this business operates," echoing off the walls. I had been left on my own to look like an asshole, and I did.

I didn't return to the studio for days after that, indulging in a reckless binge that made everything else I had done in New Orleans look like an opening act. I experimented with different prescription drugs—morphine sulfate, Percocets, Lorcets—and shoved sewing needles underneath my fingernails to test my pain threshold because my emotional one had already been crossed. The time when Twiggy and I had been so close that we didn't even have to speak to write—together—the best music we had ever made seemed so distant and unreachable. I tried to remember what that music sounded like and what was happening to it.

In a rare moment of sobriety, which must have been in the window between the first five minutes I had woken up, I called Twiggy and asked him those questions, and we pledged to return to the studio and get some work done. When I arrived there the next morning, I found Twiggy outside, pissed off.

"What's wrong, man," I began.

"Remember how David Lynch wanted us to collaborate with him on the soundtrack for his movie?" he began.

"For *Lost Highway*? Yeah."

"Well, now he's in the studio with Trent, who's fucking doing the soundtrack himself."

"I'm going to kill somebody," I fumed.

"I would have already if I could," Twiggy spat, "but we're not allowed in the studio."

"Aren't we supposed to be finishing our record?"

"It only gets worse. Dave Ogilvie is fucking in there, working with Trent."

Our relationship with Lynch had begun two years earlier through a girl we had met named Jennifer, who claimed to be Lynch's assistant. At the time, everybody else had dismissed her as a name-dropping groupie. But when it came down to it, her claim was not only true, it resulted in an offer for us to collaborate with him on the soundtrack to his new movie, *Lost Highway*, as well as appear in the

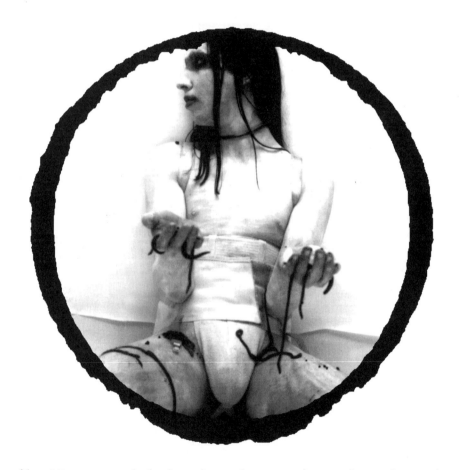

film. Now, not only had we been shut out of our relationship with Lynch, but his film was keeping us away from our album. When I called the rest of the band, I discovered that even Pogo had betrayed me, unknowingly, and was working on drones for the soundtrack while we were temporarily barred from the studio.

I decided to return later that afternoon and see if I could talk to

Lynch about it all. As soon as I pushed through the iron doors, I nearly collided into him.

"How have you been?" I asked as casually as I could, trying to hide my anger. "Good to see you again."

"So when are you coming by to work?" Lynch asked. He clearly had no idea that I had been told not to enter the studio.

"I'm not going to be able to, since we're finishing our album," I lied, biting my tongue. Trent was standing nearby.

I ran out of the studio, feeling awkward, like a girlfriend who walks in on her boyfriend while he is cheating. I wondered if I had been a fool all along, taking the advice of others when there was no one in this world anyone could trust but themselves. It hadn't steered me wrong before. I had been trying to fix what I thought was wrong with *Antichrist Superstar*: Dave Ogilvie, Twiggy, Trent. But I hadn't even considered that the biggest obstacle holding it back was myself. Maybe it was time to quit drugs and start working on myself.

<p style="text-align:center">*　　*　　*</p>

I sat in the women's clinic waiting room, imagining what was going on just three rooms away as the doctors put a rod the size of a matchstick, with two tiny thread-like strands jutting from the top, up into Missi's cervix, causing it to dilate before tearing out the brain of our child with a pair of forceps.

"Coffee?" asked a grey-haired nurse as she crossed the room to a white counter. I looked up and noticed that the brand she was offering me was Folger's. I shuddered, and lowered my head again, not responding. I didn't drink coffee. "Delusional Self," I thought, and my mind traveled back to Canton, Ohio, to a time when I used to construct buildings out of blocks in the grass across the street from my home, creating new houses as a way of escaping from my own. One afternoon I found a metal Folger's coffee can with a rotting, deteriorating, red-and-brown substance inside. I had shown it to my mother, who dismissed it as discarded meat. Only recently had she confessed that it was actually the remains of an aborted fetus. Suddenly I realized why I didn't drink coffee.

Missi had been scared about this abortion—she was well into her second trimester—and I was scared too, not only for her safety but for myself. I thought about the fact that there was no one else in the world who understood and accepted me as unconditionally as she did, no other girl I would ever feel that close to, no one else who I could share my music and my life with when I came home from the studio. But why

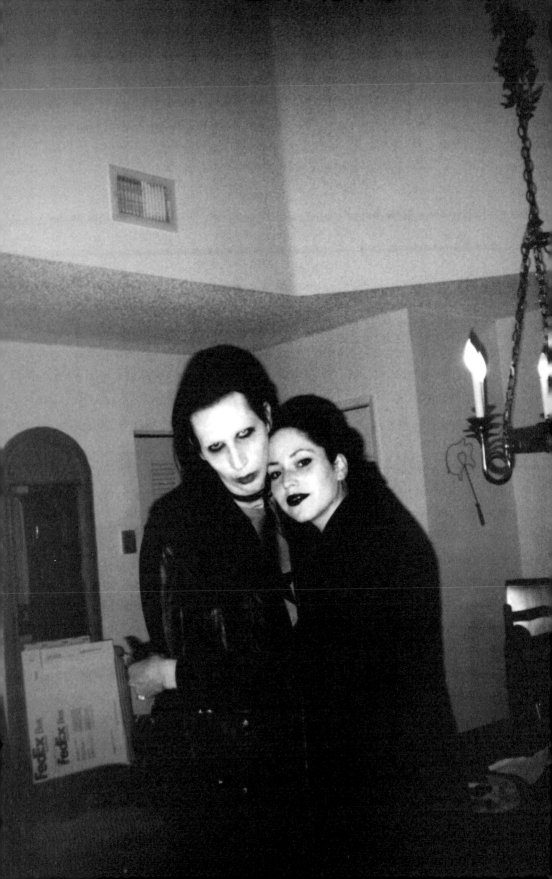

was I thinking in the past tense? Was I progressing beyond her? I cared about her and knew I would be crushed if anything bad happened, but at the same time I couldn't keep a twisted, degenerate thought from crossing my mind. I wondered if she could talk to the doctor about keeping the aborted fetus.

That night, I stayed home with Missi while she recuperated. I had been doing a lot of that lately: staying home. I had quit drugs cold turkey, something I knew I could do. I had come to realize that it was more fun looking for drugs and remembering what you did while on them than actually doing them. I may not have always exercised self-control in my life, but, when needed, I had the necessary willpower and capacity for self-denial on reserve, facilities at least as strong as anyone else's I had ever encountered. I also had ambition, tremendous ambition, and drugs were now getting in the way of that ambition. One of them had to go.

When Missi fell asleep, I snuck out of bed and climbed into the barber's chair, watching the shadows of raindrops play on a white ram's head perched atop a seven-foot human skeleton, a relic from the altar of the original Process Church in England. Behind me stood two blackened, stained gorilla skulls, staring at me through empty sockets as if angry and impatient. I had a lot of thinking to do. When I first conceived of *Antichrist Superstar*, I set out to create an apocalypse. But I didn't realize it was going to be a personal one. As a child, I had been a weakling, a worm, a follower, a small shadow trying to find a place in an infinite world of light. In the end, in order to find that place, I had to sacrifice my humanity—if you could even call such an insecure, guilt-ridden existence humanity. I had to shed my skin, purge my emotions and experience every extreme: I had to keep throwing myself onto the swords until I didn't feel a thing.

But in trying everything, all I had discovered was that I didn't need any of it. From that point, there was nowhere to go but to the grave—or to become more human. After seven stressful months of working (or not working) on the album and dealing with Missi, I had begun to emerge from that soulless cocoon of nonfeeling. As the drugs drained out of my system, humanity—tears, love, hate, self-respect, guilt—was rushing back to me, but not in the same way that I remembered it. My weaknesses had become my strengths, my ugliness had become beauty, my apathy to the world had become a desire to save it. I had become a paradox. Now, more than any other point in my life, I began to believe in myself. I had preached it all the time in my music, but had I practiced it since arriving in New Orleans? Had I ever practiced it? Had I ever been truly capable of it before now?

The next day, I met Sean Beavan, the sound engineer we had hired to coproduce the album in Dave Ogilvie's place. We had worked together since *Portrait of an American Family,* and despite his penchant for cappuccino sipping and roller-blading, we had a lot in common when it came to music and cross-dressing. Though we had to work in an auxiliary studio while Nine Inch Nails mixed "The Perfect Drug" for the David Lynch soundtrack, we didn't care. We were working, and not just on what I felt was our best song, but the first one I had recorded since quitting cocaine and alcohol. There were songs on the album that took place in the past and the future, but this was one of the only ones set in the present. "You cut off all your fingers/Trade them in for dollar bills/Cake on some more makeup to cover all those lines/Wake up and stop shaking/'Cause you're just wasting time." It was the most self-recriminating I had ever been, and it wasn't just about myself. I had been part of an epidemic of drug abuse, self-abuse and insincerity that seemed to be raging through everyone I met in New Orleans. Their motto: "I'll be your lover, I'll be forever, I'll be tomorrow, I am anything when I'm high."

When we played the song for the record company, they hated it. Not only did they want to use the rough mixes instead, they wanted to fire Sean. "Listen," I was told. "Why don't we find someone else to mix the album, delay the release, and put it out in January instead of October?"

"No way," I insisted, proud for laying down the law, my law. "This is the time to release it, and you know it."

That would be the last time I sought anyone's opinion on my work again.

 **CIRCLE NINE - TREACHERY - TRAITORS TO BENEFACTORS**

Each time I walked to the studio in the weeks that followed, I felt progressively more elated—I was making this album myself, without mentors, managers, and sycophants. The closer we got to completing the album, the more it became like a magnet, drawing the band back in the studio and back together. We found a replacement for Daisy, a deceptively benign Chicago vegetarian with horrible taste in women who now goes by the name of Zim Zum, after sifting through countless videotapes of washed-up metal guitarists kicking dead deer, eating human feces, and dressing up in ridiculous outfits thinking that we would like that. I even found a way of getting around paying the $5,000 I owed for repainting my living room: by charging Interscope Records $5,000 for a spurious photo shoot.

I didn't miss the drugs, and I didn't even mind the betrayals that continued up to and past the point when I turned the completed album in to Interscope Records. I had gotten used to defection, desertion, disloyalty and double-dealing, and I'd come to understand that I was bigger than all of that. It wasn't that I was cold and uncaring. I finally knew what was worth caring about. For perhaps the first time in twenty-seven years, I now knew myself.

This was because I had begun to see the world with new eyes, and to understand that the world was bigger than a studio in New Orleans, as was *Antichrist Superstar*. Everything and everyone who had tried to beat the album down had only made it stronger, more powerful and more effective. The album had entered the pop charts at number three, and now I was bigger than rock clubs, rock cocaine and feel-good rock; bigger than back stabbing, bullshit and shiny and/or happy people; bigger than rubber underwear, Willy Wonka, meat, *Night Terrors Magazine*, Tina Potts's pussy and the First Baptist Church of Jacksonville; bigger than anyone who has ever worked out and bigger than most of the musicians I used to idolize. To some people, I was even bigger than Satan.

Pharyngopalatine arch
Palatine tonsil
Glossopalatine arch
Buccinator
Palatine velum
Isthmus faucium
Fungiform papilla
Vallate papillæ

⑯

## *fifty million screaming christians can't be wrong*

[HIS] MUSIC IS MADE BY CRETINOUS GOONS [SINGING] SLY, LEWD, IN
PLAIN FACT, DIRTY LYRICS. IT MANAGES TO BE THE MARTIAL MUSIC
OF EVERY . . . DELINQUENT ON THE FACE OF THE EARTH. IT IS THE
MOST BRUTAL, UGLY, DESPERATE, VICIOUS FORM OF EXPRESSION IT
HAS BEEN MY MISFORTUNE TO HEAR.
— *Frank Sinatra, speaking about Elvis Presley*

# EXHIBIT A: OPPOSITION PROPAGANDA

AFFIDAVIT OF
[NAME WITHHELD]

STATE OF OKLAHOMA
COUNTY OF OKLAHOMA

I [NAME WITHHELD] HEREBY SWEAR, AFFIRM, DECLARE AND AFFITT:

1. I AM A TWENTY-YEAR-OLD MALE AND RESIDE AT [ADDRESS WITHHELD] OKLAHOMA CITY, OKLAHOMA [ZIP CODE WITHHELD];

2. ON THURSDAY, DECEMBER 19, 1996, I PERSONALLY ATTENDED THE MARILYN MANSON CONCERT IN DALLAS, TEXAS;

3. WHEN THE BAND TOOK THE STAGE THE FEMALE GUITAR PLAYER CAME OUT NAKED EXCEPT FOR VERY THIN, SEE THROUGH PANTIES. SHE DID THINGS TO HERSELF WITH A VIBRATOR AND OTHER THINGS. MANSON BROUGHT A DOG OUT ON STAGE AND HAD INTERCOURSE WITH IT. THE BAND ASKED THE CROWD TO GET ON THE FLOOR AND HAVE SEX. I HEARD THEM TALK TO THE CROWD ABOUT DOING RAPE ON YOUNG GIRLS AND BOYS;

4. THE YOUNGEST PEOPLE IN THE CROWD WERE NINE OR TEN YEARS OLD. DRUGS WERE CONSTANTLY BEING PASSED OUT FROM THE FRONT TO THE BACK. THE SECURITY GUARDS IN THE CONCERT WERE ENCOURAGING PEOPLE TO DO WHAT MANSON ASKED THEM TO DO. NO POLICE WERE EVER IN THE AUDITORIUM AREA. THEY WERE KEPT OUTSIDE. I FEARED FOR MY OWN PHYSICAL SAFETY AS THE CROWD WENT INTO A FRENZY;

5. I SAW BAND MEMBERS HAVE REAL AND SIMULATED SEX WITH EACH OTHER. DURING A SATANIC CHURCH SERVICE MANSON TALKED ABOUT KILLING ANIMALS AS A SACRIFICE, PREACHED FROM THE SATANIC BIBLE AND GAVE AN INVITATION TO ACCEPT SATAN AS LORD BY COMING FORWARD TO AN ALTAR. HE THREW OUT SOME LIQUID SUBSTANCE OVER THE CROWD;

6. I WITNESSED SEXUAL INTERCOURSE AND SEXUAL ACTIVITY BY PEOPLE IN THE CONCERT, NOT JUST ON THE STAGE, AND I SAW MORE THAN TWO DOZEN PEOPLE BEING TAKEN OUT OF THE CONCERT BECAUSE OF INJURY;

7. I LEFT BEFORE THE CONCERT WAS OVER;

8. FURTHER, YOUR AFFIANT SAYETH NOT.

EXECUTED THIS 17TH DAY OF JANUARY, 1997.

**—FAKE AND DEFAMATORY AFFIDAVIT DISTRIBUTED BY THE AMERICAN FAMILY ASSOCIATION**

# EXHIBIT B: TOUR DIARY

### UNDATED

People don't keep journals for themselves. They keep them for other people, like a secret they don't want to tell but they want everyone to know. The only safe place for your thoughts is your memory, which people can't take and read when you're not looking—at least not yet. I'm starting to think that if the Internet is the CB radio of the nineties, then the home computer is the trailer park of the soul, a dangerous tool in the hands of idiots. Eventually self-imposed fascism will destroy man as he convinces himself he doesn't have to think anymore.

### SEPTEMBER 1996, NEW YORK CITY

None of us wanted to play this Nothing Records showcase in the first place, and now I've inadvertently injured my drummer, nailing him with a microphone stand and landing him in the hospital. We had wanted to do a Marilyn Manson show to kick off the tour for *Antichrist Superstar*, but this turned into some sort of strange ego trip which I'm sure was just to make us look foolish. I'm going to go to sleep now and pretend like this didn't happen. This wasn't the beginning of the tour, it was one last favor.

### OCTOBER 19, 1996, CLEVELAND

Tony Ciulla, our new manager, came by and asked me to guess what number *Antichrist Superstar* went to on the charts today. I told him, "Three," and I was right. It couldn't be any other number. On the back of the record, there's three of us. There's three sections to the record. It's all three. The three means something else, too, something that's going to happen in the future, something that is going to change the world as far as we . . .

### OCTOBER 22, 1996, TORONTO

Someone called in a death threat today. They said they were gong to bomb the building and its occupants with mustard gas. Is that some sort of condiment? I guess I give them credit for being creative. And obviously I'm still here.

### UNDATED

For a moment tonight I felt like Christ. It was snowing on me, and I could have been anywhere—Wichita, Berlin, Golgotha. There was a mirror behind the crowd on the wall, and I watched myself like a painting, frozen. The gash in my side bled and bled. It was so beautiful I cried right there in front of five thousand people. I was letting out the boy who had died on his plastic cross in elementary school. He escaped through the hole in my ribs.

### HALLOWEEN 1996, NEW JERSEY

Tonight somehow the rumor got started I was going to kill myself. But I've died so much in the past year, I don't think there's much left to kill.

### UNDATED

I'm becoming what I used to be afraid of. When the whole world wants to destroy you, every day is your last day and every performance is your final one. The Antichrist isn't just me, or just one person. It's all of us, a collective state of mind that America needs to have awakened in them. I want to wake it in them. That's the purpose of this tour, maybe even my life, to make Americans realize they don't have to believe in something just because they've been told it all their lives. You can't have someone who's never had sex or drugs telling you it's wrong. Only through experience can you determine your own morality. Humanity isn't about constantly having to seek forgiveness for being human; humanity is leading a guiltless existence as an individual. *That* is Armageddon, because, to Christianity, if you forsake the idea of God and believe in yourself, the world is over.

GIVEN: AS BELIEVERS IN CHRIST, WE HAVE ALWAYS HAD AND WILL CONTINUE TO HAVE AUTHORITY OVER DEMONS AND EVIL SPIRITS.

GIVEN: THE "ROCK" GROUP MARILYN MANSON CONSISTS OF DEMONS OR EVIL SPIRITS IN THAT THEY ESPOUSE HERETICAL BELIEFS, CLAIM TO BE ANTICHRISTS AND SATANISTS, AND ATTEMPT TO TEMPT CHILDREN AWAY FROM CHRISTIANITY WITH SIN.

PART OF THE AUTHORITY CHRIST HAS GIVEN US OVER DEMONS IS THE POWER TO, THROUGH PRAYER, BIND, RESTRAIN AND INHIBIT THE ACTIONS OF EVIL SPIRITS.

THIS BINDING COMMAND HAS BEEN ISSUED IN RESPONSE TO A PLEA FOR HELP FROM STUDENTS AT SEVERAL CHRISTIAN COLLEGES IN FLORIDA. IT IS NOT INTENDED TO HARM IN ANY WAY THE PERSONS OF ANYONE IN MARILYN MANSON. IT IS AN ATTACK SOLELY ON THIS CONCERT AND IS INTENDED TO CAST THESE DEMONS OUT OF THE COMMUNITY OF ORLANDO ONLY.

WITH THIS COMMAND BELOW, WE NOW BIND THE DEMONS AND EVIL SPIRITS THAT SURROUND THE PERFORMANCE BY MARILYN MANSON ON THE FIFTEENTH DAY OF THE ELEVENTH MONTH IN THE YEAR OF NINETEEN-NINETY-SIX.

> O FOUL AND EVIL SPIRITS WHO HAVE BROUGHT
> THE MUSIC GROUP MARILYN MANSON INTO ORLANDO,
> AND HAVE CONSUMED AND POSSESSED THE BODIES AND MINDS
> OF ALL WHO ARE A PART OF THE GROUP OR AN AID TO THEIR MOVEMENTS,
> BY THE POWER GIVEN US BY JESUS CHRIST, AND IN HIS HOLY NAME,
> WE HEREBY BIND THE BUSSES AND THE TRUCKS THAT WILL BRING
> MARILYN MANSON AND THEIR MUSIC INTO OUR COMMUNITY.
> WE BIND THE ENGINE THAT MAKES THE CAR RUN,
> AND THE FUEL THAT MAKES THE ENGINE RUN.
> WE BIND THE LIGHTS AND THE AMPLIFIERS,
> THE MICROPHONES AND MUSICAL EQUIPMENT,
> NEEDED FOR THEIR VILE AND BLASPHEMOUS PERFORMANCE.
> WE BIND THE MOUTH AND HANDS AND FEET,
> OF THE MEMBERS OF MARILYN MANSON,
> SO THAT THEY CANNOT SOW LIES
> AND SPREAD DISCONTENT AMONG OUR YOUTH,
> OR PLAY THEIR MUSICAL INSTRUMENTS,
> OR TRESPASS ON OUR COMMUNITY.
> IN THE NAME OF JESUS CHRIST WE BIND THESE DEMONS,
> AND BY HIS HAND WE KNOW THEY SHALL BE BOUND.

* * *

OUR SCRIPTURAL AUTHORITY FOR THIS ACTION IS AS FOLLOWS:

MARK 16:15–18 (KJV)

15 AND HE SAID UNTO THEM, GO YE INTO ALL THE WORLD, AND PREACH THE GOSPEL TO EVERY CREATURE.

16 HE THAT BELIEVETH AND IS BAPTIZED SHALL BE SAVED; BUT HE THAT BELIEVETH NOT SHALL BE DAMNED.

17 AND THESE SIGNS SHALL FOLLOW THEM THAT BELIEVE; IN MY NAME SHALL THEY CAST OUT DEVILS; THEY SHALL SPEAK WITH NEW TONGUES;

18 THEY SHALL TAKE UP SERPENTS; AND IF THEY DRINK ANY DEADLY THING, IT SHALL NOT HURT THEM; THEY SHALL LAY HANDS ON THE SICK, AND THEY SHALL RECOVER.

**—PRAYER DISTRIBUTED BY PROTESTORS BEFORE MARILYN MANSON CONCERT IN ORLANDO, FLORIDA**

## NOVEMBER 2, 1996, NEW JERSEY

There's something exciting and terrifying about club shows and theater shows, but the arena concert is so *Antichrist Superstar*. And tonight seeing six thousand people raise their fist to "Beautiful People" is so Nero, so powerful, bombastic, fascistic, rock and roll. It's disgusting and I love it.

## NOVEMBER 6, 1996, WASHINGTON, D.C.

Twiggy and I called Trent. No response. I don't know what I did to be so hated. If it was being myself, then I guess that's the price I have to pay. It's behind me now. I hold no grudges. I just wish the tension would be resolved.

## NOVEMBER 15, 1996, FORT LAUDERDALE

It's funny because for the past two years Twiggy and I have listened to Dr. Hook's "Cover of the Rolling Stone" ritualistically, as if maybe it would actually land us in the magazine. And strangely enough that interview came today. I'm not sure if the writer was gay or not, so I did most of the interview in the hot tub to either confuse or excite him. I think it did both. I informed him that this would be one of the most important articles he would write, and I know that to be true.

## NOVEMBER 16, 1996, FORT LAUDERDALE

Our homecoming show was better than I expected. I thought people would be negative and resentful because they feel like I owe them something or they knew me when. But in fact, I never had a lot of friends here because nobody ever really believed in what I was trying to do. The only people I feel I owe anything to are my parents for supporting me when I didn't have a job. Anyone I may have used should feel happy that they even had a use. It's better than being useless.

## NOVEMBER 23, 1996, SOUTH AMERICA

Tonight we went to some bar in Santiago and the floor was made out of Plexiglas and there were weird lights shining out of it and we got really drunk on Chilean wine. Some bizarre character came up to me and asked if I liked Ziggy Stardust. I told him that it was a great record. He seemed upset and repeated the phrase Ziggy Stardust, making a sniffing noise this time. He explained that he wanted to sell us a bunch of hard-core South American cocaine. We hadn't really binged on the dust since recording *Antichrist Superstar*. But when in Rome, do as the Romans do. So we figured when in South America, do as the South Americans do and snort a lot of hard-core cocaine. Someone said a bunch of cops were outside. In Chile, cops aren't guys in blue suits with nightsticks. They're a squadron in a tank with machine guns. Somehow we escaped. We stayed up all night anyway, drinking wine and making people snort mysterious pink dust a roadie bought in a park outside a death metal concert. Of course we had to fly in the morning, which is where I'm writing this from, on the plane. And I feel sick.

## DECEMBER 3, 1996, GERMANY

Last night I left Twiggy at about six A.M. Apparently he stayed up until about noon. All of the hair on his forehead is missing.

## DECEMBER 19, 1996, DAY OFF

What happens someday if more people own my record than the bible? Will that make me god because more people believe in me than him? Because it's just about popularity. There are plenty of people in the world who have never heard of Jesus, while in America he's taken for granted. The key to changing the way people think is to change what's popular. That's why rather than submit to the mainstream, you have to become it—and then overcome it.

March 19, 1997

TO:  Mississippi Coast Coliseum Commissioners
c/o Executive Director Bill Holmes

Dear Commissioners:

I encourage you to cancel the Marilyn Manson appearance at
the Coliseum.

I feel that Manson's appearance and giving him a forum to
spout his poisoned philosophy is not in the best interest of the
Mississippi Coast community.

During this holiest of the Christian seasons celebrating
the risen Christ, I believe that this controversy is an affront to
the taxpaying citizens who built and support the Coliseum.

In the interest of unity and cohesion in the community, I
ask that you take action to cancel this concert!

Sincerely,

(signature)

Ken Combs
Mayor

KC/jw

## JANUARY 5, 1997

Tonight was my birthday. Too tired to go into details, but you can be sure that since *Rolling Stone* came out today (ironically), we snorted lines off my face on the cover as Dr. Hook played at an ungodly volume. I told you so.

## UNDATED

Tried to call Trent again today. They gave us some lame excuse, the same kind of excuse he would have us give when he didn't want to accept calls from people he hated.

## JANUARY 16, 1997, ON A HIGHWAY SOMEWHERE

Shitty hotels, shitty drugs, shitty shows with shittier after-parties, shitty conversations, shitty blow jobs, shitty buses, shitty bus rides, shitty fights, shitty reconciliations, shitty television with shittier Spectravision, shitty Gothic bars, shitty interviews, shitty photo shoots, shitty Christians, shitty atheists, shitty demo tapes, shitty moods, shitty food, shitty shit.

## JANUARY 17, 1997, SEATTLE

Jimmy has warts.

## JANUARY 27, 1997, 7 A.M., LOS ANGELES

Tonight—or this morning—I can't get to sleep, as usual, and I'm actually feeling happy. Trent surprised us all and showed up at our show. We hadn't talked to him—or he hadn't wanted to talk to us—since we finished the album. Right after the show I was taking a shower and he came in to the room and it was just like old times. We hugged, we were joking around. And it was a total holocaust night. We were totally high and we had Quiet Riot play at our after-show party at the Dragonfly. I think we reunited them, just like we did W.A.S.P. We take sole responsibility for the return of retro heavy metal, and I'm ashamed.

But I digress. What happened was Trent and I walked out on the balcony of the hotel room later that night and I just said to him, "Whatever happened happened, let's just put it behind us. I don't care." And then he said, "Well just for the record, I didn't . . . " He defended himself for about an hour, I defended myself for an hour. Then we told each other, "Listen, it doesn't matter, it's over, I don't care, it doesn't matter." And we meant it. Everything that had happened was necessary for the birth of *Antichrist Superstar*. It was a difficult birth but it was worth it. So supposedly everything is fine now. I hope it is.

## JANUARY 29, 1997, SAN DIEGO, 7 A.M.

A horrendous night. Daniel Ash from Bauhaus and Love and Rockets knocked on my hotel room door and wanted to hang out, which seemed strange since we'd never even talked before. Twiggy had lines of coke out in my room and Daniel Ash was with an entourage of six people. None of them touched the drugs. They just kept putting their drinks on the tabletop the drugs were on. I was getting sick because I was kissing Daniel Ash's ass, telling him what a big influence his guitar playing was on me, and he was kissing mine, telling me he wanted to remix a Marilyn Manson song. Then, out of nowhere, he turned on me.

He hissed something like, "I don't believe in what you do and I think it's a bunch of bullshit. I don't know about your music but your message—I worked with someone who hung out with you for a couple of days, and they told me what you were all about!" The rest of the band was totally cool—Kevin Haskins, the drummer, asked me for my autograph and David J. is just a weird creepy lizard man. Daniel Ash's girlfriend kept trying to shut him up, but he wouldn't. "I've been where you are, and I don't ever want to be there again. It's a hot trip to heaven, that's what my album was about. You're never going anywhere." I think he was under the impression that we worshipped the devil and advocated rape—probably from those phony fucking affidavits—and he ended up chewing us out and ordering room service all night. A total schizo, and another idol forever shattered.

# OUTRAGEOUS!!!

*"Kill your parents"
(on t-shirts)

*"Each age has to have at least one brave individual that tried to bring an end to Christianity. No one has managed to succeed yet, but maybe through music we can do it."

*"I am the All-American Anti Christ."

*Indecent exposure ON STAGE, obscenities beyond description, "Kill God" props.

*Lyrics and ideas too far out even for MTV without editing..."Totally Offensive" (as described by their own writer/singer).

These are the quotes/actions/merchandise of Marilyn Manson and his rock-metal group of the same name, appearing at the Fitchburg Civic Center on February 21st.!!!!!!!!

# DISGUSTED TOO? Join us.

At a protest, Civic Center, Feb. 15, 5:50 p.m.
At Fitchburg City Council Meeting, Tues., Feb. 18, 7:30 p.m.

OUR KIDS NEED YOUR PARTICIPATION
Paid for by Mass State Council, Knights of Columbus

## FEBRUARY 4, 1997, LUBBOCK, TEXAS

God has somehow managed to find his way into the Hippocratic oath because the paramedics here refused to treat me with oxygen for exhaustion after our performance, explaining that they didn't agree with my morality, therefore I didn't deserve their emergency life-preserving skills. Apparently Jesus saves, but the paramedics here don't.

## FEBRUARY 7, 1997, KANSAS

I'm not sure what I hate more: the bomb threats or the bomb dogs that are trying to save us. Because those happen to be the same dogs that sniff out drugs, and I don't know whether I'm more paranoid of getting blown up or arrested.

## FEBRUARY 14, 1997

I lost the last connection with my past today, Missi. The fact that I wasn't with her today must have symbolized my priorities to her, and she doesn't want to speak to me. We'll always be close, because she has a part of me inside her. But it's a part of me I no longer have—and it was the darkest part of me, too. I hope it doesn't cripple her the rest of her life.

## FEBRUARY 19, 1997, MASSACHUSETTS

I can't decide if I hate America more than it hates me.

## FEBRUARY 21, 1997, MASSACHUSETTS

Another shitty show. Now I can't decide if America hates me more than I hate myself.

## UNDATED

The ironic part about all this Christian outrage is that on certain levels this tour pales compared to some of the things that we've done in the past. The Christians are complaining about the way I compare them to Nazis. They're not complaining about me tearing up the bible; they're not complaining about me wiping my ass with the American flag. I don't know what's more ridiculous: the stories they've created or the fact that people believe them. If I didn't commit those acts, then where did they come from? Nowhere other than the imagination of my accusers. So who's the sinner now?

## MARCH, 1997, NEW YORK

I met Fiona Apple at the Grammy Awards after-party the other night. She's this little singer who no one's heard of. I'm a huge fan of her music. And she's so sexy and fragile, definitely too fragile for me. If I was ever to be put in a circumstance where I could have sex with her, I would decline because her vagina is probably too precious to be dirtied by my filthy cock. When she walked in the room they were blasting the song we did for *Lost Highway*, "Apple of Sodom," and the lyric playing was "I got something you can never eat." Total delusional self, because that song's about obsession and things you can never have and, in a distant way, is kind of inspired by her.

She was slouched over and looked very timid, almost like a wounded deer, as if she was about to cry. I asked her what's wrong, and she said she was overwhelmed and show business was too much stress for a girl of her age with her constitution. I asked her to sit down and said I'd bring her some food or a drink, but she was a vegan and—unlike me—was really picky about what she'd put into her body, which definitely means we'll never get along even though I'm attracted to her on many different levels. When I was speaking with her, I was distracted for two seconds by some celebrity's drunk teenage daughter who was bouncing around singing songs and talking about the various rock stars who had made her pregnant. Another starfucker and sycophant sucking the life out of me and distracting me from the conversation that I want to have. When I turned back around, this weird fellow had kind of slithered his way up to Fiona and was performing card tricks for her. Really lame. In the book of shitty ways to pick up women this was chapter one. But I think it worked.

# AFFIDAVIT OF
## [NAME WITHHELD]

## STATE OF OKLAHOMA
## COUNTY OF OKLAHOMA

I [NAME WITHHELD] HEREBY SWEAR, AFFIRM, DECLARE AND AFFITT:

1. I AM A SEVENTEEN-YEAR-OLD MALE AND RESIDE AT [ADDRESS WITHHELD] OKLAHOMA CITY, OKLAHOMA [ZIP WITHHELD].

2. THREE YEARS AGO I WAS A RUNAWAY FOURTEEN-YEAR-OLD WHEN I FIRST MET MARILYN MANSON (BRIAN WARNER) AND WAS ACCEPTED BY HIM INTO HIS CIRCLE OF FRIENDS OR "FAMILY." OVER THE COURSE OF THE PAST THREE YEARS I HAVE SPENT PERIODS OF TIME WITH MANSON ON TWENTY SPECIFIC PERIODS OF TIME, THE MOST RECENT BEING TWO MONTHS AGO. I DID SEE HIM LAST MONTH BRIEFLY.

3. I HAVE BEEN PRESENT IN THE CONCERT VENUES BOTH IN THE AUDIENCE AND BACKSTAGE AND BEHIND THE SCENES AT MANY MANSON CONCERTS INCLUDING THE CURRENT *ANTICHRIST SUPERSTAR* TOUR SIX TIMES.

4. EACH CONCERT STARTS OUT A LITTLE BIT DIFFERENT BUT MOST OF THE TIME THERE IS A LIGHT SHOW BEFORE THE CONCERT STARTS. MANSON WILL COME OUT ON STAGE BY HIMSELF DRAGGING A BIG BAG EITHER JUST BEFORE THE BAND STARTS PLAYING OR THE BAND WILL START JAMMING AND THEN STOP ABRUPTLY AS MANSON COMES OUT WITH THE BIG BAG. I HAVE WITNESSED MANSON PULL OUT SMALL CHICKENS, SEVERAL PUPPIES AND KITTENS OUT OF THE BAG AND THROW THEM INTO THE AUDIENCE. THESE ARE LIVE ANIMALS. I KNOW BECAUSE I HELPED TO GET SOME OF THESE ANIMALS FROM THE DOG POUND FOR MANSON. MANSON WILL THEN TELL THE AUDIENCE TO MAKE A SACRIFICE TO THE MUSIC AND HE WILL NOT START THE SHOW UNTIL ALL THE ANIMALS ARE DEAD.

5. I WITNESSED THE CROWD RIPPING THE ANIMALS APART, PULLING BODY PARTS OF THE TORSO OF THE ANIMALS. THEY WOULD BLEED TO DEATH OR THEY WOULD BE SMASHED INTO THE GROUND. MANSON TOLD ME THEY REPRESENT THE KILLING OF INNOCENCE. I HAVE SEEN THIS ANIMAL TRUCK WHICH IS LIKE A PICK UP TRUCK WITH A CAMPER TOP ON THE BACK WITH CAGES FULL OF DIFFERENT ANIMALS FOR CONCERT SACRIFICES. I HAD GONE WITH [NAME WITHHELD], A FRIEND WHO RUNS LIGHTS AND SOUND FOR THE CONCERT, TO GET TWELVE PUPPIES, BUT MANSON HAD MANY ANIMALS ALREADY IN THE TRUCK. MANSON ALWAYS HAS THE CROWD KILL THE PUPPIES SO INNOCENT BLOOD WILL BE ON THEIR HANDS BEFORE HE DOES THE CONCERT.

6. THE CONCERTS I'VE BEEN TO ARE TIGHTLY CONTROLLED BY MANSON SECURITY GUARDS. NO POLICE ARE EVER ALLOWED INTO THE CONCERT AREA. IF A POLICE OFFICER HAPPENS TO GET BY A GUARD, MANSON IS INSTANTLY NOTIFIED THROUGH HIS HEADSET HE WEARS. MANSON HAS A TEAM HE CALLS HIS PRIVATE SANTA CLAUSES. THEY COME AT THE CROWD FROM THE SIDES AND THROW OUT BAGS OF POT AND COCAINE THROUGHOUT THE ENTIRE AUDIENCE FRONT TO BACK. EVERYONE ATTENDING THE CONCERT GETS [SO] HIGH [THAT IT] SATURATES THE AUDITORIUM. ALL OF THE SECURITY GUARDS ARE VERY CLEAN CUT LOOKING. MANSON ALWAYS COMES TO TOWN GIVING THE IDEA THAT THIS WILL BE A VERY INNOCENT ROCK AND ROLL SHOW TO THE PRESS AND THE GENERAL PUBLIC.

## [CONTINUED]

THE LONG HARD ROAD OUT OF HELL

### MARCH 1997, NEW YORK

Asked Fiona to come to the premiere of Howard Stern's *Private Parts* with me. He uses a song of ours in the movie. In some ways I think Howard Stern and I are very similar because he just says what's on his mind and it pisses a lot of people off but it also entertains them. I consider him one of the people responsible for breaking "Sweet Dreams" because he really pushed it.

I thought Fiona was going to blow me off because she launched into the kind of drawn-out story about visiting a long-lost relative that I would make up if I wanted to get out of doing something. But she just called back and she's gonna go. I don't know if this makes me gay or not, but I think she would be interesting to be friends with.

### MARCH 1997, NEW YORK

In true rock star form, I picked up Fiona to go to *Private Parts* in a white limo. And in true anti–rock star form, she came out makeupless with uncombed hair. This was my first celebrity big-deal event, and I didn't know how to behave at all. There was this red carpet and apparently you were supposed to walk down it and let people take photos of you, but I was kind of confused. I walked down a few steps, thought I was going the wrong way, then came back to the car. Then somebody told me that I was supposed to be walking on the red carpet, so I went halfway down, then got scared because I didn't know if I was supposed to stop or not. Meanwhile, a bunch of media cornered Fiona and she got mixed up doing an interview with Flavor Flav. I couldn't take it anymore, I was so aggravated. It's not my scene to sit around and schmooze with a bunch of assholes who don't know who you are but pretend like they do. Fiona decided she was gonna leave and I wasn't really even disappointed because I felt bad for how overwhelmed she was.

I went upstairs with Twiggy, who was with us, and ran into Flavor Flav. We high-fived and we danced around. I couldn't see his eyes, but if I could have he probably would have been giving me the wink that people who use drugs give to one another, whether it's for real or it's in your mind. I was impressed with the fact that he didn't know who Marilyn Manson was, though I'm not sure if he even knew who he was because he was definitely out of his fucking head. At that point I ran into Billy Corgan, and I immediately gave him some muscle relaxants I had in my pocket. We decided that they made us feel "fruity," and then we decided that that would be a great name for a band to start together. So we began having a long, in-depth meeting inspired by the fruity drug to create a fruit-filled experience called Fruity, which will probably never happen because I don't know where I put those pills.

I was surprised that Billy was cool because I thought he'd be a total asshole from all the spiritual hate mail I had gotten over the years from Trent, who allegedly despises Billy over an alleged conflict allegedly dealing with Courtney because when Trent allegedly fucked Courtney, which he says he didn't, Billy allegedly fucked Trent's alleged girlfriend, which he allegedly says he did, or so I'm told.

Then I tried to give the fruity pills to Conan O'Brien, telling him they were Prozac and he looked like he could use them. He just smiled with that weird creepy baby head of his and walked away to talk to a friend. I gave him the finger, and he just laughed. It's amazing the things that you can get away with when something looks wrong with one of your eyes, you have badly applied makeup, you're six-foot-three and you're accompanied by some weirdo with the front of his head shaved who looks like a cross between Gregory Hines and a Klingon on crack undergoing radiation therapy. (If you're reading this Twiggy, I'm sorry.) Then I think we ran into Tom Arnold, who was all sweaty and anxious and racy and basically looked like he was on speed of some sort. I asked him where the drugs were because I was giving him that same wink that I had imagined exchanging with Flavor Flav earlier. And he just joked, "Shhh," and I said, "All right, well call me."

### [CONTINUED]

## AFFADAVIT [CONTINUED]

7. I WITNESSED MANSON PULL OUT HIS PRIVATE BODY PART AND PLAY WITH IT OPENLY IN FRONT OF THE CROWD. IT'S HIS PENIS HE PLAYS WITH, NOT ANYTHING ARTIFICIAL. I HAVE WITNESSED HIM GO OVER TO HIS FEMALE GUITAR PLAYER, WHO IS USUALLY TOTALLY NAKED, AND PLAY WITH HER PRIVATE PART IN FRONT OF THE CROWD. MANSON ALWAYS EXPOSES HIMSELF IN EACH CONCERT AND THE FEMALE IS ALWAYS NUDE IN EVERY CONCERT.

8. I HAVE WITNESSED MANSON BAND MEMBERS PERFORMING ANAL INTERCOURSE ON EACH OTHER ON STAGE IN FRONT OF THE CROWD.

9. I HAVE WITNESSED VARIOUS BAND MEMBERS COME OVER TO MANSON AND PERFORM ORAL SEX ON MANSON THROUGHOUT THE COURSE OF THE CONCERT.

10. I HAVE WITNESSED MANSON PULL MEMBERS OF THE CROWD ON STAGE OR HIS SECURITY GUARDS WILL BRING AN AUDIENCE MEMBER ON STAGE AND STRIP ALL OF THEIR CLOTHES OFF. MANSON WILL THEN PLAY WITH THEM IN A SEXUAL WAY. THEY ARE THEN USUALLY TAKEN BACK STAGE WHERE MANSON WILL DO ANYTHING HE FEELS LIKE DOING WITH THEM WHEN HE IS OFF STAGE. MANSON WILL TAKE AS MANY FEMALES FROM THE AUDIENCE AS HE CAN ALL THROUGHOUT THE CONCERT. I HAVE WITNESSED SOME FEMALES WHO WERE FIGHTING TO KEEP THE GUARDS FROM TAKING THEM ON STAGE. I BELIEVE IT WAS CLEARLY AGAINST THEIR WILL. BUT MOST OF THE FEMALES WERE THRILLED TO HAVE MANSON TAKE THEM FOR SEX.

11. I WITNESSED MANSON BRING A LITTLE BOY UP ON STAGE WHO WAS CELEBRATING HIS TENTH BIRTHDAY. MANSON SANG HAPPY BIRTHDAY TO HIM AND THEN HAD THIS LITTLE BOY STAND ON STAGE WHILE MANSON PERFORMED SEXUAL ACTS, INCLUDING ORAL SEX, WHILE ASKING THE LITTLE BOY IF HE WOULD LIKE TO DO THIS AND WOULD HE LIKE TO DO THIS.

12. I WITNESSED THE SECURITY GUARDS THROWING OUT DOZENS OF CONDOMS INTO THE CROWD WHILE MANSON ORDERED THE CROWD TO HAVE SEX WITH ANYONE. I HAVE WITNESSED MEMBERS OF THE AUDIENCE HAVING SEXUAL INTERCOURSE AND PERFORMING OTHER SEX ACTS AT EVERY CONCERT I'VE BEEN TO WITH MANSON. I BELIEVE ABOUT THIRTY PERCENT OF THE MANSON CONCERT CROWD PARTICIPATE IN OPEN, OVERT SEXUAL ACTIVITY AT AN AVERAGE MANSON CONCERT. I HAVE WITNESSED RAPES AT MOST CONCERTS. THE CROWD GET INTO A FRENZY AND FEMALES ARE HELD DOWN AGAINST THEIR WILL AND RAPED MANY TIMES AS MANSON PRODS THEM ON.

13. I WITNESSED THE MANSON SECURITY GUARDS GIVING LIQUID ECSTASY TO CHILDREN AND AS THOSE CHILDREN, NINE, TEN, ELEVEN YEARS OLD WERE EFFECTED BY THE "LOVE POTION" DRUG, THEY BECAME WILLING TO HAVE SEX. I HAVE WITNESSED CHILDREN HAVING SEX IN THE AUDIENCE AT MARILYN MANSON CONCERTS.

14. I HAVE WITNESSED MANSON MASTURBATING ON STAGE BEFORE THE CROWD AND THEN EJACULATE INTO THE CROWD.

15. I HAVE WITNESSED MANSON PERFORM A SATANIC CHURCH SERVICE TOWARD THE END OF THE CONCERT IN WHICH HE PREACHES FROM THE SATANIC BIBLE, AND BOOKS CALLED, "ORANGE MAGIC," "GREEN MAGIC" AND "BLACK MAGIC." THE LENGTH HE PREACHES DEPENDS ON HOW HIGH HE IS AT THE TIME. MANSON GIVES AN INVITATION TO RECEIVE SATAN INTO YOUR LIFE AND A HYPNOTIC VOICE COMES OVER THE SOUND SYSTEM SAYING YOU MUST GO FORWARD TO THE ALTAR. THIS WHOLE AREA IS WHERE THE MOSH PIT WAS. HE OPENS THE WHOLE FRONT UP. THIS INVITATION IS ESPECIALLY POTENT BECAUSE BY THAT TIME 100% OF THE AUDIENCE IS HIGH.

[CONTINUED]

THE LONG HARD ROAD OUT OF HELL

## NEW YORK [CONTINUED]

As I was trying to walk downstairs, someone pulled me aside and said, "Come do this interview." So me, Billy, Twiggy and Billy's girlfriend walked over to this couch where Howard Stern was broadcasting from. Joan Rivers was standing across from us. It was loud and chaotic and no one could hear anything anyone was saying (except us, because we had headphones on). Joan Rivers was holding up a sign that said, "I need to talk to you." So I felt like I had to explain what was going on to Howard, because it was all being filmed for television. I joked that Joan had given me a blow job in the bathroom and now she was stalking me and I couldn't get rid of her because she wanted to give me another sloppy blow job or something. I motioned for her to come over, and she came over and got down on her knees in front of me to beg for an interview. But it looked like she was supporting my claim—except for those beanbag tits she's not bad looking for her age. Since she couldn't understand what we were saying, we continued to humiliate her until we got bored.

We were just standing around afterwards when all of a sudden I saw walking towards me this blond tan girl—the antithesis of what I look for in a woman—in a bright canary yellow dress that she must have had to wear as some kind of karmic retribution for something she had done in a past life. Though she was not the kind of girl you'd want to hold hands with in public, the fact that she was attractive shone through. All this flashed before my eyes in the first few seconds because I decide if I'm going to like somebody before they even mention their name. I have a bad habit of not remembering people's names when they say them. I'm usually too busy analyzing them—trying to read their intentions and determine if they're out to fuck me or get fucked, if they want drugs or have drugs, if . . . I can't think of anything else that's important in life.

So this canary woman asked for my autograph because she's a really big fan. A little annoyed at being interrupted, I quickly dashed off an autograph, but as I did everyone was looking at me funny, like I was fucking someone's mother or shitting in the punchbowl. Afterwards, some guy came up to me and told me that the woman was Jenna Jameson. I asked him who Jenna Jameson was, and he said that she was the most famous porno star right now. In the back of my head I thought about my acid trip experience in Fort Lauderdale, and the fact that Traci Lords had actually been up for the part of a seductress in the Howard Stern movie.

She asked if she could sit with me during the movie—she seemed real innocent, or she was a good actress—and we walked to the theater, assaulted by so many paparazzi flashbulbs that for a minute I really felt like I was back on that acid trip in my bathroom with the flashing lights. I got scared for a moment, but the fruity pills calmed me down. When I sat down, in front of me was Kevin Bacon, behind me was Sherman Helmsley, and walking across the room was Corey Feldman, a name that, ironically, one of my bandmates was staying under at the hotel. I was always amused by Corey Feldman. He was a great actor in *Stand by Me* when he had the deformed ear and went around saying, "Jeordie screwed the pooch, Jeordie screwed the pooch." I always said that to Jeordie, especially when he did screw the pooch, who in some cases could be considered Courtney. (I probably shouldn't write this since, if anyone does end up stealing this journal and trying to destroy it, it'll probably be Courtney.)

Corey was in a pseudo–Michael Jackson sort of outfit that made him look stupider than any of his movies had ever made him look, and that's hard to achieve, especially after *Dream a Little Dream (Part 5)*. I felt like it was my duty to introduce Corey Feldman to Sherman Helmsley since I had known their artwork for so long. In order to shake hands, they had to reach over the head of Billy Corgan, so his bald head became the bridge over which two fallen heroes of my childhood, Mr. Jefferson and Dorky the Vampire Slayer, met.

I continued to torment Corey afterwards, putting lipstick on him and introducing him to strangers. Because it is my duty to punch below the belt, I told him I was a big fan of the rap song that I saw him perform on television, which was among the shittiest songs ever recorded yet still not cool enough by far to be the worst thing I had ever heard.

*how i got my wings*

16. I WITNESSED MANSON CALL FOR THE VIRGIN SACRIFICE IN WHICH ALL THE CHILDREN IN THE CONCERT ARENA ARE PUSHED FORWARD BY THE CROWD TO BE DEDICATED TO SATAN.

17. I WITNESSED MANSON SHARING FROM THE SATANIC BIBLE, PRONOUNCING SOME WORDS OVER THE ONES WHO HAVE COME OR BEEN PUSHED FORWARD AND THEN MANSON POURS PIG'S BLOOD OVER EVERYONE WHO HAS BEEN IN THIS GROUP. THEN MANSON CALLS FORTH HIS "PRIESTS" TO MINISTER TO EACH PERSON AND THEY TAKE NAMES, ADDRESSES AND PHONE NUMBERS FOR CONTINUED CONTACT. MANSON HANDS OUT SATANIC BIBLES AND ADDRESSES OF SATANIC CHURCHES THEY SHOULD GO TO.

18. DURING THE CONCERT I WITNESSED MANSON BRING UNDERAGED TEENAGERS, FOURTEEN, FIFTEEN, SIXTEEN, SEVENTEEN, OUT ON STAGE AND PUT THEM INTO A CAGE. THE CAGE IS THEN PUT OUT INTO THE AUDIENCE AND MANSON WANTS THE CROWD TO BEAT ON THOSE INSIDE THE CAGE. THESE CHILDREN ARE PART OF MANSON TOUR.

19. I HAVE BEEN ON MANSON'S SPECIAL TOUR BUS A HALF DOZEN TIMES AND HAVE WITNESSED UNDERAGE GIRLS AND SOME BOYS STRIPPED NAKED AND HANDCUFFED TO THE BUS SEATS. EVERY TIME I'VE BEEN ON THE BUS, THE FACES ARE DIFFERENT. I HAVE SEEN SOME OF THOSE FACES ON TELEVISION AS MISSING CHILDREN OR RUNAWAYS.

20. I WITNESSED A VIDEO TAPE THAT MANSON PLAYED FOR ME IN NOVEMBER OF 1996. HE CALLED IT HIS "BLOOD BATH" VIDEO. THE VIDEO SHOWED MANSON PLAYING A GUITAR. SURROUNDING HIM WERE PEOPLE PLAYING A VAMPIRE GAME IN WHICH THEY STARTED BITING EACH OTHERS' NECKS. THEN ONE MAN CAME OUT OF THE GROUP AND STABBED A FEMALE SEVERAL TIMES. THEN ABOUT TEN OTHER PEOPLE CAME OVER TO THE BLEEDING FEMALE AND LITERALLY SCOOPED UP BLOOD FROM HER BODY AND BATHED IN THE BLOOD. THEY COVERED THEIR BODIES WITH THE BLOOD. THIS WAS OFFERED AS A SACRIFICE TO SATAN. THEY ALL LOOKED LIKE THEY WERE DRUGGED AND THE FEMALE VICTIM THAT WAS KILLED SEEMED WILLING TO DIE.

21. THIS EXPERIENCE WITH THE "BLOOD BATH" VIDEO MADE ME FEAR FOR MY OWN SAFETY AND I BECAME SO SCARED, I DECIDED I MUST GET AWAY FROM THESE PEOPLE. THEY HAVE SENT ME A HALF DOZEN TICKETS AND BACKSTAGE PASSES TO THE OKLAHOMA CITY CONCERT ON FEBRUARY 5, 1997. THEY DO NOT KNOW I'VE TURNED MY LIFE AROUND AND I AM NOW FULLY INVOLVED AT [NAME WITHHELD] AND HAVE GIVEN MY LIFE TO THE LORD JESUS CHRIST.

22. I WITNESSED MARILYN MANSON BRING A SHEEP OUT ON STAGE, AND FROM MY VIEWPOINT FROM THE STAGE, I SAW MANSON PERFORM SEXUAL INTERCOURSE ON THE SHEEP.

23. FURTHER, YOUR AFFIANT SAYETH NOT.

EXECUTED THIS 21 DAY OF JANUARY, 1997

[NAME WITHHELD]     [ADDRESS WITHHELD]

—FAKE AND DEFAMATORY AFFIDAVIT DISTRIBUTED BY THE AMERICAN FAMILY ASSOCIATION

## NEW YORK [CONTINUED]

When the movie started, Jenna Jameson kept making comments like, "Well, what are we going to do later? Are we going to go out to a bar? Are we going to hang out? You know I strip dance to your music. Wow, I can't believe that I'm really sitting here with you. . . . " She had a whole catalog of different "I'm a whore, I'm a virgin, I'm your mom, I'm your daughter" lines; she had all kinds of fuck-me-doll looks; she pulled out the entire contents of her seduction bag of tricks. There's a scene in the film where Howard is sitting with a famous B-movie girl at a theater and she puts her hand on his leg. At the same time Jenna put her hand on my leg, which completely freaked me out because the part that Traci Lords was originally supposed to play in the film was that B-movie actress.

Jenna's hand slowly started to creep up toward my crotch, and, since I wasn't on coke, I had a hard-on. I probably could have gotten one anyways because she had some sort of magical touch to her fingertips. After the film, we rode to the Whiskey Bar in my limo. She had a friend with her that nobody wanted to talk to because she wasn't a porn star and the fact that she wasn't wearing a yellow dress didn't help her from not being as attractive as Jenna. Maybe Jenna had worn the yellow dress out of friendship, like a golfing handicap, to diminish her powers.

At the bar, we sat between Billy Corgan and Rick Rubin. Somehow Jenna had my jacket on her lap, and she put my hand up her skirt to show me that she wasn't wearing any underwear. So I was sitting there with my hand inside her trying to convince Billy Corgan, on my left, that if he wore a yellow shirt with a black zigzag across it he would be Charlie Brown. But I was so drunk and high that Rick Rubin's beard seemed like a cloud, covering the whole room. Everybody had his beard. I looked around and Jenna had the beard, I felt the beard under her skirt, all of a sudden Billy Corgan had a full head of hair made out of Rick Rubin's beard. ZZ Top showed up in the *Eliminator* car and a bunch of hot girls got out. They were all people I had fucked and they all had beards. I got stressed out, and I was having a bit of an episode, and I didn't know where my finger was. When I removed it I was too scared to look at it or smell it because if it was good, I would want to make Billy smell it, and if it was bad, I didn't want it to ruin the pleasant evening I was anticipating. So I just avoided it altogether, sitting on my hand so the smell wouldn't waft.

Back in the limo, I asked if she wanted to go back to my room. But she said she had someone waiting for her at her hotel. Then she had some kind of secret dialogue with her friend in Urdu or old Dutch or sign language or hieroglyphics. What I discovered through my years of linguistic and archeological research into women's codes was that she was married and her husband was waiting for her, which was fantastic and made me want her more. So she came back with me, of course, and I recalled from the film that the character who was supposed to be played by Traci Lords made Howard Stern get in the bathtub with her. So I thought, "Why not?" The only other thing I can remember from that night is that she had a tattoo on her ass that said, "Heartbreaker." But then again, everyone in America who has ever watched any of her films knows that, so maybe it was all a dream. But if it was a dream, it was a wet one.

## MARCH 11, 1997, JAPAN

I feel like someone I wouldn't let my own daughter fuck, and I feel like someone who, if I was that daughter, I would want to fuck more than anyone else.

## UNDATED

I'm so fucking sick of people saying we have T-shirts that say, "Kill your parents and kill a dog." What the T-shirt actually says is, "Warning: The music of Marilyn Manson may contain messages that will KILL GOD in your impressionable teenage minds. As a result, you could be convinced to KILL YOUR MOM & DAD and eventually in a hopeless act of suicidal 'rock and roll' behavior you will KILL YOURSELF.

[CONTINUED]

\*MARILYN MANSON WILL COMMIT SUICIDE ON HIS HALLOWEEN CONCERT BY
BLOWING UP THE VENUE AND EVERYONE IN IT.
\*MARILYN MANSON HAD THREE RIBS REMOVED SO HE CAN SUCK HIS OWN DICK
\*I HEARD THAT HE GIVES HIMSELF A BLOW JOB ON STAGE AND SPITS
THE CUM OUT ON THE CROWD.
\*I ALSO HEARD THAT AT A RECENT SHOW THEY CAME ONTO STAGE WITH THE TWO RIBS
THAT HE HAD SUPPOSEDLY REMOVED AND USED THEM AS DRUMSTICKS. IS THIS TRUE?
\*I HEARD MY FRIEND SAY THAT MANSON KILLED HIS WIFE BECAUSE SHE WAS PREGNANT,
THEN HE TOOK OUT THE BABY, NAMED LUCIFER SATAN DAMIAN (LSD),
AND PUT IT IN AN ABORTION CRIB.
\*MANSON WAS PAUL ON THE *Wonder Years*
\*MANSON WAS WINNIE COOPER ON THE *Wonder Years.*
\*MANSON WAS THE LITTLE KID ON *Mr. Belvedere.*
\*I HEARD THAT MARILYN MANSON WAS THE GUY ON THE *Wonder Years*
BUT THEN STARTED HIS OWN RUMOR AND SAID HE WASN'T JUST TO THROW PEOPLE OFF.
\*DAISY AND ZIM ZUM ARE THE SAME PEOPLE, BUT MANSON THOUGHT IT WOULD
GET HIM MORE PUBLICITY IF HE "GOT A NEW GUITARIST."
\*MARILYN MANSON IS ACTUALLY THE SON/DAUGHTER OF
CHARLES MANSON AND MARILYN MONROE.
\*I HEARD THAT MARILYN MANSON IS A MEMBER OF A CANNIBAL GROUP AND
HE REALLY IS BLACK AND HE BLEACHED HIS SKIN.
\*MARILYN JUST GOT BREAST IMPLANTS—I KNOW IT'S TRUE, I READ IT IN A MAGAZINE.
\*MANSON IS REALLY A WOMAN, SHE DRESSES LIKE A MAN ONLY TO HAVE
SEX WITH OTHER WOMEN.
\*MARILYN MANSON STARTED AS A SAIGON KICK SIDE PROJECT.
\*MARILYN MANSON CUT ONE OF HIS TOES OFF SO THAT HE COULD
INJECT HEROIN DIRECTLY INTO THE VEINS ON THE STUMP.
\*HE GOT HIS PENIS TATTOOED BLACK.
\*THE ONLY REASON TRENT PRODUCED MM'S FIRST ALBUM IS
BECAUSE MANSON GIVES SUCH GOOD HEAD.
\*A GIRL SAID MR. MANSON HAD SEX WITH A PIG IN ONE OF THE VIDEOS.
NOW, I'VE NEVER SEEN THAT ONE.
\*PEOPLE AT MY SCHOOL SAY THAT THE REV. REMOVED PIGMENT FROM HIS
LEFT EYE SO THAT HE COULD SEE BLACK AND WHITE.
\*A GIRL THAT I WORK WITH TOLD ME THAT MARILYN MANSON SOLD HIS RIGHT EYE TO
THE DEVIL AND THAT IS WHY HE WEARS RED MAKEUP UNDERNEATH HIS EYE.
\*MARILYN MANSON HAD HIS GIRLFRIEND'S EYE REMOVED SO HE COULD FUCK HER IN IT.
\*MARILYN MANSON'S GRANDFATHER USED TO RAPE HIM WHEN HE WAS LITTLE AND
WHEN HE TOLD SOMEONE ABOUT IT HIS GRANDFATHER RIPPED OUT HIS EYE.
\*ZIM ZUM JOINED THE BAND JUST TO GET IN BED WITH MANSON
\*DAISY AND MANSON WERE LOVERS, BUT MANSON LEFT HIM FOR TWIGGY CUZ
TWIGGY IS "ANATOMICALLY SUPERIOR" TO DAISY.
\*I ONCE HEARD THAT REV. AFTER AN INTERVIEW WENT ON STAGE AND PULLED A
COKE BOTTLE OUT OF HIS ASS.
\*THE REV. WAS MAKING CUTTING MOTIONS ACROSS HIS NECK WITH A
KNIFE AND ACCIDENTALLY CUT TOO DEEP, SEVERING HIS WINDPIPE. TWIGGY HELD HIS
THROAT TOGETHER FOR HIM SO HE COULD BREATHE UNTIL THE PARAMEDICS GOT THERE.
\*MANSON EITHER KILLED OR HAD SEX WITH A CAT.
(I CAN'T REMEMBER WHICH IT WAS. I THINK KILL.)
\*MARILYN MANSON ALSO FUCKED A DONKEY UP THE ASS ON STAGE,
THE SAME NIGHT HE SWALLOWED A CAT WHOLE!!
\*MANSON WANTED TO RUN FOR PRESIDENT BUT MISSED SOME SORT OF DEADLINE.
\*HE CHOPPED THE FEET OFF A HAMSTER.

## —RUMORS POSTED BY "FANS" ON THE INTERNET

THE LONG HARD ROAD OUT OF HELL

## UNDATED [CONTINUED]

So please burn your records while there's still hope." Can't they see I'm trying to help them. I've said a million times that if more stupid people killed themselves over stupid songs, there would be less stupid people in the world. I haven't even sold that shirt in four years. Besides, T-shirts and music people don't kill people. Poor upbringing does. If someone wants to blame art, why are kids taught to read *Romeo and Juliet* in school? Here's a story about kids killing each other for one very important reason: their parents didn't understand them.

## UNDATED

If I'd really gotten my ribs removed, I would have been busy sucking my own dick on *The Wonder Years* instead of chasing Winnie Cooper. Besides, I wouldn't have sucked other people's dicks on stage, either. I would have been sucking my own. Plus, who really has time to be killing puppies when you can be sucking your own dick? I think I'm gonna call a surgeon in the morning.

## UNDATED

Last night, or rather this morning, some skaggy whore in her forties who was convinced she was in her teens and claimed to be Anthony Kiedis's cousin or Billy Corgan's sister or Shaquille O'Neal's mother came onto our bus. She was with some goofy tan girl with braces who looked like she could have been her daughter. Neither of them looked good but they were entertaining because they were so blind to their own white trash qualities. So we let them stay and managed to convince them to snort a packet of sea monkey powder. Strangely enough, it was white and came with a small spoon, not unlike cocaine. I didn't even have to use false pretenses to persuade them to do this. I actually read them the training manual, explaining that these small creatures are actually brine shrimp and that they will go on to grow inside their bodies for a year. I told them that nothing could be more exciting than having these small creatures flowing through their bloodstream—not to mention the unknown high that might await them. Surprisingly, they did it eagerly. And I shamefully spent the night talking to the skag, who tried to masturbate me while a video of *Doom Generation* was playing in the background. I wished for a moment the girl in the movie, Rose McGowan, was here, and maybe I would let her masturbate me. I remember reading an interview with Rose about her fucked-up childhood and her father, who was the leader of some religious cult. For some reason, I feel like she would be able to relate to what I'm going through—not at the moment but in general. To nobody's surprise, Twiggy ended up fucking braceface in his bunk. I'm so ashamed to be a part of this band.

## APRIL 6, 1997, NORMAL, ILLINOIS

I'll kill anyone who thinks this town is anyone's idea of normal. It lets me know that there's a lot of work still for me to do. But I'm kind of proud of what we've accomplished so far on this tour. I really wanted to do that totalitarian shock-symbol thing, to create a part of the show that resembled a fascist rally, to make a statement about things I'm against like religion and, in some ways, rock and roll, because rock and roll can be just as blind as Christianity. At the same time I wanted to create a giant piece of performance art that said that, despite everything that's happened with the media and people trying to ban our shows, "I did this, and I got away with it." How did Bowie get away with lyrics about "the spics, the blacks . . . and the faggy bars"? It's because he's in character and he's criticizing a certain type of person. *Antichrist Superstar* isn't that at all: It's what everybody feels in their hearts but is too afraid to say. It's honest. It's not picking on any one person, it's picking on everybody including myself. We're all hypocrites, but by admitting it, you transcend it and it no longer becomes a personality defect as it is in the people who blindly cling to their own self-righteousness. By knowing all this, you grow from it. I've grown from it.

I will never admit this to anyone, but I'll write it here: The reason I haven't copped out in an interview and said, "Yeah it's just a character, this is just a concept album," is because to me it is so much more. But in a sense it is. That's why when people ask, "Well is it an act or isn't it?" it's both. I mean my whole life is an act, but that's my art.

"THIS IS PERHAPS THE SICKEST GROUP EVER PROMOTED
BY A MAINSTREAM RECORD COMPANY."
—SENATOR JOSEPH LIEBERMAN OF CONNECTICUT

"FROM WHAT I HAVE LEARNED OF THE CONTENT OF THEIR LYRICS AND MESSAGE AS
WELL AS THEIR CONDUCT ON STAGE, [MARILYN MANSON] ARE CLEARLY BENT ON
DEGRADING WOMEN, RELIGION AND DECENCY, WHILE PROMOTING SATANIC WOR-
SHIP, CHILD ABUSE AND DRUG USE. THESE PEOPLE ARE PEDDLING GARBAGE. IT'S
FURTHER PROOF THAT SOCIETY'S MORAL VALUES CONTINUE TO CRUMBLE."
—GOVERNOR FRANK KEATING OF OKLAHOMA ON CONCERT
AT THE STATE FAIRGROUNDS

"I THINK IT'S TIME THAT PEOPLE PROTEST [MARILYN MANSON] ALL OVER THE
NATION, THIS THING IS THE MOST DEGRADING, IT INCITES PEOPLE TO MURDER, TO
RAPE. SAYING THAT DATE RAPE IS NO BIG DEAL IN AN ERA WHERE WE'RE SO CON-
CERNED ABOUT SEXUAL HARASSMENT . . . IT'S UNBELIEVABLE! YET THIS IS GOING
TO THE TOP OF THE HEAP AND *Rolling Stone* SAYS HOW CREATIVE THEY ARE. WHAT
KIND OF CREATIVITY IS THIS?"
—PAT ROBERTSON, THE 700 CLUB.

"MANY PEOPLE KNOW THE DEBAUCHERY MARILYN MANSON REPRESENTS:
SODOMY, SADOMASOCHISM, YOUTH PORNOGRAPHY, SATANISM AND THE LIKE. IT IS
CLEARLY DISTURBING, THREATENING AND SICKENING TO MANY MINNESOTANS.
WE DESERVE BETTER AS A COMMUNITY.
"WE HOPE YOU WILL ADOPT SOME MORE REASONABLE STANDARDS FOR
THE CULTURAL EVENTS YOU SPONSOR IN THE FUTURE. IN ADDITION, WE BELIEVE A
PUBLIC APOLOGY FOR SUBJECTING THE TWIN CITIES TO MARILYN MANSON WOULD
BE IN ORDER."
—LETTER FROM THE MINNESOTA FAMILY COUNCIL
TO THE BEST BUY CORPORATION

"WE'RE FIGHTING FOR GOD AGAINST SATAN."
—FLORENCE HENSELL, LETTER TO UTICA CITY COUNCIL, ON CONCERT AT
UTICA AUDITORIUM

"I DON'T NORMALLY INTERFERE WITH THE FREE-ENTERPRISE STYLE,
BUT IN THIS CASE I CAN'T FATHOM ANYBODY BEING ASKED TO PAY FOR
TICKETS TO SEE THIS FILTH."
—ALDERMAN RAY CLARK OF CALGARY ON CONCERT AT MAX BELL CENTRE

"I WAS NOT EVEN AWARE OF A GROUP CALLED MARILYN MANSON UNTIL ABOUT
TWO OR THREE WEEKS AGO WHEN ALL OF A SUDDEN OUR OFFICE AND MY HOME
HAVE BEEN INUNDATED WITH PHONE CALLS WITH CONCERNS ABOUT THIS CONCERT
THAT'S PERFORMING THIS EVENING IN WINGS STADIUM IN KALAMAZOO . . . THEIR
MESSAGE IS TO KILL GOD, KILL YOUR PARENTS AND THEN COMMIT SUICIDE.
I HANDED OUT TO ALL MY COLLEAGUES AN ARTICLE ABOUT WHAT MR. MANSON
CONFESSES THAT HE'S DONE AS FAR AS ON THE STAGE FROM SEXUAL TYPES OF ACTS
TO A NUMBER OF VULGAR TYPES OF THINGS THAT PROMOTE VIOLENCE IN OUR SOCI-
ETY, AND I'M VERY CONCERNED ABOUT THAT. SO WITH THAT, WE PUT A RESOLU-
TION TOGETHER . . . THAT ANYONE UNDER EIGHTEEN YEARS OF AGE BE ACCOMPA-
NIED BY THEIR PARENTS. . . . WE'VE RECEIVED ABOUT 10,000 SIGNATURES JUST IN
THE KALAMAZOO AREA THAT ARE AGAINST THIS CONCERT."
—SENATOR DALE SHUGARS OF MICHIGAN

## UNDATED

Just got a phone call from my father. He was watching *Real Stories of the Highway Patrol* and said that on the show they caught a guy they had been chasing across Ohio. When they pulled him over, they found a trunk full of guns. He was a twenty-five-year-old Christian fanatic with missing teeth, and he said he was going to Florida to kill the Antichrist. The episode had been taped the same week we just played in Florida.

## APRIL 1997

I am enclosing the napkin on which I drafted a statement I had to make on MTV about our show being canceled against our will in South Carolina:

"Once again the so-called servants of God have proven my point with their hypocritical and hostile behavior. And once again they have illustrated their lack of separation between church and state and their disgusting similarities to Nazi Germany. Unfortunately everyone suffers: We suffer, our fans suffer, the constitution of the U.S.A. suffers, and the pious right-wing politicians of South Carolina suffer because everyone now sees them for the fascist idiots they are. What do we expect in a state that still flies the Confederate flag? You want a revolution? You'll get it!"

## MAY 10, 1997

Just found out that one of my roadies, Sean McGann, died last night. He had been drinking and was trying to rappel down the catwalk. But he forgot to attach the ropes. I know it's not my fault, but I can't help feeling that it somehow is, because if it wasn't for me he'd still be alive.

Maybe I've lived a sheltered life, because outside of my dog Aleusha this is really the first person close to me who has died. It makes me wonder what I was thinking years ago when I tried to kill Nancy and our old bassist, Brad. Trying to kill them would have been pointless. Nature takes its own course. It's Social Darwinism. People get what they deserve. But did Sean really deserve that?

## MOTHER'S DAY, BACK LOUNGE, 6 A.M.

I called my mother today, and realized really for the first time how shitty I had acted as a kid and how much abuse I had given her. If it weren't for her tolerance and unconditional love and support, I wouldn't have gotten this far. I told her I loved her, and she said she already knew that. If she didn't, her pride would have convinced her of it anyway. I've been seeing a lot of my father lately, too. He comes to a lot of the shows. He seems to enjoy the attention more than I do. He goes around telling people that he's the father of the God of Fuck. I think now that we understand each other, our relationship has become so much better than it was when I was a kid. I guess when people began to accept what I did, my parents began to accept it as well.

## MAY 29, 1997, PARIS

I talked to Snoop Doggy Dogg today. Well, I'm not sure if you could really call it talked because I could hardly understand a word he was saying. But I think what he was trying to communicate was that he wanted to work with me in some sort of capacity and something involving marijuana.

## JUNE 15, 1997, NEW YORK

With the help of our civil rights lawyer Paul Cambria, we won our case against the state of New Jersey and we were able to perform on the OzzFest at Giants Stadium today, despite the objections of the stadium's management. (It's funny because I saw the Larry Flynt movie the other day and my friend, Edward Norton—Courtney's boyfriend—played a composite of Paul and several other lawyers who worked on the *Hustler* case.) Despite the fact that the story was on the news every five minutes, I'm not sure the crowd knew or even cared there was a case. We smashed everything, including ourselves, out of frustration at their apathy. I ended up slashing myself pretty badly, and paramedics won't stitch you on the spot for insurance reasons. They wanted me to go to the hospital, but I stayed backstage and got drunk with Pantera. We talked about the first time I hung out with Dimebag Darrell,

[CONTINUED]

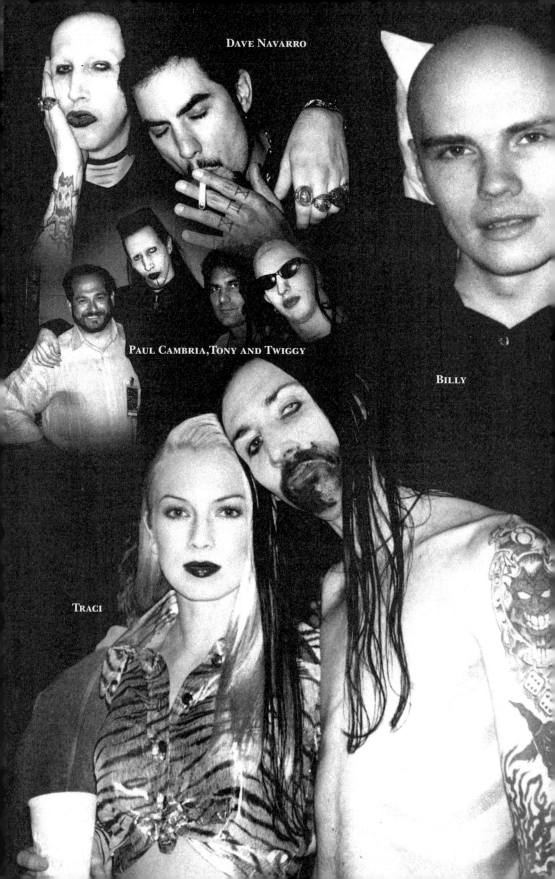

DAVE NAVARRO

PAUL CAMBRIA, TONY AND TWIGGY

BILLY

TRACI

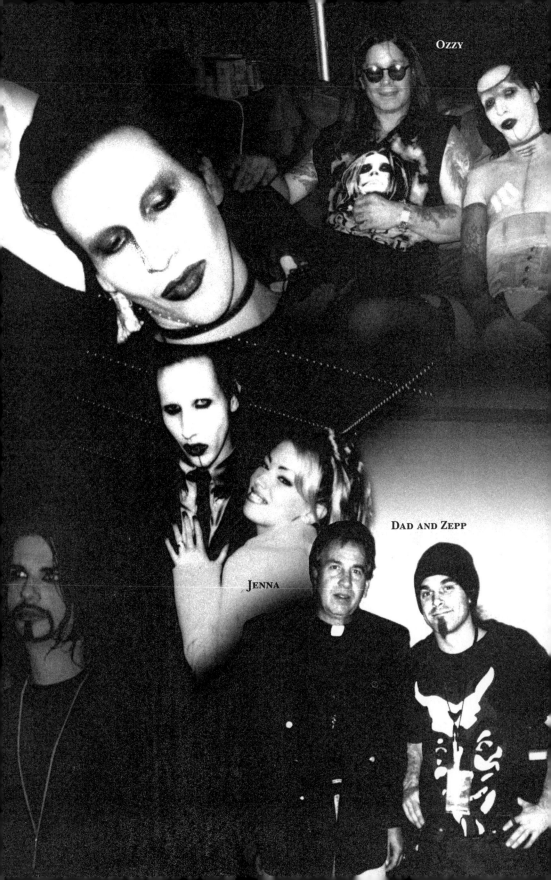

OZZY

DAD AND ZEPP

JENNA

CURRENTLY BEFORE THE COURT IS AN APPLICATION TO ENJOIN THE NEW JERSEY SPORTS EXHIBITION AUTHORITY ("NJSEA") FROM PRESENTING THE "OZZFEST '97" CONCERT, WHICH INCLUDES PERFORMER "MARILYN MANSON," FROM BEING HELD AT GIANTS STADIUM ON JUNE 15, 1997. MARILYN MANSON IS A HEAVY METAL BAND THAT THE NJSEA HAS DEEMED OBJECTIONABLE. MARILYN MANSON'S RIGHT OF PASSAGE TO PERFORM AT GIANTS STADIUM IS NOW IMPEDED BY ROADBLOCKS CREATED BY THE COLLISION BETWEEN WELL-ESTABLISHED CONSTITUTIONAL AND CONTRACTUAL PRINCIPLES. . . .

ON APRIL 18, 1997, THE NJSEA ISSUED A NEWS RELEASE ENTITLED "STATEMENT OF THE NEW JERSEY SPORTS AUTHORITY MANAGEMENT REGARDING MARILYN MANSON AND THE OZZFEST CONCERT." THE ANNOUNCEMENT INDICATED THAT MARILYN MANSON WOULD BE PROHIBITED FROM PERFORMING AT GIANTS STADIUM AND CANCELED THE OZZFEST EVENT DUE TO THE INCLUSION OF MARILYN MANSON. . . .

THE NSJEA HAS INDICATED THAT IT EXCLUDED MARILYN MANSON FROM THE CONCERT BECAUSE OF THE BAND'S "ANTICS." ACCORDING TO THE NSJEA, THESE ANTICIPATED "ANTICS" MAY [CREATE] SECURITY RISKS AND MAY [TARNISH] THE NSJEA'S REPUTATION AND ABILITY TO REMAIN A LUCRATIVE FORUM FOR CONCERT EVENTS. . . .

THE CLAUSE ON WHICH THE NSJEA RELIES FOR ITS AUTHORITY TO EXCLUDE MARILYN MANSON FROM THE SHOW CONFIRMS THE MOTIVATION OF THE NSJEA. UNDER THE NSJEA'S PROPOSED CONTRACT, IT MAY EXCLUDE A PERFORMER FOR: "GROUNDS OF CHARACTER OFFENSIVE TO PUBLIC MORALS, FAILURE TO UPHOLD EVENT ADVERTISING CLAIMS OR VIOLATION OF EVENT CONTENT RESTRICTIONS AGREED TO BY BOTH PARTIES AT TIME OF COMPLETION OF THIS AGREEMENT." THE ONLY ASPECT OF THIS CLAUSE THAT THE NSJEA RELIES UPON IS THAT MARILYN MANSON'S PERFORMANCE IS ANTICIPATED TO BE "OFFENSIVE TO PUBLIC MORALS." THIS APPEARS TO BE THE QUINTESSENTIAL ESSENCE OF CONTENT BASED REGULATION.

THE NSJEA HAS ARGUED THAT SAFETY CONCERNS PROMPTED ITS REFUSAL TO ALLOW MARILYN MANSON TO PLAY AT GIANTS STADIUM. BUT THE NSJEA HAS PUT FORTH NO EVIDENCE THAT ITS PROFFERED SAFETY CONCERNS ARE LEGITIMATE RATHER THAN PRETEXTUAL. TO THE CONTRARY, NO UNLAWFUL OR VIOLENT ACTIVITY HAS OCCURRED ON MARILYN MANSON'S CURRENT TOUR. AND IT APPEARS THAT THE PLAINTIFFS HAVE COMPLIED WITH NSJEA'S REQUESTS FOR CONCESSIONS INTENDED TO BOLSTER SECURITY. . . .

THE NSJEA ALSO ARGUED THAT THE INCLUSION OF MARILYN MANSON WOULD TARNISH NSJEA'S REPUTATION AND ABILITY TO EARN REVENUE. BUT, THE NSJEA CONCEDED AT ORAL ARGUMENT THAT THE DECISION TO EXCLUDE MARILYN MANSON WAS NOT BASED ON THE ECONOMICS OF THE SHOW IN QUESTION; THE SHOW WAS ANTICIPATED TO EARN SUBSTANTIAL REVENUE. RATHER, NSJEA ARGUED THAT THE INCLUSION OF MARILYN MANSON WOULD SOMEHOW AFFECT NSJEA'S FUTURE ABILITY TO USE THE STADIUM. THE NSJEA'S ARGUMENT IS INSUFFICIENTLY CONCRETE TO BE PERSUASIVE AND THERE ARE NO WRITTEN GUIDELINES DEFINING WHAT MIGHT ENDANGER NSJEA'S REPUTATION. CONSEQUENTLY, THE COURT IS NOT PERSUADED.

ADDITIONALLY, IT APPEARS THAT THE NSJEA'S REQUIREMENT THAT ALL PERFORMERS SIGN A CONTRACT ALLOWING THE NSJEA TO REGULATE THE MORALITY OF CONCERT PROGRAMS MAY BE AN UNREASONABLE RESTRICTION ON ACCESS TO EVEN A NON-PUBLIC FORUM. . . .

IT APPEARS PATENTLY UNREASONABLE THAT GIANTS STADIUM WOULD PERMIT AN ENTIRE CONCERT OF HEAVY METAL BANDS, WHILE EXCLUDING ONLY ONE— MARILYN MANSON—WHICH HAS DEMONSTRATED NO PROPENSITY FOR ILLEGAL ACTIVITIES ON STAGE. THUS, THE NSJEA WILL SUFFER NO IRREPARABLE INJURY FROM ALLOWING MARILYN MANSON TO PERFORM AT GIANTS STADIUM. . . .

IT IS ON THIS 7TH DAY OF MAY ORDERED THAT, PENDING A HEARING ON AN APPLICATION FOR A PERMANENT INJUNCTION, THE NSJEA IS PRELIMINARILY ENJOINED AND RESTRAINED FROM PROHIBITING PLAINTIFFS FROM PRESENTING A CONCERT PERFORMANCE BY "MARILYN MANSON" AT GIANTS STADIUM ON JUNE 15, 1997.

—FROM THE DECISION OF THE UNITED STATES DISTRICT COURT OF NEW JERSEY UPHOLDING THE RIGHT OF PLAINTIFFS, MARILYN MANSON, INC., ET. AL., TO PERFORM AS PART OF THE OZZFEST AT GIANTS STADIUM, WHICH HAD BEEN CANCELED BY THE DEFENDANT, NJSEA.

 THE LONG HARD ROAD OUT OF HELL

who in addition to playing guitar in Pantera is actually the creator of Tony Wiggins. He took Twiggy, Pogo and me back to his house in Dallas. After visiting a series of strip bars and doing other things that people who have rebel flag bumper stickers would do, I vaguely remember someone putting acid in my mouth and waking up in a litter box trying to keep a pig from shitting on my face.

## JUNE 19, 1997, CHICAGO

I expected the OzzFest crowd to be much more open-minded. This is an audience that grew up in the tradition of Black Sabbath, Alice Cooper, and other bands that put on more than your average rock and roll show. But so far it's just been a bunch of really drunk assholes who are intimidated by the fact that they are confused and maybe they want to fuck me, and it pisses them off. But in a weird way, I think I'm beginning to like this. It's been a while since we performed and weren't the headliners. Sometimes a crowd that hates me this much is as good as crowd that loves me, because it inspires me to give my best performance.

## JULY 31, 1997, TORONTO

Today the police told me that if I sang the Patti Smith song "Rock and Roll Nigger" I would be arrested under the hate crime law for promoting racial dishar-mony. So to fuck with the police I had a friend of mine, Corey, who happens to be black, accompany me and my bodyguard, Aaron, into my meeting with these moronic individuals. Wearing a police hat, I asked the officer in charge what prob-lems he had with our show. He nervously shuffled through his notes and said, "There's one song in particular," as if he couldn't remember what it was, and then he mumbles "Rock and Roll Nigger," specifically so as not to offend Corey, who looks like he'll kick the shit out of anyone who's white. I went on to explain to him that not only did Patti Smith write the song (and not me) but that the song represents the iso-lation and discrimination of people for their ideas and their beliefs and their art—which ironically was exactly what this asshole was doing. He still didn't seem to understand so I told him quite simply I would do the song and we would see what happened when it was done.

Though I told him the show would not be changed, I did change it in several sim-ple ways. I donned a police uniform and something given to me by a fan, a badge for-merly in the possession of an officer shot in the line of duty. I also invited Corey to help me sing, in particular the lines with the word nigger in them.

We performed the song as an encore, and I introduced it by saying, "I want to tell you about something that happened recently. There's a song that's twenty years old written by a woman named Patti Smith. And a couple of white cops came up to me and they said, 'You can't sing that song.' They said that it's against black people. What I wanna explain to those moronic fucking idiots is that the song's about people like me and you, people that get discriminated against for the way we are. Just like they fucking discriminated against us today. And they didn't understand. It's because they are a bunch of fucking idiots. So I dedicate this song to the Canadian police force."

What we and the crowd realized more than anything was that nobody here hated "niggers." We all hated cops. I didn't get arrested or even reprimanded. The cops might not have been listening, though. They were probably too busy searching the bathrooms for plungers to stick up our asses.

## SEPTEMBER 1997, PORTUGAL

Plenty of people could do what I'm doing on an underground level—we did it for years and nobody cared. It's not until you're a household name that people give a shit. But what we've done onstage with the fascist banners, with tearing up the bible, with the snow falling from above, with the whole beautiful thing—it's all so much more controversial than nudity or killing dogs onstage because it's so powerful and it has meaning. I feel proud because in the beginning I hesitated. I didn't know if I could

## [CONTINUED]

*how i got my wings*

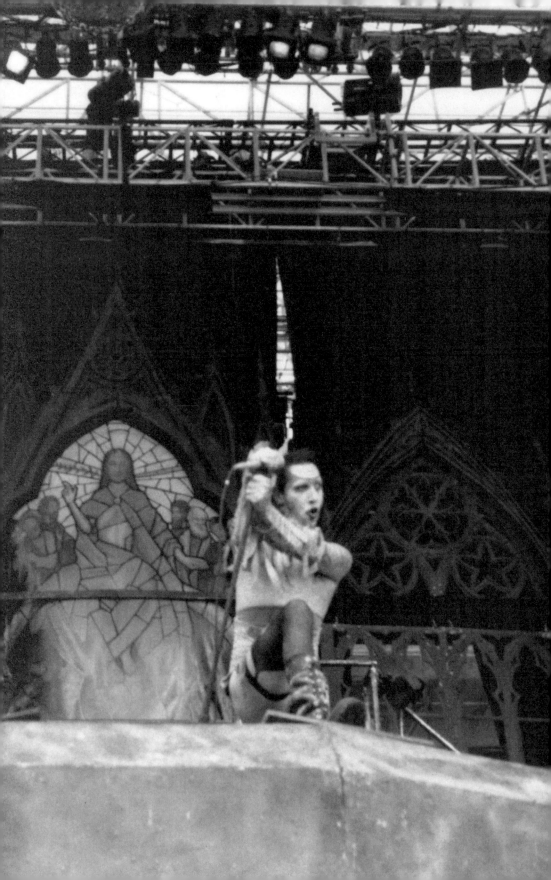

get away with it. I could have been destroyed. I remember when we first played the record for Jimmy [Iovine, head of Interscope Records], he told us, "This is the best rock record that's been written in the past ten years. But I don't want to see you step on the wrong toes because then nobody will ever hear it. Anybody can sell 700,000 records. You can do that out of your garage." So I told him that the important thing to me was that we've written good songs that people will remember and sing. We've infiltrated the mainstream in a way that they don't want, and I think that is a work of art in itself.

## SEPTEMBER 1997, BRAZIL

I opened a fortune cookie and it said, "When all of your wishes are granted, many of your dreams will be destroyed." Well, I've gotten everything that I wanted. We're the biggest band in America. We've got platinum albums. We got the *Rolling Stone* cover that Dr. Hook never managed to get. But I've managed to destroy and lose everything that I've loved along the way. The whole world now looks at me the way I looked at my grandfather. I hope they like what they see, because now I finally do.

## CIRCLE ZERO - ENLIGHTENMENT

I feel one part Elvis Presley, one part Jack Warner and one part Reverend Ernest Angley, and this disturbs me. In making my failures my success, I've become what I was once afraid of.

## SEPTEMBER 17, 1997, MEXICO CITY

Tonight's show was a disaster, a relief, a fiasco, a Mexican standoff and a drug-crazed freak-out. Twiggy slashed his hand open on the very last song of this very last show while smashing his bass. The whole thing was every bit of rock and roll and every bit of everything we represented. I feel like we've grown in the past year, and I'm glad that it's over. I can see already that America, Nothing Records, our friends and the media have perceived this to be the peak of our career. Unfortunately for them it's just the beginning.

THERE IS AN EXIT HERE.

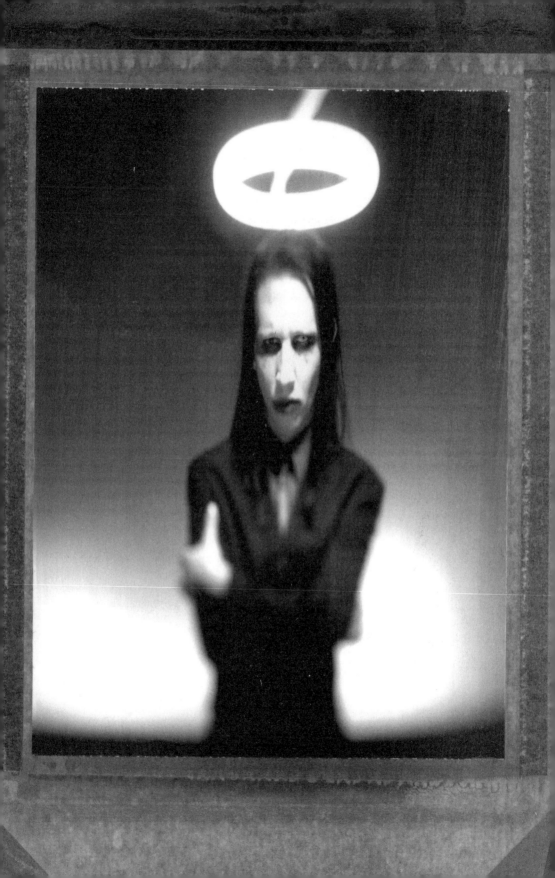

Muscular.                                Artery of the Urethral Bulb.

Inferior Hemorrhoidal.             Urethral.

Perineal.                           Deep Artery of the Penis.

Dorsal Artery of the Penis.

Fig. 561.—The superficial branches of the internal pudendal artery.

# ACKNOWLEDGMENTS

THANKS TO ALEUSHA, ALYSSA, ANDREW AND SUZIE, REVEREND ERNEST ANGLEY, FIONA APPLE, TOM ARNOLD, DANIEL ASH, ASIA, BIG DARLA, BLANCHE BARTON, SEAN BEAVAN, MRS. BURDICK, PAUL CAMBRIA, CARL, CASEY, CHAD, CAROLYN COLE, COREY, BILLY CORGAN, KEITH COST, JOHN CROWELL AND HIS BROTHER, DAVE, FREDDY DeMANN, AARON DILKS, DIMEBAG DARRELL, EDEN, COREY FELDMAN, ROBIN FINCK, FLAVOR FLAV, FRANKIE, FROG, MICHELLE GILL, JOHN GLAZER, SHERMAN HELMSLEY, JIMMY IOVINE, JAY AND TIM, JOHN JACOBAS, JENNA JAMESON, JEANINE, JEBEDIAH, JENNIFER, JESSICKA, JONATHAN, JACK KEARNIE, KELLY'S CORNHOLE, BILL KENNEDY, RICHARD KENT, MARY BETH KROGER, XERXES SATAN LaVEY, LENNY, MR. LIFTO, LISA, TRACI LORDS, LOUISE, COURTNEY LOVE, DAVID LYNCH, LYNN, JOHN A. MALM JR., MARIE, MARK, ROSE McGOWAN, MISSI, MISTRESS BARBARA, NANCY, DAVE NAVARRO, CONAN O'BRIEN, DAVE OGILVIE, GUY OSEARY, PAUL AND RICHARD, SAUCY PETERSON, ROBERT PIERCE, TINA POTTS, MS. PRICE, RACHELLE, TRENT REZNOR, JOAN RIVERS, JIM ROSE, RICK RUBIN'S BEARD, NEIL RUBLE, SHANA, SIOUX Z., BOB SLADE, THE SLASHERS, SNOOP DOGGY DOGG, HOWARD STERN, TERESA, TERRI, DJ TIM, JOHN TOVAR, JILL TUCKER, JULIA VALET, BARB AND HUGH WARNER, BEATRICE AND JACK WARNER, BRIAN WARNER, TONY WIGGINS, THE WYER FAMILY, AND ZEPP.

SPECIAL THANKS TO DAISY BERKOWITZ, GINGER FISH, MADONNA WAYNE GACY, GIDGET GEIN, SARA LEE LUCAS, OLIVIA NEWTON-BUNDY, TWIGGY RAMIREZ, ZSA ZSA SPECK, AND ZIM ZUM.

ADDITIONAL THANKS TO NOVA BONZEK, JENNIE BODDY, JASON BRODY, TONY CIULLA, KELLY COLEMAN, NINA CROWLEY AND THE MASSACHUSETTS MUSIC INDUSTRY COALITION, TODD DARROW, SAM FRANK, SILVIA GARCIA, SARAH LAZIN, PAULA O'KEEFE, RAHAV AND KIMBERLY, PATTY ROMANOWSKI, AND CATHERINE TYC FOR PROOFREADING, TRANSCRIBING, RESEARCH AND/OR LIKING IRON MAIDEN. AND TO EVERYONE AT REGANBOOKS, PARTICULARLY MY EDITORS, JEREMIE RUBY-STRAUSS AND HIS "GIRLFRIEND."

THIS BOOK IS ALSO DEDICATED TO THE MEMORY OF ANTON SZANDER LaVEY.

Punctum lacrimale

Plica semilunaris

Caruncula

Punctum lacrimale

Openings of tarsal
glands

Fig. 911.—Front of left eye with eyelids separated to show
medial canthus.

# PHOTO CREDITS

*fan club:*

**MARILYN MANSON FAMILY**
**25935 DETROIT RD., SUITE #329**
**WESTLAKE, OHIO 44145**